SIMPSON

IMPRINT IN HUMANITIES

The humanities endowment
by Sharon Hanley Simpson and
Barclay Simpson honors
MURIEL CARTER HANLEY
whose intellect and sensitivity
have enriched the many lives
that she has touched.

The publisher gratefully acknowledges the generous support of the Simpson Humanities Endowment Fund of the University of California Press Foundation, which was established by a major gift from Barclay and Sharon Simpson.

The publisher also gratefully acknowledges the generous contributions to this book provided by the following individuals and organizations:

Bobbie & Fletcher Benton
Graduate Theological Union: The Center for the Arts, Religion & Education
Hackett-Freedman Gallery
Harold & Gertrud Parker, Tiburon, Calif.
Paula Z. Kirkeby
Russ McClure
Harry Y. Oda
Hans G. & Thordis W. Burkhardt Foundation
Charles & Glenna Campbell
John B. Stuppin

Peter Selz

Peter Selz

SKETCHES OF A LIFE IN ART

PAUL J. KARLSTROM

WITH *Ann Heath Karlstrom*

UNIVERSITY OF CALIFORNIA PRESS
Berkeley Los Angeles London

University of California Press, one of the most distinguished university presses in the United States, enriches lives around the world by advancing scholarship in the humanities, social sciences, and natural sciences. Its activities are supported by the UC Press Foundation and by philanthropic contributions from individuals and institutions. For more information, visit www.ucpress.edu.

University of California Press
Berkeley and Los Angeles, California

University of California Press, Ltd.
London, England

Every effort has been made to identify the rightful copyright holders of material not specifically commissioned for use in this publication and to secure permission, where applicable, for reuse of all such material. Credit, if and as available, has been provided for all borrowed material either on-page, on the copyright page, or in an acknowledgment section of the book. Errors or omissions in credit citations or failure to obtain permission if required by copyright law have been either unavoidable or unintentional. The author and publisher welcome any information that would allow them to correct future reprints.

Library of Congress Cataloging-in-Publication Data

Karlstrom, Paul J.
 Peter Selz : sketches of a life in art / Paul J. Karlstrom with Ann Heath Karlstrom. —1st ed.
 p. cm.
 Includes bibliographical references and index.
 ISBN 978-0-520-26935-4 (cloth : alk. paper)
 1. Selz, Peter Howard, 1919– 2. Art historians—United States—Biography. 3. Art critics—United States—Biography. 4. Art museum curators—United States—Biography. I. Selz, Peter Howard, 1919– II. Karlstrom, Ann Heath. III. Title.
 N7483.S383K37 2012
 708.0092—dc23
 [B] 2011022766

Manufactured in the United States of America

21 20 19 18 17 16 15 14 13 12
10 9 8 7 6 5 4 3 2

In keeping with a commitment to support environmentally responsible and sustainable printing practices, UC Press has printed this book on Rolland Enviro100, a 100% post-consumer fiber paper that is FSC certified, deinked, processed chlorine-free, and manufactured with renewable biogas energy. It is acid-free and EcoLogo certified.

Contents

Preface

More than a quarter of a century after Peter Selz resigned as director of the University Art Museum in Berkeley, California, and returned to the classroom, he found himself four hundred miles south, seated at a table at L'Angolo Cafe in Los Angeles. His dinner companion asked him if he would like to go watch one of his former undergraduate lecture-class students paint on a large plastic "canvas" while a rock band played. Peter enthusiastically responded, "Let's go!" Shortly thereafter he walked through the door of the Whisky a Go Go on Sunset Boulevard into a wall of highly amplified sound. Norton Wisdom, covered with paint, was furiously creating spontaneous imagery, pausing only briefly to transform shapes and marks, erasing here and adding there, in an ever-changing direct pictorial response to the music. The year was 1999, and this was the "pickup" supergroup Banyan, composed of some of the top improvisational jazz-rock fusion musicians of the 1980s and '90s, on its first tour. Wisdom was already becoming known as "The Artist" for his work with various bands and highly regarded solo musicians.[1]

For all his support and promotion of the authentic modern art avant-garde, Peter found himself in a venue where he simply did not have the background or information to understand that he was amid a gathering of leading figures in music and art who happened to be in L.A. (and that was generally a considerable number). It was an important cultural evening, but of a different sort from Peter's familiar territory. He enjoyed a brief chat with his former student's attractive wife, Robin, who was there with their young daughter, Ireland. Soon, though, Peter indicated to his companion that it was time to go, to escape the noise. But he had gone there, as typically he made the effort when presented with the opportunity, to find out what he might have been missing—and what he needed to know.

When asked a decade later what he thought when he saw Professor Selz enter the club, Wisdom paused a moment and then responded that his former teacher looked entirely "at his ease, comfortable": "Selz is never out of place in any environment—always at home; never out of his element. He showed me what it is to be a human being, living fully the creative life. For him, art is not just a career; it's a morality."[2] In truth, this was not Peter's natural milieu. Although many of his favorite artist friends—notably Bruce Conner and William Wiley—moved fluidly between the visual arts and popular culture, including rock- and jazz-derived forms, Peter prefers classical, what he might privately call "serious," music. He is a fan of opera, Wagner and Mozart, and the German high culture he left behind in Munich when as a youth he emigrated to America.

Selz had no idea that Norton, sponge and squeegee in hand, was working closely with some of the most respected and admired artists in contemporary music, among them drummer Steve Perkins (from the band Jane's Addiction) and guitarist and composer Nels Cline, along with jazz-rock violinist Lili Haydn. Nor did he remember Wisdom from the large lecture classes in which he held forth on modern art to thousands of Berkeley undergraduates. Furthermore, he would not have gone to the Whisky, a club he had never heard of, on his own. But when offered the opportunity, he took it, always ready for fresh experiences. Peter was, and remains, ever open to the new and untried, both in life

and in art. The fact is that as a teacher, Peter Selz inspired many of his students in ways that affected the life choices they made. By his example and enthusiasm he demonstrated how to live life fully in intimate relation to art and in opposition to establishment restrictions. That was, even more than the information he conveyed, his great and rare achievement as a teacher, and it is the quality that many of his students, graduate and undergraduate, best remember and most value.

Up to a point, Peter was attracted to the bohemian life and the freedom to explore and experiment that he imagined it afforded. Although the penurious side of bohemia held no appeal—he enjoyed owning works of art and displaying them in a high-modernist environment—he loved the creativity and personal liberation, the almost complete relaxation of tedious social restrictions on behavior, that living the art life involved. His goal, more a product of desire than a professional strategy, was to follow as much as he could the example of his artist friends in New York and later in California, notably the San Francisco Bay Area.

This lifestyle could not have been further removed from his academic life and its professional organization, the College Art Association of America. Nonetheless, Peter sought to straddle both worlds.

Eight years later, on the opposite coast, Professor Selz stepped cautiously off a curb on the east side of New York City's Avenue of the Americas. The great ice storm of February 2007 had rendered the existence of the curb an article of faith, and I watched him attentively, ready to lend a hand. Along with other College Art Association annual conference attendees and participants, we were gamely endeavoring to work our way from CAA headquarters at the Hilton Hotel across the treacherous intersection of 53rd Street and up the block to the next venue. Earlier in the day, the snow-blanketed sidewalks and pedestrian crossings in midtown Manhattan had been almost impassable, especially for those ill-prepared individuals in ordinary street shoes. As an old-time New Yorker, Selz was outfitted in a tweed hat with a brim, a heavy rust-colored topcoat, and a scarf. But he had neglected boots or rubbers. He was, after all, now a Californian.

Selz was on his way to the Museum of Folk Art—adjacent to the Museum of Modern Art, where he had been a curator in the early 1960s.

He and other CAA award winners were to be honored with a small reception, prior to the presentation of awards back at the hotel. Peter was to receive the award for the best art book of 2006, and this was surely on his mind as we made our way east. Ready to seize his arm and provide what support I could while myself trying to stay upright, I watched his familiar shuffling gait, now exaggerated by the slippery circumstances, and listened to his labored breathing, evidence of early-stage emphysema. Peter was one month shy of his eighty-eighth birthday, but despite the weather and his physical condition, he was visibly stimulated by the occasion and the company that gathered around him. As is often remarked, his enthusiasm is that of a much younger man. He continues to engage and constantly rediscover his world. With a satisfied smile, he acknowledged the congratulatory greetings of colleagues, former students, and old friends. Buoyed by the energy he drew from this attention, he was entirely—as Norton Wisdom described him that night at the Whisky—in his element. But despite his gracious and humble acceptance of the various expressions of congratulation, an attentive observer might sense that he felt he was getting his due—more precisely, that the award he was about to receive was *over*due.

As former classmate and colleague Charles Leslie observed, "Peter has accomplished a great deal. He is distinguished in his field. And of course that creates a significant ego. To achieve at that level you need to believe that you are somehow special, gifted, even better than most of your colleagues."[3] To be an artist, that is certainly the case. Against all odds, more often than not, you must believe in yourself fully, and believe that your work eventually will demonstrate that you are not only good but superior. Peter is among those few art historians who personally identify with artists.

Peter is a creature not only of his times but also of the moment. And that fact has informed and energized his approach to art as well as life. He is, in his mind, very much one of those fascinating, even enviable, creative individuals whose lives and works he has carefully observed and promoted in his frequently effusive writing and imaginatively conceived exhibitions. Though deficient in artistic talent himself, something he recognized at an early age, Peter Selz nevertheless found a way to

live the art life. This seemed to be his defining ambition, and it probably provides the greatest insight into the course his career has followed. As his younger daughter, Gabrielle, said, "Peter is a force of nature"—and therefore, as she makes quite clear, is "accountable only to himself."[4]

The reception was under way in the cramped foyer of the Museum of Folk Art. A modestly sized group, perhaps forty or fifty individuals, enjoyed wine while conversing and congratulating the honorees—and one another. The bad weather had discouraged some of Peter's friends (he looked around for his art and politics soul mate, writer-critic Dore Ashton). But Gabrielle, his wife, Carole, and several other loyal friends were there.

The marvelous Martín Ramírez exhibition upstairs excited Peter. Roberta Smith in her *New York Times* review challenged the art world to dispute her claim that outsider Ramírez, whose extraordinary drawings were distinguished by entirely original imagery, was "simply one of the greatest artists of the 20th century." He was, she intimated, as "modern" as any "insider" artist in the neighboring Museum of Modern Art.[5] Peter was as exhilarated by the work as if he had discovered the artist on his own. He had at least helped lay the groundwork: his was among the most consistent voices insisting, during the heyday of high modernism and Greenbergian formalist thinking, that the MoMA canon did not represent the complete story of modernist art. He was looking "beyond the mainstream" to understand the depth and reach of modernism. Multiplicity, diversity, and inclusion defined Peter's understanding of modernism, and his writings and exhibitions hewed closely to that perspective. He was among those inclusive art observers who prepared the way for writers like Smith to embrace artists who operated outside the standard accepted art-historical categories. That very theme ran through the brief statement read shortly thereafter back at the Hilton during the presentation to Peter of the award for the best art book of 2006.

Selz was being honored by the College Art Association as author of *Art of Engagement: Visual Politics in California and Beyond* (California, 2006), an impressive and generally successful melding of modern art and politics, the two main concerns of his career. This moment was in some ways the culmination of his professional life. For Selz, modern art in

the service of humanity has been a guiding principle in his writing, his exhibition themes, and his left-leaning political action. The presentation text drew that critical connection between art and life while implicitly honoring his contributions to CAA over many years of active membership and one term as president:

> Peter Selz's politically courageous book is the most recent work in an important body of art-historical and critical writing by a distinguished scholar. . . . From his work on German Expressionism in the mid-1950s to the present book, Selz has placed art in a social and political context. He had never accepted the limitations of formalism or stylistic "isms" as the only means of analyzing art. . . . *Art of Engagement* is a landmark achievement [that] . . . crowns Selz's lifelong commitment to the importance of understanding the relationship between art and the context in which it is made.[6]

While honoring Selz's most recent book, the Charles Rufus Morey Book Award in fact effectively served as one bookend to an extraordinary career. The other, *German Expressionist Painting* (1957), had appeared half a century earlier. These two publications serve as well as anything to mark the journey that carried Peter Selz from his art-infused Jewish boyhood in Munich, on the threshold of Hitler's ascendancy, to New York City and his assimilation into the American art world.

. . .

This biography, constructed largely from oral history interviews, is intended to provide a variety of perspectives on the subject.[7] At the same time, no matter how revealing it may be of professional behavior and accomplishment, political ideas, private and domestic life, relationships and associations, and character, the resulting portrait will surely be incomplete. Yet within the limitations of this approach, the many voices heard should give a rich sense of the man. In addition, from the interviews emerge insights into the period, the museum world, the evolution of ideas about art, and dramatic shifts in American society and politics.

Peter Selz is aware of himself as a participant in life, and he has managed to create an image that suits him. In doing so, he—like most of us—

has ignored or suppressed certain qualities and behaviors. The richness of biography is not just in the achievements, but also in the shortcomings and even failures that are unavoidable fellow travelers. It is this more human story, with the inevitable attendant flaws and self-delusions, that gives authenticity and vitality to an account of Peter Selz's long and productive life in the world of art.

ONE Childhood

Peter Selz remembers clearly his first encounters with the art world, events that provided framework and meaning for the rest of his life. His maternal grandfather, Julius Drey, owned an art and antiques gallery in Munich, and early on he introduced his receptive grandson to the wonders of visual-arts high culture (Figs. 2 and 3). Peter was entirely captivated, his world taken over and his sense of who he was permanently formed. It was a world that he was determined to make his own.

Born at home on March 27, 1919, Peter was the younger son of Eugen Selz and Edith Drey. His grandparents on both sides were from German Jewish families that had been mainly in the greater Munich area for several generations, though Eugen's grandfather was a rabbi in a small Franconian town, and Edith's mother came from Leipzig (see Fig. 4). Edith had been previously married, and her first son, Paul Weil, lived

with his father. Eugen and Edith's first son, Edgar, was born in 1915, and then came Peter (see Fig. 6). His birth name was Hans Peter, but it was shortened by dropping the first name when he was five and then later changed to Peter Howard for his Americanization papers.[1] He was a genuine *Münchner* by birth and upbringing, and that historic Bavarian city played an important early role in the formation of his thinking and his ultimate career trajectory.

Peter's father was an ophthalmologist with a successful practice that, however, diminished during the mid-1930s as Adolf Hitler and the National Socialist Party became increasingly influential. Yet the rise of Hitler and Nazism was not the main thing Peter remembers from his youthful world. Although his education was abruptly truncated in 1935 with the expulsion of Jews from the German Catholic school system, his early memories consist of unrelated—and for the most part pleasant—experiences.

The house in which Edgar and Peter were born, overlooking the Isar River, stood on the northwest corner of Weidenmeyerstrasse and Liebigstrasse in the central district, and the family lived there for twelve years. The boys walked to school and back twice a day, returning home for lunch at midday. Peter remembers riding his bicycle to the Viktualienmarkt near Peterskirche, a location depicted in painstaking detail by Adolf Hitler in watercolor about twenty years earlier. Viewed from a much later perspective, this urban landscape gives an almost surrealistic cast to Munich as a quotidian stage on which German Jews and the architect of their annihilation shared the same temporal space.

From the large apartment on the Isar River, Peter recalled the move to a smaller but "still very nice" apartment in Schwabing, close to the boys' school. After several years residing in those comfortable but somewhat reduced circumstances, the Selz family moved again. Dr. Selz's office had been on Barerstrasse, between Theresienstrasse and Briennerstrasse— only a few blocks from the headquarters of Nazi power. But as the situation worsened, Peter's parents combined family living quarters with Dr. Selz's office in a smaller apartment on Theatinerstrasse, "which was not a good deal at all. Those last two years in Munich were a crowded situation. . . . My grandfather had a big place still. He was pretty well off. We did not live nearly as well as my grandparents did."[2]

Peter's recollections of his early childhood and family life in Munich

are mostly sanguine. He acknowledged, and seems to have accepted as normal for the time and place, an emotional distance between parents—especially mother—and offspring: "I was much closer to my father than my mother." But asked if he felt deprived in terms of her attention, her love, he responded, "No, that's the way it was."[3]

Until the Nazis came my childhood was very secure. Very well ordered. Sunday morning we'd have a family breakfast. Then we would visit my paternal grandparents, who were very old by that time. I had about an hour listening to what they had to say. Then we went to the Odeonsplatz . . . where the army band played Brahms and Beethoven. My first introduction to music, an army band playing great music, was not so good. . . . At 1:00 sharp we had Sunday dinner at my maternal grandparents', the art dealer. And they lived very, very well. In the afternoon they visited us for coffee and cake. And then we had supper. Now, this was every Sunday.[4]

Though remarkably matter-of-fact in most of his descriptions of those years, Peter remembers with fondness the mountain hikes in the Bavarian Alps with his father and, often but not always, his brother, Edgar. He describes these outings as the best part of his family life:

We always went into the Alps, and one time we went as far as the Dolomites. Another time we went to Chamonix. And then across the Mer de Glace, which was very hazardous—we had this guide who took us across the ice. The glacier is now melting. I was a great hiker. They tell me I walked eight hours when I was four years old [a story that Edgar corroborates]. . . . I was very close to my father then, because he took me everywhere so we could hike together. Those were wonderful, wonderful times—we went hiking in the mountains the winter before I left for America, just my father and I.[5]

Peter's mother, however, seems more absent than present during this time. He continues: "My mother spent most of her time with her lady friends, and especially with her parents, whom she said she knew longer than she knew my father or us. So that's where she spent a lot of her time. Until I was seven the person I was close to was my nanny. I was crestfallen when she left."[6]

That is the exception to Peter's dispassionate early-life partial amne-

sia—the bittersweet memory of his nanny, Rosa. When asked whom he liked better, his nanny or his mother, he answered without hesitation, "My nanny."[7] Several stories and memories, even a few photographs, touchingly bear witness to this deep childhood attachment as well. One studio photograph (see Fig. 5) depicts a nude young Peter sitting with his hand on Rosa's shoulder.[8] He has kept the tiny print as a valued souvenir over these many years, and is still pained by the way his parents dismissed Rosa and failed to tell him she would not be returning at the end of her summer break, as she had done reliably thus far. Peter described how he would collect rocks and other aesthetic objects on his hikes along the mountain streams, putting them in boxes that he would present to Rosa upon her return. He had her gift box waiting at the end of the summer when she did not reappear.[9] He never saw her again. His disappointment remains palpable after almost eighty years.

The other most important person for Peter at that time was Grandfather Drey. Several times a month Peter and Edgar would meet their grandfather at the Alte Pinakothek, the venerable Munich art museum. Edgar remembered that they got "a wonderful strange religious education from paintings of the old masters. . . . And Peter was particularly interested. . . . I had other interests." Eventually it was just Peter and his grandfather on these forays. According to Peter, they went in sequence to see the Flemish paintings, then on the next visit the Dutch, and on yet another, the Italian. With pride he credits his family mentor with knowing a "great, great deal" about art. "He realized that I was very interested in the paintings. And he would talk about them. *The Four Apostles* by Dürer, Rembrandt's *Sacrifice of Isaac,* a late Titian. He would tell me what was going on, the stories, what the painting was about. And the painters. He was totally self-taught."[10]

Peter's chronicles of his past connect Germany to his life in America in interesting ways. One telling example is the account of his earliest contact with German Expressionist artists. Once again, the crucial figure is his art-dealer grandfather:

> He introduced me to art. . . . And when he saw my response he took me almost every week. But the masters who interested me the most when

I was a kid were the most expressionistic, the prototypes. Especially Rembrandt, El Greco, and [Matthias] Grünewald. . . . And before long I actually saw the contemporary Germans in what was a precursor to the big decadent art show [*Entartete Kunst*] that Hitler put on in 1937. I was gone by that time, but in 1935 there was a smaller version. So interestingly enough, at the main police station in Munich you saw Kandinskys, Klees, Kirchners, and Beckmanns. Which were already vilified at that point as degenerate. I remember seeing these very badly installed paintings, and I found them extremely interesting.[11]

In 1934, with encouragement and advice from his grandfather, Peter set out on his first vagabond experience, a bicycle expedition with a close friend, Herbert Kahn, through the Alps into Venice (see Fig. 7). He describes it as the greatest adventure of his early years:

When we were fifteen, I liberated myself and my friend. We went to Italy, and I have pictures. This whole album is from our Venetian trip. We went to Venice, to Verona. Saw the Fascist monuments. I knew where to go. And Vicenza, see? [looking at photos] Went to see the Giorgione [*Enthroned Madonna with St. Liberalis and St. Francis*, ca. 1500] in Castelfranco. We went by bicycle, all the way, over the Alps. We had no money. The Germans didn't allow us to carry money across the border.

[Reconsidering when asked how he survived]: Well, we had a little money. We slept on the ground or in haylofts in barns. But connections I did have. My grandfather sent me a postcard with the name of a big art dealer in Venice. His place was right near Ponte dell'Accademia. He helped us out. . . . He was an art and antique dealer.[12]

These images of the golden days with his grandfather looking at art in the Alte Pinakothek and of his youthful journey with a friend to Venice are, in a sense, part of the Selz "creation myth," at once validating of his subsequent life and career and beautifully anticipatory, so congruent with what was to come as to be almost irresistible. Older brother Edgar, interviewed when he was in his nineties, confirms the essence of the story: "Peter was a remarkable young boy, because he got so involved in art. He spent a lot of time in the museums and art galleries. He knew every painting. And our grandfather encouraged it. He *made* him."[13] Peter

burned with desire—nothing else would do—to follow in his grand-father's footsteps and be surrounded by beautiful and thrilling objects, enjoying them and making a living by finding, buying, and selling them.

Julius Drey died in 1934, and Peter was affected deeply. "He was the person I was closest to in my family, and he died when I was fifteen. That was a great loss."[14]

. . .

During those formative years, Peter belonged to a German Jewish youth group known as *Werkleute* (Working People). Such youth groups were a solid part of German cultural life, dedicated generally to providing healthful activities, both physical and intellectual. In the 1920s and '30s, however, as German society became increasingly nationalistic, so did the youth groups, particularly those, such as Hitler Youth, associated with the *Sturmabteilung* (SA), or Brown Shirts. The Jewish version, as in other things always a separate but related phenomenon, grew to importance in mobi-lizing the young for immigration and the inculcation of Zionist objectives, and it became an important—even crucial—part of the Selz immigration story as well.[15] Not only was the youth group a context in which young German Jewish lives were molded and directed, but it is in contrast to this positive experience that the Nazi reality in Peter's past becomes more vivid: "The other important memory," he recalls, "was what was going on in the countryside with that youth group. Every Sunday when I was a little older—maybe when my grandfather died, 1934 or '35—we would go out to the countryside and hike and play ball. And other youth groups would be there too, and we would see the Nazis, the kids in their brown shirts. . . . We were running around, and they were regimented. They would be marching, and we would be playing and running."[16]

Peter has described himself—and this was seconded by brother Edgar—as an indifferent student. He was simply more interested in art and a future career as a dealer, following in his grandfather's footsteps.[17] But Peter's dislike of school was hardly unique. According to his account, it was shared by many students: "Like all kids in Germany, we hated, hated school. School was horrible. We did learn something. We had to.

But we all hated school so much that kids who cheated best at tests were the heroes because they were doing something against the establishment. Against the system. But I did a lot of reading. As far as team sports, I was never very good. But I was a good runner, hiker, and swimmer. And I looked at the art books that my grandfather gave us."[18] Judging from Peter's attitudes toward school and academic work, and the fact that for the last year he was in Germany he could not attend school at all, it seems reasonable to assume that his intellectual and physical development took place largely within the framework of the *Werkleute* and its activities. Beyond bicycle tours and hikes, the group engaged in conversation about important writers, left-wing political discussions, and Zionist planning for a future in Palestine. The group's objectives amounted to a survival strategy conceived and directed by a liberal network of elders, the ultimate objective being to escape Germany, find sanctuary elsewhere, and pursue the main goal of realizing the Zionist dream, while still maintaining German Jewish cultural ideals. Although Zionism was a minority position among German Jews, ultimately the *Werkleute* played an important role in maintaining Jewish identity for a soon-to-be scattered population.

The apparent intellectual and cultural level of these high school–age Jews was impressive. In this respect the youth groups seemed notably serious, focused, and directed. Peter describes the political focus as an important influence on his life and his way of looking at art. His social conscience and commitment form one thread of his career, culminating in *Art of Engagement: Visual Politics in California and Beyond* (2006). In the book's prologue he invoked his youthful encounters with what he referred to several times in the interviews as "fascist aesthetics": "My interest in the critical relationship between art and politics stems in large part from my personal history. In the mid-1930s in Munich, where I grew up, I witnessed the gigantic spectacles that Hitler organized: huge floats with sculptures glorifying the Nibelungs and the gods of Valhalla and depicting German medieval knights as descendents of Greek athletes rolled down the flag-bedecked streets in unprecedented pageantry."[19] He also describes his early questioning of authority, equating parents with the establishment:

> We resented pretty much what our parents did, and what the establish-
> ment did. This is very important because from the very beginning I
> was anti-establishment. And by the time I was seventeen I called myself
> a socialist. I had a pretty good idea [what that meant]—I was reading
> Marx when I was sixteen, and I used to quote his *Manifesto*. I was read-
> ing political literature and poetry. Rilke was important, and Hermann
> Hesse's novels. The writers who are still important today, they were
> important to me. It [liberal political thinking] all goes right back to that
> time. Absolutely. One particular artist I knew about, really knew and
> liked a lot, was Käthe Kollwitz. . . . Yes, our group thought of itself as
> political.[20]

Thus Selz puts additional components of his story into place: his politi-
cal engagement and challenging of authority. By implication he ascribes
these qualities to his youthful compatriots in the Jewish youth group
that seems to have constituted, especially in Munich, the main source of
his social conscience. He also characterizes the *Werkleute* spirit as funda-
mentally idealistic, even utopian.

Peter mentioned Goethe and the Jewish philosopher Martin Buber as
figuring importantly on the young people's reading list. At the sugges-
tion that this was quite advanced for such a young group, Peter agreed.
"I know. But we were fairly mature. Yes, we were intellectual. We read
books by Buber and then tried to figure the ideas out in discussion ses-
sions. Karl Marx, who we also read and discussed. Also the poet Stefan
George—we have to create a better world. That was the idea."[21]

Like many others looking back at that time, Peter sees the German
Jews' identification with broader German culture as the element that
famously made it so difficult for many Jews to recognize the danger
of their changing circumstances. However, when asked if he and his
family and friends recognized the danger as an aberration in German
society and political power that had to be escaped, he gave an enlighten-
ing response:

> Yes and no. We knew it had to be escaped, but people did not think it
> was an aberration. There had been so much turmoil during the Weimar
> years, so many chancellors coming in and out. Hitler having so few
> votes the one year and a lot the next. He seemed so far out and so crazy

that they [the Jews] thought it would pass. They sent the kids away because we couldn't do anything. But, yes, they thought it would pass, and then it got worse and worse. Like, about the time I left there was another law passed that affected my father. He could only have Jewish patients; he couldn't have Aryans anymore. Most people thought that although things were terrible, they would change. But there was a feeling that the German people were turning their backs on the Jews.[22]

Many Jewish parents eventually came to the difficult realization that their Germany was about to turn on them. On 25 April 1933, a law against "overcrowding" of German schools, directed at limiting the number of Jewish students in high schools and universities, made it evident that there was no future for Peter and his young counterparts throughout Germany.[23]

Yet when asked about the Nazi displays of grandeur and strength, Peter described with excitement the spectacular "power" parades down Munich's Ludwigstrasse. Despite what they represented and the deep misgivings they must have inspired among more attentive Jews, Peter was drawn to them as spectacle—more of his "fascist aesthetics": "I saw the Nazis marching down the streets in Munich, the center of the Nazi movement. I mean, Hitler's Brown House was not so far from where we lived. So we saw all of this, yes. The enormous great parades, which looked very gorgeous, actually, with all the flags and bunting. These great floats going down the main street."[24] Later he elaborated, "This whole aesthetic of fascism was extraordinarily impressive to me. Look at this, what's going on [he shows some photographs in an album]. I know I should have hated it because these were the Nazis and they were going to kill us—we didn't know that yet—but it was extremely impressive."[25]

But did these theatrical displays of power make him, or other Jews, proud of being German? Selz responded in the negative—adamantly: "No, no, no. Not at all. Not at all! We were never nationalists. When my father was in the World War I medical corps, for some reason they gave him the Iron Cross. And when the war was over he put the medal on his dog's collar. That's what he—we—thought. We were left wing to some extent, never nationalists. So I never felt proud of anything like this.

[pause] But it really *was* impressive. Of course, at that time we had no real idea of what was to come."[26]

According to Peter, neither his family and relatives nor the other adults he knew and observed—and certainly not his younger peers, despite their purported goal of leaving Germany—were aware of what lay ahead, the enormity of the Holocaust. *Kristallnacht* was still several years away. Nonetheless, the Selz family was presciently alarmed enough to get the boys—first Edgar and half-brother Paul, and later on Peter—out of Germany. There was no alternative.

"In '35 I was kicked out of school [*Realgymnasium*] because I was Jewish."[27] Without access to education, there was simply no viable future for young Jews or for the community itself. For Peter's parents, the critical objective became locating sponsors—relatives or friends—in England, the United States, Scandinavia, South America, China, Cuba, even Africa: any destination where they would be accepted. Palestine was for many the ideal refuge, the anticipated site of a long-desired Jewish state that through the symbolism of geography could reunite the Hebrew people with their historic past. But Edgar went to London; their half-brother, Paul Weil, already had a job in Paris. As for Peter, his journey would take him far from home—though not, as it turned out, in the direction he favored. "[My parents] didn't want me to go to Palestine. So they found these very distant relatives, the Liebmanns, in New York. In order to get an immigration visa you had to have relatives. I don't know exactly how my father found these people. I probably was told, but I don't remember."[28] As Peter recounts, "I did not want to come to America, because I belonged to this left-wing, socialist, labor, Zionist youth group."[29] But according to Edgar, Peter was tricked into going to America by their parents, who were of course aware of their son's political leanings: "Peter was an arch Zionist. Did he tell you this? He wanted to go to Israel [Palestine]. But my father discovered our relatives, the Liebmanns. And he wrote them a letter asking if they would accept, would take Peter to America. And he didn't tell that to Peter. And when the letter of invitation arrived, he told Peter, 'Look what's coming out of the blue? You can't ignore that. . . . It's a letter from nowhere, inviting you to America. It's a sign from God. You have to accept it.'"[30]

In August 1936, seventeen-year-old Peter Selz traveled with his parents from Munich to Bremen. There, alone, he boarded the German ship *Europa* for the voyage to New York City. Telling the story decades later, he recalls how poignantly aware he was that he might not see his mother and father again. He has kept the several photographs that were taken as he and his parents said their good-byes while he prepared to ascend the gangplank (see Fig. 8).

New York

STIEGLITZ, RHEINGOLD, AND 57TH STREET

Aboard the *Europa*, Peter saw Americans who had been in Berlin for the Olympic Games. "They didn't look so good to me because . . . they thought how nice everything was in Germany." Although he did not go so far as to accuse them of admiring Adolf Hitler, in fact Peter had low expectations for his destination country.[1] To him, even the Statue of Liberty was a letdown—somehow tacky, something of a cliché.

It did not take long, however, before Peter was won over. Perhaps it is not going too far to say that he was seduced by America—or, to be more accurate, by New York City. "It was wonderful. I loved New York. I thought it was the most marvelous place, and it really felt good. I adjusted rather quickly." In answering a question about whether he had studied English before arriving, he answered, "A little bit, just in high school." And then he revealed the other side of his introduction to

America: "There I was. I missed my parents. I didn't know if I'd ever see them again, and they were in constant danger. I was looking in the paper every day. That felt terrible."[2]

Peter's emigration had been relatively straightforward, effortless and without incident—in stark contrast to the experiences of other German Jews a year or so later. By 1939 it was extremely difficult, dangerous, and expensive to obtain the special emigration documents Jews required to leave Nazi Germany.[3] Yet that year, Peter's parents finally succeeded in joining their younger son in the United States. Their passage was rougher and more dangerous than Peter's had been: "They had visas to come to America, but it was a long time—a year—off. [So] they got temporary visas to go to England. They lived in Cambridge for a year, and then sailed on one of the very hazardous voyages in 1939 when submarines were attacking all the [transatlantic] shipping." Difficult as was the crossing, Eugen and Edith were more fortunate than others of the Selz and Drey families. As Peter put it, "Yeah, yeah. Some relatives of mine waited too long—I had uncles, aunts, and cousins who were shipped to the camps."[4]

Also in 1939, but on a separate voyage, Peter's brother, Edgar, came to the United States. He had first gone to London in 1934; there he stayed with his sponsors, friends of their parents, who had a metal business. Edgar attended the University of London, studying chemistry. Unable to get work legally because of visa restrictions, he did chemical analysis for his sponsors, working illegally at night ("black labor") in a rented lab. He was, however, able to find a legal job with a family for his German sweetheart, Trudy Wertheimer, who soon followed him to London. When Edgar and Trudy were able to get visas to come to the United States, they went almost immediately to Chicago, where they were married. Their son, Thomas, was born in 1946 in Evanston, where the family soon made their home. Looking back over that time of transition, Edgar described a sort of longing for Germany lost. "It's nostalgia. We had a good time in Germany, and then Hitler came along. We were very proud to be Germans [before that]."[5] Furthermore, according to Edgar, the family did not fully identify with its Jewishness: "I mean we were not observant Jews. But under Hitler . . . well, we just knew we had to get out."[6]

As it turned out, although Edgar was the better student, Peter was more adaptable, better able to fully embrace the future. It was a matter not just of becoming American but of finding a way to do it along the artful lines opened to him during his youthful years in Munich with the inspirational example and tutelage of Grandfather Drey.

The ability to quickly adapt to a new environment is an essential quality in the successful newcomer. Peter's enthusiastic embrace of the new seemed to be not just a survival strategy but a useful—even, under the circumstances, fortuitous—character trait. In this case, a familiar immigrant story was enacted by an unusually well suited and receptive subject, one who knew intuitively how to take full advantage of the opportunities offered by this new land. By being able so easily to discard the past in favor of the present and, even more, an exciting future, he has demonstrated an enviable capacity for reinvention in the face of change. Peter's story, as told by Peter, is artfully constructed to reinforce an almost picaresque idea of purpose, direction, adventure, and success.

The initial business at hand, however, was to find a place for himself where he could somehow achieve the life goals he had already defined and brought with him. First, he had to create for himself a new—American—identity. A critical part of that process was, perhaps ironically, the seamless continuation of what had provided the social, recreational, and political framework for his life in Munich as a German Jew: the *Werkleute.* It even seems that the first step toward assimilation for Peter, and for many of his immigrant counterparts who found one another in New York, took place within what amounted to transplanted versions of the youth groups they had left behind.

Peter and his friends from the early days in New York have various memories of the *Werkleute* and the crucial role it played in their young lives. Hildegard Bachert, Hannah Forbes (born Engel), and Peter were brought together far from their birthplaces through this network. Hildegard's recollection of the system is the most detailed:

> It was all over Germany. It started in Berlin, then Mannheim and Munich, and Stuttgart. . . . The people in Germany kept a record of where we emigrated to and put all of us from the *Werkleute* together. They wrote us—that's how I learned of Peter's and Hannah's existence.

There was a central place in Germany that let us know. I think our respective group leaders told us where to find others, among them Peter and Hannah and another one who was called Beate [Steinitz, nicknamed Batz]. So we did more or less the same thing that we did in Germany. We read books together. We went on outings . . . on hikes. We spoke German, and we pursued the same kind of goals [as in Germany]. We were Zionists . . . idealists . . . sort of a little oasis in this strange American world. . . . We really pursued the same goals and ideals . . . had the same principles of life because we had the same background.[7]

In addition, they saw themselves as part of a privileged class of immigrants, each and every one of them destined for success in America. The youth group, as an extension of German culture and education, provided the framework for their idealistic optimism.

The role of their group as an unofficial immigrant halfway house between Germany and the United States was in some respects the main topic of a conversation I had with Peter and Hannah in 2008.[8] The two friends, both approaching their nineties, were enjoying their reunion in the warm winter sun of a Southern California poolside setting. They had traveled a long way since the 1930s. Listening to them reminisce about their escape to America from different German cities, I was impressed by the extraordinary determination and adaptability that they and their fellow Jewish teenage refugees had exhibited.

As their reminiscences turned to politics, Hannah said she thought of him as less political than he appears to be in recent books such as *Art of Engagement* (2006), which she proudly announced she had purchased and read. Peter explained, "We were left-wing Zionists, believed in a Jewish socialist country. As time went by we became slowly more Americanized, part of this American society. I have the same political attitude—but great regret as to what happened to Israel."

But Hannah responded, "You know what surprised me in your book? I thought that you were much more radical now. Your last book . . . I do not remember that you were that radical [then]. Were you?"

"Probably not, but over the years—I was pretty much on the left all my life."

"Well, so was I. And my husband was an ex-communist!"[9]

Hannah and Peter did not talk only of their early political convictions, however. Almost out of the blue they turned their attention to sex, or rather the absence of it as an activity within the group. Hannah introduced the topic: "I went camping once with one of the guys, a tent on Lake George. My aunt, a substitute mother I lived with until I got married, said to me, 'You can't go with a fellow camping. This is not Germany!'"[10]

Peter picked up the theme. "Now, this is very interesting. Sex was not important somehow."

Hannah continued, "Not the way it is to kids these days. . . . Peter, you and I went skiing alone in Vermont, just the two of us. On New Year's Eve. Remember that?"

Peter did, and added, "Yes. And there was no sex."[11]

Hannah insisted that they—and their American *Werkleute* friends—were "really not involved in sex as much." But what about when they fell in love? Peter replied, "Well, then we had sex." In fact, his first true romantic attachment was Hildegard: "We called her Gina, which is Hebrew for [little] garden. She liked gardens. And she was beautiful."[12]

Peter has a small leather snapshot album that he showed me early on in discussions of this chapter of his life. "This is Hildegard," he told me on another occasion, "the first love of my life. You should interview her, find out why she dropped me."[13] It was evident that Peter still regretted this loss of almost seventy years earlier. Photos of Gina and Peter from the late 1930s, some taken on hikes in New Hampshire and Vermont, reveal how beautiful she was, how handsome he was, and what an attractive couple they made. In one portrait (Fig. 9) they even look somewhat alike, happy, and very young—she was eighteen and he was twenty. Peter sighed and said, "We were very much in love. I've never gotten over Hildegard."[14]

On a pleasant late-January day I took the elevator up to Galerie St. Etienne, founded by Otto Kallir, at 24 West 57th Street. Co-director Hildegard had worked there since 1940. The walls of the smallish gallery were covered with Peter's kind of paintings—Viennese Secessionists such as Klimt and Schiele, a Kokoschka, and a few other, more recent artists in the same vein. Along with Grandma Moses, these artists had been the mainstay of Kallir's gallery since about 1939.

On the phone Hildegard had seemed charming, as she proved to be in person. She expressed pleasure when I told her about the photo album and what a handsome couple they made. She smiled as she said, "We were young and idealistic." Over about an hour's time we talked mainly about their friendship, Peter's introducing her to art and her exposing him to music, her history with the galleries, and the *Werkleute* group where they met and courted. Most interesting was her description of the growing division among the young people around the issues of Zionism, German language and culture, and assimilation. "We were both children of parents who stayed behind," she said. "We grew up in a minute because of the difficult times in Nazi Germany, and we had to live on our own even though we were very young. . . . But Peter's grandmother [Marie Drey] made it across [in 1938]. She was one of those proverbially highly cultured German people . . . and she knew a great deal about art. That's where Peter came from." In this respect Peter influenced Gina, introducing her to what became her life's occupation: "He took me to all the art galleries and museums; he knew a lot more about art than I did. We knew all the galleries, just about all." Hildegard created a vivid picture of a social group that served as an indispensable support structure for these young German Jewish newcomers, many of them on their own. "We helped each other in goodness knows how many ways. And in spite of the fact that our parents were very much in danger . . . we had a good time."[15]

This had to be the most important component of Peter's new life, his lifeline as he made the transition from German to American. But Hildegard found his transformation troublesome, unseemly in its rapidity.

Peter and Gina were "engaged"—anticipating marriage, though they thought it unnecessary and unbohemian to be formally engaged. As Peter talked about his days with Gina he was visibly transformed, his voice softening as he spoke of the youthful love lost long ago. And Gina remembered just how it was lost:

> He was another man at that time and that basically is the reason we came apart. He became a different person. Young as I was, I noticed that change, and I could see that he was going where I didn't want to go. That's why we broke up, the long and short of it. . . . Basically, he wanted to assimilate and become a typical American and shed his past. He would only speak English. Maybe he moved on too quickly

for me. . . . Our activities were no longer in the depth that I wanted them
to be. Perhaps I was too much of an idealist. . . . And I was slower in
adapting. Faster in learning the language but not as fast in translating it
into our relationship. Especially as the standards changed.[16]

Nonetheless, Hildegard fondly recalled their best moments and
acknowledged that she herself had done some "stupid things along the
way." She seemed to take pleasure in her former (presumably first) boy-
friend's professional accomplishments: "He really arrived. My goodness,
he did very well."[17] Still, at the mention of Peter's becoming a Californian,
attracted to the lifestyle and intrigued by the hippie youth culture,
Hildegard astutely observed, "He was in his element. And I couldn't
have gone along with that to save my life."[18] For her, the distance from
Mannheim to New York was less than that from Manhattan's 57th Street
to the Berkeley hills. Peter's capacity for adaptation and change may
have lost him Gina, but it ultimately gained him the art life in California
in which he has thrived.

For Peter, Gina was the great event of his first five years in New York.
And as a companion, she was a part of his other object of desire, as he
shared his "romance" with the New York art world with her, creating
a thoroughly seductive experience. Then Gina unexpectedly "dropped
him," as he put it. But he had close at hand something to replace her,
finding some degree of consolation in throwing himself even further
into the art social scene. As she observed, with the "gallery-crawling"
life he was in his element. In this observation she was not only percep-
tive but also prescient. Peter was a natural creature of the insular and
self-congratulatory world of galleries, dealers, and artists.

. . .

When Peter came to live with the Liebmann family in 1936, he enrolled
in the Fieldston School of Ethical Culture (the humanistic secular high
school) in the Riverdale section of the Bronx. Founded by Felix Adler
in 1878, the school has a long list of notable (and sometimes notori-
ous) alumni, many of them art world luminaries—artists as well as

administrators. Whether or not he was aware of it, Peter was in the right company for the realization of his ambitions. Victor D'Amico, who headed the art department at the school from 1926 to 1948, was also director of the education department at the Museum of Modern Art for more than thirty years until his retirement in 1969. Their paths were to cross again.

As Peter was approaching the end of his only year at the school, he was asked at one of the Liebmann family meetings around the table what he would like to do; he couldn't stay in school indefinitely. He responded that, in light of his own family history, he'd like to make a living doing something in art. This was met with the disapproving observation that "we already have one relative in the art business"—Peter remembers and has often repeated the exact wording of the following judgment—"and nothing's ever become of Cousin Alfred." At his very first opportunity, of course, Peter went to introduce himself to this "unsuccessful" relative—Alfred Stieglitz, whose gallery, An American Place, was on Madison Avenue.

A career in art did not come immediately or directly, however. Upon graduation from Fieldston, Peter spent a year at Columbia University before his parents arrived in 1939, whereupon he supported himself and them by working at the Liebmanns' Rheingold brewery in Bushwick. But Peter benefited enormously from the fortuitous opportunity to spend time with Stieglitz, who was among the leading advocates of modernist art, American as well as European. Peter describes Cousin Alfred as picking up in New York where Grandfather Drey left off back in Munich: "If my grandfather was my first mentor, Alfred Stieglitz was my second."[19] Peter described the beginning of this relationship: "I introduced myself to Stieglitz and spent all the time I could hanging out at the gallery and meeting all the artists. He loved to talk. I didn't know anything about modern art at that point, and he started telling me what it was all about."[20] These conversations continued over some time: "He sort of took me under his wing, and I spent a great deal of the spare time I had at the American Place, talking to him—or rather more listening to him—and watching him, and looking at the Doves, O'Keeffes, and Marins he had on the wall. Those were the only painters he still had in those days. And

I learned a great deal from Stieglitz about how to look at painting, what modern art meant, about the aesthetics and the social values."[21]

Stieglitz also introduced Peter to his patron/colleague (and lover), Dorothy Norman, who had helped Stieglitz establish An American Place. Although Peter was working long days in the brewery—it was the Depression and there was no other work—he managed to get several of his translations of Rainer Maria Rilke poems published in Norman's literary journal, *Twice a Year*. The boost to his self-esteem and confidence is evident in his proud telling of this achievement and its literary and intellectual ramifications:

> I suddenly found myself in the same magazine with André Gide and Thomas Mann. I was this poor immigrant working in this brewery, and so I just lived for this kind of thing. But by that time I also went around New York to a lot of the galleries and met some of the art dealers, especially the Germans who had come over here, [Karl] Nierendorf, J. B. Neumann, and Curt Valentin. Neumann, with whom I became very friendly, was second in importance to me after Stieglitz. I spent a lot of time there and got more involved in modern art at that point, especially through those three galleries—also [Otto] Kallir. And I was very much in touch with these people, so I got involved in contemporary art on that level at that time, and read a lot—read the art magazines.[22]

On another occasion he noted, "Basically this was my context, with Stieglitz on the one hand and the 57th Street dealers on the other—until I went into the army."[23]

The indisputable low point of Selz's initial period in New York was the three miserable years spent working at the Rheingold brewery. He acknowledges that he would have infinitely preferred a job in one of the 57th Street galleries, as was Gina's good fortune thanks to Peter, who introduced her to the world of art commerce. The painful irony for Peter was that it was when Gina was hired away from Karl Nierendorf by Otto Kallir that she broke off their engagement. She eventually became a partner in the business, which is now owned by Jane Kallir, Otto's granddaughter.[24] "Hildegard worked in this aristocratic gallery, and I had a lousy, horrible job in a brewery in Brooklyn."[25]

To the degree his brewery work and family responsibilities allowed, Peter managed to immerse himself in the art life with some success.

He met Georgia O'Keeffe and Kurt Seligmann, the only one of the Surrealists he encountered at that time. "I saw Marin around, but did not really have much contact then."[26] But his difficult circumstances, above all at the brewery, dominated those years: "I didn't know what I was going to major in my freshman year at Columbia. I didn't know what was going to happen to me. I actually had to take the job in that brewery in order . . . to support my parents. I worked there for three horrible years; there were a lot of Nazis working around me—German people."[27] Beyond the decent wage, there was little to recommend the Rheingold brewery as a workplace for a slender eighteen-year-old German Jewish boy. Peter recalls the situation:

> That brewery job was pretty well paid because it had a strong union. All the brewers were Germans. And the people who worked for them were all Nazis. I suffered much more from anti-Semitism there than I ever did when I was a kid in Germany. There were these big, big brewers. These were big strong guys. And I was the Jew boy. I was put in there by the boss. And these were the union boys whose union meetings were in German. And they celebrated every time there was a victory, which was almost every day, by the German army. That was '39 and '40. . . . They'd drag in extra beer. They belonged to the German-American Bund in New York, where they marched in brown shirts, some of them. You know, you could do that before Pearl Harbor.[28]

The German Jewish Liebmann family had founded the brewery in the mid-nineteenth century and over generations had experienced the vagaries of political events and their effect on their business. When Peter told the Liebmanns of his treatment, they replied with a philosophical "That's the way things are." He was the only Jew working in the brewery, and "they [the Germans] weighed 300 hundred pounds and I weighed 100 pounds." In the end, the abuse was more psychological than physical—"No, they couldn't do that"—but it took its toll and Peter longed to escape. His deliverance came unexpectedly at the hands of the draft board and U.S. Army in early 1942. Looking back, Selz remarks, with more than a hint of pride at having survived those three years at the brewery, "None of our colleagues in academia or the museums have that kind of a background, that's for sure."[29]

In fact, he bears to this day a small souvenir of his tribulations in

Bushwick. It is the result of an accident involving two barrels of beer and a conveyor belt on which it was Peter's tedious job to place beer bottles ready to be filled. Somehow the equipment jammed and he almost lost two fingers. The tip of one finger is deformed because the reattachment was faulty. The upside of this experience was workers' compensation and six weeks off, during which time he had his first art job, helping Kate Steinitz mount an exhibition of refugee painters—among them Fernand Léger and Lyonel Feininger—for the 1939–40 New York World's Fair in Queens. Kate, a close associate of the artist Kurt Schwitters in Hanover, Germany, was the mother of Batz, one of Peter's close *Werkleute* friends. "She was almost like a mom to me in many ways," he said.[30]

> Kate was in New York at that time before she came to California, and she put on a painting show at the World's Fair called *New Americans*. . . . Many of the Surrealists, well-known artists and a lot of now-forgotten, were shown. And I helped her hang the show. Yes, that was my first experience with exhibitions, helping Kate Steinitz to hang the pictures. We remained very close until she died [in 1975]. In the early forties she came out here to visit her daughter, and she became sick with a kidney ailment and went [in Los Angeles] to the big specialist Elmer Belt. She noticed that he had some books on Leonardo . . . and she talked him into starting this important research library at UCLA. She wisely built herself in, and he eventually turned it all over to her and provided the funds. She became a Leonardo scholar. Many years later I sort of paid back a little by hiring her to teach Renaissance art at Pomona College. So she was among the important people for me—Stieglitz, the German art dealers, and then Kate Steinitz.[31]

Steinitz was also instrumental in bringing Peter together with another lifelong friend, Kenneth Donahue, an art historian and docent at MoMA who was, many years later, director of the Los Angeles County Museum of Art:

> Kenny was a docent at the Modern. So I got involved with the Museum of Modern Art and spent a lot of time with him. Kate had a little salon. We had both arrived in New York at the same time, I from Germany, and he from Louisville . . . and we became very, very good friends. As a matter of fact, Kenny was the chief witness when I got my citizen papers

[in 1942 in Brooklyn]. You had to have two American witnesses, and I had my friends Kenny and Daisy Donahue.[32]

Peter had filed his first papers toward citizenship, the declaration of intent forms, as required soon after his arrival in the United States. He signed his naturalization papers, as Peter Howard Selz, on 3 March 1943 at the Eastern District Court in Brooklyn. Having been drafted into the army as an enemy alien, he was "exceedingly happy" (his brother Edgar's description) to have at last shed his citizenship in the Third Reich.

. . .

Selz's military experience was relatively uneventful. He was drafted as a regular in the Army Signal Corps, but once he had U.S. citizenship he spent a year volunteering for the Office of Strategic Services (OSS). He never was shipped overseas, and by his own account, he "didn't do very much" during his army tenure.

> I was in communications training near Washington, in a secret place [Langley, Virginia] where the CIA is now. It was a very strange thing . . . on a hillside in Virginia, and we weren't supposed to know where we were. They took us away for weekend passes—in a truck with tarpaulins over it so that we couldn't tell where we were—dropping and picking us up at Union Station [Washington, D.C.]. The other guys . . . you could talk to them about everything, except your past and future. [laughter] There wasn't much to say. By the time my training was completed, they didn't need people in Europe; the war was over. Then they sent me to another camp before I could be discharged, for almost a year—in Oklahoma.[33]

Judging from Selz's photos, the high point of his army career and proudest moment as a soldier took place in basic training. Two photos in the scrapbook tell the story. One shows Peter with huge boxing gloves on, smiling and squatting on the ground (Fig. 10); in the other he is standing over a fallen opponent. "In basic training, 1942, there was this guy, and he didn't like me. He was practically pulling me down. I didn't like it. And so he said he was going to challenge me to a fight. I had never had

gloves on in my life. This was a big, big guy—and I beat him."[34] Another photo shows Peter with the medal he won for "sharp shooting." It seems that as well as a natural boxer, the new draftee was also a marksman. These achievements, and the pleasure with which he recounts them for interviewers, come as a bit of a surprise, unless we acknowledge a strong competitive streak in this self-described humanist committed to the life of the mind.

Two other stories from the army years provide a further idea of how Peter bided his time in the military, waiting for his service to be completed so that he might resume his efforts toward making a living out of his interest in art. One of the ironies of Peter's army career was his volunteering for the OSS, which he discovered only much later was the precursor of the Central Intelligence Agency. At an army ski camp in Wisconsin, Peter was approached by the company commander, who asked him if he was willing to volunteer for hazardous service. "I asked him what it would be, and he said that he could not tell me more. I thought about it for a short time and, feeling very strongly about the war, said, yes, I would."[35] Times and attitudes change; two decades later Selz was avidly demonstrating against the Vietnam War and the role of the CIA, to which some assign the covert operational blame for drawing the United States into that conflict.[36]

One of the more amusing stories from Peter's career in military intelligence involves a snafu when he and a fellow low-level OSS operative found themselves in Buffalo on a clandestine assignment to test the range of a new transmitter. His colleague was on the roof of a hotel setting up the transmitter's antenna while below in their room Selz was tapping out Morse code, trying to contact Washington, D.C. Someone had apparently noticed the activity on the roof and notified the police. In the midst of performing his duty, Selz was interrupted by a loud pounding on the door. The situation was especially awkward since OSS personnel were forbidden to tell who they were and what they were doing. Undoubtedly, given the understandable paranoia of the times, Peter, with his heavy accent, was suspected of being a German spy. When asked repeatedly what he was up to, Selz could only answer, "I cannot tell you. I must speak to your commanding officer."

When that was finally arranged, the officer checked with the D.C. contact provided for such contingencies and was reassured. The two young "spies" were then released and escorted to the railway station to board the next train headed south to Union Station. Peter seems to have been unwittingly involved, at a low level, in preparations for OSS participation in clandestine operations behind enemy lines in Europe. Radio communication was the essential ingredient in the success of covert Allied efforts to disrupt German military movements, to arm and coordinate local Resistance fighters, and to prepare for the landings in Italy and France. After the war, many of the OSS agents would go on to create and run the CIA.[37]

A last army story provides insight into Peter's ongoing education and the beginnings of his awareness that it is possible, even easy, to outsmart the system. This lesson could be viewed as the starting point of Peter's evolution into a worldly and sophisticated player in the world.

Several weeks before his date of discharge, Selz was back in Oklahoma at Fort Sill, eagerly awaiting his release. This particular day he was assigned to drive a jeep as part of the artillery training for which the base was renowned. There were frequent stops with nothing to do but wait, so he and some fellow soldiers passed the time by playing black-jack. Behind him in a command vehicle was the officer in charge, and in the midst of the game the card players heard the command, "Move on!"

As Peter drove off he looked behind and saw cards dancing out of the rear of the Jeep. He stopped and turned to backtrack and collect the cards. But in doing so he managed to run his vehicle into a ditch. Knocked unconscious, he came to only as he was being carried out of the ditch. He suffered only minor scratches, but the less fortunate jeep was totaled.

Back at base headquarters, Peter was called into the lieutenant's office. The cost covering the loss of the jeep, three thousand dollars, was a huge sum in 1943, and of course Peter could not pay it.

"Well," said the officer, "I guess you'll have to extend your tour for six more months to work off the debt."

Peter noticed that the lieutenant had lying open on his desk a copy of the army field manual, to which he referred for the regulation regard-

ing repayment in such cases of damage to government property. Peter suspected that if he looked closely enough at the manual, he would find some other regulation that would get him off. It turned out that every GI who drove a vehicle needed a military driver's license. This rule was seldom followed, and his case was not an exception to this loose practice. There was little the captain could do when confronted with this oversight but say, "Okay. Let's forget it."

For Peter, the lesson was that the individual can beat the system and authority, even the army's. He took this to heart and never forgot. As he now says, "It's all in the research. Most people wouldn't have checked."[38]

The most important aspect of Selz's military service, however, had little to do with these experiences and nothing to do with the war and his wish to contribute to the eventual defeat of Hitler and the Nazis. Instead, in a way that he could not have anticipated when he was drafted, the military opened a new door for him. He was no longer obliged to return to the brewery. In fact, he had very attractive alternatives that fit perfectly into his longtime dream—all provided by the GI Bill.

THREE Chicago to Pomona

NEW BAUHAUS AND EARLY CAREER

Upon his discharge from the army in 1946, Peter set out to identify which university was the best in the country. With the support of the GI Bill he could aim high, and he decided that the top honor went to the University of Chicago. "Chicago had a program more like a European university; you could go straight to the end, sort of catching up [along the way]. . . . It was a wonderful school, the best university, there's no question about it."[1] Since Peter had completed only one year of undergraduate work at Columbia, this was an important consideration. "I never did get a B.A. degree. Almost from the beginning I worked on a master's degree and just had to take courses where there were gaps. I tested out of things that I acquired on my own through reading."[2]

In making decisions about how to direct his studies, he could look to his friend Kenneth Donahue, who attended the Institute of Fine Arts at

New York University and, Selz reports, already had a position at Queens College teaching art history. Until he learned of Donahue's good fortune, Selz had no real idea that a living could be made in art other than by buying and selling it. With this new information, Peter decided he would follow his friend's example.

Selz describes the faculty at Chicago in glowing terms as composed of "absolutely first-rate people," starting with his advisor, Ulrich Middeldorf, who remained a mentor over the years and who became director of the German Art Historical Institute in Florence, and also including Peter-Heinrich von Blanckenhagen (classical art) and Otto Georg von Simson (medieval art). Peter went to work in this environment to "catch up." Then the time came to make the decision that would both draw on his personal past and distinguish him in his newly chosen course. He describes the process:

> Looking for a Ph.D. topic, you look for something that hasn't been done. I saw there were books on Cubism, people had already been working on Surrealism, and I saw this enormous gap. . . . There was this 1919 drypoint self-portrait by Beckmann [Fig. 27], given to me by a friend soon after I first arrived in America, hanging over my desk. I was looking at it all the time. Before the war, in the New York galleries—Neumann, Valentin, and Nierendorf had brought many of these painters to this country—I was looking at the Kirchners and especially Beckmann.[3]

Peter also singles out the importance of William Valentiner, director of the Detroit Institute of Arts from 1924 to 1945 (he later went on to the Getty Museum, the Los Angeles Museum of History, Science, and Art, and elsewhere): "He knew German Expressionism very early, and when he came to America in the twenties he collected their pictures. . . . The Detroit museum was the only museum in the country with a whole room of German Expressionist material."[4]

The choice of German Expressionism as a dissertation topic was unusual at the time: "I was in a field that had not been discussed much. I was in America, where modern art was still considered to be French art—until New York took over. . . . My professor, Ulrich Middeldorf, agreed that I write not just a small-subject dissertation, like most are. He said, 'You know, why don't you write—nobody's written about the whole

German Expressionist movement.' I asked, 'Can I do this for a disserta-
tion?' And he said, 'Why not?' So it became my dissertation."[5]

In a field otherwise dominated by connoisseurship (questions of attri-
bution and formal-stylistic considerations), at Chicago students were
permitted, even encouraged, to try different approaches to studying art
and writing about art history: "Now, in the way that I understood it, at
that point I was looking at art history not just in the formal sense. I had
been doing that for too long even then. I was relating [art] to the political
background of the Wilhelmian era in pre–World War II Germany."[6]

With the benefit of hindsight, Selz now considers that contextual
approach and his recognition of the relationship of abstraction to emo-
tional (empathetic) qualities of expressionist art as advanced for the
time. His explanation of how he arrived at that approach is enlighten-
ing in terms of reconfiguring thinking about art, and it is instructive in
the way it drew upon an existing reservoir of theoretical writing. Selz's
approach, despite its freshness, seems to have been greatly influenced
by German scholarship, notably that of Alois Riegl, Wilhelm Worringer,
and especially Hermann Bahr, which provided a basis for expression-
ist theory: "That was very unusual and rather ahead of its time. But I
realized in order to deal with German Expressionism [one must recog-
nize] the move toward abstraction—or rather the abstract-based [style]
in which Kirchner painted the human figure—and then to full abstract
expressionism in Kandinsky and the Munich Blaue Reiter. I wondered
where these ideas came from."[7]

During this time Selz was fortunate in the arrival at Chicago in 1950
of Joshua Taylor, just out of Princeton, who took over as his disserta-
tion advisor. Taylor was a preeminent scholar of late-nineteenth-century
and modern American art who, like Selz, became known for looking
well beyond the mainstream. But regardless of the academic process
involved and guidance provided, Selz conceived and, in 1954, produced
one of the first two dissertations on twentieth-century art written up to
that time.[8] Not only did he develop an important dissertation topic but,
shortly thereafter, he published a career-making book as well—*German
Expressionist Painting* (1957): "I became interested in the theory of abstrac-
tion, ideas leading to the book. Despite some needed corrections in the
opening chapter about theory, if you look at it now, it *does* seem rather

ahead of its time."[9] Selz was referring to his book, but if the book was, as he says, ahead of its time, the dissertation was even more so.

Peter's personal life was developing in a way that contributed to the direction of his career perhaps as much as his doctoral work did. He met Thalia Cheronis, an art history graduate of Oberlin College, at an art department tea. She was enrolled in the university's master's program in English literature. In 1948 they married, becoming intellectual as well as wedded partners. Both received their M.A. degrees a year later, and Peter immediately started teaching. Along the way, frequent visits with Peter's brother, Edgar, and his family (wife Trudy and son Thomas) in nearby Evanston were an important part of their nonacademic life, although time for such familial pleasures was limited by the couple's work schedules.

In fact, Peter had two part-time positions teaching art history. One was at the Chicago extension branch of the University of Illinois (later called the Chicago Circle campus, and now the University of Illinois at Chicago, or UIC). The other job was, as he says, much more interesting and "very, very important." That is not to say that his position was so important—he was teaching a basic art history survey course and modern art—but the place definitely was, especially for a young scholar embarking on a career as a modern art specialist at a time when the field was brand new:

> I taught at the Institute of Design—with an interruption of a Fulbright in Paris [accompanied by Thalia]—from 1949 until I left Chicago in 1955. . . . That's when I got totally involved in modern art, with a great faculty. [László] Moholy-[Nagy] was gone—he was already dead—but there were all these others. [Architect Serge] Chermayeff— recommended by Gropius—was director, and some of the best people, Europeans and Americans, came and went. The students . . . came from all over with the specific purpose of being at this place and at this time. It created all sorts of problems . . . we were fighting all the time because we thought this was *the* most important art school in the world. This was the New Bauhaus; this was where everything was happening.[10]

In light of his interest in emotionalism and empathy, it would seem that the Bauhaus precepts and the design and architecture focus of the classes

at the Institute of Design would have been at odds with what appealed to Selz within the German Expressionist aesthetic and the making of an individualist creative life. But at the Institute he found an echo of what he had experienced in Munich and then in New York with the *Werkleute* emphasis on group activity, socialist communalism, and utopian ideals. He described his participation in the Bauhaus-inspired curriculum with a combination of pride and excitement: "The first two years were very much like the foundation course at the Bauhaus: introduction to form creation, color, texture . . . then students went into different fields: product design, graphic design, photography, or architecture. In photography alone there were people like Harry Callahan, who was head of the department; Aaron Siskind and Art Sinsabaugh were teaching there. I think photography was one of the best parts of the Institute of Design. But also the graphic designers—the Institute changed American graphic design. The feeling was definitely that this was the significant place."[11]

The "interruption" of the Fulbright sojourn in Paris in 1949–50, however, helped Peter find his own personal understanding of and relationship to modernist art. To this day he delights in telling how his Fulbright research differed from that of several of his counterparts in Paris. It was as if he and he alone discovered what mattered, how you get close to the secrets of art and the creative life by embracing contemporary art and artists, the makers. And that was not to be accomplished by reading books:

> I had finished my master's in German Expressionism, but since I was in France I studied postwar French painting—what was going on right then and there. That was very exciting. Paris was wonderful in '49 and '50, all the things happening. . . . There were a couple of other Fulbrights in Paris, spending their time in the archives and the libraries while I was spending my time in the galleries, cafes, and the studios. I had much more fun. Having come from the ID, which was really the most advanced place in art education and the whole concept of new design and architecture, I felt very much at home working with contemporary material.[12]

But Selz later acknowledged the gap between his own artistic interests and the formalist style and design preoccupation of the Institute. By

the time he and Thalia had returned from his Fulbright year in Paris, his attention had shifted markedly to a very different group of artists. Part of the impetus was the discovery of Jean Dubuffet and Alberto Giacometti, both very influential in the formation of his views and his attraction to particular forms of artistic expression.

Nonetheless, Peter maintained his interest in his German Expressionist subjects, meeting several of them during his European sojourn: "In the early days [of the Fulbright trip], when I was in Germany, I met the people who were still around. There was [Karl] Schmidt-Rottluff, [Erich] Heckel, and then later I met George Grosz—although he was not really an Expressionist." He visited Schmidt-Rottluff in his studio in Berlin and Heckel in Hemmenhofen and Lake Constance: "Both had remained in Germany during the Nazi period, when they were prohibited from showing their work. They were in what the Germans liked to call 'inner emigration.' Both painters talked about their early Brücke work and were very pleased to see this interest from an American."[13]

In 1949 in Chicago, Peter had met Max Beckmann and his wife, Quappi. "They took me to tea in a hotel restaurant, and Beckmann seemed interested to talk about the Institute of Design (Moholy's new Bauhaus), where I was teaching at the time." Although "I didn't think of him as an Expressionist either . . . , I realized rather early on that he was the giant of the artists coming out of this group, and I still think he's one of the major artists of the century."[14]

Upon the return to Chicago, Peter was eager to get back to work on his dissertation and to resume study of the German modernists. Nonetheless, his experiences in Paris—Left Bank life and the pleasant hours spent in bistros and cafés with artists—reinforced his desire not only to study the bohemian art life but to actually try to live it, a tendency of identifying with his artist subjects that began to set him apart from the majority of his colleagues. Peter and Thalia had even thought about extending the Fulbright stay in Paris, but both academic and economic considerations prevailed.

Back in Chicago, both Peter and Thalia had jobs at the Institute of Design. Thalia taught a film history course, and Peter was teaching full time as well as developing a graduate program in art education, which

he ran until he left Chicago in 1955. However, he was becoming dissatisfied with the Institute. His experiences in France and with the artists he became acquainted with there, his reimmersion in the expressionism of his Ph.D. topic, and his concurrent involvement with Chicago contemporary art and a group of "rebellious" young artists called Exhibition Momentum soon cast the school in a new and unappealing light. His earlier enthusiasm waned along with the fortunes of the Institute itself.

Selz describes those years as critical in the formation of his career, for they allowed him to identify the qualities he felt were most significant and meaningful in terms of creative activity. Writing in 1996 in an essay titled "Modernism Comes to Chicago," he looked back at those years, and particularly at the history of the Institute of Design, and concluded with a declaration of what he most valued in the contemporary Chicago scene. At least in retrospect, he championed the working local artists over the declining academic design school that paid his salary: "When one thinks of the Chicago artists of the postwar period, it is the idiosyncratic Imagists, once mislabeled the 'Monster Roster,' that come to mind, [among them] Leon Golub, H.C. Westermann, Irving Petlin. And then we think of their successors, The Hairy Who, The False Image, and The Non-Plussed groups and later individuals, such as Ed Paschke, whose expressions, fashions, and often raunchy vitality relate to the Second City in a manner forming a significant contrast to the utopian optimism of the Bauhaus tradition as exemplified in the Institute of Design."[15]

Elsewhere, when explaining what attracted him to German Expressionism, Selz goes on to discuss personal art tastes and interests that inform his own work—exhibitions, essays, books, reviews—throughout his professional life:

> I guess it was the vitality of the art—the emotional, the anti-formalist, the anti-Bauhaus quality of the art. These two things were very closely related . . . my interest in German Expressionism and my contact with the Momentum artists in Chicago. This was a give and take, because they learned from what I had to tell them about German art. I was one of two non-artists in the group [the other was architectural historian Franz Schulze]. They had big exhibitions every year and brought important jurors. This is how I first met Jackson Pollock, Alfred Barr,

and even old guys like Max Weber. All these people were brought every year, three of them, to jury the shows. They were regional shows of this Midwestern avant-garde, and that's where I met a lot of artists.[16]

Selz's natural position was aligned with the individual and the subjective, rather than the communal and the objective (pragmatic, social). This aesthetic led him to many artists who operated independently and who certainly would not fit in with the Bauhaus idea of a utopian art designed to transform society. A good example is the selection of artists for the University of Chicago's 1947 exhibition of contemporary Chicago art, an early demonstration of Selz's strong inclination to look beyond the New York art world.[17] This exhibition, an innovative effort by the Student Committee (of which Peter was chair) of the Renaissance Society in which students selected the artists who then submitted works, received favorable attention in the local press. A review by Frank Holland described it as presenting "a more balanced and true representation of local art than is achieved by the Art Institute's annual."[18] At the opening on July 11, S. I. Hayakawa gave a lecture titled "The Semantics of Modern Art." The sophistication of this program no doubt reflects upon the committee chairman's knowledge of modernism, but it also is a reminder of the intellectual climate and resources at the University of Chicago.

Selz's attention was more and more being directed to Leon Golub and the artists of the Exhibition Momentum group—among them George Cohen, June Leaf, Cosmo Campoli, and Ray Fink. These artists, some from the School of the Art Institute of Chicago (SAIC), others from the Institute of Design, many with opposing views, were however united in their response to the SAIC's decision to exclude students from its juried annual exhibition of works by artists from Chicago and vicinity. They mounted their own annual exhibitions, which in Peter's judgment were better than those at the Art Institute. Though they did not have a unified style, they were working from the human image. The expressionist figuration that characterized much of their work drew him to them much as he had been drawn to German Expressionism.

While looking closely at Chicago artists, Selz also reestablished connections with contemporary New York art, making discoveries that countered some of his earlier convictions:

Around 1950 . . . I knew what was going on in Chicago. I read *ArtNews* and also knew what was going on in New York. I went there and began to meet some of the artists. The first one I met was Ad Reinhardt, and that became a lifelong friendship. That was very important. . . . Why? Because there was somebody who had altogether new ideas. He *hated* [Abstract] Expressionism. . . . So, I began to see and learn and meet people, and I think he [Reinhardt] was my prime contact with the New York school. But I also began to have contact with the New York museum people, dealers, and artists while I was in Chicago. And being at the Institute of Design itself was important because of the people coming through. There was this constant give and take also between [the ID and] the other Bauhaus, Black Mountain [College, in North Carolina]—people like [Josef] Albers, [Herbert] Bayer, Bucky Fuller, and many of the old Bauhaus people came by.[19]

Now finished with his dissertation and growing increasingly disenchanted with the Institute of Design, Peter began putting out feelers for another position. But, as he observed, "jobs were still hard to find in the mid-1950s."[20]

Selz attributes the decline of ID to a lack of purpose: "The brilliant old place, really the whole Bauhaus idea, was falling apart. . . . It was an ingrown place. . . . In a way the purpose was no longer quite there. It had been achieved. . . . Modern design had been accepted."[21] Later, however, as he began to develop a broader and more inclusive understanding of modernism, he softened his negative view of the Institute of Design, arriving at a more balanced idea of the complexity and diverse component parts of modernism: "Eventually I more or less took a historic view. I also began to see the connections [with] the Expressionists—after all, the Bauhaus started as an expressionist thing and then later moved in a different direction—and I met [Walter] Gropius and [Ludwig] Mies [van der Rohe] and all those people."[22]

The cash-strapped ID was soon to be absorbed by the Illinois Institute of Technology, pretty well destroying its once fabled reputation as the great center for modern art. According to Selz, everybody was trying to get out—including him.

Then fate stepped in. In 1954 at the annual College Art Association conference he presented a paper on Herwarth Walden, the great modern art impresario of Berlin. As Peter remembers it, the paper was well

received. And fortuitously, art historian Richard Krautheimer was in the audience. At about the same time, Pomona College, one of the Claremont Colleges in Southern California, had launched a search for a new chairman because Seymour Slive (who had come from Chicago) was leaving to go to Harvard. "The president, E. Wilson Lyon, did the right thing," Peter recalls, "and went to the Institute of Fine Arts [New York University], asking Krautheimer whom he might suggest: 'I heard this very good paper by this young man from Chicago.' So it was through Krautheimer's recommendation that I was offered the Pomona job [as art department chair and director of the gallery]."[23] Selz at that point was delighted to leave Chicago. "California seemed wonderful and Pomona College was very good."[24]

Why was California "wonderful"? At that time, a successful career either in teaching art history or in museum work was unimaginable outside the northeastern seaboard. Why would Selz, at least in his retrospective telling of it, embrace what must have seemed like something of an exile from the "serious" American art world, within the narrowly focused field of art history? Even then he saw his own pattern developing, the most significant aspect of which was openness to the new—modernist art, alive and constantly changing. So although many might have questioned the professional advisability of a move to California, Peter apparently saw it as an opportunity. Besides, he and Thalia had now been married for seven years, and he desperately needed a better job.

Perhaps he was simply grateful for a job at a very good liberal arts college nestled away among palm trees and orange groves, but in fact the three years at Pomona prepared Selz for his role as a distinguished thinker about art and the originator of provocative exhibitions. His personal experience of regional American art, when added to his appreciation of the unusual and original in European art, enabled him to create a fresh vision of the course of modernism.

. . .

Pomona was important for Selz in several ways. For one, he was able to leave the deteriorating situation at Chicago's Institute of Design for

an idyllic college campus that, though set in the sunny environment of Southern California, looked and felt as if it had been transplanted from the northeastern private-college preserve. Tree-lined streets surrounded and penetrated the leafy campus with its year-round grassy quadrangles and vine-covered buildings. At the time, it was known as the "Oxford of the Orange Belt." As Peter said approvingly, "Pomona was a nice college, academically strong, and people got along very well. It was a calm place and we had good students."[25]

Among the young people Selz encountered on arrival in Pomona were two studio art students, undeniably talented, who met at the college, married, and went on to become successful and admired artists in Seattle. For Michael Spafford and Elizabeth Sandvig, Peter was both teacher and mentor, and the three remain friends to this day.

Peter played a central role in inspiring Michael to remain at Pomona when he was about to give it up in his freshman year. "When I was pissing and moaning about school," Michael recalls, "he just said, 'Well, I don't particularly like it here either, but if you stay a year, then I will.' I still don't know if he meant it or not, or if he just was encouraging me to stay."[26]

Michael and Elizabeth recalled the excitement generated by the faculty at Pomona, with Peter playing a central role in their shared memories: "Peter would often hang out with the students. He wasn't trying to be young or anything, just curious about how the students were responding to their education." But finally, what seems to distinguish Peter from his colleagues was an almost unique quality—that of not just appreciating artists, but to a degree *being* one himself. According to Michael, "He was different . . . with this ability to size up the situation and become part of it. He was able to empathize with great energy. I think a lot of the students benefited from this." To which Elizabeth added: "It was his energy. When he gave a lecture, he wasn't exactly giving a lecture. He moved all around the room. And he talked and he waved his arms around."[27]

Sandvig and Spafford were attracted and moved by the emotion Selz brought to his subject matter in inspirational lectures. But what equally impressed them is that he extended that excitement about art and ideas

beyond the classroom. He did not simply theorize about art in an academic way; he applied artistic ideas and an aesthetic view of the world to his own life. At Pomona, the artistic—the "bohemian"—behavior was already in evidence, according to Michael: "Sure, at Pomona he was gregarious. And there are all kinds of stories about things that he did at parties. I don't know if they're true or not—but very often they were outrageous. It's sort of like the kind of behavior you'd expect from an artist rather than an art historian. And I feel that that really made his art history come alive, that he really empathized with the artists—as well as the times and the people that he was talking to."[28] Michael put a positive, philosophical spin on Selz's "outrageous" behavior by invoking artistic license, supposedly granted by the romantic myth of creative exceptionalism: "I think that Peter did not want to call attention to himself, but more to the situation. He'd be a great performance artist. He'd probably be a great painter too. If he wants to do it, tell him I'll loan him the paint."[29]

Peter Selz's political views were also evident to his more perceptive students. Sandvig and Spafford agree that he was not as deeply, or at least as actively, involved in liberal causes at Pomona as his friend the anthropologist Charles Leslie was, but "Peter would explode on an issue, and then he'd find something else to explode about."[30] In fact, this political consciousness, which was already an important component in Peter's private life and which he eventually understood to be a central purpose of art, was something his friends the Leslies could speak to.

Charles and Peter had both been at the University of Chicago—though they had known each other only slightly there—and had both been involved in left-wing politics, including active participation in the socialist veterans' group AVC (American Veterans Committee), which, according to Charles, the Stalinists were always trying to take over. Charles considered himself more politically engaged than Peter,[31] and that view was shared by Michael Spafford at Pomona, though he characterized Peter as "more passionate" in his views and causes.[32]

In Pomona, however, what mattered more than politics for Peter and Thalia and for Charles and his wife, Zelda, was the small-town experience and an active social life. The intellectual-bohemian quali-

ties of these deliciously unconventional faculty couples attracted and intrigued the students. Sandvig and Spafford recall seeking to emulate their professors in both erudition and lifestyle, and Elizabeth remembers the women's creative manner of dress, which set them apart from other faculty wives.

In Peter's accounts of his days at Pomona, the Leslies, who lived just down the block, play a role in happy memories. It was here, too, that the Selzes enjoyed what Peter now regards as the most satisfying chapter of his domestic life. Their two daughters were born in Pomona: Tanya in early 1957, and Gabrielle (Gaby) in the summer of 1958. Charles and Zelda's reminiscences of those days—and of Peter and Thalia—are warm and generous. Zelda recalls Thalia giving her one of her maternity dresses to wear to the college president's dinner dance. They fondly think of her as a "sweet, loving person," an intelligent and talented writer whose ambitions, however, were frustrated by the demands of family life combined with her teaching an English class at Pomona.[33] It is easy to see how, certainly for young couples like Spafford and Sandvig, these four were attractive marital role models.

. . .

The only serious objection Peter had to Pomona and Southern California, from the evidence of his interviews, was the presence at Scripps College of Millard Sheets, with his ultrareactionary art views. This is a harsh judgment, but Sheets's great influence in the region—partly due to his connection to savings and loan mogul and art patron Howard Ahmanson—and his very traditional posture assured a collision course with Peter Selz. The progressive, international art perspective that Selz represented was anathema to Sheets, and to much of the Southern California art community. Peter, meanwhile, was unsparing in his denunciation of the narrow and fundamentally "anti-art" influence of Sheets: "The problem in Claremont was . . . Millard Sheets. He had established a great art empire at Scripps College . . . and he was totally opposed to the two things that I stood for: art history—he hated art historians—and modern art, which he also hated violently. So this was the situation at Claremont

and the Los Angeles area. Sheets hated me and tried to get me out. He had enormous power in Southern California, but Pomona College was an older institution than Scripps, and he couldn't do much."[34]

Peter also objected to Sheets's deplorable taste in architecture, which, according to Peter, Sheets was determined to impose upon the Claremont Colleges during a major building program. In fact, Sheets reached farther. He was a part of a faction that was against the establishment of a separate identity for the Los Angeles County Museum of Art: "He tried to demolish that. Later on, of course, he wanted to have the design himself, and this was a big problem . . . when [Richard (Rick) Brown, who had risen to directorship of LACMA] wanted Mies [van der Rohe] to do it." Howard Ahmanson, who established Home Savings and was the great benefactor of Sheets, was on the board of the museum; Brown's rejection of Sheets caused a "big problem."

More important to Peter, however, was what he saw as attempts by Sheets to dictatorially impose on students a single (and *retardataire*) view of art by executive order: "Sheets's [impact] was really devastating. At that time many of the Pomona students also took classes at Scripps, where [the teachers] had an extraordinary antagonism against modern art which was left over from the thirties. We were doing a lot of modern art shows at Pomona [see Fig. 12], and the students were actually told not to go, not to see the shows."[35]

The battle lines were drawn between traditionalism (not just abstraction) and modernism, and the newcomer Selz found himself not just on the front line, but the leader of the progressive forces arrayed against what was perceived as the Sheets-led reactionary art establishment. In fairness, some of the students who later established themselves as professional artists remember the situation as being less severe. According to sculptor Jack Zajac, for example, Sheets did not *actively* discourage students from seeing Selz's exhibitions.[36]

In 1956, Selz and several others—including Rick Brown, who was chief curator of what was then the Los Angeles Museum of History, Science, and Art—joined together to counter the conservative forces in Southern California, calling themselves the Southern California Art Historians. This group brought a new sense of professionalism to the

teaching of art history in the area. There quite simply was nothing like it before in Southern California. Other members were Peter's friends at UC Riverside, Bates Lowry, Jean Boggs, and Carl Sheppard. Also in the early group were Donald Goodall (University of Southern California) and Karl With and Ralph Altman (UCLA). They were later joined by Karl Birkmeyer and Frederick Wight, along with Kate Steinitz (mother of Peter's *Werkleute* friend Batz), all also from UCLA. "A very, very nice group," Selz approvingly called it.[37]

When asked how and why the professional organization came together, Selz responded that it was to give papers, share ideas with colleagues, and try to establish art history in the area: "Art history had never been established in Southern California. For many years we were the only ones teaching there . . . [the idea] was to create a foundation and help each other out, to do things together, like exhibitions. I had some very nice ones at Pomona. One of the first was devoted to Pasadena's legendary [Arts and Crafts architects the] Greene brothers—the first Greene and Greene show."[38]

Peter arrived in Pomona with his trademark enthusiasm for art and artists, a great curiosity about what was going on around him, lack of prejudice, and the kind of mind that favored the overlooked and non-mainstream work of innovators. And he absolutely left behind the typical New York self-consciousness that by that time all but defined the art world.

He put his enthusiasms and ideas to work immediately, giving them visibility at the college through an innovative and highly informed series of small exhibitions. Nothing comparable had taken place in Southern California, especially in Claremont where Millard Sheets's conservatism still held sway. As Michael Spafford recalled, "Peter brought the Golub show, which was a huge turn-on for me. It was a real powerful exhibit because it had all the energy of abstract painting, and yet it was figurative also. . . . Peter really responded to that kind of work."[39]

Peter takes justifiable pride in what he accomplished at Pomona, where he transformed the small gallery exhibition program and established his legacy in Southern California. Later, in an interview for the Museum of Modern Art's Oral History Project, he described without false modesty

these early accomplishments, focusing first—as would be expected—on his exhibitions and his rapid immersion in the local art scene:

> I did shows and I ran the art department. I had a small budget and did exhibitions, starting with Toulouse-Lautrec posters. I did all kinds of interesting exhibitions. At the same time I rewrote my dissertation into the German Expressionism book published by the University of California Press. There was a lot happening out in Los Angeles, and I became very much a part of it. . . . All these exciting painters—like Wally Berman—became especially interesting to me. The show I hoped to do was the Ferus Gallery group. Robert Irwin was a part of that. [Eventually the group included Ed Kienholz, Craig Kauffman, Ed Moses, John Altoon, Wallace Berman, Ed Ruscha, and, briefly, Llyn Foulkes.] But then I also found out that there was one unique thing [geometric abstraction] going on in L.A., which was very different from the Abstract Expressionism . . . everybody else was doing.[40]

As much as he liked the college environment, Selz was not satisfied to limit himself to Pomona. He correctly sensed that there must be more to Southern California than peaceful campus life. Unlike most of his colleagues, who took pride in traveling more often to London than to Los Angeles, which they disdained as a cultural wasteland, he regularly made his way to the few galleries and various art events spread from downtown across Hollywood to what is now referred to as the West Side. He became proficient in navigating the early freeways and surface streets over the thirty to forty miles required to get him to his spread-out destinations. Behind the wheel of his blue 1952 Studebaker, acquired in Chicago and driven west, he motored along the existing stretches of freeway that were beginning to connect the far-flung communities of mid-1950s Los Angeles. His route from Pomona took him along the partially completed Foothill Freeway, which connected to Pasadena's Arroyo Seco Parkway, the first such urban highway in the country.[41]

In addition to the galleries along La Cienega Boulevard and in Beverly Hills—the most interesting of which to him were Felix Landau, Frank Perls, and Paul Kantor (among the relatively few important Los Angeles dealers and, as in New York, Jewish immigrants)—Selz was drawn to the new music scene as well as the classical concerts presented by the

unparalleled community of refugee composers and musicians living in Los Angeles. With his faculty artist friends James Grant and Frederick Hammersley, he often attended the Monday Evening Concerts in West Hollywood. Another of Peter's friends, Austrian-born avant-garde composer Karl Kohn, pianist and professor of music at Pomona, was on the board of directors of this concert series. The Monday Evening Concerts were the extended legacy of "Evenings on the Roof," founded in 1939 by music writer Peter Yates and his pianist wife, Frances Mullen, in the rooftop studio of their Schindler-designed home in the Silver Lake area of Los Angeles. Their historic programs now loom large in the history of advanced serious music. Among the names associated with the concerts—immensely popular with the displaced population trying to maintain some connection to European high culture—were immigrants Igor Stravinsky, Arnold Schoenberg, and Lukas Foss, as well as Karlheinz Stockhausen, Pierre Boulez, and John Cage. The serious music world of Los Angeles was, largely by a tragedy of history, for a brief period unequaled elsewhere.[42] Peter Selz and his friends were in the audience of the continuation of this important development in twentieth-century music history. He was *the* visual arts modernist on the West Coast at the time, but he typically looked beyond his own field to seek out the other expressions of the modernist vision, continuing his natural habit of seeking the company of the most creative people among his colleagues.

Selz's most important contribution in Southern California was his recognition of what became known as Hard Edge painting. The term was originated during the early planning of the *Four Abstract Classicists* exhibition that Peter initiated for Pomona but that, with his departure for New York, went to the Los Angeles Museum of History, Science, and Art in 1959. Peter recognizes the significance of the show and the counteraesthetic represented by the featured artists, whose innovations, especially in the case of John McLaughlin, still have not been adequately acknowledged in American art history. Seeking to clarify the circumstances surrounding this pioneering exhibition, Selz begins,

I'll try to tell you exactly as I remember it. I think it started in Karl Benjamin's studio. . . . I was looking at his new work and liked it a

lot. We talked about that kind of work and I mentioned I was doing the McLaughlin essay [an introduction for a show at the Felix Landau Gallery]. And he said, "Why don't you do an exhibition of this group?" . . . I saw Hammersley every week and always admired [Lorser] Feitelson, and so I suggested to them that we do the exhibition . . . at Pomona. I called them all together in my living room in Claremont to discuss the show. But in the meantime, I was offered and accepted the appointment at the Museum of Modern Art. This was late spring 1958 and I had to finish things up at Pomona, including the dedication of a new gallery building, and go to New York in a matter of months.

So I asked [art critic and art historian] Jules Langsner—who was a friend and as much in tune with these artists as I was—if he would carry through on the project. He thought it was a wonderful idea and agreed. The six of us met and decided to proceed, with Jules taking over the exhibition. He said he could probably place it at the County Museum, which he did. As far as the title of the show was concerned, after six or seven suggestions, Jules came up with a term nobody had heard of, Hard Edge painting. Most people think that is a New York term, invented by Lawrence Alloway. But it came up right there in my living room in Claremont. None of the artists liked it, so I said, "Look, we have Abstract Expressionism; let's call this—after all, it's in the classical tradition—Abstract Classicism." And they thought that was a great idea. Oh, yes, the title was my idea; the show was my idea. Jules mentioned the word "hard edge" in his introduction to the catalogue, which was called *Four Abstract Classicists*. [pause] You know, maybe you want to publish this particular part of the interview.[43]

Equally inspired, certainly from the standpoint of dramatically enhancing the collegiate and regional cultural experience, was Selz's idea to place a mural by the artist Rico Lebrun in proximity to the great Orozco *Prometheus* in Pomona's Frary Hall. The resulting mural is called *Genesis*. Peter recalls that in 1956 he mounted an exhibition of Rico's work, in which he was "tremendously interested."

During that time I met the local collector Donald Winston . . . who had come to some of the college gallery exhibitions. He asked if there was anything he could do for Pomona, so I thought about it and said, "Well, if you really want to do something for Pomona the most marvelous thing—since Rico has spoken about his desire sometime in his life to do a mural—is to let us find a place on campus and pay for it." The

three of us met that same night, and the thing got going. We had to get permission and we had to get the wall. Rico and I admired enormously the Orozco mural and so we found a nearby wall just outside Frary Hall.

The president said, "Well, let him bring some sketches to show to the Buildings and Grounds Committee and see if they approve." Rico and I didn't want to do that. I knew that there was not a single person on this committee who had any understanding of modern art. And if they liked art at all, it was the Millard Sheets kind, which they saw around them all the time. So I said, "Look, when you hire a professor you don't ask him or her to give sample lectures; you hire on the basis of previous accomplishments. Here are all the catalogues, reviews, and work that Rico has done." This was an important precedent at the time, and it took about six months to get the idea through committee.[44]

Rico went off to Yale and then to the Academy in Rome, where he developed the design for *Genesis*. There were still problems involved, such as his own idea of competing with, or being in the same building with, Orozco. But he wanted the challenge. He decided that the mural should be painted in black and gray. The powerful result is a departure from the expected in mural tradition, and Millard Sheets, who considered Rico a competitor, an interloper in his home territory, predictably hated the design and vociferously campaigned against it. With the ongoing support of Donald and Elizabeth Winston, however, Selz prevailed and the Lebrun mural was installed at Pomona.

At the same time, Peter continued to cast his gaze westward toward Los Angeles, where he had become aware of—or as he put it, "close to"— the Ferus Gallery artists. Perhaps as early as 1957, the year of the gallery's opening, but certainly with the benefit of hindsight, he recognized Ed Kienholz, Walter Hopps, and the Ferus Gallery as driving some of the most exciting art in Southern California. Although in the end Peter hitched his wagon to the more formalist, polite work of the Abstract Classicists, his natural instincts might have been expected to draw him to the irreverent, antitraditional bohemians—notably Kienholz, Foulkes, and Berman—who constituted the Ferus circle.

In some respects, again drawing upon his earliest exposure to American modern art under the tutelage of Alfred Stieglitz, Peter's grand finale exhibition at Pomona was the most important. More than any other

show, *Stieglitz Circle* demonstrated how his individual view of modernist art was shaped and what it meant:

> That was in 1958 and people paid very, very little attention to that [modern] aspect of American art. Now, [in 1982,] O'Keeffe has become the great culture heroine. At that time, she was considered some kind of sentimental flower painter. That was really the attitude in the late 1950s about this kind of American painting, and I felt strongly that this had to be reexamined. Nobody had paid serious attention to these artists for fifteen, even twenty years. For the opening of the new Pomona facility I did this show called *Stieglitz Circle*, which included O'Keeffe, Marin, Dove, and Hartley. And the early work of Max Weber and Demuth. While I was working on the show I had to go to New York to borrow important pictures, which at the time were fairly easy to get because nobody was paying attention to this group. So we could get the very best examples. My main sources were Edith Halpert's Downtown Gallery, the Whitney, and the Museum of Modern Art.[45]

At the Museum of Modern Art, Peter was talking to Alfred Barr, then director of the museum collection, about borrowing pictures, and Peter reports that Barr said, "If you have this kind of vision, if you do this kind of show now, well, this is interesting." Barr had seen Peter's recently published *German Expressionist Painting*, and he commented on its superiority to the catalogue they had just published for their German show, saying, "This is what *we* should have done." And then he said, "Why don't you come and take over the painting and sculpture exhibitions department?"[46]

By the time the Pomona show opened, Selz was in fact on his way to his new job at the Museum of Modern Art. *Stieglitz Circle* constituted a major statement about Selz's approach, his vision, and his ability to make the right modernist connections, and virtually announced what he would do at MoMA. His vision for the future is contained in his retrospective appraisal of the show and its reception: "The comments were positive, but it was still too early. America wasn't ready for this kind of evaluation. It took a few more years. Everybody was totally involved in Abstract Expressionism. They were interested in the earlier American modernists as a nostalgia kind of thing. Nobody saw the connections

between Dove, or Marin, and the new kind of painting. But some New York artists got it."[47]

Peter Selz was now prepared to make his mark on the modern art world from the most effective bully pulpit available, the Museum of Modern Art. With the preparation provided by Chicago and Pomona, he was fully equipped to establish a singular intellectual position and an international reputation.

Back in New York

Peter's personal relationship to the Museum of Modern Art reaches back to the 1930s; he recalls visiting it regularly and wishing he could get a job there selling postcards. He could not then have imagined the realization of that youthful dream, but the day after the 1958 dedication of the new gallery at Pomona, he went directly to New York—"I could postpone it no longer"[1]—to begin his new job as curator of modern painting and sculpture exhibitions at MoMA.

A year earlier the former curator, Andrew Ritchie, had departed to become director of the Yale Art Gallery, which created the fortuitous vacancy that Selz was hired to fill. Ritchie's associate curator, Sam Hunter, was not being considered for promotion. Selz recalls that there were about half a dozen people vying for the position, "people who have become prominent in the American art world."[2] But it was Peter who got

the nod. This appointment took him back to New York for what surely must have been considered the top museum job in the modern art field.

It looked as though Peter's art career was unfolding exactly on schedule—though he did not actually expect to get the job, considering the competition: "I was very much surprised. I thought the offer would go to somebody older and much more established. The only museum experience I had was running a little college gallery on a shoestring, so I was amazed. . . . I think the job was offered to one other person, who turned it down. I'm not sure, but I believe it was offered to [art critic and art historian] Leo Steinberg—who also had no museum experience at all."[3] After acknowledging the obvious fact that, surprisingly, experience working in a museum was not a priority or even a requirement for the job, Selz went on to acknowledge the support of founding director Alfred Barr. Whereas the final decision was made by director René d'Harnoncourt, it was Barr who first raised the possibility of Selz's fitness for the job. Peter described in a few sentences the qualities that made Barr an art legend as the architect of MoMA's identity and, at the time, clarity of purpose:

> My first wife [Thalia] said to me . . . , "You always wanted to show
> you could do this kind of thing"—to have the chance to do it in a place
> which at that time was much more important than it is now, because
> it really was the only place, it was *the* place that called the tune. . . .
> Barr . . . was our mentor. I've had students who are doing all kinds of
> things now to break down the canon, but he established the canon [the
> accepted measure of modernist importance based upon French art].
> He did all these marvelous things in bringing the different aspects of
> modernism together in one museum, and we admired that enormously.[4]

Barr's role in creating what is often erroneously described as the "first" and greatest museum of modern art was huge,[5] but he did not accomplish this extraordinary feat on his own. As it happened, he was selected in a seemingly arbitrary manner by three motivated and determined female fans of modern art, Abby Aldrich Rockefeller, Lillie P. Bliss, and Mary Sullivan. These three New York collectors of modern art, with a shared interest in contemporary American art (Rockefeller had been collecting since the mid-1920s), met while traveling abroad in the winter of

1928–29. Rockefeller and Bliss each were delighted to discover a kindred spirit as they were examining the pyramids in Egypt. Aboard ship on the voyage home, they—and eventually museum history—enjoyed the good fortune of meeting another enthusiast, Sullivan, with whom they bemoaned the lack of a museum in New York devoted to their modernist interests. Back at home these informal conversations continued over tea, culminating in an invitation to Buffalo businessman and art collector A. Conger Goodyear to join them for lunch at Mrs. Rockefeller's home. Unaware of what they had in mind, Goodyear accepted solely to see his hostess's house and art collection. When asked to head a committee to establish the new museum (social protocol indicated a chair*man*), he asked for a week to consider the matter. He accepted the next day.[6]

Paul Sachs, associate director of Harvard's Fogg Art Museum, was empowered to find a director for the new museum. In 1929, he shocked the organizing committee by recommending his former student Alfred H. Barr Jr., "a callow and often tactlessly outspoken twenty-seven-year-old professor with less than two years' experience in teaching modern art to Wellesley girls."[7] Barr was reportedly charismatic when he spoke with excitement about art, however, and he impressed Abby Rockefeller in his interview with her. Thus the Museum of Modern Art was launched. A big part of the story was Barr's ability to work with what he referred to as his "adamantines," the women whose brainchild the museum in fact was. MoMA was not Alfred Barr's inspiration; it was theirs. But he proceeded to take the idea and run, mostly with their support, especially (although not unconditionally) that of Abby Rockefeller.

Over several decades, first as director and later in a curatorial capacity, Barr successfully crafted what MoMA became—and what it was when Peter Selz arrived. Barr, however, had a vision, an administrative style, and curatorial "quirks" that soon began to grate on the museum board. Although beloved by the curatorial staff and over time earning a reputation as the leading museum authority on modern art—some would say the "final word"—Barr managed eventually to alienate the museum board, even his patron Abby Rockefeller, and board chairman Stephen Clark fired him in 1943. Tenacious in the extreme, Barr refused to leave. His one full supporter was James Thrall Soby, appointed assistant director the same year to "further ease Barr's position." Soby finally

arranged for a small office to be constructed in the library, where Barr could devote himself to researching and writing his long-promised history of modern art. In 1947 Clark partially recanted by appointing Barr director of collections, to be joined in that capacity by his loyal sidekick and trusted collaborator, Dorothy Miller.

In retrospect, Barr came to regard what he initially viewed as "betrayal" by Abby as being in his best interests, for his new position allowed him to do the things he liked best without the administrative responsibilities. With typical modesty and admirable objectivity, Barr wrote, "I had some abilities as a writer, curator, showman . . . and perhaps a modicum of professional integrity, but I was inadequate as a fund raiser, general administrator and diplomat."[8] With the hiring of the far more diplomatic René d'Harnoncourt as director in 1944, the working team that ran the Modern that Selz joined was close to being established. D'Harnoncourt insisted on having Barr as a critical resource, and he frequently described his own "main duty" at MoMA as preserving and nourishing the "genius of Alfred Barr."[9]

When Peter joined MoMA's staff, his primary responsibilities, made clear by his title, had to do with the exhibition program. Acquisitions were handled by Barr. This curatorial arrangement, separating collections and exhibitions, was in place before Peter's arrival, and he heartily approved of it. In fact, MoMA was everything he could have hoped for—at the beginning, at least. His tenure there started on a high note:

It seemed to be at that point to be a very good arrangement. I didn't question it. I was on the acquisitions committee; I had a little voice—not a vote, but a voice. I thought the separation between collection and exhibitions made sense. I had a good staff. Alicia Legg was my number one assistant. I had this great welcome and, especially in the beginning . . . everybody was very cordial. But the marvelous thing was that I could do whatever I wanted. I would come to the curatorial meetings and propose some shows and they were generally accepted. It worked very, very well. Then after two years an associate curatorship was open, and I got Bill Seitz to work with me.[10]

Peter's account of the "acquisition" of William C. Seitz by MoMA in 1960 is well worth telling, for it reveals his disarming but ultimately

damaging innocence regarding the internal dynamics of the museum. Peter truly believed that everyone, or almost everyone, liked him and wished him well. What he didn't seem to grasp was that there was a competitive underbelly to the institution, and he had a small company of detractors, despite his "cordial" welcome. Nonetheless, he proceeded with an optimistic view of the place and the people, and his memories preserve that sanguine perspective. In the beginning, as when he brought Seitz in as his assistant, that optimism may have been justified:

> I was looking for somebody because I couldn't do it all by myself. When I met Bill [the study of] modern art was a very new thing. . . . One reason I respected Barr so much was that he and Meyer Schapiro really made modern art into a scholarly discipline. Bill was an assistant professor at Princeton . . . when I met him. He had written his dissertation on Abstract Expressionism, and he had finished his book on Monet. He suggested that we do a Monet show—the *Claude Monet: Seasons and Moments* exhibition [1960]. I liked the idea very much, and he came in as an independent curator. We got along beautifully, I loved the way he did the show, and I liked the way he wrote the catalogue.
>
> I asked him if he'd be interested in being the associate curator, and he said yes. Then I went to René and he said, "Well, we thought you'd hire somebody on a lower level for this job. Do you really want somebody on the same level as you are?" Coming from academe, I thought this would work very well. "Yes, I think we'd get along fine, and we respect [one another]. We don't have exactly the same opinions . . . which is only a good thing." And then we hired him. René was wrong because Bill and I worked out beautifully.[11]

The interviewer, however, picked up from this anecdote something that Peter had missed. She pointed out that René seemed to be telling him something larger, something about staff interaction and the working environment at the museum in general. At this point Selz acknowledged that, in a way, he was "very, very innocent." As an example, he talked about what he perceived as the background machinations of Porter McCray, the museum staff person attached to the international program of the International Council and one of the few colleagues Peter actively disliked. Although Selz was in charge of exhibitions, McCray was responsible for *international* exhibitions. Peter and Arthur Drexler

(curator of the architecture and design department) protested what they saw as an artificial dichotomy, and eventually McCray had to give in. When asked about McCray's presence at the museum, Selz responded, "I never liked him . . . and I didn't quite know what to make of him. He was on a different wavelength from people like Alfred and René and Arthur and myself. *We* all got along very well."[12]

Porter McCray was a longtime and powerful presence at the Museum of Modern Art. His initial entrée was through Nelson Rockefeller, who in 1947, as chairman of the board, invited McCray to join the museum as director of circulating exhibitions. In November 1962 McCray arranged a "major" Mark Rothko exhibition for Paris. In fact, this was Peter's Rothko show, on view at MoMA in 1961 (18 January–12 March) before touring the United States for a year. Three weeks before the scheduled Paris opening, French culture minister André Malraux canceled the exhibition with no convincing explanation. In recalling the incident, Peter speculates that Malraux was acting in a thinly disguised way to protect French art from the competition posed by the up-and-coming New York School of painting.[13] In any event, McCray went to the mayor of Paris, who obligingly offered basement space at the Musée National d'Art Moderne, "shabby" rooms that managed to be refurbished in time for the opening date.[14]

Selz reports that there was considerable friction caused by the bifurcated nature of the exhibition program, divided between the national and international arms, with the final authority apparently falling to the latter. Selz also volunteered that as a Rockefeller appointee and favorite, McCray had special authority and privileges, including board membership. Furthermore, there were rumors—unverified—that McCray worked for the CIA.[15] Given the tenor of the cold war times and the government practice of deploying civilian cultural representatives abroad for various covert and intelligence-gathering purposes, such rumors were not surprising.

Foreign venues for Peter's exhibitions grew fewer and farther between. The first exhibition Selz organized after arriving at MoMA was a small one for the first Paris Biennial. Titled *U.S. Representation: I Biennale de Paris,* it was, Peter recalls, memorable for introducing Robert

Rauschenberg to Paris. But at that early point in his MoMA tenure he began to see that there were, in his words, "some strange things going on in the museum." He and Drexler determined that this confused situation regarding international authority within their departments could not continue: "We didn't want to have somebody else in charge of painting and sculpture or architecture and design. We felt that was what we had been hired for. Porter McCray ran his own institution [International Council], which we didn't know much about; it was sort of like the CIA. He never told anybody what was going on. He had his own press office in the building next door, and we never knew what they were doing either."[16] More significant than the details of this organizational irregularity was the way René d'Harnoncourt dealt with it—or did not. Peter's account of the McCray problem may provide some degree of insight into the director's management style. After saying he never discussed the matter with Alfred Barr, Selz described his boss's usual answer for such things: "You'd talk to René about it and [he'd say], 'We're going to work it out, everybody's going to be happy.' Any time you went to René about something he smoothed it over. . . . He was an extraordinary diplomat, and he tried to make everyone feel good. Every time you walked into his office with some kind of complaint, you walked out feeling good. [laughing] . . . But things did not really change."[17]

Having said this, Selz was eager to heap praise and admiration on the leading figures at MoMA, notably Barr and d'Harnoncourt. But he also had complimentary words for many others among his colleagues, in fact most of them. And his overall description of MoMA as an institution and of his experience working there was mainly positive, even enthusiastically so. He seemed most impressed, however, by the director, d'Harnoncourt:

Well, there was probably less in-fighting there than people thought, either among the staff or between the staff and trustees. One reason why things ran fairly smoothly was that René d'Harnoncourt was an absolutely brilliant director. He had been director for about fifteen years by the time I arrived, and here was this man with his highly polished European background, this great diplomat, an enormous man, six and a half feet tall. A man who had come—he dropped the "Count"

somewhere along the line—from the highest European aristocracy, and whom the trustees really admired. . . . And [he] knew how to handle the board with the greatest Habsburg kind of diplomacy. . . . He knew how to handle all the prima donnas, department heads and directors—he did a truly admirable job.[18]

Selz also had high praise for James Thrall Soby, the trustee who had stepped in to run the painting and sculpture department for a year after the departure of Andrew Ritchie: "Jim Soby was a trustee, collector, very active in the museum from the beginning. Always sort of the pinch hit-ter, he was a very able man. He was a great connoisseur, a marvelous critic—he was a critic at the time for the *Saturday Review*—and a very astute historian."[19]

Selz recalls a spirit of cooperation among the staff. Judging from his account, there was a sense of common purpose (actually, a mission) and encouragement to do original exhibitions without interference. Still, the limited exhibition space did foster some problems:

The museum space was—it's been enlarged many times since then— very limited, so there could only be about four major shows a year. And you had the painting and sculpture department, architecture and design, photography, prints and drawings, all ogling this space. So there was this competition, because if I did a big show, then Arthur Drexler couldn't do one, and we all were very eager to do big shows, even little shows. There were two [exhibition] areas, one medium-sized and one small. And it was important, very important, whether you had the first-floor or the third-floor space. One, the third, was bigger and had a lot more prestige. For instance, European painters were generally shown in the bigger space and Americans in the smaller space. . . . When I did the Rothko show, it was only the second new American artist show, the prior one being Pollock. Even that was in the smaller space. And I did not get the large space for Rothko; I got it for Dubuffet, and they were pretty much at the same time. [Rothko was 1961, Dubuffet 1962.][20]

Perhaps the feature of the Museum of Modern Art's operation for which Selz was most grateful was a hands-off policy from the top that allowed for an unusual degree of curatorial creative independence. This was an atmosphere in which those receptive to new art and alternative expres-

sions within modernism could thrive, Barr's canon focused on French artists and movements notwithstanding. This freedom to engage art with an open mind, trusting intuition and personal excitement when confronting the unfamiliar and making judgments accordingly, became the basis for Selz's approach, and the artists he "discovered" and championed through writing and exhibitions were seldom those already established within existing critical circles, national or international. Although he encountered disapproval on a couple of occasions, most notably with Tinguely's self-destructing installation *Homage to New York* in the museum's garden, it seems no effort was ever made to rein in Peter or any of the curators:

> One good thing about the Museum of Modern Art, one of the important things that I must emphasize . . . was that practically nothing was done by committee. Everything was done by individuals. . . . [But] not doing things by committee had interesting ramifications. For instance, years later when Bill Seitz and I left the museum, we had scheduled some shows that we were going to do. Bill was going to do a Noguchi show and I was going to do Sam Francis. These shows never happened at MoMA, and people said, "Well that's terrible, the museum just promises these shows and then doesn't do them." In a way that's true, but on the other hand the shows were by committed individuals . . . who when they left took the idea with them.

Peter relished the freedom that came with the job, the opportunity to explore new directions and approaches: "I did part of the Venice Biennale in 1962. I organized many international shows. The big sculpture thing at Battersea Park in London, in the early sixties, where I introduced David Smith to Europe. Bill Seitz, Dorothy Miller, might do something similar abroad—but it was always individual initiative and commitment, never by committee."[21]

This liberal approach to exhibitions is rare in contemporary museum practice. In the era of the blockbuster show and of complicated traveling exhibitions—necessarily involving great expense—museums now more typically operate through committee approvals. Selz, as museum curator, director, and now trustee, recognizes this as the salient difference between the 1960s and today. For that reason, his description of the working situation at the Museum of Modern Art in the early 1960s is both interesting and instructive:

Every week we had a curatorial meeting, and you would bring up your ideas and they would be discussed around the table. But it was more a question of how you could schedule a show, how you could find the space. If Arthur Drexler wanted to do a show of Le Corbusier—which never took place because Corbu was not very cooperative—or whatever he wanted to do, I was not going to question it. He had the competence, which I acknowledged—and he acknowledged mine. Or [if] Bill Lieberman, who was in charge of prints and drawings [proposed something] . . . people wouldn't say, "No that's really not worthwhile." That very rarely happened. But then, of course, everything had to get trustee approval.

While acknowledging the need for approval of the board in connection with exhibitions, Selz emphasizes that it was not binding. He credits the director for preserving an enviable degree of curatorial independence at MoMA, using a personal example:

That was a matter of the [effective] way d'Harnoncourt [dealt with the board]. For example, the trustees wanted at least every other year a late-nineteenth-century show, an "old master" show. And they generally wanted reflections of their own tastes and, frankly, investments. So they always wanted a show of Vlaminck, Derain, or Dufy. But we didn't do it. I remember one time I said, "All right, if you want late nineteenth century, I'll do a show of Symbolists." And I did: Redon, Bresdin, and Gustave Moreau. And I had three other people actually curate the show. So that is how we compromised, and it was a wonderful show, these three artists together. The Moreau part was done by Dore Ashton, Bresdin by Harold Joachim, and Redon by John Rewald. That's how we handled it. I remember other curators coming to town, needing to borrow things for shows at their museums, and frequently they would say, "Well, the board has asked me to do such and such a show." That was never the policy at the Modern. It really was a good place.[22]

Several questions arise from Selz's generally positive recollection of the working environment at MoMA. The first concerns the friendly relationships between departments and staff. Retrospectively it may well be that, for Peter, the ideal of modernist art as common cause allowed him to overlook the familiar workplace phenomena of personal ambition and strategic action to achieve a competitive edge. There is no question that such tension obtains in the nonprofit world of fine arts where power and

prestige are the available measures of success. Is it possible that the situation wasn't as sunny as Selz recalls? Second, the almost utopian respect for individual expertise and creative thought would seem to be at least slightly exaggerated. For example, the Symbolist project was, by Selz's own account, a group achievement (though not committee, it is true). Three outsiders were engaged to choose the art and write the catalogue essays for an important exhibition, one that the staff curator, Peter Selz, refers to as *his* show. This notion of idea over execution puts Selz ahead of himself into the realm of Conceptualism, an art phenomenon that he has partly resisted. In fact, Peter appears to have a broad understanding of what qualifies as ownership of projects that require the high-level expertise of others to bring to successful fruition.

Finally, the powerful presence of the MoMA trustees, including members of the Rockefeller family, must have presented a challenge in museum decisions and operation, even if the Modern's board was as enlightened as Peter describes. MoMA was not exempt from some board interference, though with d'Harnoncourt as mediator this may have been less of a problem then than it is today. In museums as elsewhere, those who pay the bills and underwrite grand new facilities—or raise the money to do so—want to have a say in how things are run. It appears that d'Harnoncourt did a remarkably good job dealing with this conundrum. Indeed, that ability, along with fundraising skills, became the main qualification for success as a museum director. Curators such as Peter Selz were thereby supportively insulated, which allowed them to happily devote their energies to thinking up and producing provocative, enlightening, and educational new art exhibitions. This turned out to be Selz's strength as well as his pleasure.

Peter had a fundamentally positive view of MoMA's board. He felt that the curatorial staff—in his mind, the key people in terms of creating the collections and exhibitions—was for the most part respected and left alone by both administration and the trustees. However, one anecdote about Nelson Rockefeller tells another side of this story:

> Rockefeller was very smart. First of all, they never called the museum the Rockefeller Museum—like the Guggenheim and the Whitney.

That was the first thing they did that was smart. . . . And they did an absolute minimum of interference. Occasionally there was some, as in the last show . . . that [Edward] Steichen did. It was the Farm Security Administration photographs—a marvelous show. It was the biggest show after *The Family of Man* [1955]. I remember when I saw the show installed in the afternoon . . . as you walked in there was this frontis- piece, not actually a Farm Security Administration photograph, [but] a portrait of FDR. That evening at the opening I saw this big portrait gone. This was precisely when Nelson was running for governor [of New York] on the Republican ticket, so he did not want the portrait of FDR staring people in the face as they walked into the museum. He said he removed it, or "suggested" that it be removed, because it didn't belong; it wasn't a Farm Security photograph. But that was really one of the few instances I remember when there was a bit of interference. Most of the time . . . politics did not get in.[23]

Elsewhere, however, Peter supplies two other examples that suggest the influence of political or market-driven forces on exhibitions, and gives the impression that this regrettable tendency to step outside the institutional mandate became more pronounced as time went on. These "lapses," he explained, violated the rule of maintaining a fine-art high ground. As he saw things, the responsibility of the museum was to pre- serve and explain the cultural artifacts (paintings and sculpture being Peter's department) representing the creative highlights of art, beginning with recent European art but increasingly including American modern- ist art. As the balance shifted, however, politics and commerce inevitably shouldered their way in. Peter described the situation thus:

There was another thing that was going on, which I can only look at now with [benefit of] hindsight. Abstract Expressionism was shown internationally all the time, in embassies, and then there was the big *New American Painting* show [1959] that Barr was in charge of, and that was when I came. The idea behind it, as Barr wrote in the catalogue, was the freedom of the American artist. That was against, you know, the restriction of the avant-garde behind the Iron Curtain. And that [claim] was going on all the time—and the Abstract Expressionists were quite upset. They were very ambivalent about it. They couldn't understand how their work, which was such a private matter for them, would be catapulted into an international thing. They liked it and they didn't like

it. I think their response was pretty negative in the long run, because they didn't know how to deal with all the success—it was such a different world. . . . Most of them ended in some kind of despair . . . they didn't know how to deal with sudden acclaim.[24]

Peter allowed that Barr—perhaps not fully conscious of the fact— was using the art politically, possibly as a weapon in the cold war. Nevertheless, Peter insisted, Barr's interpretation of the art, even within this international context, was sincere, not forced on the museum by powerful members of the board (or, presumably, Washington propaganda agencies). Still, the Abstract Expressionist artists probably never saw themselves as players in a political arena. And they surely would have been shocked to learn of the cultured André Malraux's purported attempts to politicize contemporary art along nationalistic lines by sabotaging the 1962 Rothko exhibition in Paris and attacking the American show at the 1964 Venice Biennale while pressuring the jury to award France top prize.[25] In the end, Robert Rauschenberg took first prize at the Biennale, and Alan Solomon, the American commissioner, declared chauvinistically that this single event marked, in Peter's words, the "demise of the School of Paris and the triumph of American painting."[26]

According to Selz, everything changed that year—1964—when the "dealers took over," enabled by a last-minute juror vacancy at the Venice Biennale. As Peter recalls, the word went out that Leo Castelli, Rauschenberg's dealer, would pay the expenses for any prominent curator who would fill the position—and, of course, vote for Rauschenberg. Three were invited from the Modern: Peter, Bill Seitz, and Dorothy Miller. All of them declined. The inherent conflict of interest was obvious.[27]

That was the mid-1960s, and the art world had moved its headquarters to New York, a migration fully in the interests of the American art market. Peter's view is that this historic shift was largely the doing of art dealers: "There were all kinds of distortions going on, like . . . I remember press releases claiming this was the first time that an American [Rauschenberg] had won the first prize in Venice, which was important to people at the time. But it wasn't true at all; Mark Tobey had gotten it a few years earlier. But Tobey was not a New York painter, so that was

hushed up and nobody paid attention. He was not part of 'the group,' and nobody could make money on Tobey anyway."[28]

In addition to the political ramifications of this newly achieved stature of American painting—as evidence of the cultural and economic benefits provided by capitalist democracy—Peter describes the "snobbism" of New York cultural centrism, aided and abetted by the growing art market in Manhattan. Even then, in the mid-1960s, he recognized the exclusivity that accompanied creative success as fueled by a powerful and motivated art market. Here is how Selz, whose own museum participated in what he was criticizing, describes the situation:

> Anything that wasn't happening in New York was totally neglected with an extremely nationalistic, chauvinistic attitude which I was always fighting. I'll give you a couple of examples. They were saying this kind of abstract art could only happen in a free country; then I found out, in the late fifties, that there was some very exciting—maybe not the greatest in the world, but some very, very good—abstract painting being done in Poland. And I went to Poland and eventually organized a show of Polish art called *Fifteen Polish Painters* [1961]. It was my purpose to show two things. One, that good art—in this case Tachiste rather than Abstract Expressionism, because it was more oriented towards Paris than it was towards New York—was going on in Europe. And, second, it was not only going on in Western Europe but in a Socialist country.
>
> The whole idea in New York was that anything going on outside America was not worthwhile . . . that Miró was the last important European artist. I remember one time when Bob Motherwell had a show in Paris and he came back furious. He said, "I will never show in Paris again. Here I had that show and the French artists didn't come to see it." So I said, "Bob, how many shows of younger French artists have you gone to see?" And he said, "There aren't any." That was very much the attitude—a very insular kind of attitude.[29]

You might say that New York centrism in the early 1960s and for several decades following was one of Peter's pet peeves. He simply found it self-serving and, from the standpoint of the dealers, commercially opportunistic. Yet at the time, his was not a majority view. There was, in fact, every reason for the art and culture establishment to embrace New

York exceptionalism. Superiority to and independence from contemporaneous European modernism came along with—indeed, defined—the Triumph of American Painting myth that attached itself to the 1950s New York School painters and their successors.[30] When America appeared to take the art mantle from France, it really was exclusively New York and Abstract Expressionism that accomplished the historic coup. Peter, as a major curator at the Museum of Modern Art, was fully aware that New York had become a center for significant modernist art. However, he was too well traveled and too open to different creative expression, wherever it emerged, to restrict himself to Manhattan and environs in his ongoing search for new art and artists.

Selz's early appreciation of Peter Voulkos is an important example, illustrating the frustrations that accompanied his forays outside the defined center. Peter arranged a small show of Voulkos's irreverent Abstract Expressionist ceramics, which he'd created in the pot shop at Otis Art Institute in Los Angeles. Held in MoMA's Penthouse Gallery in 1960, the show did not create much of a stir. In fact, according to the curator, it was virtually ignored. Although Voulkos's transgressive use of media, his "unnatural hybrid" forcing Abstract Expressionist painting and clay sculpture to share the same formerly utilitarian object, soon came to be recognized as a major breakthrough, he was in the end a Californian showing in New York City. When asked if Voulkos would have attracted more attention had he been a "local" artist, Peter's unhesitating response was, "No doubt." As he put it, the attitude was that Voulkos "hadn't been around. . . . He hadn't paid his dues; he was not part of the in-group. It was very much an in-group kind of thing, and it was something I could never accept. . . . Much earlier on I was working on the German Expressionists as against Paris, and I never doubted for one minute that what was going on in Paris between the wars and what was going on in New York after the war was of primary importance. But it also seemed to me that other things were important as well."[31] This parochialism bothered Selz, and the fact that it did, and that he acted accordingly, seeking artists from outside those narrow confines, put him from the beginning on the edge, if not outside the mainstream as represented by his own museum.

Another, even more dramatic, example of New York parochialism, according to Selz, was the response of many critics to his 1959 *New Images of Man* exhibition, his first after arriving at MoMA. In some ways that exhibition represented Peter's throwing down of the gauntlet. He absolutely insisted on not just stylistic but also geographic latitude as he set about defining the modernist creative universe. Having spent three years at Pomona, he had discovered artists in California whom he believed worthy of broader recognition.

> From California I picked three people: Rico Lebrun from the south, and from the Bay Area new figurative movement, Nathan Oliveira and Richard Diebenkorn. And New York screamed; the critics didn't like it at all. They thought the idea of showing totally unknown people whom nobody in New York had heard of—let's say like Oliveira and James McGarrell—with the holies, de Kooning and Pollock, was heresy. It was really bad. You know, "This guy couldn't tell what's in from what isn't in." So in general the response to that show was pretty negative . . . because this was the time that the New York School was "it," and the only thing that was happening was in New York. And here I come [from Pomona College], and in the very first show I do at the Museum of Modern Art I did two terrible things: I showed artists from the American provinces, and I brought in artists from Europe. So the most "in" kind of journals, like *Art News*, hated the show and panned it.[32]

Another hallmark of Selz's years of exhibiting and writing about modern and contemporary art was his refusal to accept that the modernist impulse could be contained in any critically or art-historically constructed box, or that abstraction was the measure of significance in art. Modernism and significant originality were simply not so limited. The context for this battle involved Willem de Kooning and his fundamental connection to the figurative tradition, something that Selz understood more fully than did most other New York writers and curators. In this, he had the benefit of his graduate focus on German Expressionist figuration and a keen interest in the various Chicago figurative movements. He spoke of his interest in a "newly emergent" figuration after Surrealism and Abstract Expressionism. "This was a time when very few people looked at anything which wasn't Abstract Expressionism, which wasn't

abstract. And when de Kooning painted his women, people were saying, 'Well, these are really abstract paintings,' which de Kooning, of course, thought was totally ridiculous. He wanted to paint pictures of women. The most important people in *New Images of Man*, the key artists, were de Kooning, Dubuffet, Bacon, and Giacometti."[33]

. . .

The years at the Museum of Modern Art were heady ones for Selz in many ways. Leaving the quiet, idyllic college campus at Pomona and becoming immediately immersed, without much preparation, professionally or socially, in the high-powered Manhattan art and museum world had to be both exciting and stressful. The job was all-consuming, a situation that Peter admits had a negative effect on his young family and his marriage. But there were other experiences, either within the museum itself or related to the influence his job gave him, that began to shape the person he was to become. Surely the society in which he moved as one of the Modern's leading curators gave him greater self-confidence and sophistication. Artists and others were paying attention to him, hoping that their careers could benefit from his interest in them and promotion of their work. Selz remembers this as a difficulty he had to learn to finesse. And it may be that for him, a social creature very interested in people, separating enthusiasm for the artist as a person from judgment of the work itself was a complicated and even compromising process: "It became very embarrassing when I was working at the Museum of Modern Art, and I had these artist friends who expected me to do something for them. But they were not at all equipped . . . they were just friends, people I liked."[34]

In New York, perhaps more than elsewhere, success depended in part on whom you knew and socialized with. Peter Selz was open to the new opportunities that came with his position, and he readily availed himself of many of them. How judiciously he did so may be questioned, but there is little doubt that living and working in New York in the first half of the 1960s molded Peter Selz in the city's ambitious and worldly image.

The situation at the museum offered notable advantages, but as a Jew

he undoubtedly ran into certain obstacles. The degree to which Peter perceived his being a Jew as an impediment to his career and ultimate happiness is difficult to assess now. He says that he thought about it very little, that it was not an issue. The minimal attention granted to what must have been a significant factor in his life, starting with his early years in Munich, suggests a personal strategy of denying obstacles to achieving the life he imagined for himself. Here, in the MoMA years, may be the best place to record the few anecdotes about anti-Semitism that Peter deems worth telling.

His experience as the only Jew among the workers at the Rheingold brewery has already been mentioned. In New York, one experience stood out in Selz's mind as a reminder of the second-class position of Jews both at the museum and in professional cultural life more generally. Peter's lengthy account suggests that the incident stands, in his memory at least, for his broader experience of discrimination:

> There was this retreat in Northeast Harbor, Maine, in the summer of 1960, maybe 1961. Anyway, they decided to have a retreat to talk about the future of the Museum of Modern Art. The director, René d'Harnoncourt, and all the department heads were invited to the huge estate of William Burden, president of the board. The Rockefeller cottage [nearby] was a wooden building about a block long. Edsel Ford had his place there—it was the richest of the rich. And I remember Arthur Drexler saying to me, "Do you realize, Peter, that this is the first time any Jews have been on this island?" Referring to himself, me, and Bernard Karpel, who was the original librarian at MoMA. . . .
> There was not a single Jewish museum director in America at that time. . . . You had to be New England or you had to have a foreign accent like René, who had a combination of French and German, a European accent. That was all right. But Drexler and I made an imprint. We were not head of the museum, but we were chairmen. And Jews were [previously] not in these positions. . . . In the lower levels there were Jews— but no blacks. . . . Jews were not at the highest level, because they would have to move in society. They had to raise the money.[35]

What is interesting is that Peter Selz says he felt very little, and attended to even less, the subtle discriminatory mechanism at work. As he looked back to his days at MoMA, he saw little or no evidence of anti-Semitism.

When asked if he personally noted the presence of discrimination, he passed over it lightly: "I noticed it. I noticed it, and when Drexler made this remark about being the first Jews on the island, I was amused . . . because I didn't feel anything. I felt no personal anti-Semitism at all. But it was still prevalent."[36] With this statement, Peter is downplaying the actual situation at MoMA and most other museums. In a contemporaneous *Art News* editorial, Thomas B. Hess famously wrote that "when trustees go shopping for a director, it goes without saying that no Jew need apply (unless, naturally, he has changed his name and religion)."[37]

It is almost as if Selz decided to banish from his mind this lingering blemish on post–World War II society, at least as it affected him personally. The self-image he was constructing simply did not allow for racial or cultural insults to be acknowledged. He says that this coping device went back to his Munich childhood. Who he was and what he was becoming had no room for such unpleasant distractions. In fact, Peter tells stories about the Jewish "question" as amusing anecdotes, not as anything that had a particularly negative effect on him—an example of his remarkable ability to apply positive spin whenever events called for management. The following "good story," as he calls it, exemplifies this skill to neutralize by appearing to trivialize what others might find seriously offensive.

In Hanover, West Germany, negotiating loans for his 1963 *Emil Nolde* exhibition at the Museum of Modern Art, Peter was talking with Dr. Bernhard Sprengel, a major collector of modern German art after whom the Hanover art museum, opened in 1979, was named and from whom MoMA borrowed heavily for the show. The director of the Hamburg Kunsthalle, Dr. Alfred Hentzen, joined them for dinner and proceeded to sound Selz out on another directorship that was about to open.

"The director of the state museum in Hanover is about to retire. Would you be interested in his job?" So I said, "No, I would not. But thank you very much." Two days later, the same people: "The director of the Kestner Gesellschaft"—an early museum of modern art, like the MoMA in New York . . . they're still doing great shows—"is leaving. Would you be interested in becoming *Generaldirektor* of all the art museums in Hanover?" I said, "Why are you offering me this job?" And they said, "Well, we discussed it and we thought it would be good to once

again have a Jewish museum director in Germany." They would not say anything like this in Germany now. But that generation didn't know the implication of this offer, and of course I said no.[38]

The critic Dore Ashton, Peter's friend, fellow activist, and frequent collaborator, was less generous in her appraisal of the situation at MoMA. Among his colleagues, she may have been the closest to him in terms of an ideological approach to art. Above all, they were and remain political allies, as Ashton's comments in her interview reveal: "The Museum of Modern Art at that time didn't harbor many Jews. I think Peter may have been the first with a major job there. He had that to deal with. We talked about that, among other things. He was forced to associate with the kind of people that he and I don't admire. . . . I don't know all the details . . . but surely that was difficult for Peter, as it was for me."[39]

Some years later, another close woman friend of Peter's, this time a Californian, shared with Peter a travel experience that cast light on his deeper feelings about Germany, the Holocaust, and anti-Semitism. A native San Franciscan, Marianne Hinckle had worked as a researcher and writer for her brother Warren's literary and political magazine, *Ramparts*, associated with the New Left, and the subsequent *Scanlan's Magazine*. In 1976 in Italy, after visiting some friends at the American Academy in Rome, she was writing for various local English-language journals in Milan and discovering the Italian world of art and culture firsthand.[40] She first met Peter in Venice as they were both touring the Biennale. She had supper with him that evening and the next day joined him and German author Hans Maria Wingler for lunch at Café Florin. Wingler asked her to join them in Berlin, where Peter was scheduled to give some lectures. With the spirit of adventure that had taken her that far, she accepted the invitation.[41] She describes the visit as a good "introduction to Peter's German background and influences." She could see that being German influenced his entire approach to the history of art, and she began to understand also the influence that growing up in a nonobservant Jewish family had on his personal identification as a Jew.

The following year, Marianne accompanied Peter on another trip to Germany, where he was gathering art for a German Expressionist exhibition. In Essen they saw an exhibition about Nazi art and architecture,

which included a scale-model proposal for the redesign of Berlin as the "capital of the world." "I'm not sure Peter had ever seen this, but it made a big impression on both of us," Marianne remembers. Then, driving to Munich, they passed the exit sign for Dachau, and Peter told a chilling story. The year before, he had been traveling with an artist and they took the Dachau exit to tour the notorious camp in which thousands of Germans were exterminated at the hands of their countrymen. "Peter told me there would always be a little old lady in a cottage, nearby or across the fence, who would say, 'It's all a lie. We didn't kill any of the Jews.'"[42]

A few days later, in Munich, they decided to see a recently released documentary on Hitler. During the preceding year, Peter had been considering another invitation to return and take a post as a museum director. Marianne did not think it was a good idea. "Peter by now was too Californian, I thought, too broad and poetic." But he remained torn by the overture. During their travels, Peter had been "sentimental" about his childhood, even under Hitler. Seeing this movie, though, brought Peter back to dark reality. This postwar bio-documentary about the rise of Hitler, depicting the general unemployment and aimless youth ripe for organization, made the appeal of Hitler's rousing speeches "almost understandable. You kind of got carried away in the emotion, the propaganda of the film," said Marianne. Not understanding German, she could respond only to the visuals; however, when the movie was over, she said, "Peter, let's just sit here for a while. I want you to listen to what people are saying around us." They sat there until almost everyone else had left, and then she asked what he had heard.

"Marianne, they said things would have been different if we [the Germans] had won the war."

Marianne said, "There's your answer."[43]

This incident seemed to dispatch any inclination Selz might have had to repatriate as a German Jewish intellectual.

. . .

Peter Selz's career at the Museum of Modern Art can best be defined by the artists and work he presented as the first curator of modern paint-

ing and sculpture exhibitions. He conceived and organized many shows personally, while some were developed from his ideas but assigned to others, primarily his associate William Seitz. One of the most important exhibitions was to be a retrospective for Willem de Kooning. There was every reason why the two MoMA curators would enthusiastically embrace this project. Seitz had done his dissertation on Abstract Expressionism, and Selz had already built a reputation on a modernist view combining figuration and painterly abstraction, the hallmark of de Kooning's most important work. In addition, there are interesting parallels between de Kooning and Selz in their individual experiences of coming to and thriving in America.

De Kooning's immigration story was not that of Selz, but there were similarities in their almost effortless assimilation through attraction to the fast pace and excitement of their new home. Neither spoke English well when they arrived, and to a certain degree both were loners, although Selz managed to remedy that situation fairly quickly by immersing himself in the social world of art galleries. And both successfully reinvented themselves (Selz several times) in response to the very different American environment. But perhaps most important, they both witnessed and later participated in—one as an artist, the other as an art historian—the transformation of American art from a parochial reflection of European models to the so-called triumph of the New York School. As American critics in the 1950s celebrated the shift in the balance of power from Paris to New York, de Kooning was a leading figure among those artists, mostly immigrants, whose work fueled that shift.

At the same time, art history was continuing to establish itself as a legitimate field at the leading universities in the country. Selz was a contributor to the eventual Americanization of art-historical writing and publishing. Above all, both men were either at or close to the center of the rise of modernist art in the United States, the most modern nation in the world. And the Museum of Modern Art provided the setting for the paths of these two immigrants to converge.

Among Selz's contributions to an evolving understanding of modernism was his ability to think of it in both nonobjective and representational terms. His specialty was German Expressionism, and he contin-

ued to view art through an expressionist lens. De Kooning's brand of Abstract Expressionism, in which the figure appeared and disappeared, showed a dedication to the best art of the past as well as contemporary stylistic discoveries; in this, it provided an ideal locus for Selz's expressionist-inspired ideas about modernist art. The artist's violent women paintings of the early 1950s offer perhaps the best visual equivalents to Selz's thinking about a new figuration, particularly as presented in his controversial *New Images of Man* exhibition at the Museum of Modern Art. De Kooning was represented in this groundbreaking exhibition by six works, more than any other artist except Jean Dubuffet and Alberto Giacometti, two other Selz favorites.

Selz recalls the regrettable cancellation of the de Kooning show as due to reluctance on the part of the artist:

> I would go to his [de Kooning's] studio and admire his work. And then Bill [Seitz] and I decided to give him a retrospective. He withdrew for many reasons, including one involving Mark Rothko. Mark and I had taken the train down to Washington, D.C., to see a big Franz Kline retrospective at the Institute of Contemporary Art. There was a sign saying that this was a memorial exhibition because Kline had just died. Well, de Kooning was there, and Mark said to Bill, "I hear the next show at MoMA is your memorial," having just looked at the announcement of Kline's death. I don't know if that was a Freudian slip. And then he of course said, "I mean retrospective."[44]

Rothko's slip of the tongue may have put de Kooning off on the idea of the exhibition, but another reason for his change of mind, according to Selz, lay squarely on Seitz's shoulders. In Peter's words, his curator "really screwed up." Seitz knew a great deal about Abstract Expressionism, "far more than anyone else." But at that particular time he seemed to be more interested in the conceptualist Marcel Duchamp than in the painter de Kooning. Not surprisingly, this did not sit well with the subject of their show:

> He [Seitz] would go down to Bill's [de Kooning's] studio to supposedly work on the show, but he talked about Duchamp—he asked Bill what he thought of Duchamp. And Bill asked me that at an opening one time, "Why is this guy talking about Duchamp all the time?" Bill Seitz was

involved with Duchamp at that point, [trying to understand] him. And the other stuff, Abstract Expressionist painting, he [already] knew. . . . Well, what [de Kooning] meant was, "I'm not interested in Marcel Duchamp." He thought as little of him as he thought of the Abstract Expressionist artists. There was a big, big division between the mind and the paint project.[45]

When Peter was asked which side he would come down on if he had to choose between the intellect and the feelings, "the mind" and "the paint," he not surprisingly returned to his roots in German Expressionism and the emphasis on personal subjectivity: "I was never as impressed with Duchamp as many of my friends were. I found him an extremely interesting phenomenon, but I've never seen a work that moves me. But when looking at a de Kooning painting, my heart palpitates."[46]

Throughout his career, when it comes to matters of art, Selz has been guided by intuition, instinct, and emotion. He *feels* his decisions about art and is guided by those feelings at least as much as by the mind. Certainly no one could accuse Peter Selz of following the cerebral dictates of theory, like many of his colleagues and almost an entire generation of their students did. So it is sadly ironic that the debate between these two approaches, as perceived by de Kooning in any case, contributed to the cancellation of an exhibition that would have been a fitting expression of Selz's thinking about modernist art, in which de Kooning occupied an iconic position.

MoMA Exhibitions

When asked to identify his most important exhibitions at MoMA, Peter Selz selected six: *New Images of Man, Mark Rothko,* Jean Tinguely's *Homage to New York, The Work of Jean Dubuffet, Max Beckmann,* and *Alberto Giacometti.*[1] In each case they represent a different and revealing aspect of his thinking about modernist art.

Before he left Pomona for New York, Peter was asked by director René d'Harnoncourt to propose three shows he would like to mount as curator of modern painting and sculpture exhibitions. His list represented interests he had nurtured since the Chicago days and that still inform his perspective on what constitutes modern art. It was also noncanonical; that is, it challenged or enlarged upon the Museum of Modern Art's take on modernist art as established by Alfred Barr. The three exhibitions he proposed, all of which were realized during Selz's tenure at the

Modern, were *New Images of Man, Art Nouveau,* and *The Art of Assemblage.* Peter believes that his list clinched his getting the job at MoMA. And the implication is that Barr, to the extent that he was still involved in guiding the exhibition program, and d'Harnoncourt were in fact more open to fresh thinking about modern art than the then-accepted Barr canon might indicate. Selz's proposals, however, do raise a couple of questions: Why did Selz choose these relatively unexamined topics to present at the world's most prominent showcase for important modernist art? And what do these choices tell us about his personal understanding of modernism? The answers appear fairly readily throughout the interviews, in his descriptions of what distinguished each exhibition.

In fact, perhaps more than any other aspect of his career, Peter loves to talk about his exhibitions:

> I felt that the *New Images* and *Assemblage* shows dealing with contemporary work, which had somewhat been neglected, and an historic survey of Art Nouveau, which had been totally neglected, was a pretty good balance. What I was trying to do with *New Images*—put together in 1958 and shown in 1959—was to present something I'm still very much interested in, a newly emergent figuration after Surrealism and Abstract Expressionism. . . . I was very much involved with this kind of art, and in the catalogue of the show I was drawing parallels between the new figuration and existentialism. Paul Tillich wrote a preface to the catalogue, and I see it now as a pretty important document for some of the artists' thinking at the time. I was really concerned at that point with an artist's response to the world situation, let's say the world after Buchenwald, Hiroshima, and World War II—the existentialist attitude.[2]

One may well wonder why Peter, an avowed atheist, would choose a famous Christian theologian like Paul Tillich to introduce what Peter viewed as an exhibition of secular humanist images.[3] When asked about this, Peter paused for a moment before his response. The first thing he mentioned was that Tillich was also from Germany and came to America, at the invitation of Reinhold Niebuhr, at about the same time he did (the Tillichs arrived in 1933). Also, Tillich took a great interest in and wrote about art, including essays on Matthias Grünewald and Picasso's *Guernica.* He was interested in the Christian aspect of German Expres-

sionism, especially Peter's favorite, Max Beckmann. In short, Tillich was a highly respected intellectual who advocated the kind of art, generally figurative, that made up the *New Images of Man*.

Peter called Tillich at home in New York and invited him to write about the show from an existentialist perspective. Tillich agreed, and there began a long personal and professional association. Peter recalls a dinner with the Tillichs and the Filipino American artist Alfonso Ossorio at the Selzes' rented summer house on Long Island. Ossorio, a devout Roman Catholic, is noted for the Christian iconography that persisted even as his work became more abstract under the influence of his Long Island neighbor Jackson Pollock, whom Peter greatly admired. The fact that Ossorio sought out Dubuffet in France only reinforced a camaraderie of taste and interest. This community of aesthetic humanist artists and thinkers doubtless provided support for Peter's basic non-formalist approach at MoMA. And the religious component—perhaps better described as subjective, emotional, and mystical—played a part in that broader artistic vision.

At any rate, the prefatory note in the *New Images* catalogue, with its eloquent positioning of art within the larger context of the human condition, leaves no doubt as to why Peter Selz chose Paul Tillich. And since it states so completely Peter's own view, it is worth quoting here:

> Each period has its peculiar image of man. It appears in its poems
> and novels, music, philosophy, plays and dances; and it appears in its
> painting and sculpture. Whenever a new period is conceived in the
> womb of the preceding period, a new image of man pushes towards
> the surface and finally breaks through to find its artists and philoso-
> phers. We have been living for decades at a turning point, and nothing
> is more indicative of this fact than the revolutionary styles in the visual
> arts which have followed each other since the beginning of our century.
> Each of these styles transformed the image of man drastically, even
> when compared to the changes of the past five centuries. Where are
> the organic forms of man's body, the human character of his face, the
> uniqueness of his individual person? And finally, when in abstract or
> non-objective painting and sculpture, the figure disappears completely,
> one is tempted to ask, what has happened to man? This is the question
> which we direct at our contemporary artists, and in this question one
> can discern an undertone of embarrassment, of anger and even of hostil-

ity against them. Instead, we should ask ourselves, what has become of *us*? What has happened to the reality of our lives? If we listen to the more profound observers of our period, we hear them speak of the danger in which modern man lives: the danger of losing his humanity and becoming a thing among the things he produces.[4]

The hostility, even ridicule, that *New Images of Man* aroused in several critics and even other artists took Selz by surprise.[5] The writer of a long *Art News* review—evidently hostile to formulaic latter-day Abstract Expressionism—entirely missed the point, setting up abstraction and figuration as irreconcilably antithetical, either/or stylistic phenomena, the opposite of Selz's inclusive and flexible modernist view. The New York provincialism to which he so vigorously objected is also evident in the reviewer's condescending regional put-downs: "'New Images' has a moderately entertaining effect, thanks to the talent scout mentality which has filled the center of the show with blooming starlets from far-away stops on the Golden State Limited. The most stunningly slick painting is oozed onto canvas by Nathan Oliveira [illustrated: *Seated Man with Object*, 1957], a fast shuffle artist whose . . . spatial adventuring . . . and great attention to the small, fractional movements in the rugged outcoasts of forms have long been clichés in San Francisco abstraction."[6] And so on. In general, this particular critic, Manny Farber, treated the Europeans better than the Californians (with his backhanded reference to "stops on the Golden State Limited") and Chicagoans such as Peter's friend Leon Golub.[7] It is no small irony that Farber ultimately spent a big chunk of his distinguished career as an admired film critic and painter in California.

In reading other prominent critics, it appears that Peter may have exaggerated the proportion of negativity. For the few scathing reviews, more display a willingness to look closely and provide intellectual (if not always aesthetic) justifications for images that were frequently described as unsettling and disturbing. The view of "man" as presented in the exhibition was not seen as a positive one, but it was generally taken seriously. For example, even conservative John Canaday in the *New York Times* offered what might be called qualified praise—stingy, but hardly the negative response his conservative reputation would lead one to

expect: "In spite of questions of selection, this is an important exhibition. As it sets out to do, it demonstrates that the cultivation of expressive imagery by artists who have seemed isolated from one another has been a pervasive constant in contemporary painting and sculpture. If it means to say further, by implication, that this constant is the white hope of art at the moment—then Hear! Hear!"[8]

Greater insight and understanding of the deeper implications of the show's theme were brought to the subject by two distinguished critics, Aline B. Saarinen, also writing in the *New York Times,* and Katherine Kuh, newly appointed art critic for *Saturday Review.* Saarinen's article was especially attentive to and descriptive of what she viewed as the horrific quality of much of the imagery—"human figures with bodies distorted, misshapen, mutilated, flesh decayed and corrupt, corroded or charred"—to which she devoted an entire paragraph:

> Is this some freak show of horrors inspired by a sadistic impulse on the part of Peter Selz, the director of the exhibition? Is this mere Grand Guignol? Has the exhibition been put on by the Museum of Modern Art with no more significant intention than that of a movie theatre displaying a "chiller" in order to boost attendance? Unquestionably, some of the public will answer these questions with impassioned affirmatives. But others will recognize that this exhibition is concerned with the human predicament, with the troubled states of the soul in our time. They will understand that it is disquieting and unsettling precisely because it ruthlessly invades our inner privacy and inexorably lays bare modern man's fears and anxieties, his bestiality and his loneliness.[9]

Earlier in her piece, Saarinen states that the main issues in the "debate" she anticipates will be provoked by the show are not aesthetic but rather center on the questions of "premise and justification." And she also recognizes the implied confrontation between expressive figuration and Abstract Expressionism (something that Selz in his catalogue introduction denied was intended),[10] cautioning that the yearning of "New Humanists" for "a return to the ideal or naturalist figure" will find cold comfort here. "Such dreamers had best remain with abstract expressionism, which they can smugly and comfortably misunderstand as mere decoration."[11] In this observation Saarinen seems entirely in

step with Selz and his stated disinterest in challenging anything but the hegemony of Abstract Expressionism. Both critic and curator seem to share the opinion that the recognizable human presence was desirable, perhaps essential, to make certain important points about the condition of contemporary men and women.

Katherine Kuh was thoughtfully critical of the exhibition, pointing out where the claims of the exhibition were not always evident from the work on view. She rightly cited German Expressionism as a major source and pointed out that "despite their arresting vigor, these artists as yet have not produced a language appreciably different from their predecessors'." Recognizing the source of "disturbing images of man in Grünewald, Bosch, and Goya," Kuh acknowledged that these great painters differed from modern-day artists in that they were "less concerned with the merging of form and content":

> This unique contribution of the twentieth century is particularly well demonstrated in the current exhibition, where artists depend on appropriately pitted surfaces, discarded materialism and gashed pigment to describe the decay and destruction. This very union of meaning and means may well prove to be the new realism of our time. . . . There are those who will be shocked by the brutality of the exhibition, but for me it remains curiously romantic and moral: romantic in its zeal for personal expression, moral in its concentration on the evils of our time. Anger here is so strong as to become an ethical judgment.[12]

How could one wish for a better appreciation of curatorial intent? It is puzzling, not to mention out of character, that Selz selectively remembers only the negative response to his first great exhibition. Both of these reviews, especially Katherine Kuh's, grasp in one way or another just what Selz was after. And they provide an entry into an exhibition that was, certainly in retrospect, as morally honest as anything else of its time. Figuration versus abstraction was not the issue. It was a moral and ethical need that brought the show together.

Remarkably, the critical controversy surrounding the show and its reception, compounded by limited understanding of Selz's goals, endures to the present day. Peter recently felt compelled to take to task critic Peter Schjeldahl for his characterization of *New Images* in a *New*

Yorker review of Leon Golub's late drawings.[13] In a letter to Schjeldahl, he wrote: "It is dead wrong to call the exhibition at MoMA a 'flop.' As I understand it, 'flop' refers to minute attendance and I wonder if you checked the attendance records. To my recollection, it brought a very large number of visitors to 53rd Street, partly because of the controversy which it aroused." Selz went on: "Alfred Barr congratulated me on this, my first exhibition at MoMA, saying that controversial exhibitions and acquisitions were the lifeblood of the Museum." The irate Peter Selz concluded his letter with an observation that goes back to the contemporary worldview that the art seemed to reflect: "It is totally absurd to write that 'only Golub of the young artists survived without despair.' What the hell does that mean? Among the younger artists were Karel Appel, Richard Diebenkorn, Nathan Oliveira, Eduardo Paolozzi, H. C. Westermann, as well as Leon Golub. It seems clear, Mr. Schjeldahl, that they managed to survive without despair."[14]

The second show with which Peter was closely associated after joining the MoMA staff, Jean Tinguely's *Homage to New York*, attracted as much attention as did *New Images of Man*. Peter was stepping into dangerous water when he decided to pursue this event. Tinguely had visited New York for the first time in January 1960. According to one account, on the flight he sketched ideas for a work that would express his feelings about the idea of New York: "I thought how nice it would be to make a little machine there that would be conceived, like Chinese fireworks, in total anarchy and freedom." It would be a machine called *"Homage to New York,* and its sole *raison d'être* would be to destroy itself in one act of glorious mechanical freedom. . . . He decided at once that the only proper locale for the event was the outdoor sculpture garden of the Museum of Modern Art, and as soon as he landed he set about achieving this almost impossible objective."[15] Even with only partial information, collections curator Dorothy Miller had been suspicious of what Tinguely planned and had turned down his proposal. As Selz recalled, "Dorothy Miller said, 'No, our job at the museum is to preserve, not destroy, works of art.' So then Dore [Ashton] talked to me; Tinguely talked to me. Tinguely said it was fine [what Miller said], but that applies to acquisitions. And this was an exhibition, not an acquisition."[16]

Although Peter assigned Miller, the first woman to occupy a responsible curatorial position at MoMA, exclusively to the collections side of museum operations, she had been involved for years (hired in 1934) as Barr's main associate in planning exhibitions. Since 1941 she had been in charge of a series devoted to introducing young artists supposedly associated with new trends. Among these shows, two were of particular note: *Twelve Americans* (1952) and *Sixteen Americans* (1959), the latter on view the year of Peter's *New Images*. But rather than representing the leading edge of art trends, according to intellectual historian Richard Cándida Smith, "neither Miller nor the Museum of Modern Art had been at the forefront of exhibiting new developments in the visual arts."[17] For example, *Sixteen Americans* gave the museum's blessing to Abstract Expressionism at a time when it was already being discussed in the past tense. And in 1936, Miller's *New Horizons in American Art* included a large sampling of Works Progress Administration (WPA) art, much of it of indifferent quality—especially when compared to French painting, as even her boss, Alfred Barr, noted with exasperation.[18]

Peter, new on the job but committed to modernist innovation, was willing to take a chance on Tinguely, whose work he admired. In this, he was encouraged by his friend Dore Ashton and by the former Berlin Dadaist-turned-psychiatrist Richard Huelsenbeck. Peter understood that the destruction was the point, and he took the request to d'Harnoncourt, who approved the project. According to Selz, René believed MoMA *should* take chances. Peter further remembers Tinguely's reasoning behind his self-destructing sculpture: "Tinguely told me, 'No matter how you try to conserve and preserve, it will be gone anyhow. It's just a matter of time.' His whole idea was that art like life is in flux, and he emphasized that flux. Simply put, destroy the structure of art and the [inevitable] process is quicker. Tinguely [also] wanted the white-painted junk sculpture to be beautiful, so people would be dismayed. I had no idea how beautiful it would be."[19]

The idea and preparation of the piece, and above all the key feature of artist-planned destruction, were kept secret. Even Peter and the MoMA staff did not know just how transgressive of traditional museum values the sculpture would prove to be. In an extensive 1982 interview, he

described the project, the creation of the piece, and the initial shocked reaction:

> We [had] just had a Buckminster Fuller geodesic dome exhibition . . . so in that gigantic dome, over a period of three weeks, Tinguely assembled an enormous machine, with hundreds of wheels. Going out to junkyards—in Europe he had never seen junkyards like we have in America—in New Jersey. He loved all that stuff, and assembled and built it with the thing becoming bigger and bigger. Everything from a little baby carriage to a bathtub; even the upright piano which finally burned down. The event took place in the [early spring] of 1960 in the museum garden, in front of a number of invited spectators.
>
> But there it was, burning up, and this was exactly the wrong time because the museum had had this terrible fire about three months before I arrived. . . . I had heard about the fire, which burned a Monet diptych, but I wasn't there. So they were much more aware of fire, and then all of a sudden there was a flame in the museum garden. The museum had just engaged in a $25 million fundraising campaign, most of the money [being] allocated for acquisitions—and here I was destroying a work of art![20]

The frisson of anticipation among the 250 invited spectators as they waited to see the much-heralded performance was compromised by a long wait standing in cold slush and the unruly behavior of the work of art itself. The immediate response to the Tinguely installation, however, was shocked disapproval. Peter and Thalia were, according to his account, shunned at the reception following the "assisted suicide" in the garden: "My wife and I went to the reception given by George Staempfli. At that time Tinguely had a show at Staempfli Gallery. We were just avoided; nobody at the reception talked to me. Including d'Harnoncourt and Barr. On the way home we agreed that maybe my days at MoMA were numbered."[21]

However, among the guests was critic John Canaday, whose review appeared in the following day's *New York Times*. The initial "outrage" was followed almost immediately, as Selz put it, by appreciation. Canaday's review focused on the failure of the piece to properly self-destruct, but he recognized the importance of the underlying concept: "The significance of the event lies not in the fact that it was, overall, a fiasco, but in

the intention of Mr. Tinguely and the Museum of Modern Art in staging it in the first place. In conceiving what must seem to most people a preposterous and wasteful stunt, Mr. Tinguely was, rather, a kind of philosopher . . . the leading one of a current generation of artists descended from the Dadaists." And his observation that "Tinguely makes fools of machines, while the rest of mankind supinely permits machines to make fools of them," is a small gem of critical irony.[22]

The event added quickly to Selz's curatorial reputation for daring and innovative exhibitions: "My colleagues at the museum were dubious about this kind of thing. But they also liked the fact that here was somebody who came to the museum with new ideas, who was doing new things, and as time went by my position was pretty well cemented."[23] Judging from this description, he enjoyed playing the "bad" boy, the creative provocateur, at MoMA—an idea that is reinforced in a 2008 video interview Peter did for a British documentary on *Homage to New York* produced by artist Michael Landy. Tinguely's short-lived work appears to represent to this day some of the key notions of conceptualism, kineticism, performance, assemblage, and—above all—the nonessential nature of the physical artifact. The art in this case was Tinguely's *idea*, not the elaborately complicated object itself, which in fact was sacrificed to the idea. Peter Selz, more than many of his colleagues at MoMA, grasped that concept, which in turn became a main theme of the art of the late twentieth century.

The Tinguely experiment was important for Peter in that it further developed his interest in and thinking about art that moves and the idea that movement and change actually define modernity. The single-sheet flyer for the event (now a collector's item) consists of a drawing by Tinguely, seemingly a fanciful "blueprint" for his machine; statements by Selz, Barr, K.G. (Pontus) Hultén, Ashton, and Huelsenbeck; and a handwritten punning poem in French by Marcel Duchamp, certainly the most direct influence on Tinguely's "suisssscide métallique."

A few lines from K.G. Hultén's statement in the flyer suggest that Peter was participating in some of the more advanced art thinking of the time, at least in museums. "Tinguely's machines are . . . anti-machines. They make anarchy. They represent a freedom that without them would

not exist. They are pieces of life that have jumped out of the systems: out of good and bad, beauty and ugliness, right and wrong. To try to conserve the situation that exists will make a man unhappy, because it is hopeless. This kind of art accepts changes, destruction, construction and chance. These machines are pure rhythm, jazz-machines."[24]

Selz seemed to relish his "embattled" position, viewing the controversy surrounding his shows as a sure sign of their success. He was open to exploring movements that had gone out of fashion, such as Art Nouveau, or individual artists, such as Dubuffet, who had not gained acclaim in the United States. From contemporary accounts and reviews it would appear that this approach generally kept things fresh and provocative—though in the case of *Art Nouveau*, the direction was more toward nostalgia.

Art Nouveau, in Peter's view, had been totally neglected. His personal attraction to the style lay in the ways it had influenced modernist art, as he explained in the catalogue: "Scholarly investigations on Art Nouveau began to be published in the 1930s, but it was not until 1952 that the first all-inclusive exhibition of the movement was organized by the Kunstgewerbemuseum in Zurich. The recent turnabout in the evaluation of Art Nouveau calls for renewed interpretation and, above all, a definition of this elusive style . . . in which a specific creative force broke with the historicism of the past to prepare the ground for the art of this century."[25]

Peter is convinced that this exhibition, which opened in the summer of 1960, introduced Art Nouveau to an American audience and ignited the stylistic movement that came to dominate graphic and fashion design for much of that decade. The omnipresent Peter Max ashtrays and the stylized flowing lines of album covers and rock poster art testified to Art Nouveau's impact on visual youth culture of the time. And almost every young couple decorating their first "pad" aspired to a Tiffany lamp, inevitably settling for one of the hundreds of copies, most of indifferent if not dreadful craftsmanship. Selz provides an amusing anecdote about the exhibition and changing tastes: "A man who sounded like a little old lady on the telephone said: 'Mr. Selz, you did a terrible thing.' 'So what did I do?' And he said, 'Well, I inherited this large quantity of Tiffany

glass from my family, and with the Museum of Modern Art doing nothing but good design, the Bauhaus and Mies van der Rohe kind of design, I sold it all for a song. And now that you bring it [Art Nouveau] back, I have nothing left!'"[26]

Selz also recalls more important things about the show, not the least of which was that he was told it was the first time since the museum's opening that every department had worked together.

> Architecture, painting and sculpture, photography, and design departments, we all worked together. I was in overall charge, but we presented the exhibition together. And Drexler installed it beautifully. It was a very exciting thing because it was the first time that people reexamined Art Nouveau, not only as an important international movement, but [as] something historically important. . . . We put together a book rather than [the usual] catalogue, with four contributors on different aspects. I wrote the painting and sculpture section, Alan Fern did the graphics, Greta Daniel did three-dimensional design, and Henry Russell Hitchcock, architecture. . . . Now the literature is so enormous, but this was the first thing published in English as a reexamination of Art Nouveau.[27]

Peter had a firm grasp on the significance of his exhibition. Beyond the virtue of providing the opportunity for people to look at utilitarian objects in a new way and recognize the shared design that makes them documents of creativity at a certain time, his complementary emphasis on painting and sculpture illuminated the stylistic design component. He was interested in pointing out the relationships between different categories of forms. In this respect, he was drawn to the international Symbolist movement and the unity of the arts: "Bonnard, Toulouse-Lautrec, Munch, Klimt—and my theory was that, with exceptions like Cézanne, let us say, or Renoir, most artists working at the turn of the [twentieth] century, especially the younger generation, were much involved in Art Nouveau or helped create it, as in the cases of Lautrec and Gauguin. . . . In the catalogue I start out with Debussy, [who was part of] a Symbolist unity that prevailed for about ten years."[28]

Citing Gauguin's decorative flatness, use of outlines, and arbitrary color (as in his studio door panel of 1899), Selz sees that artist's design

work of the period—including decorative plates and bucolic scenes on vases—as closely related to the spirit of Art Nouveau. Gauguin's affirmation of two-dimensionality is one aspect of his influence on other key artists associated with the movement: "Bonnard, in his activities as a painter, sculptor, book illustrator, lithographer, and designer of decorative screens and posters, is perhaps typical of the all-embracing attitude towards the arts of this period."[29] Selz further points out the obvious influence of Japanese decoration, which permeated the style.

Selz the art historian was always careful to look for the present in the past. He also appreciated patterns, recognizing that the course of history was meandering and even circular, with old ideas and styles being repeated and altered in a way that continued to unify the arts over time. In *Art Nouveau*, Selz reified that thinking. For him, modernism did not represent an absolute break with the past, and he explicitly underlined the connection between past and present in the *Art Nouveau* catalogue: "Art Nouveau claimed to be the new art of the new time. Yet its avowed break with tradition was never complete. In certain ways Art Nouveau actually belongs with the nineteenth-century historical styles. The century had earlier run the gamut from the Egyptian revival of the first Empire to the baroque revival of the second."[30] At the same time, Selz concluded, with emphasis, that "historically Art Nouveau fulfilled the liberating function of an 'anti' movement. It discarded the old, outworn conventions and set the stage for the developments which followed with such extraordinary rapidity in the twentieth century."[31]

Selz was not the first to recognize Art Nouveau as an influential precursor of twentieth-century modernism. Some of the most insightful writing on the connections between primitivism (which Selz honors in his essay), Symbolism, Art Nouveau, and the fundamentals of modernism had appeared two decades earlier. In his classic study *Primitivism in Modern Art* (1938), Robert J. Goldwater provided a subtle and enlightening interpretation of the workings of artistic influence and appropriation, one that later was further articulated by Meyer Schapiro: "The accomplishment of the past ceases to be a closed tradition of noble content or absolute perfection, but a model of individuality, of history-making effort through continual self-transformation."[32]

Although Selz, who considers both Goldwater and Schapiro as mentors and models, was not the first to present these central ideas, he had one thing they did not: the public forum of the world's leading museum of modern art. The popular visibility of the MoMA exhibition may not have initiated the 1960s vogue for Art Nouveau, but it could not avoid being a contributing factor.

. . .

Peter's access to modern art has always been through the individual artists themselves. Among his many artist friends, Mark Rothko occupied a special position. Along with the nonobjective paintings of Sam Francis, Rothko's lyrical color-resonant (not, in Peter's view, color-field) paintings represented for Selz a high point in modernist abstraction. It should be kept in mind that Selz was particularly devoted to expressionist figuration, as opposed to exclusively formalist approaches. Nonetheless, Rothko is a reminder that Peter understood and appreciated abstraction as *important*, perhaps even central, in how we view both the physical aspect of nature and the spiritual longing of human beings. In any event, for Peter modernism was never a matter simply of styles or surface manipulation of form and color.

Mark Rothko was Selz's first one-person show at MoMA, opening in January 1961. The Tinguely installation had preceded it by several months, but that show was really inserted into the schedule and did not involve the preparation that *Rothko* required. Peter talks about the exhibition in glowing terms:

> It was the most beautiful show I've ever done. Even today, when I think back, it was absolutely magnificent. Just as with *Art Nouveau,* all the departments worked together—I broke the rules there. The museum had the idea that if you show an artist's work, the curator makes all the decisions and the artist should not take part. I broke with that also by inviting Rothko to take part . . . by deciding what should go in the show, and how the show was to be hung and lit. Now this is done a lot. But that was the first time [at MoMA], and my colleagues protested, [but] I said, "I'm going to do it this way." . . . The two best Rothko collections

at that point were at the Phillips in Washington and at Count Panza's in Italy [part of that collection went to the Museum of Contemporary Art in Los Angeles]. We borrowed heavily from those two. We divided the space into small rooms, so that the viewer would be very close to the pictures. And the lighting was fairly low. Mark wanted to hang them right down to the floor—but they would have been ruined when the floors were cleaned. But we hung them as low as possible.[33]

The slim catalogue (only thirty-six printed pages) belies the significance of this exhibition, which amounted to public recognition by the leading museum of modern art of one of the most important contemporary American painters of the time. In choosing Rothko as the subject of his first solo show, Peter made a statement that his view of modernism extended beyond the figurative focus of *New Images of Man*. However, it bears noting that what he was looking for in that first show, a humanistic—even a spiritual—strain that continued to inform modernism despite the formalist character of much contemporary art, he also found in Rothko. There was no inconsistency in these choices.

The reviews of *Rothko* were numerous and frequently appreciative, if not exactly enthusiastic. In truth, what praise there was seems to have been grudgingly offered. This lukewarm reception must have been disappointing for both Selz and the artist. What is striking is the *retardataire* critical vision (or lack of vision) that many New York art writers revealed. Two examples should make the point. The first is Emily Genauer's determinedly dismissive review, "Art: They're All Busy Drawing Blanks": "Light that failed: About two years ago, Rothko changed his palette. The sunny yellows and misty blues gave way to blood-browns, with sometimes a bar of white for contrast. The bands went vertical instead of horizontal. The paintings are still primarily decorations—but for a funeral parlor. I'd as soon wrap myself in a shroud as in one of them."[34]

Genauer sets out to skewer Rothko's paintings by lifting Selz's words out of the context required for them to make sense. "The open rectangles," he writes in the catalogue, "suggest the rims of flame containing fires, or the entrances to tombs, like the doors of dwellings of the dead in Egyptian pyramids behind which the sculptors kept their kings 'alive' for eternity in the *ka*. . . . These paintings—open sarcophagi—moodily

dare, and thus invite the spectator to enter their orifices. Indeed the whole series of these murals brings to mind an Orphic cycle . . . the artist descending to Hades to find the Eurydice of his vision. The door to the tomb opens for the artist in search of his muse."[35] It is indeed difficult to see how this mixture of Egyptian and classical references could help a viewer understand a Mark Rothko abstraction. But what it does reveal is Selz's struggle to find a verbal equivalent for decidedly nonverbal works of art. This passage presents Selz at his most poetic, reaching for some way to explain that which is, finally, ineffable. He seems to be proposing that Rothko's abstractions may be best understood as an expression of spiritual yearning, universal and timeless, and the artist's way of coming to terms with the inevitability of death. Emily Genauer just did not get the metaphorical essence.

John Canaday represents another misunderstanding of Rothko's art and Selz's effort to provide a framework in which it could be fully appreciated. Like Genauer, he describes Rothko's abstractions as "decorative," albeit "great decoration." What follows is interesting beyond the artist and the show itself, however:

> Offering an explanation for Mr. Rothko's progressive rejection of all the elements that are the conventional ones in painting, such as line, color, movement and defined spatial relationships, Peter Selz . . . states that the "paintings disturb and satisfy partly by the magnitude of his renunciation." This is nothing but high-flown nonsense if we begin with the assumption that the audience for painting today is anything but an extremely specialized one. But it makes sense if we understand to what a degree the painter today has become a man whose job it is to supply material in progressive stages for the critic's esthetic exercises.[36]

This may be New York Times critic John Canaday at his most reactionary, but he nonetheless makes a thought-provoking observation about the relationship of artists to critical writers and museum curators, not to mention galleries. Even Peter, given other contexts and artists, would agree with what is now acknowledged to be a more or less mutually beneficial alliance.[37]

Futurism (1961), which came directly on the heels of Mark Rothko, was

a first of a somewhat different kind. Futurist art also had not been show-cased in an exhibition, major or otherwise. When Peter introduced Art Nouveau as a phenomenon worthy of both attention and a major exhibi-tion, it was, he said, "like bringing in something that had been discarded. So that was controversial." In the context of his career at MoMA, he went on, "In general, I would say that almost all the shows that I did, and that I've been doing since then, were never mainstream. The third show that I did was *Futurism*. At that time, Futurism was considered an aberration away from Cubism, because they didn't know what they were doing—a misunderstanding of Cubism. Or, that they were Fascists—which they were. [laughing]"[38]

But as he wrote later, "Motion and speed, the watermarks of the new epoch, have long since been accepted as integers of urban life in the twentieth century . . . that have altered the realities of the human condition."[39] And the Futurists, anticipating key elements of modern-ist art, represent both motion and speed. "With a violent burst on the public consciousness, the Futurists demanded 'that universal dynamism must be rendered in paintings as a dynamic sensation.' As they were conscious of the fact that 'all things move, all things run, all things are rapidly changing . . . ,' they searched with the fervor of disciples to new religion for the key which would translate their sense of the dynamic into painting and sculpture."[40] One artist who learned these lessons and impressively applied them to his own work was Tinguely. *Homage to New York* was about movement and change, anticipating—among other things—kinetic art. But it was also created from junk, thereby placing itself squarely in the assemblage phenomenon.

Before going to the Modern, Peter proposed an exhibition on assem-blage that he called *The Collage and the Object*. Co-organized with William Seitz (who played the major curatorial role), by the time it opened in October 1961 it had been renamed simply *The Art of Assemblage*. According to Peter, the term was made "official" through the Selz/Seitz collaboration: "There was no word for this [before then,] . . . what was going on in New York with Rauschenberg and Kienholz in California. And one day I was working on the Dubuffet show . . . and he coined that word, *assemblage*, for his collages cut up from previous paintings

and put together [recombined]. . . . Bill looked and said, 'Let's call it [the other show] *Assemblage.*' So, that's how the term came into being."[41] Selz insists that the French and English terms are neither identical nor inter-changeable. The French term *assemblage* applies only to Dubuffet's work, whereas the American term (pronounced in English fashion, not French) describes the MoMA exhibition and is now widely used to describe a specific phenomenon.[42] Exemplified in the art of Robert Rauschenberg, it is also still evident in some of the most interesting and inventive California artists working today.

Peter believed that assemblage, like the kind of art presented in *New Images,* was being neglected. In the latter case, this neglect was due largely to the strong representation of figurative art among the works in the exhibition. Assemblage, in contrast, approached more closely mod-ernist ideas about formalist abstraction. Its constituent parts—discarded junk—had a myriad of associations beyond themselves, but in no respect did their combination as art adhere to strict Greenbergian ideas about formalist purity.

Selz's next major one-person exhibition surveyed the development, from an increasingly chauvinistic American perspective, of the "outsider" French artist Jean Dubuffet. Selz represents his show as almost introduc-ing Dubuffet to New York and an American audience, a claim that is not entirely justified. However, he did encounter this *art brut* (naive or "primi-tive" art) iconoclast in France many years before, while he was there on his Fulbright Fellowship. And Dubuffet was a hero in Chicago, appeal-ing to sensibilities shared by some of the younger artists with whom Peter kept company in the late 1940s and early 1950s. But the important point is not one of discovery and introduction, but rather of the inclina-tion and willingness to make the commitment of a one-person show at the Museum of Modern Art, in effect giving the Modern's imprimatur of approval to a difficult foreign artist who worked decidedly outside the mainstream. And the reason for that seemingly bold step was Selz's ongoing interest in figurative innovation as a viable expressive alternative to abstraction and related formal concerns within modernist art.

In his review of the exhibition in the *New York Times,* John Canaday quotes a statement of Dubuffet's that elucidates perfectly Selz's attraction

to the Frenchman's art. Interesting in this review is the dramatically different tone struck by Canaday when compared to his harsh dismissal of the Russian American Mark Rothko:

> For some years Dubuffet has been called the most important French artist since the Second World War, a position that he can now be said to hold without serious challengers. Such challenge as he has been offered for the same title in the international field has come not from a single painter but from the group called the New York School—Mark Rothko, Franz Kline, Willem de Kooning and the others. But the challenge has become weaker within the last couple of years as these Americans have given increasing evidence of having reached an esthetic stalemate. . . . The exhibition, hung chronologically . . . ends with a group of paintings done in 1961 in which Dubuffet abandons an approach that had become very nearly completely abstract for one that is essentially humanistic. "I believe that my paintings of the previous years avoided in subject and execution specific human motivations."[43]

Even the prominent critic Harold Rosenberg seemed sympathetic to Peter's way of thinking about the artist. In a long and thoughtful review of a second Dubuffet retrospective at MoMA (1968), he quotes Wylie Sypher, who called Dubuffet's art "the supreme embodiment of brute matter from which all human presence has been eliminated." Sypher continues on this tack as he attempts to identify what separates Dubuffet from other modernists: "In Dubuffet's painting . . . man becomes anonymous and both painter and figure are absorbed into a turbulent geography that has the quality of mineral or mud. Dubuffet reaches a 'zero degree' of painting."[44]

This idea of total human absence, however, may be misleading, or at least incomplete. Looking at the same art in a less nihilistic way, and with an eye to twentieth-century art that preceded it, Rosenberg also quotes Selz from the earlier MoMA exhibition: "Among his [Dubuffet's] contributions to primitivism are his aggressive formulations of its theoretical premises. 'Convinced that ideas and intellectuals are enemies of art,' wrote Peter Selz in his catalogue for the huge Dubuffet retrospective at the Museum of Modern Art in 1962, 'he began a systematic search for "true art," untouched by artistic culture and unspoiled by contact

with the Western classical tradition.'"[45] Both Selz and Rosenberg seem to recognize that Dubuffet represented a highly original and thoroughly different artistic vision from that of New York Abstract Expressionism and its immediate American successors, but one that was equally valid and possibly more potent in modernist terms. In 1962, Peter Selz had insisted that was the case—that modern art was expansive and inclusive, bound neither by geography (including within the United States) nor by narrow definitions of what is significant in contemporary art.

Peter took pleasure in introducing less familiar modernist art and artists, such as Dubuffet, to what he imagined to be a receptive museum audience eager to learn. With *Emil Nolde,* he did just that, returning to his roots in German Expressionist painting. Sponsored by the Federal Republic of Germany, the exhibition was in fact a collaborative retrospective, by far the largest show ever devoted to the artist; Selz selected the two hundred works and wrote the long catalogue essay. Apparently people especially loved the watercolors. It opened on 6 March 1963 (see Fig. 14) and ran to 30 April. The exhibition then traveled west to both the San Francisco Museum of Art and Pasadena Art Museum. What distinguished *Nolde* from the standpoint of Selz's involvement was the collaborative ambition, an approach that appealed to Selz as a way to tackle large projects. At one point he and Seitz were considering a two-man show with Nolde and Beckmann, but they decided each artist was far too important to share the stage. Selz's participation in *Nolde* and his book *German Expressionist Painting,* which had served to open up the field, were recognized by an award from the Federal Republic of Germany, signed in Bonn by the president of the republic, Dr. Heinrich Lübke—an Order of Merit, First Class, for interest in twentieth-century German art, presented in New York on 18 September 1963.

Peter takes great pride in his track record of "firsts," even when his ideas were brought to fruition by others. Another big collaborative project resulted in the groundbreaking *Rodin* show of 1963.

Believe it or not, the Rodin show was the first ever held in America. There were many Rodins in American museums, but nobody had done a show. So I decided to do it, with most of the loans coming from the Musée Rodin in Paris, and we had all kinds of problems.

Curator Madame Cécile Goldschneider did not answer letters; René d'Harnoncourt had to go to talk to her directly. I couldn't do everything myself, so I asked Albert Elsen, who had been writing on Rodin, to do the catalogue. . . . I did this show in '63, and Elsen was my friend at the time; he wrote the monograph. So later on he told people that it really was his show. He had moved to California; he was at Stanford. So I confronted him and said, "How can you say this was your show, Albert? This was my show and you did the book." "I say it was my show, and if you don't like it, you can sue me."[46]

The exchange that Selz cites here took place at a dinner table in the home of a prominent San Francisco collector. Its intensity, particularly on Elsen's part, was shocking, even for a man known for his volatility.[47] But recalling the event in 1994, Peter said only, "This is the kind of thing one runs into. We haven't talked since." Professor Albert Elsen died in 1995.

Among Peter's favorite artists, two in particular were especially close to his heart: Max Beckmann and Alberto Giacometti. It is almost certainly no accident that—at least from the standpoint of synergism—they were the subjects of his final two exhibitions at MoMA. One a painter and the other primarily a sculptor, both were figurative modernists. And it could be further claimed that each embodied the qualities that Peter Selz clung to as representative of meaning in modernist art.

The catalogue for the Beckmann exhibition demonstrates in every aspect Peter Selz's devotion to his subject.[48] Starting with Peter's long main essay, through Harold Joachim's brief commentary on Beckmann's prints, and closing with Perry T. Rathbone's affectionate "Personal Reminiscence," the catalogue is lovingly constructed to honor its subject. Selz's lead essay occupies ninety-five pages, albeit with seventy-six carefully chosen and discussed illustrations. The essay is divided into nine parts and follows Beckmann's journey from Leipzig through various European cities to, in 1947–50, St. Louis and New York. Selz's attention is divided equally between the man and his art, an approach that was not necessarily in high critical favor at the time but one that proclaimed the fundamental humanism of both artist and writer. This theme runs throughout the exhibition as well, placing Beckmann in a virtually unique position within modern art.

In discussing individual works, Selz devotes most of his attention to *Departure* (1932–33), the famous triptych that is in MoMA's collection (see Fig. 1). Peter begins his discussion of this masterpiece by quoting Alfred Barr, who described the work, when it was displayed at the museum in January 1951 as a memorial to Beckmann, as "an allegory of the triumphal voyage of the modern spirit through and beyond the agony of the modern world."[49] These words provide the key to Beckmann's importance to Selz, who writes, "Beckmann wished his paintings to remain private and personal, to communicate a feeling but not necessarily to be understood in the literal sense. He used the human figure and a diversity of objects because he wished to have every means at his disposal in order to speak most effectively: not only space and color and shape, but also the active human figure."[50]

Selz then quotes his museum colleague James Thrall Soby, who describes the triptych as "one of the major works of art our century has thus far produced." Noting that the Beckmann often hung at MoMA on the same floor as Picasso's *Guernica*, Soby considers the two very different masterpieces as providing proof that "modern art's symbolism can be as forceful, moving and impressive as anything produced in earlier centuries."[51] Selz picks up and expands upon this idea with a statement that reiterates his own understanding of modernism and its relationship to art of the past. For him, the critical difference between *Departure* and *Guernica* lies in the area of specificity:

The iconographic program and meaning of the great frescoes on the walls of San Francesco in Arezzo [Piero della Francesca was among Beckmann's favorites] or the ceiling of the Sistine Chapel, or even those in the Ajanta caves, becomes clear once the key has been found. But it is an *essential aspect* [italics added] of modern art, even when natural forms are retained, that much of it must remain unintelligible. (And this is even truer of *Departure* than it is of *Guernica*, a painting that makes reference to a specific historic event. . . .) At a time when the media of communication . . . spare no effort to avoid interference, "noise," any kind of imprecision, the poet and painter set up all kinds of traps and impediments precisely to resist any easy approach. The ambiguity and unpredictability, so germane to the modern spirit, must find expression.[52]

Later, in the section devoted to Beckmann's three short years in America, Selz further reveals his allegiance to the artist by citing Perry Rathbone's "splendid" 1948 St. Louis exhibition that launched, according to at least one critic, recognition of Beckmann as "one of the most important living European artists."[53] Selz then offers an explanation for the tardiness of Beckmann's reception that goes right to the heart of MoMA's own philosophical and programmatic orientations: "This acknowledgement has been slow in coming because modern art was equated solely with French art by a great many influential critics and collectors; also, other groups were imbued with a type of reactionary chauvinism that came amazingly close to the Nazi view Beckmann had battled many years earlier; and finally, his arrival to the United States coincided with the emergence of an abstract expressionist idiom considerably at variance with Beckmann's own style."[54]

This thoughtful and enlightening catalogue ends with Rathbone's "Personal Reminiscence" and an appendix, "Letters to a Woman Painter," featuring a series of five touching "letters" composed by Beckmann and subsequently read by his wife, Quappi (Mathilde Q. Beckmann), at several venues during the years 1948 to 1950.[55] What sings out in Rathbone's reminiscence and also Peter's more art-historical essay is an extraordinary appreciation of Beckmann the man as well as the artist. This way of looking at art and its sources in life experience, however, was soon to become suspect as scholars turned increasingly to an antibiographical approach to understanding artworks.

There can be no question that Selz and Rathbone shared an appreciation of what distinguished Beckmann among modernist artists, his full engagement of the raw life as encountered in the cabarets and clubs of Berlin and, at career's end, Manhattan. They understood that in this demimonde—whether German, French, or American—Max Beckmann found his connection with humanity. Art, for him, was by itself not sufficient. This is evident in Rathbone's chronicle of an evening he spent with Max club crawling in Manhattan:

> Max Beckmann loved cabarets. For him they represented a sort of microcosm of the world of humankind where he could observe and scrutinize without self-consciousness or embarrassment. . . . For some

reason that he did not explain, he long cherished the idea of taking me alone on a tour of night clubs in Manhattan. . . . We progressed to Broadway in the heart of the theater district to a huge middle-class night club, a grand cabaret such as I had never seen before but which was one of Max's favorite haunts. In this arena for the masses, vulgarity reigned. Here the tables were set in tiers ring upon ring; here the waiters were dressed in exotic costumes, and here we were treated to an elaborate and pretentious stage show with nearly naked girls merely strutting about when not engaged in some gymnastic dance. Surrounded by this extravaganza, Max was totally absorbed . . . stimulated by the spectacle, amused by the deliberately lunatic behavior of humanity.[56]

Clearly, Selz and Rathbone agreed on the central issue of modernism: its division between the human (life experience and raw feeling), on the one hand, and the formal (self-referential, art for art's sake), on the other. One view had it that in painting the ascendancy of abstraction was obliterating the human factor, a "closeout" that Beckmann viewed with "profound misgiving." As Rathbone reports, Beckmann considered it his mission to inculcate respect for a humanistic art. "Abstraction was for him a form of *Kunstgewerbe,* as he so often said."[57] Thus, judging from the commentary on Max Beckmann as it develops in the Selz catalogue, modernism's seamless union of the figurative and the nonobjective "wings" was, to a degree, a shotgun wedding.

There is little question about the importance of the human presence, and the human figure, in Peter Selz's ideas of modernity. As much as he appreciated abstraction, and certainly expressionism, the real "work" of art required a constant reminder that it is made by human beings and its highest calling is to address the human condition. In this respect, for Selz, Alberto Giacometti the sculptor is the complement to Max Beckmann the painter. More than any other artists, these two spoke for Peter Selz's view of what matters most in modernist art. It therefore seems entirely appropriate, even if simply fortuitous, that *Giacometti* was Peter's last show at the Modern. And in his view, it was also the most significant: "My last show, the most important I did, opened in June of '65. I left soon after that. . . . It was a great retrospective, from the Surrealist time to the work that he was doing at the time—very, very beautiful. Wilder Green did a beautiful installation, and it traveled around the country. . . . It just

was one of the great retrospectives, paintings as well as all the major sculpture. It wasn't as big as somebody would make it now; we were much more selective."[58] Judging from the small, elegant hardcover catalogue (only 119 pages), the show was a pure distillation of Giacometti's achievement. As is the case with the attentive and admiring treatment of Beckmann, Giacometti is presented as a modernist artist who stands outside schools and movements.

Selz gets directly to the point: "For young painters and sculptors Alberto Giacometti occupies a position apart from all other living artists. His work, neither imitated nor slandered, is out of competition. Like a saint, he is placed in a niche by himself. . . . Although his work, changing relatively little over a period of almost twenty years now, is very familiar, its resources are inexhaustible and the impact of his approach is inevasible."[59] In his introduction, in connection with the postwar grisaille paintings—"out of place in a time when our sensibilities are constantly blunted by the brilliance of fresh and garish color"—Selz presents the artist clearly in just two sentences: "But colors, Giacometti feels, adhere to surfaces, and his problem—the problem of the sculptor as painter—is to grasp the totality of the image in space. His linear painting, nervous mobile drawings, and sculptures of 'petrified incompletion' testify to a great artist's struggle to find an *equivalent for the human phenomenon* [italics added]."[60] Selz's priorities and values become entirely transparent. As in the final sections of the Beckmann catalogue, the personal dimension is emphasized in Giacometti's autobiographical statement. Selz leaves no question that the men and their art are inextricably joined.

Selz makes enlightening connections while traveling in his thinking, and in much of his writing, from the specific—artist, medium, work of art—to the general, and then fluidly back again to the individual. The questions he raised about the way recent and contemporary art were understood and presented both informed and determined his most significant and memorable exhibitions as, for a time, he held forth with a considerable degree of power from his position at the Museum of Modern Art.

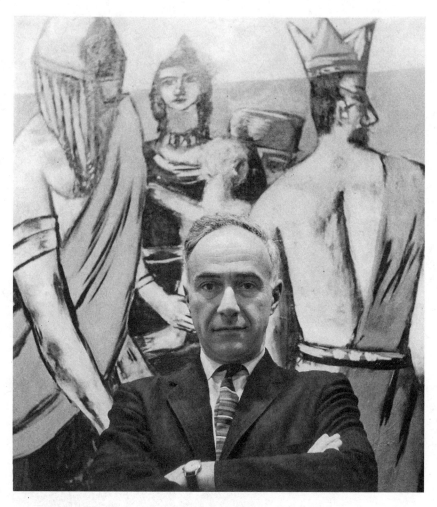

Figure 1. Peter Selz, in front of Max Beckmann's *Departure* (1932–33), MoMA 1964.
Photograph by Marvin P. Lazarus.

▲ *Figure* 2. Drey (maternal grandparents) mansion, Munich, n.d. The Drey art and antiques gallery was on the first floor, residence above, and top floor rented.

▶ *Figure* 3. Grandfather Julius Drey, Munich (?), n.d.

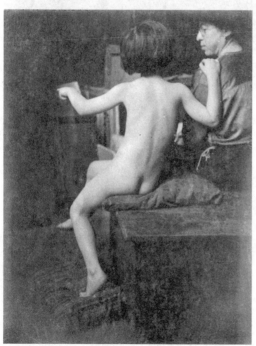

▲ *Figure* 4. Selz family portrait
on the occasion of Adolf
Selz's eightieth birthday
at Hotel Reichenhall, 1925.
Peter is in the front row,
kneeling; Eugen Selz stands
at the far left; Edgar Selz is
standing fourth from left in
the third row; Edith (Drey)
Selz is fourth from right in
the third row.

◄ *Figure* 5. Peter, age six, with
his beloved Bavarian
nanny, Rosa, Munich, 1926.
Inscribed on the back:
"Peterle mit seiner Rosa"
(Little Peter with his Rosa).

Figure 6. Edith (Drey) Selz
with her sons Edgar (left)
and Peter, Munich, 1927.
Photograph: Müller-Hilsdorf,
Munich.

Figure 7. Peter (left) with his
best friend, Herbert Kahn, on
a stop in the Tyrol en route by
bicycle to Italy, 1934.

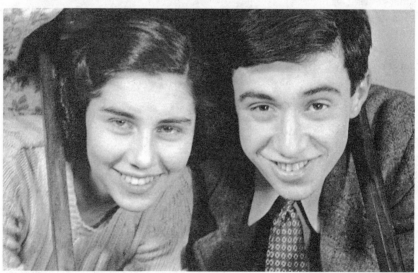

⚓ *Figure* 8. Peter (right) with his parents as he boarded the steamship *Europa* for the Atlantic crossing to New York, Bremen, 1936.

▲ *Figure* 9. Hildegard (Gina) Bachert and Peter, New York, 1939. Gina was Peter's first love, whom he met in the New York *Werkleute* German Jewish youth group. Photograph: Hans Oppenheimer, New York.

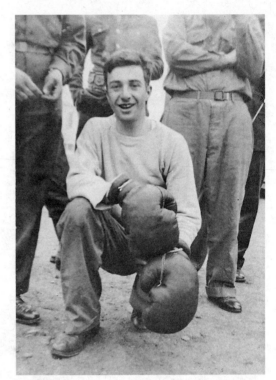

Figure 10. Peter with boxing gloves during army basic training, 1942. He accepted the challenge to a boxing match with a bully. To his surprise, Peter, who had never boxed before, prevailed.

Figure 11. Peter seated on the roof of his car in front of the Institute of Design (New Bauhaus), Chicago, 1955.

EXPRESSIONISM

Figure 12. Flyer for the arts festival *Expressionism* at Pomona College, 1957.

Figure 13. Thalia (Cheronis) Selz and Peter at home with their daughters, Gabrielle (Gaby), seated, and Tanya, New York, 1959–60.

◄ *Figure 14.* (*Top*) Opening of the *Emil Nolde* exhibition at MoMA, 1963. From left: Mrs. John D. Rockefeller 3rd, Gertrud A. Mellon, William S. Lieberman, Peter Selz, Mrs. John Rewald.

◄ *Figure 15.* (*Bottom*) Man Ray (center) and Peter Selz at MoMA, 1964.

▼ *Figure 16.* Peter Selz with the model for the University Art Museum, Berkeley, 1966. Photograph by Ansel Adams. Contemporary print from original negative by Ansel Adams, UCR/California Museum of Photography, Sweeny/Ruben Ansel Adams FIAT LUX Collection, University of California, Riverside.

◄ *Figure 17.* (*Top*) Mark Rothko, Mell Rothko, sculptor Dimitri Hadzi, and Peter (from left) in Hadzi's studio garden, Rome, 1966. Photograph by Norma Schlesinger.

◄ *Figure 18.* (*Bottom*) UC Berkeley art faculty and visiting artists in Norma's garden at her Indian Rock home in Berkeley, ca. 1966. Front row, from left: Harold Paris, Erle Loran, unidentified woman behind Peter, Emilio Vedova, and George Miyasaki behind his wife. Back row, from left: Arthur Formichelli (attorney), Frieda Paris, Arnoldo Pomodoro, Pete Voulkos, Norma, and an unidentified man.

▲ *Figure 19.* Anna Halprin dancers performing at one of the grand-opening events at the new University Art Museum, November 1970. Photograph: Chester Kessler Estate, courtesy of Robert Emory Johnson.

⚊ *Figure 20.* Peter with Sam Francis at Garner Tullis's San Francisco studio, 1972. Photograph by Sue Kubly. Reproduced with permission.

▲ *Figure 21.* Carole and Peter Selz, Eduardo Chillida, and Herschel Chipp (from left) at the site of Chillida's *Wind Combs* (1977), San Sebastián, Spain, April 1988.

⚑ *Figure* 22. Peter, Hans Burkhardt, and Jack Rutberg (from left), at Jack Rutberg Fine Arts, Los Angeles, 1990. Reproduced with the permission of Jack Rutberg.

▲ *Figure* 23. Peter with artists Tobi Kahn (left) and Bruce Conner, 1999.

Figure 24. Carole and Peter
Selz marching against
George W. Bush's Iraq War,
San Francisco, 2002.

Figure 25. Peter and Carole in their Berkeley backyard, n.d.

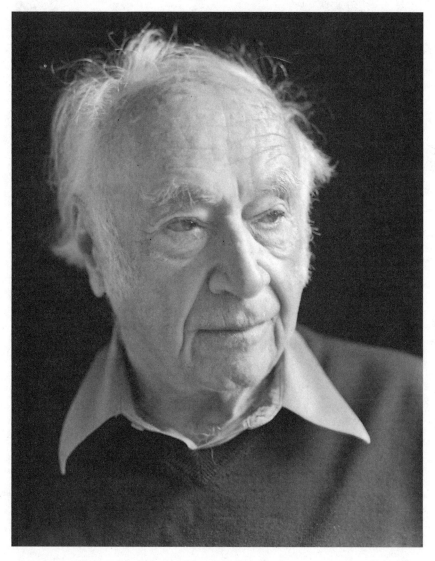

Figure 26. Peter Selz, 2010. Photograph: Dennis Letbetter, San Francisco. Reproduced with permission.

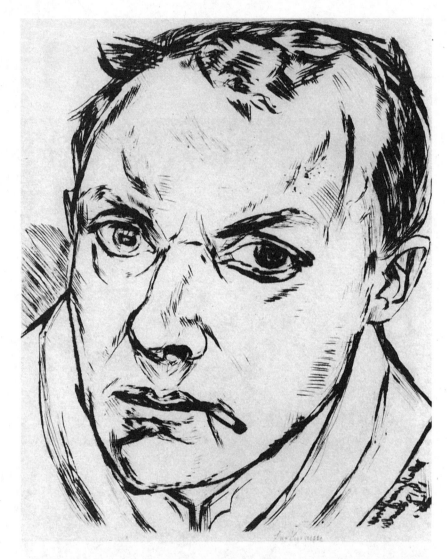

Figure 27. Max Beckmann, *Large Self-Portrait*, 1919, in the collection of Peter Selz. Drypoint, 9¼ × 7¾ in. (23.5 × 19.5 cm). (Beckmann catalogue raisonné no. Hofmaier 153)

POP Goes the Art World

Covering a 1960 appearance by Peter Selz at the Detroit Institute of Arts, local art editor Louise Bruner gave an account of the evening that suggests both the casual informality of such events in the early 1960s and the speaker's awareness of his role in the art world: "After a few introductory remarks about the forthcoming Futurist show he is organizing, which will come to Detroit, Dr. Selz lit a cigarette, leaned on the podium, took a sip from his highball and answered questions from the audience. The first, from me: 'Does the Museum of Modern Art create taste because of its great influence, or does it guide and reflect taste?' Dr. Selz: 'It is regrettable but unavoidable that we create taste. We are conscious of this responsibility and try to be diversified.'" Bruner described the curator of painting and sculpture exhibitions at the Museum of Modern Art as, "by

virtue of this position alone, . . . one of the high priests of contemporary American and international art."[1]

The 1960s, however, brought a dramatic change to the art world, most notably in New York and specifically at the Museum of Modern Art and the commercial galleries, which were forging an ever closer relationship. Despite Selz's comment quoted above, and a similar assertion by Alfred Barr, the museum's hitherto undisputed position as trendsetter had begun to decline as early as 1950.[2] The emergence of a generation of artists who questioned what was left for them—where they could go with their own art after Abstract Expressionism—is meticulously described in Jed Perl's 2005 book, *New Art City*.[3] It is difficult to trace all the forces at work. There was a shift from the individualistic and romantic art projects typical of the 1950s and earlier to a more cerebral and structural approach to art making. And there were new relationships between artists, critics, curators, and, especially, dealers. Peter Selz watched with disapproval as this change occurred, and he was more than willing to speak out on the subject. The qualities that he valued in artists and in their creations were, in his view, being replaced by a cynical, superficial, "boomtown" mentality. Even Perl is unable to say just how the change came about and in what venues it was recognized as something ominous for the future of American art. According to his account, everything was simply new and exciting. In fact, it *was* exciting, and it was important precisely *because* it was new.

Smitten collectors, most notably New Yorkers Robert and Ethel Scull, did their part to establish a commercial base for the new art. As the prices for contemporary art rose dramatically, museums such as MoMA (in part due to Barr's reluctance to embrace the so-called cutting edge) were increasingly left behind. Reviewer Fred Kaplan described the Scull enterprise in 2010: "A half century ago, before the phrase 'Pop Art' was even coined . . . Robert C. Scull started buying up dozens of works by artists like Jasper Johns, Robert Rauschenberg and Andy Warhol. . . . As much as anyone, Mr. Scull and his wife, Ethel—a fashion plate and socialite whom everyone called Spike—created the market for Pop, making it the occasion for lavish parties, an emblem of high society and the *new face* [italics added] of art in the 1960s."[4]

Critic Sidney Tillim, who started writing about Pop Art as early as 1962, before its "formal debut," faults the Museum of Modern Art for falling behind.[5] He does so, moreover, in a way that calls into question the museum's understanding of American contemporary art in general, its "internationalist preoccupation," and what he refers to as "crisis" aesthetics that led to an exaggerated focus on the figure (presumably including *New Images of Man* in that judgment). The French art foundation of Barr's modernist canon, along with the Peter Selz–Dorothy Miller figurative emphasis (though it was not a shared perspective), is in effect challenged by Tillim as indicating MoMA's increasing irrelevancy in connection with current art. In 1965, he wrote that the museum's "exploitation of Optical Art as an alternative to Pop has to be considered." He was responding in part to John Canaday, who in the *New York Times* described Optical Art as the art of our time:[6] Tillim acknowledged that MoMA may have recovered some lost prestige through the Optical Art show *The Responsive Eye*, "organized by William Seitz . . . [and] conceived for the purposes of counteracting the popularity of Pop Art, [but] it did illustrate the difficulty the curatorial Establishment has had in approaching modernist art with anything but an international bias."[7] This hardly seems fair in light of the catholicity of the exhibitions produced in Selz's department up to that very year.

Tillim's article goes beyond the Pop phenomenon, however, to point out a general deficiency in MoMA's relationship to contemporary American art. Although he credits MoMA for a series of "informative" exhibitions about American art—"Indian painting, photography, and even George Caleb Bingham"—these shows, he charged, nevertheless demonstrated a fundamentally parochial attitude toward American art that "seems to persist to this day":

It is only in the last few years that the Abstract Expressionists have been honored. But among the first of these was Mark Tobey, who can hardly be described as typical; and besides, the present series of retrospectives seems curiously belated. In the thirties and forties there may have been some justification for the Museum's intransigence. . . . The problem is that the Museum has been ambivalent on the one hand, and aggressive on the other, and has retarded the development of indigenous sensibil-

ity by constantly relating art in America to values that over the years have applied less and less to the problems whose issue now simply repudiates what the Museum down deep still thinks is the mainstream.[8]

By virtue of his position at MoMA, Peter Selz was able to observe firsthand what turned out to be fundamental structural, ideological, aesthetic, intellectual, and commercial changes in the art world. Previously accepted values of art, including the sense that art could contain profound meaning and even transformative power, were themselves transforming under the "weight" of the ephemeral and transitory. Peter, whose career was built on the belief that form and content together served a serious goal, one not touched by a passing parade of "isms," did not like what he saw. And he was wary of art history and criticism leading the way for art; rather, their duty was to follow, observe closely, describe, and, when possible, explain. Everything, for Peter, started with the art and the artist.

The curator and critic Henry Geldzahler, sympathetic to what was going on in New York and particularly receptive to Pop Art, put his finger directly on the fundamental shift in power and influence in the art world. The lead in the art dance, he noted, moved rapidly back and forth between critic/historian and artist, with the museums and galleries watching and waiting to pick winners and then moving in:

> We are still working with myths developed in the age of alienation . . .
> [but] there no longer is any shock in art. About a year and a half
> ago [1961] I saw the work of Wesselmann, Warhol, Rosenquist and
> Lichtenstein in their studios. They were working independently,
> unaware of each other, but with a common source of imagery. Within
> that year and a half they have had shows, been dubbed a movement,
> and we are discussing them at a symposium. This is instant art history,
> art history made so aware of itself that it leaps to get ahead of art.[9]

The conservative critic Hilton Kramer, though hardly in the same camp as Geldzahler, echoed this point with the observation that "the relation of the critic to his material has been significantly reversed. Critics are now free to confront a class of objects about which almost anything [they] say will engage the mind more fully and affect the emotions more subtly than the objects whose meaning they are ostensibly elucidating."[10]

Geldzahler and Kramer were speakers (along with Dore Ashton, Leo Steinberg, and Stanley Kunitz) at the Museum of Modern Art symposium on Pop Art organized and moderated by Peter Selz. (In the audience was Marcel Duchamp, who reportedly commented that Kramer was "insufficiently light-hearted.")[11] The symposium was held on 13 December 1962, six weeks after Sidney Janis opened his *New Realists* exhibition, a survey of contemporary Pop Art. According to Thomas Hess in his *Art News* review, "The point of the Janis show ... was an implicit proclamation that the New had arrived and it was time for all the old fogies to pack."[12] Selz was no fan of Pop Art, and few of the other panelists, with the exception of Geldzahler, were favorably disposed toward the new movement. But the art fashion tide picked up Pop and swept aside the unbelievers, the "old fogies" who'd been brought up in what might as well have been a different era.

Selz had been particularly vocal in his criticism. Writing in *Partisan Review,* he dismissed the new movement by accusing it of being "as easy to consume as it is to produce and, better yet, easy to market because it is loud, it is clean, and you can be fashionable and at the same time know what you are looking at."[13] According to Selz, Pop Art was a product of American consumerism and drew its subjects directly from that source in a kind of circular process. He missed the evidence of engagement and suffering that informed the great modern art of the recent past, such as German Expressionism. For him, the new art operated exclusively on the surface; it was both literally and figuratively devoid of depth.

The issue of surface versus depth was of great significance to Selz. He claimed to be open to the new, regardless of style, but if subjectivity and human qualities were removed, he had little use for what was left. A 2009 article by Richard Dorment in the *New York Review of Books* tackles that issue head on in a discussion of three recent books about Andy Warhol.[14] The essay discusses what constitutes an original work of art by asking to what extent the artist's hand need be evident or even required in its production. Warhol's fame, of course, is indebted to the Duchampian tenet that art exists not in the execution, but in the idea. How the object is manufactured or even if it is mass-produced (appropriate terms in connection with Warhol) is beside the point.

This subversive view of authorship and handcrafted originality remains highly offensive to traditionalists. At best, they would hold, it smacks more of philosophy than of art. In fact, the philosopher and art critic Arthur C. Danto seems to agree when he describes Warhol as "the nearest thing to a philosophical genius the history of art has produced."[15] According to one of the assistants responsible for painting many of Warhol's later works, the artist's primary role was signing them when they were sold. A painting could be an original Andy Warhol whether or not he ever touched it.[16]

This practice alone could be taken as a fundamentally cynical view of fine art, and many observers at the time did so. But that was not what Selz objected to most. Rather, it was the attitude that art had no life, no passion—no humanity—breathing beneath the surface, eagerly waiting to emerge and affect the viewer. As Warhol famously said, "If you want to know all about Andy Warhol, just look at the surface of my paintings and films and me, and there I am. There's nothing behind it."[17] Influential though this erasure of the artist became in aspects of postmodern thinking, this notion was antithetical to Selz's humanistic approach to art. And it pretty much precluded any true détente between Selz and one rising current of contemporary art and cultural criticism.

In our 1982 interview, Peter had very little good to say about the situation in New York prior to his departure for California. Above all, he deplored the cozy commercial relationships between artists, curators, galleries, and, finally, museums. There was a new way of creating reputations that fueled the art market, serving the immediate interests of every part of the art scene—except the art itself. Everyone was involved in a kind of new art "world order" in this New Art City.

> What is happening is, a new kind of merchandise is being offered. I think the whole thing started with Pop Art and its sales pitch. Now, there are things in Pop that I find fascinating. I think Oldenburg is a great artist, as is George Segal. There are things in Realism, especially somebody like Chuck Close, which I also admire. But by and large, what you had in the beginning of Pop was a gallery-oriented art. It became very obvious what Lichtenstein was doing—he was enlarging a comic strip into gallery scale; and Rosenquist, diminishing the billboards he had been doing to gallery scale. So you suddenly had a gallery kind

of art which could be sold and has been sold at very, very high prices. Then museums, of course, take part in all this—they can't neglect it. But I feel that to a great extent it's done by dealers . . . which is one reason why I was perfectly happy to leave New York when all this happened.[18]

As Peter talked about the new and powerful role of the art market in New York at this time, he shifted his attention to the commercial aspects of rediscovering the art of the past. He recalled San Francisco writer and critic Alfred Frankenstein's asserting "more than once" that before historic American art was valued by the market, it received little attention in art history departments in this country's colleges and universities. Then, as interest caught on and prices went up, *voilà:* American art was being taught about on American campuses. Selz pointed to two illustrations of contrary developments deriving from this market-driven "discovery" phenomenon. One was the great increase in value of Thomas Eakins photographs as the artist began to be recognized—justifiably, in Selz's view—not merely as a great American realist painter but as a "major figure of the nineteenth century."[19] In contrast, he disapproved of the parallel situation in which the works of minor American Impressionists (Impressionism was never very good in America, in his view) suddenly became extremely high priced.

Turning to realism and the figure, Selz compared his *New Images of Man,* involving art that deals with personal feeling, to *The New Realism,* which at the time of the interview (1982) was on view at the Oakland Museum and which he considered for the most part "appalling."[20] He explained why he felt that way in a statement that eloquently reiterates his fundamental position on the subject of realism. To erroneously group artists together under that convenient rubric, he insists, entirely misses individual differences, including artistic goals, thereby obscuring the very meaning of the work:

To my mind, the most important painting in America in the past decade is the last work of Philip Guston. But I wouldn't call that realist. This is the kind of humanist figuration, human image feeling . . . that relates to our world, our life. Guston was the only one of the Abstract Expressionist generation who reached a great style in his old age, who painted pictures which are absolutely astonishing. Or the kind

of figuration that [R. B.] Kitaj and Jim Dine have done, very different from Guston but also extraordinary. The other kind, most of the Photo-Realism, is tour-de-force painting—it shows what a painter can do by using photographs. But once you get over the fact—"my god, isn't it remarkable how he managed to do this"—it isn't all that exciting.[21]

What Selz wants in art is subjectivity and metaphor. He never was interested in simple realistic rendition, whether academic nudes by William Adolphe Bouguereau or soup cans by Warhol. He acknowledges that dealing with photography has a point, but not enough of a point to engage his interest. As he warms to his subject, Peter's efforts to convey his personal critical/historical perspective, referring to certain favorite artists, become both more urgent and more eloquent. The eagerness to convince an audience reveals the passion he brings to his work:

> Kitaj comes out of a collage tradition which deals with film and what Germans like [George] Grosz and [John] Heartfield were doing, with what the English were doing at the beginning of English Pop—but he's bringing it into the context of American consciousness. He deals with a complexity of issues: reality, history, poetry, and the whole history of art (of which he's totally aware). . . . And when I look at these complex paintings and try to figure them out, at the same time they have an extraordinary impact because of their intensity. Yes, that's the important word: intensity. That's what I find missing in paintings of cows and motorcycles, as much as I miss it in the kind of color field painting that [Clement] Greenberg was sponsoring.
>
> These are just formal exercises, and it really doesn't matter to me if these exercises are abstract or realistic—they're simply not interesting. They don't have the kind of personal intensity, the personal engage-ment, the metaphor, the feeling, and the knowledge of art that should be in them—what I see in late Guston, and also in his early abstractions of the fifties and early sixties—the same knowledge of art, of himself, and deep [social/political] engagement. An emotional feeling, a sense of order, and an incredible sense of composition and color. It's when the subjective vision is absent, the commitment—like in the new realism and some of the color-field painting—that I lose interest. But certainly I don't have any stylistic preferences.[22]

Selz's ideas about significance in art unfold consistently, representing a carefully chosen vantage point. It is far less the particular style than the

vision that he seeks and most admires when he finds it. In this he always returns to the work of his New York friend Mark Rothko. And the basis for this loyalty is that Rothko, more than any other artist, satisfies Selz's desire to reconcile the nonobjective and the figurative poles. Selz also embraces the minimalism of John McLaughlin and Josef Albers's Hard Edge abstractions, but that requires, given the human "presence" as the final measure, going beyond formalist criticism: "It is a sense of order. Art is broad enough that it should incorporate a person's vision, whether an obvious sense of order or random. And it's this [visionary] sense of order that I see in, for example, John McLaughlin—who had an extraordinary sensitivity to form. When I see that, I admire the work. Now, I admire it most when it comes together as in Mark Rothko. That I admire more than anything."[23]

By the mid-1960s, even Rothko and de Kooning were being viewed in some quarters as a "dead end," at least for younger artists and critics. So Peter Selz's exhibition record was subject to criticism from an impatient and changing art world that wanted to move forward. His willingness to adopt a contrary position in the face of prevalent art world fashion, most memorably 1960s Pop Art, appears to have also played a role in growing pressure for him to leave MoMA. The following account may be apocryphal, but it expresses the mood of the time and the rapid changes that were under way in the art world: One day in the early 1960s, Peter was rushing to a meeting somewhere in MoMA. Passing through the galleries he encountered Frank Stella, perhaps the leading figure among the "young Turks" of contemporary American art. Peter had forgotten his watch, so he stopped, greeted Frank, and asked him for the time. Frank paused and then responded, "It's time for you to leave."

In New Art City, Jed Perl draws a picture of the Manhattan art world that is simultaneously positive and negative—vital, youthful, exciting, superactive, but increasingly cynical and commercialized. For nouveau riche collectors, art was an extension of personal wealth, a means to demonstrate power and social standing. Although the Museum of Modern Art still served as the institutional identity of modern and, to some extent, contemporary art,[24] it was already coming to represent what a younger generation of artists was beginning to reject. There was a growing sense among them that the museum was becoming outdated, certainly in terms

of their ideas, interests, and objectives. The popular Chuck Berry 1956 rock-and-roll youth-culture anthem, "Roll over Beethoven," could just as well have been the theme song of the day in all creative fields.[25] Others of Peter's generation—including Greenberg and his favored artists, all supported by MoMA—were also subjected to the same suspicion and, finally, rejection that Selz was beginning to sense personally.

In fact, the situation at the Museum of Modern Art was deteriorating for Peter. What started out as a dream job had become less so. Interviews conducted by Sharon Zane with MoMA staff in a 1991 oral history project, along with internal museum memos, suggest several factors leading to Selz's growing discomfort in his position at MoMA. Taken in no particular order they include curatorial infighting and rivalry (the oft-repeated but unsubstantiated rumor that Bill Seitz wanted Peter's job); the extreme unlikelihood that Peter would ever realize his ambition of the top job as director; and possible dissatisfaction with him personally, or his performance, on the part of the administration. And one cannot discount the "Jewish issue" as an obstacle to Peter's hopes for advancement. A fuller quote from the previously cited *Art News* editorial by Thomas B. Hess describes the Jewish "glass ceiling" in many museums, not excluding the supposedly progressive MoMA:

> Because most museums were founded by Old Money—the town's country club set, established bankers, merchants, landlords—their boards of trustees retain a distinctive coloration chiefly marked by a suspicion of—let's say snobbishness to—the New Rich. Which suggests a reason for one of the more curious anomalies in the museum world: its anti-semitism—the most widely known, unspoken fact in the field. Key positions in the best art-history departments . . . are open to Jews, but when the trustees for Eastern and Midwest museums go shopping for a director, it goes without saying that no Jew need apply (unless, naturally, he has successfully changed his name and his religion).[26]

These difficulties, his co-workers generally agreed, combined to create a pressure to move on that Peter could not ignore.

As much as Peter admired René d'Harnoncourt, a few of the MoMA interviewees speculated that Peter was rubbing him, and possibly Alfred Barr, the wrong way. In his 1973 history of the museum, *Good*

Old Modern, Russell Lynes writes only that "Selz stayed for seven years, and was encouraged—indeed, urged—by d'Harnoncourt to accept a job at Berkeley."[27] Peter no doubt had detractors among his colleagues, most notably Porter McCray, who resented him and wanted to minimize his influence. It is difficult to draw conclusions about the actual situation, and Peter himself continues to paint a generally positive picture of his collegial relationships. Reading his 1994 MoMA interview, one would think that even if everything was not all roses, at least the working environment was civil and generally supportive. And that may have been the case on a superficial level. With the possible exception of Bill Seitz, however, Peter admits ruefully that he had no close friends among his colleagues at MoMA. Once in a staff meeting he looked around and tried to locate a single person who had invited him to his or her house, even just for cocktails if not dinner. He came up empty, a disappointment that evidently bothers him to this day.[28]

Peter does bemoan the lack of real friendships at MoMA, but he tends still to think of his colleagues as "liking" him. That was presumably true in some cases, but a few colleagues, speaking for the record, were not always flattering. Collector and MoMA trustee Walter Bareiss, when asked by oral historian Sharon Zane about the departure of several key curators (among them Selz and Seitz), described a kind of administrative housecleaning:

> Even though I liked him personally, Seitz was not a very efficient person. I don't think he could really hold the job the way he should. . . . Selz was a little too *abrasive* [italics in transcript]. I think he left because Barr wouldn't stand for that—Dorothy Miller wouldn't stand for it either. He was ambitious, a person who would take over. . . . But that in itself, why not? I don't have any objection to people who try, and then they go and make their future at some other institution. It is nothing negative for their character. But there are some institutions [presumably MoMA was one] who [sic] cannot afford to have kings and princes.[29]

Helen M. Franc, editorial associate and special assistant to d'Harnoncourt, who apparently got out before the situation further deteriorated, offers her own characterization of the environment during Selz's tenure at the museum:

It was a time of considerable internecine rivalry. I guess it was aggra-vated by the fact that after Alfred [Barr] was shunted from his position as director, the Museum was run by committee, which never does any institution any good. . . . It was a very disruptive time. Everybody hated everybody else in the Museum and there were alignments·of who was against whom. Also, when I got to work with Porter [McCray], well, with René particularly, I realized there was a rather naive view of the staff towards what the function of a director was. So they thought he wasn't paying enough attention to their little needs. . . .[30]

Bill [Seitz] was more charismatic [than Selz] . . . but very self-centered. And when he was working on an exhibition he would bug out from all the responsibilities of the department and stay home, theoretically writ-ing a catalogue. . . . Peter, who was less liked, was really a much better administrator; he carried on things. Bill was always trying to put the skids on Peter.[31]

Generally speaking, the MoMA interviews give the impression that virtually *everyone* was unhappy and that many harbored grudges, espe-cially against those above or in direct competition with them. Of course, this condition is true of many organized working environments, and apparently MoMA was no exception. Even Peter's assistant, associate curator Alicia Legg, for whose work he had kind and appreciative words, described her boss's departure in less than favorable terms: "Selz was sort of dismissed . . . was essentially asked to leave. Something about vouchers for trips he'd taken." And surprisingly, in light of what Peter remembers as a positive working relationship, when Legg was asked if there weren't some other dissatisfaction, her answer was "Yes. He just wasn't up to the job."[32] Elsewhere in the interview, however, in speak-ing of her boss she sounds almost affectionate. And another co-worker, publications manager Frances Pernas, remembers Peter as a pleasure to work with: "He was a nice man. He had a warmth about him."[33]

Whatever the truth of these after-the-fact and sometimes almost hos-tile oral profiles, the overall picture is fairly dismal. As for Legg's asser-tion that travel voucher irregularities, submitting claims for "more than he deserved," were cause for his dismissal (as his colleagues believed he was), Peter acknowledges there was indeed a problem, documented by memos in the MoMA archives, but it was a small matter of $63.25

and occurred four years before he left the museum.[34] Although it seems unlikely that this single early infraction would have been left simmering for so long, it may well have become part of a plan for later administrative action. But this was not the only, or even the most telling, aspect of a deteriorating situation that contributed to Selz's decision to abandon New York for a fresh start both professionally and personally.

. . .

One mark of a full life is achieving some meaningful degree of balance between the professional arena and the private realm built around friends and, above all, family. These areas, though overlapping, remain separate experiential entities, and often work in competition with each other. While Peter's successes at MoMA were compounded by the string of exhibitions for which he is still known, everything seemed to be on track. The family lived well, in a large apartment at 333 Central Park West (see Fig. 13). But something was lacking in the area of close personal relationships. Peter and Thalia socialized with couples well known in art and literary circles, among them Lionel and Diana Trilling. But whereas Thalia was willing to enjoy these friendships at face value, Peter felt a distance.

Despite their active social life—museum events, art receptions, dinners—Peter feels to this day that they had few "real" friends in New York.[35] The exceptions were Bill Seitz and Dore Ashton. These two were his best friends in New York, and Ashton has remained in Peter's close circle. As for Seitz, there is much to learn from their working relationship at MoMA and what Peter understood to be a close friendship.[36] Their association began well. Much later Thalia, speaking to Peter, recalled: "You really ranked [thought highly of] them, you wanted to get a duplicate of that closeness—a substitute for family." Peter did not disagree: "That's right. And you felt close to them too. You remember the time we were out at Princeton and Bill was taking mescaline? That brought me closer to him."[37] The incident he refers to, a visit with Bill and Irma Seitz at their Princeton home, reveals a very sixties aspect of their social interaction. The mescaline, he explains, was an "informal experiment."

On this occasion, he and the two women observed Bill with considerable curiosity as he experienced a mescaline high. A week or two later, Peter was scheduled to conduct the same "experiment" in the same company. But the second event never took place.

It was not just his social life that failed to satisfy Selz. His domestic life had also frayed into disorder. There are ample clues as to where things went wrong between husband and wife. Sadly, Thalia's ability to recall the past was stolen from her by Alzheimer's disease. She lived out her last years in a Long Island care facility and died in early 2010. During that time she was visited regularly by younger daughter Gabrielle. Gaby, as friends and family call her, lives in Southampton not far from the Hampton Care Center, where her once strikingly beautiful mother, an accomplished writer of short stories who by her former husband's admission helped him significantly with his own writing, spent her final days. Nonetheless, Thalia contributes to this biography through the gift of analog recording technology and taped conversations. Ten cassettes recorded in 1993 and 1994, provided by Gabrielle, give her a compelling presence as an intelligent and knowledgeable individual, though one held captive by anger and bitterness.

Although the Peter and Thalia story, their seventeen years together, began as an intellectually stimulating and personally fulfilling relationship,[38] he had one serious weakness: an inability to limit himself to one partner. This probably was the deal breaker for Thalia, who, as Peter's Pomona faculty colleague and good friend Charles Leslie put it, was "almost insanely jealous." In the end, Peter's infidelity was, as later wives discovered, one of the unspoken and nonnegotiable terms of being married to him.

The taped conversations were initiated by Thalia, ostensibly to gather material for a memoir of their art world life together. Peter readily agreed to her proposal (though they had divorced almost thirty years earlier, they had stayed connected), and they met several times to do the tapes in New York and Berkeley in the early 1990s. The fundamental differences in their approaches to forming the memoir are evident from the beginning. Thalia's interest was in their troubled personal life; focusing on their marriage and family, she sought answers. For Peter, in contrast, professional life trumped the personal. The reasons for their failure in

the domestic sphere, a central concern for Thalia, were for Peter less worthy of discussion than was his career and success in the art world, specifically during his seven years at the Museum of Modern Art.

The one point on which they were in agreement was that in the early days—in Chicago, Paris, and even Pomona—they were very much in love. As a young couple building a life together, they, as Thalia puts it, "worked as a unit." Throughout this long mutual interview, Thalia's tone is determined and, at times, combative. She is on a mission to understand what went wrong, and to force Peter not only to recognize but to acknowledge the hard and destructive realities of their relationship, especially as it fell apart in New York. Peter, for his part, is conciliatory but apparently oblivious to the downward spiral their family life was taking. In fact, he seems genuinely mystified by Thalia's harsh critique of their last years together and puzzled by her negative memories. He either ignores, or is unwilling to discuss, the underlying problems and their causes, despite the collateral damage to their young daughters. What on the surface might seem an admirable trait—insistence on the good parts of a shared history—here resembles more a pattern of willful denial in service to a carefully cultivated self-conception.

What happened to the love, brimming with optimism for the future, that these attractive and interesting young quasi-bohemians shared? Some answers emerge almost immediately as Thalia tries to establish the direction of the planned memoir:

> I see the focus on our life together in New York. . . . I also see a very personal impact that the New York art world had on me. The immense excitement it offered and the degree to which it probably permanently warped some of my better values. I'd like to explore the depth of my hostility. . . . I remember those years as the *seven lean years,* when you were at the Museum of Modern Art. I don't blame the museum for everything that happened to me, or to *you.* I think it was an extremely important formative period in your life and career. I do think it had a destructive impact upon me—and on our marriage, although we can't blame our breakup on MoMA. I think it made childrearing immensely difficult, virtually impossible.

Peter's response is surprisingly neutral, as if he were listening to someone else's story, agreeing that these difficulties would "add a great deal

of interest to the book." Thalia perceptively observes: "I am, I think, like Peter, very concerned with history—but I'm more concerned with personal history, and he with a history both personal and public."

Here and there, the two momentarily set aside the personal element for an interesting conversation about artists in New York, allowing a glimpse of the stimulation that the art world provided. The discussion of their friend Mark Rothko and his chapel in Houston, Texas, suggests just how much they had in common; Thalia recalls: "I saw the last great paintings of Rothko in his studio. I was sitting beside him, liked them, but didn't have a strong feeling—until I saw a slide of the interior of the chapel last spring with the painting in situ. It hit me like a sledge hammer."

Although Peter and Thalia had a common interest in art and literature and what appears to be a lasting admiration for each other's creative and intellectual abilities, they differed markedly in their respective views of matrimony and the obligations of childrearing. Both agreed that they were lacking as parents, but Thalia more than Peter seemed to take the deficiency seriously. This comes into painful relief as their taped conversation proceeds, growing ever more candid. At one point, Thalia asks Peter what it was like being a husband and father during their time in New York; his answer probably reveals more than he intended: "The museum really occupied my time; it was the focus of my life. Not being home many nights during the week—I must have been writing then—and on the weekends. During the day I was in my office, running my department. That must have been very, very difficult for you. In the evening, I worked on writing. So wrapped up in my work—but that isn't so different from all these artists we've been talking about. They led the same kind of lives with wives and children."

Thalia then confronts Peter directly on his role in their failed family: "One thing occurs to me. I don't think we had a life together, after a certain time." Peter, seemingly shocked by the harsh judgment, murmurs, "Oh, my God." Thalia is not in a mood to be dissuaded: "You lived there at 333 [Central Park West], we went out together in New York, went to parties. . . . There is, should be, a family bonding that creates a unit. We were a dysfunctional family. We didn't know how to put together a

working unit—except for the two of us. . . . It didn't really work when we had kids."

Thalia's Greek American family may have been, to use her own term, crazy, but they managed to work together. And she wonders if maybe she did not want to replace *that* family unit with another, thereby almost guaranteeing failure. Peter's sympathetic response reinforces what we already know of his Munich childhood: "That's a great contrast to *my* family. . . . Hadn't thought about it in that way, but maybe that was responsible. I really did not have a close family unit. So I did not know how to recreate a family of my own. In Munich the German youth group took center stage—our labor Zionist group getting ready to go to Palestine. That was the center of my life—certainly not home, certainly not school. Neither of them was important."

Peter professes a considerable fondness for Thalia's father, so it comes almost as a shock that the otherwise liberal father-in-law at first had difficulty accepting a Jew as his daughter's husband. Thalia's younger brother, Dion, describes the situation: "My father, Nicholas D. Cheronis, was a political radical and was in no way ever considered to be anti-Semitic. But when Thalia announced her engagement to Peter, he went into the basement (we had a study down there) and sulked for three days. Unusual behavior for him, as he was anything but silent about anything. He and Peter eventually became quite close, but I think that the original jolt that his daughter was marrying a Jew was a bit too much for him."[39]

And so it went—Peter always trying to put the happiest construction, or at least the less damaging one, on indiscretions and related lapses. Peter has his own views as to what ended the marriage:

> After all these years, seventeen we were together, I think in a way that the marriage had just run its course. We felt very separate from one another. And I must say, Thalia was more interested in—Gaby and Tanya can tell you—writing than her family, her children, her husband. Writing was always first in her life. And in my case I was more interested in my career. And then also I had a very heated affair with Norma [second wife-to-be]. She was married and I was married; she was married to a New York lawyer named Spiegel. . . . Norma represented a new

kind of excitement. She was getting her master's at the Institute of Fine Arts in art history. So we talked a lot. We had that in common, although she never did much with it. She was pretty and bright.[40]

When asked if he viewed Norma as a means to escape what was becoming a boring, even stifling marriage, he responded emphatically: "Yes, yes, yes, yes, yes. Exactly . . . I took a big step which I regretted very much. One reason I divorced Norma [each claims to have divorced the other after two years of marriage] was that I wanted to get back with Thalia. . . . But it didn't work. The same problems were still paramount."[41] Norma's account has it the other way around: she left him.[42]

Peter is straightforward about his views regarding marriage and family responsibilities. He readily confides that "basically I'm not monogamous. Very few of us are, although we try."[43] Peter believes that the freedom and independence to pursue personal interests is a reasonable position and, if accepted by both partners, can bring about a kind of bohemian domestic utopia: "A shared life, shared interests, a shared family with your kids, these things come first. The physical—a sex partner for one night isn't very different from a tennis game. It's a physical experience, sometimes with no more significance than a game of tennis. And in many cases I think this is nice, and why not? I made a big distinction between loyalty and possessiveness."[44]

There was, however, another complication in this ill-starred marriage, and it effectively deprives Thalia of much of the injured spouse role. In terms of adultery, within the Selz union there seems to have been plenty to go around. Thalia had her own share of lovers during the married years, beginning at least as early as Pomona.[45]

As for daughters Tanya and Gaby, one event very early in their lives demonstrated the degree to which Peter and Thalia were either unprepared or unwilling to be effective parents. Peter recalls the incident thus:

What happened was this. The family, including Thalia's parents, rented a house in Northern Italy for the summer [1960]. The six of us were living in this house. And my father-in-law simply could not stand the fact that Tanya never stopped crying. You know, as a father it was bad enough, but for somebody else it was very difficult. And a neighbor

said, "Why don't you send her to a *kinderheim* in the Alps, where they are taken care of very nicely." And that's what we did. . . . I was working on the Futurist show for MoMA. We left them in Innsbruck and rented a car and went as far as Rome. Gaby thought Thalia was nearby and writing. That was only part of the time. It was more a combination of working on the exhibition and sightseeing. But she remembers it that way because Thalia frequently put her writing ahead of her children.[46]

Although he calls the *kinderheim* a "terrible mistake," Peter's version of the debacle reveals an unawareness of his daughters' feelings of abandonment, which are clearly expressed in their interview accounts and in Gaby's unpublished work of autobiographical fiction, "Rush."[47]

In fairness, it can be said that each of the Selz girls has her own happy memories of their father during the difficult New York years. Tanya remembers especially that Peter escorted them to Broadway shows: "Dad loved musicals, and sometimes he would take us with him."[48] And Gabrielle recalls excursions with him to museums and galleries, a practice they continue to this day when he visits New York or she the San Francisco Bay Area.[49] Gaby makes it clear that she did not think of her parents' behavior toward her and her sister as cruel or intentionally hurtful: "People are imperfect and their love is imperfect. But I have always felt loved by both my parents."[50] That at least seems to be an improvement over Peter's own childhood memories, and possibly Thalia's in some respects as well.

Thalia's fundamental affection for the girls is expressed in a newsy 1964 letter to Peter (who was in Europe primarily on museum business), part of a numbered series in which she tried to talk him out of moving the family to California: "The cards from Ravenna were lovely and they moved me, remembering. What sillies we were. How we fought! And we were so pretty. Remember how pretty we were? Our girls are pretty now. They are making you swimming pools out of old watercolors of theirs. . . . Please be amazed. They were very eager to make you a present. Their own idea."[51]

Shortly after these cajoling letters were written, the Selzes seemed to be enjoying getting out and about together in New York. One example from Thalia's journal reports an amusing incident they witnessed at an art world event:

At a party in honor of Marcel Duchamp the night of his opening at
Cordier Ekstrom. We come up with Dalí and Gala. The girl behind the
desk in the foyer recognizes P. and hands us our packet, containing
catalogue, invitation signed by Duchamp, etc. Then she asks Dalí to
identify himself.

 Dalí (sputtering): "But I am Dalí!"
 Girl (deadpan): "Your full name, please?"
 One side of those waxed mustachios works up a good 3 inches in
outrage and embarrassment, but he finally has to submit to a formal
identification in order to pick up his packet.[52]

Now that Thalia was getting into the swing of the lively New York
social scene, California had come along to threaten her. And this after a
period when she felt her life was being ruined by Manhattan and even
MoMA (Peter's job).[53] Her letters to Peter that summer of 1964 vacil-
lated between petulant complaints about the inferiority of California to
coquettish musings on American culture:

> Don't tell me about the one-week runs of "everything" in S.F. I saw
> the theatre announcements and you didn't. Ugh! I just can't bear the
> thought that I've just managed to get out into NY and now you want
> to move me 3000 miles away from it. IT'S JUST NOT FAIR![54]

> By the way, *are* there naked bosoms on the Riviera???? Bonwit's and
> Bergdorf's are both shocked and won't carry the [Rudi Gernreich]
> "topless" suits. One store in town does, but *where* are the suits worn!!!!
> It's too funny because all you have to do would be to wear the bottom of
> a bikini or short shorts and let it go at that. . . . Honestly, this country![55]

By 1965, Peter's domestic life was undone, and he and Thalia divorced.
With her own divorce papers, Norma Spiegel provided him what he
imagined to be a less encumbered situation and a fresh start: "We
decided we loved each other . . . then we moved to Berkeley. And she
bought a big house on Indian Rock with an acre of land."[56] Thalia said
at one point in the tapes, "Peter loves change—always moving on to
something else." Although that solution did not last long, it was part of
a pattern: discarding the present wife—or job—and expectantly moving
on to the next thing, often (again, his own assessment) with inadequate
thought for ramifications and consequences.[57]

Peter Selz had worn out his welcome at MoMA and in younger corners of the New York art world as well as at home. But an attractive position was waiting for him across the country—as director of the University Art Museum at Berkeley. He departed New York City with his professional life still intact and a new life ahead of him.

SEVEN Berkeley

POLITICS, FUNK, SEX, AND FINANCES

Selz arrived in Berkeley in 1965 as something of a star. Everyone in the art community knew that he came from the Museum of Modern Art, and with those credentials and a record of including Californians in important exhibitions such as *New Images of Man,* a great deal was expected of him. There is every indication that he relished both the challenge and the attention that came with the high expectations. His goal was to "bring new light to the art of the past and be on the cutting edge of the new."[1]

In the early 1960s, California was barely recognized by the New York–centric art world. Nonetheless, in 1963 a New York painter, Hans Hofmann, who had been invited in 1931 to come from Germany and teach at Berkeley for a year, promised a gift of forty-five paintings and $250,000 to the University of California at Berkeley for a new museum. That promise led to the founding of the University Art Museum, and it set Peter Selz on the final journey of his immigration story:

Walter Horn [one of the founders of Berkeley's art history depart-
ment] had come to New York several times to persuade me to make
the move. . . . The plans were to build a big museum, and they needed
someone to run it. I would become a tenured faculty member and
director of the new museum, a $5 million project. I thought about it for
a year—back and forth, back and forth. It was a tempting proposition,
which I then accepted. They were going to form a collection and fund
it properly. And there were other very tempting things. First, there was
moving from being a curator to museum director. There was the whole
idea of going to California—I had enjoyed my life at Pomona very much.
I liked California, and I admired the university a great deal. They said
they would start out the first year with at least a million dollars for
acquisitions. And the idea of getting away from involvement with only
modern art to running one that covered all of Western and Oriental
art—to start a museum from scratch—appealed very much.[2]

Peter did not, however, have to start completely "from scratch." The
university had a small collection and used as an art gallery the pow-
erhouse designed in 1904 by architect John Galen Howard. It had been
made obsolete by greater demand for power in the 1920s, but in 1934 the
Romanesque building became the university's Powerhouse Gallery. So,
although the new structure for the University Art Museum was awaiting
funding, its new director did have an arena for exhibitions.

Another attraction for Peter at Berkeley was the political excitement
around Mario Savio and the Free Speech Movement, about which
people in New York had heard a great deal.[3] Unfortunately, that was
also one of the main campus developments that interrupted the flow of
funds for the museum. No sooner had Selz arrived than he was told,
"Well, we may not even be able to build the museum, but now you're a
tenured professor—we'll just have to wait for the funds."[4] Selz discov-
ered that some of the trustees of the San Francisco Museum of Art (now
San Francisco Museum of Modern Art [SFMOMA]) were concerned
about perceived competition for patrons. His first task, therefore, was
to solidify support, which he was able to do with the crucial help of
UC president Clark Kerr. The building proceeded, with the innovative
design by Mario Ciampi and associates Richard Jorasch and Ronald
Wagner intact; construction began in 1967 and was completed in late

1970 (see Fig. 16).[5] But the million dollars a year for acquisitions never did materialize.

Despite these disappointments and delays, or perhaps because of them, Selz was determined to maintain his contacts with New York artists. Among them was Mark Rothko, with whom Peter and his new wife, Norma (curiously renamed Nora by her husband), visited Italy in the summer of 1966 (see Fig. 17). They met up in Rome and then drove to Florence, at Rothko's request, to see again the transcendent Fra Angelico frescoes. As Peter recalled,

> Driving north in my little Fiat, we stopped in Arezzo, as I wanted him to see the Piero della Francesco murals in the church of San Francesco. He did not respond to the Renaissance painter's early mastery of aerial and linear perspective or the modeling of his figures. He found [Fra Angelico's] *Legend of the True Cross* too narrative. At the monastery of San Marco in Florence, however, he admired the small frescoes in the monks' cells, especially for the intimacy of the setting in each cell where the monks would be confronted by the painted images at all times.[6]

Norma remembered the trip differently.[7] For example, she insisted that Rothko did not particularly like Peter, and that indeed it was she who was his friend—though she didn't explain exactly what she meant by that. But her description of her ongoing relationship with Rothko, after leaving Peter and returning to New York, is enlightening in several respects.

> We went to Italy in the summer of 1965, I think [in fact it was 1966], and joined up with Mark, Mell, and Kate [the Rothkos' daughter]—can't remember if Christopher [Rothko] was there. The Rothkos stayed with [art dealer] Carla Panicali; we stayed in a hotel, but we spent a lot of time with them. After I came back to New York after I *divorced* [Norma's emphasis] Peter, I was extremely close to Mark. No, I was not his lover. But we loved each other, and I wrote a whole story about it. . . . I knew that Mark was not fond of Peter on a personal level. In addition to which Mark had a distrust of museum curators in general, which was not unusual among the New York school of painters at that time. We took the red painting [given to them both by Rothko] with us to Berkeley and hung it [in the] living room of our home in the Berkeley hills. After two and a half years I left the painting with Peter, divorced him, and moved back to New York in 1967.[8]

Rothko's alleged low opinion of Peter notwithstanding, he showed up in California the following year through Selz's arrangement. Peter recounts: "A year later I was able to persuade Mark to accept a Regent's Professorship for the summer at Berkeley, which required no teaching and provided free time for painting in the Bay Area—where almost twenty years earlier he had begun the paintings which we now call his classic style. We spent a good deal of time together that summer. Critic Brian O'Doherty and art historian Barbara Novak were also at Berkeley at that time, and the discussions between the artist, art historians, and critic were lively and provocative. I wish we had recorded them."[9]

Alongside these pleasant social breaks, however, were the ongoing funding difficulties. According to Selz, Clark Kerr never did get along with the legislature, so Kerr had to come up with another idea and said: "Let's do this museum with no connection to state funds. It [will be] funded out of student fees, and the students are going to love this."[10]

One innovation that Peter arrived at to bolster student involvement was the Pacific Film Archive. In 1966 a young film scholar from New York, Sheldon Renan, arrived in Berkeley with the idea of creating a film archive in a museum in the area. Although interest in avant-garde and independent film was evident throughout the Bay Area, Renan met resistance at both the San Francisco Museum of Art and the Oakland Museum. Peter Selz, in contrast, was interested. Selz says he believed that film was probably the most important art expression of the time, and, taking his cue from the program at MoMA (a Barr innovation implemented by British film critic Iris Barry) and Henri Langlois, founder of the Cinémathèque Française in Paris, he established film as a separate department of the Berkeley museum.[11]

In many respects now acknowledged as the central jewel in the Berkeley museum crown and recognized worldwide for its active collecting and preservation program, PFA initially had a difficult time establishing itself and securing even minimal support for its innovative programs. In fact, according to Renan and Tom Luddy, a student who worked on the early film programs, despite Selz's support and ambition to establish a film program to rival MoMA's, the UC administration was fundamentally hostile to the idea of film as a legitimate component of an art museum. Peter had great enthusiasm for the idea, and "the late

1960s was certainly the time for an individual with a passion to act first—just do it—and think about the details (and the funding) later. This is exactly how the Pacific Film Archive came into being." But he had neglected to follow procedure. The administration's response was something of a rebuke: "As the Archive's existence was quite unofficial as far as the university was concerned, the year's budget, $800, was appropriated from the art museum's publication allocation." Founder Renan, who was made director of the PFA in 1967, described the situation in a 1971 interview: "This whole thing is put together with spit, chewing gum, good intentions, cooperation from the film community, and overhead paid by the Museum. I'm not over-budget or under-budget because I haven't got a budget."[12] In a 2010 e-mail, Renan had more to say about the struggle to realize his personal dream of a true film archive. He begins by acknowledging the supportive role of Peter Selz: "History seems to be treating Peter too harshly. Accomplishing great things done is rarely achieved by perfect people and philosopher kings. Juicy excess and painful hubris are usually required. Neither the Berkeley Museum nor the Pacific Film Archive could have been as successful as they became without the counter-intuitive virtues resulting from the out-of-balance and slightly dysfunctional teams that started both. They were essentially separate endeavors, but each nevertheless relied on the other."[13]

Tom Luddy, who in 1972 returned from working in New York to succeed Renan as director, was more forceful in his denunciation of the treatment PFA and Peter Selz received from the administration: "We were recognized around the world, except [by the administration] in Sproul Hall. The university savagely opposed the film program and punished Selz for setting it up without authorization."[14] Luddy and Renan both moved on to successful careers as consultants, and Luddy became co-founder and is the current director of the Telluride Film Festival (2011 having been its 38th season). Neither of these men, important contributors to creating and developing a world-class film program at Berkeley, has anything positive to say about the university's treatment of PFA and UAM. But Renan gives Peter high points as a "great talent scout." Selz describes the PFA as one of his most important accomplishments—sec-

ond only to building the collection—as director of the museum. And it proved to have the student appeal that he had hoped for. In the beginning, at least, Kerr's student funding strategy was a success.

When he arrived in California, Selz recognized immediately that art trends were quite different from those in New York. Indeed, he was one of the first East Coast observers of contemporary art to recognize this difference, a difference that is now an accepted fact of American cultural history.[15] His opening show at the Powerhouse Gallery at Berkeley was *Directions in Kinetic Sculpture* (1966). It had been planned for MoMA, "so I had all my research done when I came out here and simply transferred it from the Museum of Modern Art to the Berkeley museum, and that really started the thing, literally, with a loud bang."[16] The exhibition was a great success, with attendance in the first month alone numbering sixty thousand. That pleased the university's public relations department, which had been reeling from the bad press generated by the Free Speech Movement.

Impressive shows followed, one after another, establishing a distinctive identity for the museum even before the new building was dedicated. *Kinetic Sculpture* was followed by an exhibition of the Surrealist work of René Magritte and the first American show of Jules Pascin's work, both of which Selz brought with him from New York. Selz's assistant, Tom Freudenheim, curated the Pascin show, which went directly on national tour. But the most memorable exhibition, especially in terms of California art history, was *Funk*. As Peter recalled, "In 1967 we followed the great success of the kinetic art show with another popular one, Funk art, which was very local . . . growing out of two artists whom I found of particular interest: Peter Voulkos on the one extreme and Bruce Conner on the other. These artists all were doing art of a certain kind which was very different from what was going on anywhere else in the country."[17]

In fact, the course Selz was charting at Berkeley, reflecting his quick study and adoption of a specifically Californian social and cultural situation, was innovative, even subversive—far more so than the University Art Museum itself, which had a reputation as being "elitist." The new director described Funk, as it was presented at the Powerhouse, as a "hot, involved, biological, sensual, sexual, erotic kind of art."[18] Taking his

adjectives to heart, Selz soon was seen largely in the company of artists, learning to live the California art life (see Fig. 18).

. . .

Five years after Selz's arrival in Berkeley, in November 1970, the new University Art Museum at last opened, with considerable fanfare and an exhibition, *Excellence: Art from the University Community*, that consisted of six hundred works of art from antiquity to the present. Drawn from the collections of regents, alumni, and others connected to the university— including two of California's preeminent collectors, Norton Simon and J. Paul Getty—the exhibition did double duty as a wish list for future gifts. This "elitist institution's" new home, with its show of artworks representing the wealth and power of California, opened at the height of the student antiwar movement. But the students were able to separate art from the university administration they were battling; they "came in flocks and loved it." The new museum on the Berkeley campus, funded by student fees, had "total support."[19]

The opening exhibition at the new museum represented the high-end collecting establishment, hardly the avant-garde to which Selz was by this time personally attracted. However, a proposal from avant-garde dancer Anna Halprin established, albeit inadvertently, a point of view and direction that pushed the museum right into the Bay Area counterculture (see Fig. 19).

Prior to the three-day grand opening celebration, Halprin offered to have her dancers "wash" and "soften" the concrete ramps, overlooks, and galleries with body movement. Selz readily agreed, but without ever having seen Halprin's work. According to Selz, curator Brenda Richardson cautioned that this could create some problems with the administration:

"'Do you know,' she asked, 'that Anna's dancers are generally nude?'"
"'No, I didn't,' I responded. 'But what can I do? I can't withdraw my acceptance of her offer at this point. And I don't want to censor her art.'"

So the evening went forward, with a limited group of people there by selective invitation. By all accounts, they loved this demonstration of the

new museum's "spirit." "The performance was a feast for the eye," Selz recalls, with "beautiful naked young men and women flowing throughout the museum. Soft flesh against hard gray concrete."[20]

The museum could not have received a more appropriate California-style launching. The Halprin event was actually one of several launching the grand opening. At one, minimalist composer Steve Reich performed late into the night. Selz had met Reich, at that time not well known, in New York and invited him. The program also had happenings created by Robert Hudson and William Wiley, who found in it a role for the museum's new director. Wiley recently described the event in colorful detail in an idiosyncratic handwritten account:

> At the opening of the Berkeley Museum when I and Robert Hudson and Jim Melchert, Pete Volkus, Richard Shaw, Brenda Richardson, Bonnie Sherk, Steve Reich, and Carl Dern and Peter Selz—along with many others presented our event the "Impossible Dream" and just before the finale—Peter standing at the swinging doors—me handing him a black cowboy hat with white trim—and strapping on a couple of guns and holsters and telling him to walk to the bar draw his guns and tell the bartender—give me some art!!
>
> Just before Peter pushes through them swingin doors the other afore named involved made a path—from louvered doors to bar—saying— Peter's coming! Peter's coming!! Peter strode forward hat cocked low right up to the bar where Carl Dern waited quivering in fear. Drawing his gun on reaching the bar—Peter said give me some art!! Carl from below the bar brought up an enormous flat—shot glass—with a decaled shop through it—it was wide and an inch or so thick. He proceeded to empty a fifth of 90% proof A.M.S. corn whiskey into the large flat plastic shop glass—Peter holstered his guns and raised the whiskey to his lips—
>
> At that point with Melchert at the piano—all the dance hall girls wear up on the card tables—with song cards and the players and the audience sang—The Impossible Dream.[21]

In addition, there were poetry readings by Gary Snyder, Robert Duncan, and Richard Brautigan. It was, according to curator Lucinda Barnes, a "multidisciplinary contemporary art extravaganza heralding a radical new building and an ambitious cultural enterprise, which within a matter of months would also include the Pacific Film Archive."[22]

Over the course of the three days, Steve Reich did several impromptu pieces; artist Norton Wisdom recalls one vividly. In his recollection, he was one of a dozen students seated on the concrete floor of the main gallery. There was no announcement of the event; somehow the word spread and a few curious individuals showed up to see what was going on. Reich incorporated them into the performance, clustering them together with half a dozen reel-to-reel tape decks placed around them. One long tape snaked through the Sony decks, producing competing but related musical passages. Wisdom remembers that it was beautiful, and it stirred his newfound interest in performance art and music, which became, years later, central elements in his mature art.[23]

The move from New York to "laid-back" California put Peter in touch with a counterculture that seemed organic and natural to the place rather than invented or imposed. It provided the context for him to realize the full liberation he had sought earlier and that in a fundamental way represented his authentic personal identity. Aligning himself with artists and their natural readiness to step outside the rules of art and society, Selz still likes to think of himself as a sympathetic mediator between artists and the essential institutions—museums, universities—that serve them, or should do so. Each of his books and exhibitions was based on the idea that the creative individual, the artist, was at the center of the whole cultural enterprise, not the scholar or the curator. Peter places himself in the artists' camp.

．　　．　　．

Selz's exhibition record at Berkeley, whether at the old Powerhouse or in the new Ciampi building, is an impressive one. The kinetic art show, the first with Selz as director, remains the one he generally points to as his most historically significant. *Directions in Kinetic Sculpture* grew out of Selz's encounter with the work of Jean Tinguely and most immediately the 1960 installation at MoMA. Selz was fascinated by the introduction of motion and change into art making, with the subject of the sculpture becoming movement itself. And he saw the issues and ideas involved, especially time and change, as fundamental to modernist thinking.

In his brief but carefully considered catalogue preface, Selz in effect introduced a new subject and did so by suggesting connections to other manifestations of modernism:

> The Constructivists' point of view was propagated by László Moholy-Nagy who . . . clearly saw into the future and formulated a theory of kinetic art which would not materialize for more than a generation. He advocated the activation of space by means of a dynamic-constructive system of forces and hoped to substitute relationships of energies for the old relationships of form in art. . . . Kinetic sculpture was widely discussed at the Bauhaus and at its offshoot, the Institute of Design in Chicago. There Moholy-Nagy published his influential book, *Vision in Motion*, in which he postulates that kinetic sculpture is the fifth and last of the successive stages in the development of plastic form.[24]

Selz also knew Buckminster Fuller from the Chicago years, and he quotes him to establish the scientific relevance of kineticism in art, invoking the triumphant image of Einstein "shattering" the Newtonian cosmos: "Einstein realized that all bodies were constantly being affected by other bodies, and this meant their normal condition was not inertia but continuous motion and continuous change. The replacement of the Newtonian static norm . . . really opened the way to modern science and technology, and it's still the biggest thing that is happening at this moment in history."[25] One of Selz's gifts is his ability to syncretize his subjects, whether artists or movements, within a historical context that does not obviate their creative identity outside of that history.

Directions in Kinetic Sculpture featured the work of fourteen sculptors, only four of whom were American, and boasted several "firsts": it was not only Peter's first show at Berkeley but also the first show in kinetic sculpture in the United States; it featured the first catalogue essay by kinetic sculptor George Rickey; and it introduced a struggling young San Francisco sculptor, Fletcher Benton, whose career took off thanks to his inclusion in the exhibition. Benton was eager to go on record recalling his fortuitous "discovery" by Selz, at the same time expressing admiration for what Peter contributed in a broader sense to Bay Area art and cultural life:

The word got out that this Museum of Modern Art curator had taken
a professorship at Berkeley. And he totally changed, from my point of
view, the local atmosphere and the hopes of the artists. . . . So we all felt
that this man was a god—that he was going to do great things for the
Bay Area. . . . One day I got a phone call: "This is Peter Selz." And any-
body who's talked to Peter knows he has this deep, impressive baritone
voice. He had heard that I was making some moving things, wall pieces.
And he asked if he could come by to see them. My first thought was, my
god, here's this incredible museum man coming to my basement studio.
 Well, in a few days he showed up, and he was so friendly. . . . He
looked at what I had and asked me if I would be interested in being in
the show. I had no idea what he was talking about. I didn't even know
there was a [kinetic art] movement. . . . And then . . . *Time* magazine did
an article [on the show] . . . and my phone started ringing off the hook.
I was in many other kinetic shows, but never such a pioneering group as
the one Peter brought here.[26]

In a similar way, the *Funk* show helped define Selz's career at UAM,
and was certainly at least as important for the local scene. But exactly
what was Funk? How was it identified as a distinct phenomenon, and
how were the artists selected? Selz found this important question dif-
ficult to answer.

Well, I don't know. In the catalogue to the show I wrote that Funk
can't really be defined. When you see it, you know it. But it was a
kind of art which was totally irreverent, an art that was loud—I said
"unashamed"—in a way that relates to Dada and was very different
from the Pop Art. It also came out of the Slant Step show that Bill Wiley
and Bruce Nauman had been involved with slightly earlier [1966]. . . . I
knew Harold [Paris], I knew Bruce [Conner], I knew Pete [Voulkos]—
and I met Wiley, Bob Hudson, and Arlo Acton. And then the ceramic
people like [Robert] Arneson and [David] Gilhooly. All of a sudden it
seemed to me there was a close relationship [among them] in this kind
of art. A casual, irreverent . . . art, art which dealt with bodily func-
tions . . . biomorphic art which was sloppy rather than formal.[27]

Selz thinks of Jeremy Anderson as "sort of the daddy" of Funk, but
looking back, he singled out Wiley and Arneson as the leading expo-
nents. He goes on to say, "There were dozens of people in Berkeley,

Davis, San Francisco, and up in Marin County who were doing this kind of work." Along with his staff—assistant director Tom Freudenheim and curators Brenda Richardson and Susan Rannells—Selz went to "a great many studios," and together they picked twenty-seven artists who they felt represented the "movement." Selz would not use the term *movement* today for funk, even though his exhibition implied some cohesiveness. The artists surely did not feel they were part of a movement; in fact, they resisted the idea. Selz now, if not then, is very much aware of the limitations of the term in regard to individual artists and works.

"With all its color and . . . irreverence," Selz recalled, "it seemed like a marvelous show, [which] put its finger on a certain pulse of this land of funk . . . this bohemian kind of art."[28] It had a somewhat mixed response, however. The public "loved it, almost as much as they loved the kinetic show. They thought it was a delight. . . . That was a popular response. The art critical response was slightly different: *Artforum* tore it to pieces. *Artforum* [founded in San Francisco, then moved to Los Angeles] had moved from California to New York and was taken over by the Greenberg contingent, so they hated it. But in general the response was very, very positive."[29]

From the moment of his arrival in Berkeley, Selz had been interested in the "totally different . . . local kind of thing" he observed in the art being made in Northern California. He and his museum colleagues, as well as some of the artists themselves, soon began talking about the idea that became the *Funk* show. And Peter says it was at his suggestion that his best artist friend and UC Berkeley colleague, Harold Paris, had published an essay on the subject in *Art in America* a month before the show opened.[30] Selz was attuned to what was original in reflecting a peculiarly Californian sensibility, and the selection of artists presents a similar attitude and aesthetic: much of the work looks the same. Among the artists, Selz particularly admired one: Bruce Conner. In his opinion, in fact, Conner was possibly the most important artist working in California, from the standpoint of pure creative originality and power of statement. And there was an even more fundamental quality that Selz believed Conner shared with another of his favorites, despite the great differences in their work:

The reason I think Mark Rothko is such a great painter is because of the internal look—his are all emotional paintings. They are paintings of the soul. I think there is a tremendous distinction between this kind of internalized abstraction and what Greenberg called color field painting, which is nothing but color design on a flat plane. It has nothing to do with the human soul. . . . Well, form and style don't matter when I see quality that I respond to. In 1960 I saw this child in a black box by Bruce [Conner]. And I had never seen anything like it. It was true that Rauschenberg was doing assemblages in New York. But, wonderful as they were, they didn't have quite the power of Bruce's work.[31]

On other occasions Peter has invoked these two names together as representing what he looks for when thinking of greatness. Although he may not put it as directly in connection with Conner, there is no question that the shared quality is a spiritual search for the soul through art. This is the quality that Selz has consistently sought, beginning with his study of German Expressionism, throughout his long career. And when he encounters the work that exhibits these expressionist qualities, he does his best to encourage the artist and promote his or her work.

Several of the artists in the *Funk* show received this preferential attention, but none more than Bruce Conner (see Fig. 23). Even Harold Paris and Pete Voulkos did not seem to ignite Selz's passion to the same degree.[32] But in a phone conversation a year before he died in July 2008, Conner was unexpectedly withholding—one might even say ungrateful—in his comments.[33] Then again, he was notoriously difficult to work with, especially in the later years, marked as they were by a long illness that limited his activity, and he seemed to blame almost every part of the art world—and virtually every individual—for his perceived lack of success. This despite the critical acclaim he received almost from the beginning of his career and to which Peter contributed. Selz would certainly agree with the judgment of curator Peter Boswell, who, comparing Conner favorably to Rauschenberg and Warhol, suggested that the San Franciscan "will eventually be recognized as one of—perhaps *the*—most important West Coast artist of his time."[34]

Conner did reluctantly allow that Selz was "a great supporter. But I'd rather not say more."[35] His main complaint, in general but in this

case clearly directed at Peter, was that the support he'd received had little influence on sales. He further claimed that he'd had no income for the past five years. Peter was understandably disappointed by this criticism, but he also understood that Bruce was in a sense a perpetual outsider, challenging the art establishment and especially the market, despite his being represented by devoted dealers such as San Francisco's Paule Anglim. In particular, Paula Kirkeby remembers Bruce as a unique artistic force. She thinks of him not only as the artist she represented but as her mentor. "It was, above all, Bruce's spirituality and the Jewish mystical Kabbalah"—they were for her the "key" to Bruce. Paula admired that Bruce's interests were based, but not slavishly dependent, on Eastern philosophy. Among art professionals in the Bay Area who understood Bruce in this respect were Peter Selz and de Young Museum curator Tom Garver. Peter especially "got it," and Bruce recognized and appreciated that fact. Kirkeby thinks of Bruce and Selz, and Garver, as connected by mutual understanding.[36] Selz's opinion of Conner's importance remains unchanged. Furthermore, his presence in the *Funk* show was essential: "More than the other artists, many of whose work did not go much deeper than a blasé surface irreverence, Conner was profoundly engaging the major issues of the human condition."[37]

The debate about the term *Funk*, its specific meaning and relationship to a regional art, continues. Harold Paris claimed the honor of naming Funk. Artist Sonia Rapoport reports that Harold, seeking her help, called her when he was writing an article on the subject for *Art in America* and admitted that he needed a name for the new movement. She went to her dictionary and somehow arrived at the word *funk*; when she read him the jazz-related definition, Harold said, "That's it!"[38] One of the artists in the show, and another who should have been, also speak to the term and in doing so provide some insight into what Selz and his colleagues were thinking as they prepared this spectacularly non-mainstream effort. William T. Wiley and Wally Hedrick (whose absence from the exhibition was a noteworthy oversight), in comments separated by thirty years, provided the same definition of Funk. In a 1974 interview, Hedrick answered the big question with a specific example. According to him, Funk would describe the peculiar practice of his

eccentric former wife, artist Jay DeFeo, of storing her dirty underwear in the refrigerator:

> When I first got to know Jay DeFeo, I'd go over to her house and talk. One day when she'd gone to the john or someplace, I began looking for something to eat. I went to the refrigerator and opened it up—and all of her old underwear was in it. It was a couple years' supply. The refrigerator was off, probably hadn't run in ten years, and she never washed her clothes. And so—instead of putting it somewhere else or throwing it away when she finally took off her underwear—she'd just stick it in the refrigerator. . . . Funky, but I also think she's obsessed with being that way.[39]

At a dinner at the Selz residence early in 2009, Bill Wiley cited exactly the same example.[40]

Wally Hedrick also provides insight into one of the controversial aspects of the Funk art exhibition. Many of the artists, despite the recognition that the invented catch-all term conferred, objected to it, Hedrick chief among them:

> Yeah, I think Selz was just trying to give us a working term. . . . And he has given the artists a style. [But] the artist's job is to do the work. The museum person should be accurate and check his facts, try to get them straight. So, the artist sits around and says, "That guy isn't doing his job—right?—as well as he could." And this is what I guess maddened the people I talked to, it [the show and term] gets international recognition, and it's all based on an inaccuracy. Here's a reputable guy who is now known internationally for something that's a fraud. I personally don't care, but a lot of people are upset about it.[41]

Harold Paris provided a much less angry response and a more evocatively descriptive view of the phenomenon in his "Sweet Land of Funk" article for *Art in America:*

> The artist here [San Francisco Bay Area] is aware that no one really sees his work, and no one really supports his work. So, in effect, he says "Funk." But also he is free. There is less pressure to "make it." The casual, irreverent, insincere California atmosphere, with its absurd elements— weather, clothes, "skinny-dipping," hobby craft, sun-drenched mentality, Doggie Diner, perfumed toilet tissue, do-it-yourself—all this drives the artist's vision inward. This is the Land of Funk. . . . Idiosyncratic,

eccentric, its doctrine amoral. . . . In essence "a groove to stick your finger down your throat and see what comes up." This is funk.[42]

In its rhythmical cadence and random listing of arbitrary characteristics, this description reads very much like a Beat-era poem. Indeed, the attitudinal connections between these artists and poets and jazz musicians characterized the creative community of the Bay Area, where there was, above all, the intersection of art and politics. This is what Peter was looking for and found in California.

Curator Connie Lewallen, describing the unusual situation at Berkeley in the 1960s, outlines the cultural framework that not only distinguished Selz's new environment but also pointed in the direction the new museum was to take.[43] Berkeley, more than any other location, brought the antiestablishment forces at work in America together in a university-based protest counterculture that is generally regarded as without precedent in this country. The major social and political issues of the day took hold in and around the Berkeley campus, providing a focal point for debate and action, a kind of mirror to contemporary American social change. The broader context, Lewallen points out, was the Vietnam War, which "defined the consciousness of the late 1960s and 1970s. . . . The fulcrum of protest against inequality at home and the war abroad was the University of California, the scene not only of countless antiwar demonstrations but also of the Free Speech Movement, the 1969 third-world student organization strike, which met with violent police action, and conflicts over People's Park."[44]

Within this volatile atmosphere, the University Art Museum demonstrated, from its earliest years, a commitment to radical, politically engaged new art. It was in Peter Selz's nature to pick up the activist cause immediately upon arrival (in fact, he claims that confrontational politics were part of his attraction to the Berkeley job), and he did so looking to the Bay Area assemblage movement on which the *Funk* show was based. Lewallen called it Selz's "eponymous 1967 exhibition," pointing to the characteristic use of found objects and urban debris that was suggestive of decay. Sexual and political overtones characterized the work of the Beat-era literary and art underground, which provided the foundation for the decade's cultural "upheavals" and the emergence of a new avant-

garde. Lewallen's claim that the art museum was one of the major sites to recognize and bring to public view radical changes in the visual arts does not seem overstated.[45]

In a surprising contradiction, however, Selz says that making such sweeping claims for Funk as a series of illustrations of the times is over-reaching, that assigning such historical importance to cultural events puts at risk full appreciation of other aspects of the moment. In the case of the *Funk* show and the admittedly varied works on display, he insists that he and his colleagues—Freudenheim, Richardson, and Rannells—had no large goals in mind. They were interested simply in recognizing what they saw as a regional manifestation of the larger assemblage movement. And beyond the often-present politics and social commentary, Selz wanted to acknowledge the humor and appreciation of the absurd that the art he called Funk owed to Dada. "We did not think this was an Important Art Movement, but we saw it largely as a fun thing to do in keeping with the work itself. I had a great deal of fun organizing the show, installing it in the old Powerhouse, and writing about it to conclude with a quote from King Ubu."[46] Despite this disclaimer regarding art-historical intentions, Selz now describes Bay Area Funk as the last significant regional movement in America.[47]

The appropriateness of the term in the visual arts context is neatly presented by cultural historian Richard Cándida Smith: "[The term] *funk* suggested the use of rough and dirty materials, along with a lack of concern for a fine surface. As in jazz, the term primarily indicated a mental framework in which immediate response to the performative possibilities of materials took precedence over theory . . . funk became closely associated with the use of found objects and the assemblage tradition."[48]

Art historian Sophie Dannenmüller takes a slightly different point of view in terms of Funk as an art phenomenon with a particular relationship to assemblage. She sees Funk art and California assemblage as two distinct movements, converging in the work of certain artists at specific times. For her, Funk is above all a uniquely Bay Area expression of an aesthetic attitude, one that encompasses assemblage but is not restricted to a single medium (as was assemblage). Politics may be present, but it remains peripheral to the "movement's" core identity,

which is a "countercultural and anticonformist [not just *non*conformist] aesthetic attitude."[49] The importance of Selz's *Funk* exhibition, according to Dannenmüller, was that it introduced the art world to that specifically Northern Californian aesthetic. (Even France learned of it, through a 1970 article in the magazine *L'Œil* by art critic José Pierre.)

It may be that the *Funk* show, with its sly irreverence, playful humor, and sociopolitical commentary, was closest to Peter's own sensibilities, even though the preceding kinetic exhibition was internationally more significant. Funk represented the bohemian ideal of unfettered creative freedom. In its sexual forms and imagery, it reflected aspects of the libertine lifestyle that so attracted Peter and in which, through his friendship with artists, notably Harold Paris, he became an enthusiastic participant. In California Peter learned that one could do more than just make a living in art; one could actually *live* art.

In many respects Peter and Harold—along with Pete Voulkos—were regarded as the bohemian triumvirate of the UC Berkeley art faculty. Many of their colleagues and students saw them as exemplars of the fully liberated California lifestyle, which included sexual freedom. Peter sees those years as a period of "amorous relationships," usually sequential and occasionally leading to short-lived matrimony. Yet there was another side to that social culture, produced and driven by a bohemian/hippie ideal focused on sexual adventurism and homegrown orgies.

Harold Paris's widow, Deborah (Debby), was both a witness to and a participant in the life and times. She remembers the erotic life that her former husband and Peter pursued as being a keystone of their close friendship. On select nights in 1972, Harold's vast studio on Oakland's Market Street attracted both artists (including UC faculty) and (mostly graduate) students. She characterized the behavior of the group in which they moved as awash in a kind of ingenuous sexual opportunism. "The Free Love Movement wasn't started by Harold and Peter," she observed; her impression, rather, was that a much younger group took the lead and Peter and Harold simply "took advantage" and followed.[50]

When Debby met Harold, she was an art student, with a job binding slides for the art history department in the work/study program. They married in March 1972, but, she said, it "wasn't much fun living with

someone who was out screwing that often, reveling in it." However, she understood that it was part of the times, and certainly the place, for many counterculture artists. And she admits that she was drawn into it herself: "Peter and Harold led; I reluctantly followed."[51] Looking back, she describes these activities as sources for her husband's sexual imagery; and she is "glad that I didn't miss these parties and the other strange events that Harold put on (and my part in it all)." Her account is only one voice, but it does suggest that the social freedoms of the day created a world that was exciting, colorful, and, for some, troubling.

In the wake of the Free Speech and Free Love movements, the atmosphere at Berkeley was charged with an inebriating sense of change and opportunity. One art history undergraduate, Terri Cohn, recalls the laissez-faire campus ambience of the early 1970s as being in stark contrast to the present: "Smoking in lecture halls, people going barefoot everywhere, dogs in the classroom."[52] Terri studied with Herschel Chipp, whom she describes as "an inspiring and very supportive professor"—whereas Selz (who was then on sabbatical) had a "complicated reputation," as a consequence of which she was "a bit afraid of taking a class from him." She recalls rumors about the parties and wild behavior, but she also describes Berkeley as liberated and experimental in many areas, sexual self-discovery being a primary one. "The sexuality of the time was pervasive, yet from my position now in the twenty-first century, and as a curator and art school professor, it seems like it was somehow a more innocent *zeitgeist*." In those days, as she points out, many students had their "going-naked period."[53] For many, sensuality and (heightened) authentic sensation were part of the overriding spirit of the times, as it had been for Selz's Die Brücke painters cavorting nude in the German forests and on lakeside beaches with models and mistresses, as well as wives and assorted children, in tow. A Utopian modernist/primitivist fantasy was being imitated, however incompletely, in the hippie redoubt of California.

. . .

At Berkeley, a major part of the director's responsibility was building the collection. This was new for Peter, who had been responsible only

for exhibitions of modern painting and sculpture at MoMA. Part of what attracted him to Berkeley was the opportunity to become more involved with collecting, and although the incentive million-dollar annual acquisition budget never materialized, he was determined to make the new museum among the best of any college or university campus. Selz describes the University Art Museum's permanent collection when he arrived as having "very, very little to start with . . . a large collection of stuff which the university had accepted over the years. Much of it totally uninteresting." He described this disappointing accumulation of objects not even with faint praise: "There was everything from a Rembrandt to a Cimabue in the basement, and the Cimabue was some kind of nineteenth-century worm-eaten copy . . . made in Florence. So we had to sift through . . . and we did find a number of nice things like the Bierstadt and the big Leutze. But most of the stuff was really not acceptable, and some . . . is still in the basement, rotting away."[54]

In this negative judgment, however, Selz was too harsh. The museum's existing collection included worthy examples from the eighteenth and nineteenth centuries, such as *Boy in Green* (ca. 1795–1805), by early American itinerant painter John Brewster Jr., and Théodore Rousseau's *Forest of Fontainebleau* (1855–56), from the 1920 bequest of Phoebe Hearst. Lucinda Barnes characterized the collection that greeted Selz upon his arrival as constituting the "cornerstones" of the museum's current collections—historical Asian paintings and works on paper; European old masters and nineteenth-century paintings and prints; nineteenth-century American art, including the grand Albert Bierstadt and Emanuel Leutze paintings, works of considerable historical significance; and finally, a strong representation of Abstract Expressionism and other twentieth-century works, with a focus on the San Francisco Bay Area. Despite his disparagement of the collection, Peter put it into a broader community perspective when he wrote, "The contemplation of works of art from all periods of history, from all cultures of mankind, can lead to a greater understanding of our own problems and place them in a universal context."[55] Although the Berkeley collection was and is not comprehensive, the basic idea of public benefit deriving from exposure to diversity in art—in styles, subjects, periods, and origins—can be served

by what the museum has assembled. Still, Peter takes pride in the burst of collecting that he initiated (between 1965 and 1970, thirteen hundred works of art were added) and the quality of the art acquired.

The great Hans Hofmann collection, which Peter refers to proudly and perhaps too proprietarily, had its own Hofmann Wing in the new building, a fitting recognition of its status as founding gift. The gift had been negotiated at the suggestion of Clark Kerr by faculty painters Erle Loran and Glenn Wessels. It also did not hurt that the art department faculty was made up largely of former students of Hofmann's from his two teaching stints at Berkeley. In addition to Loran and Wessels, the list included Karl Kasten, Jim McCray, and John Haley. So, for Hofmann, Berkeley was a logical place for his work to reside and be permanently on view. Selz says he was involved in the acquisition in two ways: in New York, he "knew Hans very well" and supported his work; and the final selection of paintings was made by Peter with Loran, their decisions subject to the approval of New York gallery owner Sam Kootz.[56]

The Hofmann gift and several of the Powerhouse shows put Berkeley on the art museum map, and in the beginning Peter had every reason to applaud himself and his decision to leave New York and MoMA. His relationship with Clark Kerr was not just good but enviable. Berkeley chancellor Roger W. Heyns came at the same time as Peter, and they became friends and eventually worked together "beautifully." An anecdote about one early acquisition makes the point; according to Selz, it was but one of many such purchases made possible by support from the university administration, in this case expedited directly by Kerr:

> Things were going beautifully at the start. . . . I'm in New York and I see this oil sketch, a superb small Rubens. And it was very cheap, $95,000— and that was about 1967. So I said, "We must get this picture authenticated by tomorrow." I had one week to buy it, because the dealer had only two weeks before sending it back to England. I called Clark Kerr and told him I wanted to buy this Rubens. So he asked me questions about the quality and the authenticity. Then he said, "I'll take your word for it, and I'll allocate half the price from university-wide funds, if you can get the other half from Berkeley." I said, "I'm here in New York, how am I going to get the other half within five days?" . . . Kerr said, "I'll get it for you."[57]

The Road to Calvary (ca. 1632) was a source of great delight for Peter and is counted among the most important acquisitions of the time. Peter's enthusiasm seemed to be justified by the expert opinion of his discerning colleague, seventeenth-century Dutch painting specialist Svetlana Alpers, who called it among the "most beautiful as well as one of the most technically interesting of Rubens's late oil sketches."[58]

Imagine Peter's delight, after his tenure at MoMA dealing exclusively with modern art, to be able to purchase works such as the Rubens and, his first acquisition, a sixteenth-century *Pietà* by Giovanni Savoldo. The latter has attached to it a humorous story that Selz is fond of telling to illustrate the workings of UC Berkeley bureaucracy: "The first painting—and a great purchase it was—was Savoldo's *Pietà with Three Saints*. It was sent here, along with the invoice which I forwarded to Financial Services. The money was in the budget. Well, after a while the dealer calls, wondering about payment. When I called the Financial Office they said, 'Professor Selz, you are new here and didn't know that for purchases over $1,000 we need *competitive bids!!*'"[59]

The experiences Selz had enjoyed with his grandfather, visiting the museums of Munich, had finally become pertinent to his job, and he went on to collect vigorously. The current museum director, Lawrence Rinder, speaks to the contributions that resulted: "Indeed, his legacy is truly remarkable, for the works he was able to purchase as well as acquire by gift. Not surprisingly, Selz focused much attention on building strong holdings in post–War abstraction to complement the extraordinary gift of paintings from Hans Hofmann. . . . Because of [this] and because of its adventurous contemporary exhibition program, it developed a reputation as a contemporary art museum [with a] foothold in several important areas of art history including Surrealism, Expressionism, Pop Art, and Photorealism."[60]

Many other knowledgeable observers agree with Rinder that the variety and, in many cases, the quality of works acquired during the Selz years provide a provocative overview of modern art, with an emphasis on California. Yet "one of his many distinctive contributions was to attend to European painting as well as American," according to Rinder. Along with works by many of Peter's favorite twentieth-century art-

ists—among them Beckmann (*Woman Half-Nude at the Window,* 1926), de Kooning (*The Marshes,* 1945), Tinguely (*Black Knight,* 1964), and Sam Francis (*Berkeley,* 1970)—appear, for example, the unexpected *Pietà* (1527) by Savoldo, the Rubens, and a pen-and-ink drawing of a flying female figure by Giovanni Battista Tiepolo. Selz, in short, took the opportunity to shape a collection that would reflect a history of art that extended back well before the modern era.

. . .

But the dream did not last long. Shortly after the move into the new building, a variety of things—not the least of which was funding support—began to deteriorate. What had started so well, "with a bang," began to unravel from both within and without. Much of this had to do with the new administration in Sacramento and wide displeasure with the management of the state-funded University of California, in particular with the relationship of the UC regents to student activism at the various campuses, especially Berkeley. Caught in between were the chief administrators of the university. Peter's account puts the situation in terms of his own difficulties, including loss of several important potential gifts of major collections, one of which was planned to become a UC art study center in Venice:

> The thing that started to put the damper on was the [1966] election of Governor Ronald Reagan. We almost got the Peggy Guggenheim collection. A year before I came out here I was in Venice at the Biennale. [Art critic] Herbert Read and Peggy were there; we were at the beach. I knew Peggy slightly and she said, "I don't know what I'm going to do with my collection. My intention was to give it to the Tate, but I found out that the Italian government won't let me take anything out over fifty years old, so it all has to stay here. . . . What should I do?" And I said, "Well, I'm going to leave the Museum of Modern Art to start a new museum . . . in California. And I have a great idea: you can gift your collection to the University of California in Berkeley and leave it all here, and it will be like I Tatti [the Bernard Berenson collection handled by Harvard], a great study center and collection in Venice. . . . And you will be the curator." Then we corresponded more.[61]

Walter Horn, who of course knew from Peter of this great opportunity for the University of California, was on sabbatical in Europe at the time (1965–66), and he courted Peggy. Horn discovered that, across the street from her residence, the former American consulate building was available. Walter proceeded to sketch out a plan for dormitories and study rooms. Apparently Peggy Guggenheim was very pleased.

At about the same time, Peter went to the regents, who accepted the Guggenheim proposal, despite board art expert Norton Simon's remarkably offhand (and uninformed) dismissal: "Well, it's not such a great collection." Peter was and remains incredulous: "He did say that. He *did* say that." It soon becomes clear that Selz is no great admirer of Norton Simon, the latter's stunning old-master collection notwithstanding. In connection with modern art, the formidable Simon was at the time still something of a novice.

A letter was sent to Guggenheim; she responded that she liked the proposal, and "I especially like this Walter Horn." Peggy knew Peter but she did not know much about UC Berkeley, and she told Selz she needed to "meet his boss" before she made her decision:

> So, I called Mr. Kerr and I said "Peggy wants to meet with us." You have to remember that the whole museum was Kerr's idea in the first place. . . . We arranged for the Kerrs and the Selzes to go to Venice, and we took Peggy out for dinner. She was enormously impressed with Clark Kerr, who would mention things like being offered a secretaryship in the Kennedy administration—I think it was Labor—and a secretaryship in the Johnson administration. And she asked him, "Why didn't you take this?" [Kerr replied], "These things are very important, but the University of California is even more important."[62]

The next morning Peggy talked further with Peter and told him this was the best proposal she had received and she was going to have her attorneys draw up papers. Having her own version of Berenson's I Tatti was very appealing. This was the summer of 1966; in the fall the attorneys began to talk. But in November Reagan was elected, and in response to the political right wing both in the legislature and on the university's Board of Regents, he fired Clark Kerr in January 1967. This appeared very prominently in the European press, and Selz got a call from Peggy

asking, "Is this true what I read? How can I trust an institution in which things like that happen?"

She withdrew her support, saying she couldn't stand behind a university where a great president could be fired for purely political reasons. She wanted nothing further to do with it. As for Peter, in addition to losing this prize collection and a great modern art study center, he saw a personal fantasy evaporate as well. "You see, I had envisioned that I would spend six months in Berkeley and six months in Venice. Now, what could be better?"[63]

Still, the Hofmann gift was a great beginning for building a serious modern art collection at Berkeley. And the later acquisition of works by various contemporary artists, predominantly local figures from exhibitions such as *Funk*, began to form the nucleus of a distinguished California representation. Among these artists are Robert Arneson, Joan Brown, Robert Bechtle, Sam Francis, Richard Diebenkorn, Bruce Conner, and Nathan Oliveira. Selz especially remembers the fortuitous circumstances of an early William T. Wiley acquisition:

> I think it was the time of the Funk show that Bill Wiley donated a painting to the museum. Some time later he wrote me a letter, telling me that he did not like the painting and asked me to *destroy* it! I responded that our function was to preserve, not destroy, works of art (contrary to the Tinguely episode) and that I would be glad to exchange it for a work he liked better. He said, "Okay, once you open the new building I want you to give me a space to work and I'll paint you a new painting." This was done. Bill painted a fine new picture. We brought out the old one, he looked at it and said it was much better than he thought. Result: the museum had two William T. Wileys.[64]

There were, however, more disappointments to come following Peggy Guggenheim's withdrawal and the consequent loss of her great collection of Surrealist and related modern art: "The other great blow was that Rothko had kept paintings from the Museum of Modern Art exhibition together, and he said many times to me that he might give this group to Berkeley. But before he could do anything about that he died. At one point it looked as if, in addition to the Hofmanns, we would have a large

group of Rothkos—and possibly the Guggenheim in Venice. So, not everything I tried worked."[65]

After Reagan fired Kerr, new presidents took over who, according to Selz, were not much interested in the museum or art. It had been Kerr's pet project, and without him there was no hope that the museum would be properly funded. Eventually it became a burden to the university.

> The only way I could have maintained any kind of standard was to spend ninety percent of my time fundraising, as many directors do. And this I didn't want. . . . The reason I finally left was financial. But I also found out that the art department wasn't really backing the museum, so that source of support was never there. They had impossible ideas like doing big shows of Rubens. . . . The department was not interested in being on the cutting edge of the new, because none of my colleagues—*not a one*—was interested in contemporary art. . . . Herschel [Chipp] was primarily interested in early-twentieth-century art. His interest wasn't there, and nobody was interested in things like nineteenth-century American art—they couldn't have cared less.[66]

One faculty member, however, calls into question Selz's blanket indictment of his art history colleagues' lack of interest in the museum. James Cahill came to Berkeley from the Freer Gallery at the Smithsonian Institution at about the same time Peter arrived. He brought with him an extensive knowledge of Chinese art, for which he was renowned in academic circles, along with a personal collection, from which key works entered the museum collection. Cahill established a support group of patrons to collect major works of Asian art, notably Chinese paintings from the Sung, Yüan, Ming, and Chi'ing dynasties.[67] He also initiated a series of pioneering exhibitions that grew out of his graduate seminars.

Cahill's memory of the relationship between Selz and the art history department, one that he describes as "strange and ambiguous," is based on firsthand observation:

> In principle he was supposed to be teaching a museum-practice course, but I don't think he ever did, or if so only a time or two. We could never work out just what form it should take, how it should relate to Bay Area museums, etc. Herschel Chipp was our modernist, but he was more traditionally art historical, working on earlier 20th-century, not

contemporary—which for most faculty was a highly suspect area for art history (better journalism). Peter was [required] to come to faculty meetings, but he seldom did [Selz denies this]. And relations between him and most of the faculty were indeed very cool—most of them barely approved his museum appointment, certainly didn't want him as an active department member.

Cahill continues his account with a description of the few attempts at collaboration between the department and museum: "For a long time, no faculty cooperated with him on an exhibition; the first, I think, was Dick Amyx in an exhibition of Greek vase painting, one of several Kress Foundation–sponsored seminar-exhibition projects [Selz points out that he got the Kress grants specifically for such collaborations]. I did another, and I think Joanna Williams did one on Indian art [Selz says not]. At exhibition openings . . . few faculty members showed up. Or such is my memory."[68]

It is surprising that there was not greater support for Selz's efforts to create a museum that served not just the art students but the broader university population, the Berkeley community, and even a national audience. Presumably everyone involved at Berkeley would recognize that as a worthy goal for the new museum. It appears that Selz was aware of the challenge to fully engage faculty, as evidenced by his desig-nating department colleagues as subject-specialty curators. In fact, this covered the entire art history faculty at Berkeley.[69] How much input they had remains a subject of disagreement. But at least Selz seems to have made the effort. Apparently, it wasn't enough; as he recalled in 1982, "We didn't quite see eye to eye. I didn't have much support. . . . We had the standard kind of internal turmoil, because we all felt what we were doing was so important. . . . I was reaching my late fifties, and there were other things I wanted to do. I wanted to do more writing. I was eager to get to this book I finished just two years ago, *Art in Our Times*—a book . . . [that] I wanted to do more than anything, and I knew I couldn't do it running the museum."[70]

It was not just his interest in writing that led his to his resignation as director. He was also drawn by the classroom and the students, both undergraduate and graduate, whose company he so enjoyed. In fact,

Professor Selz appears to have been famous with his students for his accessibility and openness to social contact outside the classroom. It may be that giving up what had become a frustrating administrative position in a fractious workplace for a full-time academic career was yet another opportunity for escape:

> Eventually I said, "Well, okay, it's about time to get somebody else to run the museum," hoping that my resignation . . . would prompt the administration to find more money. . . . Instead they found less. In fact, they found somebody who went along with all the budget cuts, and finally almost buried the place. . . . They turned it over to [Jerry Ballaine]—a painter friend of the dean—who . . . didn't run it very well at all. So Brenda Richardson, [by then] the chief curator, ran the thing. . . . Then after Ballaine left, the museum had no head at all for almost a year [there were several acting directors from among the art faculty]. They offered the job to a number of good people who turned it down when they saw the financial situation.[71]

Selz's years as UAM founding director involved increasingly difficult relations with the administration and with at least a few of the board of regents, notably art collector Norton Simon. Simon had encouraged a number of museums—Los Angeles County Museum of Art, UCLA, Berkeley, and even the Fine Arts Museums of San Francisco's California Palace of the Legion of Honor—to hope they might receive his stellar old-master collection. But he eventually set up at the Pasadena Museum of Art in a controversial takeover of the building that included the Galka Scheyer Blue Four collection. His record as UC regent was both good and bad, but it appears that he was not helpful to Selz on behalf of the museum.[72]

The two men also diverged in terms of politics and social values. An event that took place at the time of the violent confrontation at People's Park in 1969 provides a perfect example:

> The National Guard was all over Berkeley. . . . There were planes overhead spraying the demonstrators. . . . [James Rector, reportedly a student bystander, had been killed in the first confrontation, on May 15.] One solution to the standoff would have been for the city to take over the park, and the Berkeley City Council [offered to do so] if the University would deed it to them. . . . Well, Norton Simon was [at the

Board meeting to discuss the proposal]. He had [with him] a transparency of a painting by Franz Marc which he was considering buying, . . . and he wanted me to look at it. We made an appointment to meet for coffee after the Regents' meeting. At the meeting he took out this transparency and I said, "Let's not talk about Franz Marc. I want to know, did the Regents agree to turn the park over to the city?" And he says, "No." I said, "Why not?" And he showed me a photograph of this topless woman on the truck and he says, "We can't have our students subjected to this kind of behavior." He says, "Look, naked girls." Now, naked girls are all over San Francisco and North Beach. You can see all of the naked women you ever can imagine, but he said, "We can't have this on campus, and we turned it down. And what do you think of this Franz Marc?" "I don't want to talk to you anymore. I'm disgusted. . . . You showed me a topless woman when I talked about a man being killed."[73]

Events like this one must have colored Peter's relationship with other UC regents as well. But it was not a dramatic confrontation with Norton Simon that brought matters to a head. Instead, according to several friends and colleagues who were familiar with the situation, Peter was simply not cut out to be an administrative museum director. Later Selz provided his own amplified account:

It is certainly true that Brenda Richardson, whom I had hired and did not get along with toward the end . . . constantly undermined me. Walter Horn [head of the Museum Committee] urged me to give her the sack, but I kept her on as she was a very capable curator. She did expect to take over when I left, but I insisted that the job would go temporarily to Jim Cahill until a new director was in place. The main reason for my move from the museum to full-time faculty was, as I have mentioned before, that most of my time would have to be spent raising funds rather than curating or working on acquisitions. The funding of the Berkeley Museum was never set up correctly by the Regents. After I left, Jim Elliott set up a Board of Trustees, and the Museum began to operate almost like a private museum, raising its own money. This I did not need, as I could go back to teaching full time, which I enjoyed until the day I retired.[74]

Then, too, there is the fact that Peter and his staff were increasingly, as Richardson put it, "at odds."[75] An atmosphere of frustration and conten-

tion, readily acknowledged on all sides, along with the lack of adminis-
tration support for the museum itself, precipitated his departure.[76] There
is, however, disagreement about the precise circumstances of the end of
Selz's time as director of UAM. The statements of the two main protago-
nists stand in direct contradiction, and Richardson challenges Peter's
version, which casts her as difficult and even insubordinate. To her sur-
prise, she was presented with a reprimand listing charges submitted
by Peter to provost and dean Roderic Park. Acting dean Richard Peters
delivered the document to her home. Peter was calling for her termina-
tion. Following his instructions, she provided the lengthy and detailed
response required by the university.[77] Whatever the actual purpose of
this document and the subsequent details of the deliberations of the
dean's committee, Peter left the museum and Brenda stayed. It appears
that Brenda was in fact exonerated of the charges by the university, and
she continued working at the museum for a year and a half before join-
ing Tom Freudenheim's staff at the Baltimore Museum of Art.

The accounts of these events from various faculty and museum staff
all involve what were regarded as shortcomings of Peter's administration.
The consensus is that Peter was seriously out of step with the university
administration. As his successor Cahill put it, Peter "was good at making
enemies."[78] Of the various accounts touching on this theme, one adheres
strictly to the facts of the situation. Jacquelynn Baas became director of
the museum in 1988. Avoiding the pitfalls of rancorous personal (and
usually unsupported) commentary on both sides of the issue, her brief
account puts the events in a larger university perspective: "The 'bottom
line,' so to speak, would seem to have been the fact that, despite regular
infusions of cash on the part of the University for acquisitions, etc., the
museum ran major deficits every year Peter was in charge—something
that simply could not continue."[79] Tom Freudenheim, a supportive friend
of Peter's to this day, also takes a balanced position in regard to the fac-
tors that brought an end to the Selz era at UAM. He acknowledges that
he had left for the directorship at Baltimore before the "Peter/Brenda
problems arose." Having later hired Richardson to join him, he essen-
tially echoes Peter's initial positive view of her abilities with his own
description: "I did, happily, bring Brenda to Baltimore, where we had

a very close and productive working relationship. She is exceptionally able." Still, his observation of her fundamental working style echoes that of her former boss, Peter Selz: "She wasn't into worrying about making friends or offending people, if her principles were at stake."[80]

From this and similar accounts of infighting, one could reasonably conclude that the university had lost patience with the museum. As Jacquelynn Baas recalls, "I know Jim Elliott suffered from this, and I was still dealing with the after-effects some fifteen years later."[81] Regardless of the internal staff problems and differences between individuals, lax financial management brought down the director, as it often has elsewhere. Fortunately for him, he was hired with tenure and accordingly was able to realize his expressed desires for teaching and writing.

Selz's tenure as founding director of the University Art Museum lasted seven years, exactly the duration spent at the Museum of Modern Art. His friend Richard Buxbaum, law professor at Berkeley's Boalt Hall, sums up qualities that have followed Selz throughout his professional and political life:

> Peter is not a man whom administrators can administrate. And as
> a result, to this day his splendid accomplishments in bringing [the
> Berkeley Art Museum]—both the building and the profile—to national
> attention have not been rewarded as they might well have been. And
> while this is only speculation, I would guess that for the two art depart-
> ments, practice as well as history, having someone like Peter (and
> indeed perhaps anyone with a similar "outside" background) come into
> the essentially self-referential academic world—no matter how intel-
> lectually vital that departmental world may well be—also cannot be an
> easy or comfortable situation. That likely is a structural issue, but some
> personalities might try to adapt to such a setting—not Peter Selz![82]

EIGHT Students, Colleagues, and Controversy

In fall of 1972 Peter Selz closed the door on the director's office at University Art Museum and without a backward glance strolled across Bancroft Street, through Sather Gate, and onto the University of California campus. Crossing Sproul Plaza, he found his way to his new office and the second part of his Berkeley career, as a full-time art history faculty member. This academic "safety net," which had been part of the terms of his accepting the museum directorship, was an arrangement that rankled some of his colleagues, and his welcome to the Berkeley academic club was lukewarm at best. There were various reasons for the reservations about Peter, but in one way or another they converged upon his approach to art history, which was object oriented and artist focused. His way of looking at and understanding art was more emotional than analytical, and his anecdotal method of conveying a sense of art as a

living entity, directly relevant to individual experience, was viewed by some colleagues as insufficiently academic. Yet this approach turned out to be a major part of his appeal to a number of the students at Berkeley.

Selz's problems at Berkeley, as museum director and professor, dogged him for years. He was a controversial figure about whom opinion seemed to divide into two extremes. An enlightening view of the perspectives of supporters and detractors alike emerges from the accounts of a number of his students, professional colleagues, artists, and friends. For some, Peter's appeal was almost charismatic, while others found him arrogant, self-centered, and presumptuous. The challenge is to find the authentic Peter Selz. A good place to start is with his students, those who most directly encountered his enormous enthusiasm for art and artists.

Among the most susceptible to the Selz appeal was Norton Wisdom, whom Peter reencountered years later at the Whisky a Go Go on the Sunset Strip in Los Angeles (see preface). As a student at Cal (1968–73, MFA), Wisdom was greatly influenced by Selz's lectures and, above all, his exhibitions and museum programs. He admired, for example, the way the art was presented at the university galleries, claiming that Peter's shows were installed as if artists were sharing work with one another in their studios: "An artist doesn't need to have gallery walls to see somebody else's painting. I think Peter was like that: I'm going to do this as an artist who loves art and wants the audience to enjoy it just like he does. Leaning against the wall, salon style, or—hanging from the ceiling. I'm just going to take a flashlight and go into this dark cave, and when it lights up, you're going to have an experience."[1] Whether or not this picturesque image captures Selz's practice or intention, this is the way Wisdom remembers the exhibitions at the Powerhouse and later at the University Art Museum. And by his acknowledgment, their impact did nothing less than point the direction for his own life in art. Wisdom's unconventional materials and crossover performance art reflect Selz's openness to new forms of expression—ideas also picked up from Peter's friend Pete Voulkos, for whom Wisdom served as foundry assistant.

Sidra Stich, who was Peter's teaching assistant in the early 1970s, was especially well positioned to observe Peter's singular style.[2] She studied

primarily with Herschel B. Chipp and is thereby able to compare the contrasting styles of the two modernists in the department. When she later became chief curator at the museum in 1984, Peter had been gone for twelve years, but her observations and memories of the art history department and the museum are informed by a career of paying close attention to museums and the academic art world. Stich gives credit to Selz for his programs—not the least of which was the Pacific Film Archive—and for his success in transforming a relatively undistinguished collection into something very respectable.

Along with other museum staff, Stich expressed disappointment at the lack of use the faculty made of the museum as a teaching resource. She had been attracted to Berkeley because of Selz's reputation as founding director of the museum and his background at MoMA. He was, as she puts it, "a drawing card" for students. But "lo and behold, you arrive and find out there's absolutely no talking between the two [museum and art history department]. Working in a museum at that point was not considered sufficiently professional. The faculty was moving away from the orientation of Peter Selz and other colleagues to a much more sophisticated kind of art history . . . dealing with cultural and intellectual history. That was not what Peter was all about."[3]

Despite his acknowledged scholarly contributions with his book *German Expressionist Painting* and his high-level career at the Museum of Modern Art, along with the string of important and provocative exhibitions there and at Berkeley, some of Peter's colleagues considered him lacking in academic rigor. But even earlier, Peter faced the criticism of faculty who considered contemporary and American art, two of his main interests, outside the discipline of proper art history. Men like Walter Horn (who nonetheless was the faculty member who courted Peter to accept the Berkeley offer) and L. D. Ettlinger, trained in the German philological method, were part of an immigrant generation that introduced art history as an academic discipline to this country. This group of academics had arrived in the same influx as the younger immigrant, Peter, but they had been educated in Germany, and many disparaged American postgraduate education.

Furthermore, post–World War II art was still considered the purview

not of art history but of art criticism. Herschel Chipp was the accepted modernist in the department, and although he was trained in the United States, he taught from a more traditionally art-historical platform. Peter's American educational credentials, combined with his interest in contemporary art and his affinity for artists, made him an outsider. The situation was further complicated by the rise of more analytical, intellectual approaches to art history. Among them was critical theory, one of the French-derived philosophical approaches that was sweeping through many university departments, combining such strains as poststructuralism, semiotics, and cultural studies. The Berkeley art history department was conservative in that respect, remaining grounded in archival research, with an emphasis on the conditions, social and psychological, that allow art to communicate. According to University of California intellectual historian Richard Cándida Smith, the department at Cal was heavily invested in the *Representations* group, responsible for "one of the most interesting journals exploring the translation of ideology into systems of representation." In literary studies, this was called the "new historicism." These theoretical systems were reflected in an emphasis not on objects per se but in intellectualizing them as expressions of ideology.[4]

Peter Selz did not have a chance of being accepted in that particular academic environment. However, he provided a nontheoretical approach that was interesting to a number of students at the time, even if he was out of step with his department and the conceptual turn in the art world. Furthermore, what appealed to many students, his identification with artists, also put him on the wrong side of the growing rift between artists and art historians at Berkeley, further eroding his credibility with his more traditional colleagues. In the classroom, Selz was seen as enthusiastic but not deeply interested in analysis. This view is generally qualified by an important caveat: Selz loved the art and the artists, and he communicated his excitement to his students. The best of his students, undergraduate and graduate alike, recognized his interest not just in studying art, but in living it—a quality that has been defining and inspiring for students ever since Mike Spafford and Elizabeth Sandvig took his courses at Pomona.

Derrick Cartwright, former director of the Seattle Art Museum, is well placed to comment on Selz as both teacher and museum director.

Cartwright enrolled at Berkeley in 1980, just a few years before Peter's departure from the faculty, and took Selz's survey of twentieth-century sculpture. In retrospect, he feels that this contact with Selz provided the direction for his career. The class was not strictly academic, but it *was* about where to direct your passion. What made the difference for Derrick Cartwright, and what he says led him to choose art history as his field, was the fact that Selz talked from firsthand experience, which set him apart from most other professors. Cartwright appreciated in Selz what some faculty and students viewed as a deficiency: his refusal to embrace analytical approaches over the art itself.

The professor was interested in museums, loved art objects, and cared about students. Cartwright was attracted to the biographical approach to art as a way to understand the sources for ideas, forms, and creative process in the artist's life. Selz was a natural storyteller, and artists such as Christo and the late Jeanne-Claude were among the colorful and often exotic subjects of his anecdotes. As it happened, at that time Selz was the project director for Christo and Jeanne-Claude's *Running Fence* project in Marin and Sonoma Counties, and Cartwright remembers that Selz spoke about the artists from the perspective of a personal friend. He also recalled the excitement of seeing that cloth fence snaking west across the landscape from Highway 101 to the Pacific Ocean.

In an interview, Christo and Jeanne-Claude provided the background for their collaboration with Selz and his artist assistant and companion at that time, Lynn Hershman (now Hershman Leeson):

> I believe it was 1973 when we got in touch with Peter Selz. We told
> him that we had a project in California called *Running Fence*—and
> we needed a project director. Would he be able to recommend some-
> one? Jan van der Marck [Walker Art Center and later the Museum of
> Contemporary Art in Chicago, wrapped by Christo and Jeanne-Claude
> in 1969] had been the project director for *Valley Curtain,* and he told us
> that Peter Selz in California "knows everyone." Peter came to see us
> in New York and we expected a list of names and telephone numbers.
> Instead he said, "I'll do it." But first he asked, "How much do you pay?"[5]

Peter disputes Jeanne-Claude's memory on this point, but what mat-
ters is that he accepted and served *Running Fence* as a well-connected

figure in the art world. He was ideally positioned to introduce the artists to people they needed to meet to navigate the difficult process of getting permits and winning over a suspicious group of landowners and envious artists. There were eighteen permit hearings (according to Christo and Jeanne-Claude, Selz attended only one or two), and a big part of the challenge was to convince the opposition—which was led, ironically, by artist and writer Mary Fuller McChesney and her artist husband, Robert, who lived the bohemian life atop Mount Sonoma—that the project was a temporary art installation, not a "front runner" for developers. As Peter, appreciating the irony, relates the situation, "A committee of disgruntled local artists tried to stop the project, complaining that a bunch of foreigners—a Bulgarian artist with a French wife and a German project director—were about to get national, even international, attention by doing a stunt on their territory."[6] At the hearing, Christo maintained that opposition was an essential and expected part of the project.

Among the best-known supporters of the project were artist Bill Morehouse and, especially, director Francis Ford Coppola. Jeanne-Claude described the process: "The most difficult part of all our projects is to obtain the permits. So the part which Lynn [Hershman] was so good at is the art of getting permits. Meeting each one of the fifty-nine ranchers and their families, explaining the project, trying to get them to sign the contract allowing us to place a part of *Running Fence* on their land. And for that she was fantastic."[7] Hershman's contribution to the project notwithstanding, Jeanne-Claude recognized the great value of having Selz aboard: "In my country, France, we say he had a long arm, and Peter used his."[8]

Many of Selz's students maintained contact over the years. Particularly close is Gary Carson, Selz's self-described "aide-de-camp,"[9] who found a special way of joining for the long haul in Peter's life. Selz describes Carson as his "son," and Gary reciprocates by acknowledging a "sort of father/son relationship."[10] Even more significant is his designation as "artist agent." The latter term reinforces the idea of Selz's identification with artists. Among Carson's responsibilities has been ensuring that Selz stays in touch with the art friends his welcoming personality has attracted. A significant handful of students made a point of staying in

touch over the years, encouraged in this by Peter himself. In Gary's case, the close relationship goes back almost thirty years.

Carson was interested in Dada and Surrealism and related modernist movements that had the potential to change not just art but society as well. In 1973, he independently sought out Selz in his office, and in 1975 he enrolled at Cal. Gary remembers one of his first papers for Peter was on Simon Rodia's Watts Towers, one of the great examples of folk art as an expression of the human creative spirit in a way unparalleled in mainstream modernist art. Peter, with his few years spent in Southern California, knew of them and appreciated their significance. This assignment convinced Carson of Selz's "comprehensive view of art as a living phenomenon," an individual but synthetic approach to creative activity.

The key qualities that drew students to Selz as a mentor were, according to Gary, careful looking and original thinking—art history from lived experience, popularization at its best. In this intuitive approach, Carson observes a connection to the art historian and renowned creative thinker Robert Rosenblum—whose method Selz admires, if not always his taste. But as Carson put it, both were "open to new perspectives and phenomena," moving comfortably across media.[11]

Carson's and Cartwright's undergraduate memories of Selz as a professor hew closely to those of other favored students, prominent among them art historians Kristine Stiles, Moira Roth, Terrence Dempsey, and Susan Landauer and artist Rupert Garcia. For them, Peter Selz was an influential, even inspirational, presence. All have become, in one way or another, collaborators with Peter in both his and their own pursuits. This "working with friends" seems to be a hallmark of his professional modus. Though each had some specific criticism of aspects of Peter's working habits, these former students all expressed an affection and loyalty that defined the relationship.

In 1980, undergraduate Susan Landauer, a studio and art history double major, took Selz's lecture class on contemporary art. As just one of two hundred students, she had no personal contact with her professor. But a friend in the same program did have what Susan described as a more "direct experience," and as a result she became "wary of him."[12] As she remembers it, Peter stood out in two distinct ways for his female

students: many of them tended to avoid him outside the classroom because of his reputation as a womanizer, but at the same time they were attracted to his undeniable energy in his approach to art. In her admiration Susan was apparently typical, holding these two seemingly contradictory views.[13]

After graduation from Berkeley, Landauer went on to Yale; there she wrote a pioneering doctoral dissertation on San Francisco Abstract Expressionism, which later was published as an influential book.[14] The first personal contact she had with Selz came in 1989 with her return to the West Coast, their paths crossing at openings and other art events in the Bay Area. Since then she has collaborated with him on several publications and exhibitions, most notably in her former curatorial capacity at San Jose Museum of Art.[15] Her introduction to Selz's 2002 monograph on Nathan Oliveira, a surprise bestseller, offers important insights into his approach to an artist whose work he has championed since the late 1950s.

Landauer points to Selz's passion for "underdog artists" such as Peter Voulkos and Nathan Oliveira as among his most attractive qualities. Their world is his world, the place where he chooses to live. But she also suggests another aspect to this attachment, seeing in the license that is often granted to creative individuals—"Well, what do you expect? He's an artist!"—justification for libertine and otherwise self-absorbed behavior. She remembers a meeting at the University of California Arts Club at which she expressed concern about Marcel Duchamp's "kinky, predatory sexual behavior." Selz responded, "Who cares? It's all about the art."[16]

From the standpoint of an ongoing publishing collaboration, Kristine Stiles, a professor at Duke University and formerly Selz's doctoral student at Berkeley, occupies a unique position. Stiles met Peter in 1973 and entered graduate school the following year. She credits him for her switch from Etruscology to contemporary art studies. Why did she change? Stiles offers the following partial answer. She describes Selz the teacher as having "wonderful descriptive powers," although, she laments, "Unfortunately, he could not explain to me when I asked him what it meant to have his 'great eye' for art—and how one could

achieve such vision. Also, [academically] non-ideologically driven, albeit politically left. Open to new ideas but resistant to those that differed from his own (Pop Art). Taught material that no one else in the U.S. was teaching at that time—particularly art and technology coming from his deep involvement in Kinetic Art."[17] Stiles found Selz, as a writer, to be critical, but without a contemporary theoretical foundation. That is not to say that he was uninformed. Rather, he remained invested in existentialism and the philosophical thinking of the 1940s to 1960s. Above all, and against the academic trend, Selz resisted Stiles's interest in critical theory—semiotics, structuralism, and poststructuralism—chiding her for using the related jargon. "We argued about this." Now she allows that in this judgment of her youthful dependence on these theories and their languages he probably was partially correct.[18]

Stiles offered one anecdote from her experience as a research assistant that speaks to both his strengths and his shortcomings. While working with him on his book *Art in Our Times* (Abrams, 1981), she lobbied for the inclusion of feminist artist Carolee Schneemann. His final response was "Okay, but *you* do it."[19] Most likely, Selz could not have written the entry on Schneemann at the time; in his acknowledgments he mentions Stiles's contribution to the more recent sections of the book.[20] As time went on, Selz retroactively came to fancy himself a feminist. Rather than asserting a political position, what he may really have been saying was that he liked women—but he still had no real understanding of women's issues of the time.[21] However, Kristine Stiles, who was there, now insists that Peter was "always supportive of the women's movement."[22] The two discussed feminism, especially with regard to *Art in Our Times*. In her view, for some people Peter's personal interest in women unfortunately clouds the concurrent social and intellectual support his female students received.[23]

Moira Roth, a committed feminist and prominent women's rights advocate, had Peter as her doctoral advisor, and although she could easily have taken issue with Peter's perceived flaws, in a recent conversation what she mainly recalled was Peter's friendship and support. It is surprising that this dedicated feminist made no mention of the criticisms of Peter's treatment of women, both personally and professionally,

that had been leveled at him during many of his years at the university. But his genuine concerns and advocacy for marginalized individuals and groups, especially artists, evidently has corrected some of that history. Moira's 1974 dissertation was on Marcel Duchamp, and Peter was supportive of her oral history method, an unorthodox approach in academia at the time. She was impressed with his firsthand knowledge of European art, as reflected in his famous *New Images of Man* exhibition at MoMA. In addition, "Peter had a passion for art, more so than other art historians. It was so impressive how much he looked at, touched, works of art. He was putting order into disorderly contemporary art. And he was comfortable with artists, and they with him."[24]

Selz's interest in "marginalized" and nonmainstream artists and expressions influenced Roth, or at least pointed the direction for her own engaged art history. She has nothing but accolades for his award-winning *Art of Engagement: Visual Politics in California and Beyond* (2006). "Wonderful," enthused Roth. "Nobody else would have done it!" With a twenty-page section devoted to "The Women's Experience," beginning with the feminist movement, Selz *had* come a long way. Whatever his blind spots in connection with earlier feminist art, he made up for them in this book. He also cast himself as an enlightened supporter of women artists in his 1999 Abrams monograph and much earlier (1973) UAM exhibition devoted to sculptor Barbara Chase-Riboud. He proudly proclaims that the Berkeley show was among the "first solo shows in this country on a woman artist of color."[25]

That may well be the case, but it would not satisfy the objections to Selz's earlier exhibition program made by artist Eleanor Dickinson and her colleagues in the West East Bag (WEB, predecessor to the College Art Association of America [CAA] Women's Caucus for Art [WCA], founded in 1972). A respected Bay Area painter, teacher, and activist, Dickinson played a prominent role in the movement to remedy underrepresentation of women artists in art museums and books. Especially in the early 1970s, with the rise of feminism in general, gender inequality in the art world radicalized her and many other California women artists—prominent among them Judy Chicago, Miriam Schapiro, Arlene Raven, Sheila de Bretteville, Rachel Rosenthal, Suzanne Lacey, Eleanor Antin, Lynn

Hershman, and Moira Roth.[26] The two most influential consciousness-raising figures on the national scene were critic Lucy Lippard and art historian Linda Nochlin. The latter's famous 1971 essay "Why Have There Been No Great Women Artists?" inspired women—Dickinson among them—to challenge this perception and fight for greater recognition.

Eleanor was particularly angered by what she describes as Peter's poor record in this regard at the University Art Museum. In 1973, she participated in a WCA/WEB picket that led to a meeting with Selz in his office; he was "shocked" at the grievances and agreed to "mend his ways."[27] But, as Dickinson reports, although there was in fact 50 percent representation the following year—a great improvement—all the artists shown were "pretty young women." In her view, the letter of the agreement was observed, but not the underlying spirit. For his part, Peter points out that when Eleanor and her fellow feminist protesters appeared at his office, the Barbara Chase-Riboud exhibition was on view at the museum. His comment: "Either they didn't see it, or they didn't care."[28] Moreover, Selz furthers his claim to supporting women artists with an account from his first year at Berkeley. He was invited to attend art practice faculty meetings, and in discussing names for a new painting faculty appointment, Peter suggested a woman. His colleagues responded, "Peter, you're new here. You don't know that we don't seek women artists." Peter asked why, and the response was "Margaret Peterson O'Hagan." The teacher of Sam Francis and Jay DeFeo, O'Hagan was dismissed when she refused to sign the loyalty oath. O'Hagan was on faculty from 1928 to 1950.[29] The implication was that the loyalty oath of 1949 imposed by the university regents had served as a convenient means to get rid of unwanted faculty. Margaret O'Hagan was adamant in her refusal to sign, and uncompromising in her reasons. It may be that such a strong female personality had not been a comfortable fit for her male colleagues. In any case, no woman had been on faculty in the art practice department from her departure up to the time of Peter's suggestion.

In 2003, Dickinson was honored by the College Art Association of America, specifically by the Women's Caucus for Art. No doubt contributing to her Lifetime Achievement Award was the famous interview she conducted at the CAA annual convention in 1979 with H. W. Janson,

author of the art history text that through many editions has served as the basis for most undergraduate instruction in art. *History of Art*, with presumed authority, declared what art was important and which artists had "changed the history of art"—Janson's criterion for inclusion in his book. At the time, not a single woman artist appeared in the book. Janson did not hesitate to inform Dickinson that there was, so far, no woman— not one—who met his standard. He even seemed amused when she asked if he was aware that the Coalition of Women's Art Organizations was launching a national boycott of his book. He laughed as he replied: "No, but this is a free country and they are certainly at liberty to do so."[30]

Selz was far less dismissive of Eleanor's objections. And it is worth considering how similar he and she were, not necessarily as colleagues, but as kindred spirits. Dickinson understood the conflict between his professional life and bohemian inclinations. An example of Peter's personal independence is his posing nude for Eleanor's 1987 *Crucifixion* series, a group of large-scale works for which several friends agreed to disrobe. The unveiling of his portrait was the occasion for a performance in Eleanor's Belcher Street studio in San Francisco. An exotic dancer seductively removed her seven veils, floated each in the air, and, one by one, let them settle on Peter and Carole Selz as they sat on a low couch, watching. At the conclusion of the dance, Peter's nude crucifixion portrait was revealed to "oohs" and "aahs" from the delighted audience. Peter and Carole were as pleased and amused as was the audience.[31]

Before he became one of the models, Peter had written a review of an exhibition of the *Crucifixion* series at San Francisco's Hatley Martin Gallery for *Art in America:* "The Crucifixion series from which this show was drawn is based on the religious premise that all men (and women) carry their own crosses through life. The individuals who served as Dickinson's models for these large (6-to-10-foot-high) pastels on black velvet are people whose emotional concerns and spiritual life are known to the artist, and indeed, in rendering the bodies of her sitters who came to her studio 'to make their statements,' Dickinson seems to have captured their feelings and thoughts as well."[32]

Peter's closest friends and colleagues resemble him in their views of life and art. They tend to be independent outsiders, sometimes fiercely

so. And to a person, they are politically aware and engaged, on the left side somewhere between liberal and radical. Yet as Kristine Stiles and others have pointed out, Selz was never polemical in his teaching. "Maverick" may not be the most appropriate term for Peter himself, but his favorite collegial friends, including Agnes Denes, Dore Ashton, Wayne Andersen, and former student Rupert Garcia, could very well be so described. Carole Selz dismisses the term in connection with her husband, pointing out that he cares too much what people think of him.[33] In short, he wants it both ways, to be a friendly and much admired insider-outsider hybrid.

Agnes Denes, whom Peter met in New York in 1975 while writing a piece on her work for *Art in America,* is a strong and steadfastly independent artist who expanded his thinking about contemporary art. He considers her one of the truly innovative artists working today. They quickly became close friends. He was, in her memory, attracted to the conceptual core of her art. In fact, they seem to agree that her work was Peter's true introduction to conceptualism, a phenomenon to which he was not naturally attracted. "Peter was probably introduced through my work to an art that he then became interested in. As he says, the 'conceptual' part of it. I am a conceptualist—and I started very early, in the late 1960s, when only men were doing conceptual art. Keeping anybody else out. I was doing my own work and I was very much on my own. Still am."[34]

The qualities that distinguished Denes's art from that of her conceptualist peers are exactly those that enabled Peter to engage with it, thereby establishing his own relationship to what was becoming the main thrust of twentieth-century practice. This is made clear in an insightful—and somewhat surprising, given Selz's usual enthusiasms—essay of 1992: "Although Denes had little contact with the largely male group of conceptualists, she shared similar concerns with the conceptual artists of her generation. But her probes often went more deeply into essential human concerns. And unlike most of the conceptualists, Denes never renounced the object. On the contrary, her art is endowed with an intensely visual character of broad dimensions and perfection of execution, which is always specific to the particular work in question."[35]

Selz found himself in his philosophical comfort zone with Denes,

and in the same essay he further praised her objectives in staying away from the Clement Greenberg formalist rulebook: "Agnes Denes was one of the artists who broke these odious constraints, and she did so in a most unique manner by incorporating the investigation of science and the development of philosophy into art of universal dimensions. Her attitude toward philosophy was different in kind, although no less profound, from the philosophical paintings by artists such as Rothko, Reinhardt, and Barnett Newman."[36]

Like another close artist friend, Ariel Parkinson, Agnes Denes has a combative relationship with her friend Peter. They disagree about a great many artists. She tells about standing in the gallery at a Picasso/Braque exhibition at MoMA shouting at each other, having a "huge fight." She said that Braque was the more original artist and Picasso stole from him, used it in his work. And Peter said, "Well, no, you can't say that." He accused her of not having adequate knowledge of art history, and she "snapped back" with, "I'd rather make it than study it." By her account, they both laughed.[37] But Agnes greatly admires Peter's curiosity about everything, above all about people—not *only* but *especially* artists and the wonderful, exciting things which they make: "He can hardly walk, but he still goes to see sixteen exhibitions. And he keeps going. He's seen enough, he knows enough—but he never gets tired of seeing more art. New Yorkers go to galleries at the start of the season, then are done. It takes another two months to go out and see something. Peter comes to New York, and he never stops—even when he has problems with his knees, his legs, he keeps on going."[38]

Denes has an ambivalent relationship to feminist art because her work was not considered sufficiently (perhaps politically) feminist. She describes herself as among the first true conceptualists and postmodernists, an achievement that is only belatedly being recognized—as in the 2007 $25,000 award from Anonymous Was a Woman, an organization that supports women artists "anonymously."[39] In considering her career, Denes expressed the importance of her friendship with Selz: "My relationship with Peter is that we became friends through mutual respect, and we have remained friends for more than forty years. I don't want anything from him. It's like I'm always there. I was there [Berkeley] at his eightieth birthday party. And I was supposed to be somewhere else,

but I didn't want to say no. It's just that we like each other, and it's going to be that way forever. When one of us dies, the other one's going to be very sorry."[40]

For his part, Peter experiences social and intellectual happiness knowing artists with whom he can form a personal bond. They then become part of his extended art family, and as such they earn his ongoing support as he finds ways to fit them into his world. Agnes Denes is a prime example of this process. In her case, it is accomplished by connecting what he sees as the true meaning of her art, conceptualism notwithstanding, and the humanist figurative imperative of *New Images of Man*. Two examples should make the point. The most interesting one involves her ongoing project "Study of Dust," and specifically the 1969 work *Human Dust*. Selz describes this remarkable piece as consisting of a "pile of calcareous human remains, the residue left after cremation," and an accompanying text telling the "prosaic life story" of a fictional deceased artist, with all the vital statistics listed in a "dispassionate, clinical" manner. The text's final words, supposedly summing up the meaning of it all, are devoid of individual identity and life purpose: "34 people remembered him or spoke after his death, and his remains shown here represent 1/85 of his entire body."[41] The dehumanization of a person in death, the loss of identity, and the "vulnerability" of human existence were themes of Peter's *New Images*; Denes's *Human Dust*, created a decade later, fits perfectly within those themes.

Peter says he believes that Denes would agree with his old friend Paul Tillich, who wrote that "art indicates the character of a spiritual situation. . . . It does this more immediately and directly than science and philosophy for it is less burdened with objective considerations."[42] Selz concludes his 1992 essay on Denes with a concise statement of his own—and presumably his subject's—faith in the transformative power of art: "At a time when objectivity is no longer possible, Agnes Denes postulates the feasibility that art can deal with the ultimate questions concerning humanity."[43] In this, Denes provides for Peter another bridge connecting the two poles of human experience—subjective and objective, emotional and rational, spiritual and secular—between which his personal humanist understanding of modern art travels.

Dore Ashton, another New Yorker, is one of Peter's oldest friends.

A major part of their bond has always been in their shared left-wing politics, for which Ashton was well known in art circles. They met at the 1950 College Art Association conference. Dore was about to graduate from Harvard and was scouting for a job. She didn't find one; instead, as she says, "I found Peter Selz." "I was interested in Peter quite aside from the fact that we flirted with each other. But I was eager to meet him because I already knew who he was. . . . We had many conversations and [then] went our own ways. . . . But we always kept in touch. And then eventually, when he was an important fellow at the Museum of Modern Art and I was an important girl on the *New York Times* . . . we saw each other professionally—and we cooked up things together." Ashton goes on to say that "we were very unusual in that [art] world—if you want to call it a world. . . . Very few people were as committed politically as we were. And that was a big bond between us."[44]

On the question of whether Peter's critical judgment may have been clouded by his great enthusiasm for knowing artists personally, Ashton is both firm and indulgent, seemingly amused by Peter's weakness for young women but protective of his critical integrity. He would, she recalled, bring artists, often female, to her New York house, and she would say, "Peter . . . that artist is no damn good. But while he was engaged with them, they were the greatest artists in the world." When she would call him on this triumph of the personal over the objective, he would respond with, "Yeah, you were right."[45] Responding to a question about his infidelity and domestic lapses, she acknowledges that her friend was perhaps lacking in maturity: "I think that Peter could be seen as selfish—or as an impulsive adolescent. But . . . [that] doesn't seem important to me and never did."[46]

In summing up her relationship with Peter, Dore Ashton gave an eloquent tribute to their long friendship. With respect to his professional accomplishments, she said she respects him as an art historian and critic, especially for his major works, such as *German Expressionist Painting* and his "excellent" 1975 monograph on Sam Francis. But her regard extends strongly onto moral ground as well: "He never . . . shirked his moral obligation as . . . a proper thinking intellectual with values that I respect. . . . That's the most important thing I could say about Peter. . . .

[And that's why we] remain friends, even when it was sometimes awkward to defend him. . . . Underneath he was brave and had principles [which] he acted upon—unlike almost everybody else in what they like to call the art world. . . . So he was the only one I had . . . other than one or two artists, that I could depend on in terms of anything I was doing. And I'll say, in very leftish kinds of causes."[47]

The ties between Dore Ashton and Peter Selz remain strong and speak to their shared values about the essential role of political and ideological belief in serious art. Yet as Dore recalls, "He did only one thing that I thought he shouldn't do, and I told him not to. And that was to get involved with the Rothko trial."[48] In this, Peter would have done well to listen more closely to his friend. One common and uncharitable view of his participation in the Rothko estate trial was that he went mainly for the $20,000 expert witness fee from Marlborough Gallery. Whatever the truth is in this regard, Selz's involvement in the infamous Rothko trial remains, fairly or not, the single largest blemish on his reputation.

In broad outline, the complex trial went as follows: While still a struggling artist with a young family, Rothko set aside a few of his best canvases as an endowment for his wife and children—an indication of his intentions.[49] His 1968 will clarified his plans for the family as well as set up the Mark Rothko Foundation. It also named three trusted friends—Theodoros Stamos, Bernard Reis, and Morton Levine—as executors. In May 1970, less than three months after he committed suicide, these men secretly turned over control of 798 paintings to Rothko's sometime dealer, Marlborough Gallery. Director Frank Lloyd notified the widow, Mary Alice Beistle Rothko ("Mell")—the Rothkos were estranged and living apart when he died—that under the terms of agreement, Marlborough owned all of the paintings. Three months later she, too, died. In July 1971, at artist Herbert Ferber's urging, the guardians of the Rothko children and heirs, Kate (age twenty) and Christopher (almost eight), sued the executors and Marlborough on behalf of the estate. The trial was, according to Lee Seldes, author of a 1974 book on the subject and the only journalist to cover every day of the proceedings, "the longest [the court's decision did not come until December 1975], most complicated, and costliest in the history of art." The Marlborough's directors and the estate

executors were convicted on several counts of defrauding the Rothko estate and ordered to pay $9.2 million, including fines. The executors were removed for "negligence and conflict of interest," and Marlborough was ordered to return the 658 unsold paintings.[50]

In discussing the trial and its ramifications, attorney Henry Lydiate points out some of the hyperbole typical of the expert opinions rendered: "In order to assess the 'true value' of the paintings in question (the restitutional value of the works sold by Marlborough under the terms of the unfairly generous contracts), the court called upon a series of experts to give testimony to the past and future standing of Mark Rothko. There followed the most farcical interlude. The dealers, critics, historians, who had so carefully nurtured and fattened the baby of Abstract Expressionism to create the single most important movement in the history of American painting, were required to justify themselves."[51] Selz's assignment as expert witness was to back up evaluations he had provided for Marlborough. These conservative estimates of Rothko paintings' worth and projection of future value, which were then presented by the Marlborough and the estate executors, favored the defendants' interests. At the trial, however, Selz spoke glowingly of Rothko's stature. In his decision, Judge Millard L. Midonick cited these high claims: "Both Professor Selz and Robert Goldwater . . . compared Rothko to Michelangelo, and the professor stated that the artist's paintings can be likened to Annunciations"[52]—in which case the works could reasonably be expected to be priced accordingly.

The broader impact of the case, according to Lydiate, was to expose the "sophisticated machinations of the art market, underlining the need for all artists to seek and take independent professional legal advice when entering into any contractual arrangements."[53] Suspicion of the art market and recognition of the potential for corruption as greater sums of money land on the table were something Peter Selz noted with concern while still at MoMA. He came to deplore the influence of galleries on contemporary art.

In some corners of the art world, and in Seldes's book, Peter was all but vilified for his involvement as an expert witness for Marlborough. There are of course other perspectives from informed observers, and Peter naturally denies any wrongdoing.[54] In his own account, he is aligned with

the forces of good. Selz's main defense is that he was a close friend of the artist, and so he would of course do nothing against Rothko's interests. But Dore Ashton's account brings a different and frankly less ingenuous perspective to the situation: "Well, I'll give you my point of view. I wrote a book about Rothko and knew him very well. I refused to get involved on either side in that messy, horrible lawsuit. And I told Peter, 'Don't get involved. I don't care which side you're on, because it certainly will be bad for you.' I think I understand why he did it; other people didn't. . . . Anyway, I think that in the Rothko case his judgment was poor—he should have listened to me."[55]

But even having said this, Ashton still attempted to shield her friend. She went on to elaborate the details of the "messy" Rothko matter, and in doing so she appears to close ranks with Peter on the side of the defendants:

[Peter] and I saw it, I believe, in the same terms. If I had been involved, I would have been on the side of the people who were being sued— all of whom . . . died soon thereafter. . . . It destroyed a lot of people's lives. Stamos, for instance, went to Greece because they were going to seize his house in New York. And Stamos, I can tell you, was a very close friend. I never was in Mark's studio when the phone wouldn't ring and it was Stammy. So, I'm a good witness in that respect. I know who his friends were . . . the ones who were attacked—which is really paradoxical. And those children were, in my opinion, in the hands of a very manipulative former friend [Herbert Ferber] of Mark Rothko, who Rothko in my living room called a traitor. . . . He got the kids to sue. Ferber was very angry at Mark. . . . So, there are lots of things about the Rothko case that all the accounts leave out.[56]

When pressed on the subject recently, Selz finally explained why he testified. Yet despite his apparently good-faith account, which focuses entirely on his appraisals, his personal motivation remains less than clear:

Mark had told me more than once that he wanted to leave enough assets in his will so that his two children would be taken care of. When this provision was taken out of the trust, I hoped that it could be reinstated during the court hearings. Unfortunately, this did not happen. The people who were against the executors claimed that Bernard Reis had

a conflict of interest, as he was both an executor of the estate and the accountant for Marlborough, Rothko's dealer. This Mark knew and must have felt comfortable with it. Reis was a very close friend of Mark's and very much in the center of the art world. Stamos, who was vilified in Seldes's book, was Mark's closest friend and not a self-serving man. As, at the time, I was probably the person most knowledgeable about the value of Rothko's pictures, it made sense for Marlborough to ask me to do the appraisals. They were not the kind a certified appraiser would do, but figures that were as close as I could come, with the sale and auction records that I consulted. Although the court eventually decided against the executors, it accepted my estimates.[57]

Peter later clarified several important details. He believed that Rothko never intended his children to be so financially independent that they would not have to work, and the Rothko Foundation was established for the support of older artists. What Selz hoped would be reinstated during the court hearings was the provision for funds to go to the foundation for that purpose. That, in effect, seems to be Selz's main argument with the suit by the plaintiff children. But his main justification for his role in the trial is that he possessed the insurance evaluations for the works in the MoMA Rothko exhibition.[58]

Wayne Andersen agrees with Dore Ashton that their friend should not have become involved in the Rothko trial, suggesting also that the fee clouded his judgment.[59] Wayne, however, is disturbed that Dore took the side of Frank Lloyd and Bernard Reis for the sake of Stamos, rather than the side of Rothko's wife and the children. Lloyd was a superb player in the international art business, in which, as Wayne puts it, "crookedness is the name of the game." With that judgment Peter concurred: "Frank Lloyd was a crook—there's no doubt about *that*."[60]

Wayne, who knew Rothko well enough to "have an occasional beer with him," had his own reasons for distrusting Lloyd. In 1963 Wayne was recommended by artist Robert Motherwell and renowned art historian Rudolf Wittkower to direct Lloyd's new gallery on 57th Street. Lloyd tested Andersen's knowledge of artists by holding up photographs of artworks and asking who painted them. Then, again displaying a photograph, he asked, "Now, how would you *sell* this Rembrandt?"

Wayne, after studying the image for a moment, testing Lloyd's patience, responded, "I don't think it's by Rembrandt."

"Then who is it by?" Lloyd asked.

Gambling, Wayne said, "I think it is by Jan Lievens."

For a moment Lloyd seemed trapped. Then he continued brusquely, "All right. Now tell me how you sell it *as* a Rembrandt?" That ended the interview and any possibility of Andersen's association with Marlborough Gallery. David McKee, whom Andersen describes as "impeccably honest," took the job four years later. In 1972 he left to establish his own gallery, eventually signing on two of Marlborough's most important artists, Franz Kline and Philip Guston—the latter, according to McKee, after a contractual disagreement with Lloyd.[61]

Both Andersen and McKee consider Peter's role in the trial as minimal and having little effect. McKee, who says he admires Peter for his observations on modern art, views the whole business as relatively unimportant in the Selz story. At the same time, Andersen and McKee agree that Rothko's intentions may have been ignored by the executors and Marlborough. Andersen describes Peter as being "like a media-trapped celebrity caught in a sex scandal," providing testimony that "reverberates and constantly comes up, even though by now no one seems to remember what testimony he gave or what side he was on, if any."[62] Still, he managed to insert himself recklessly into the middle of a scandal and apparently did not acquit himself well on the stand. In her book on the trial, journalist Lee Seldes goes out of her way to disparage Peter's performance at the trial. She compares his testimony most unfavorably to that of Meyer Schapiro, incidentally one of Peter's heroes: "Professor Schapiro, whose authority in his field was unquestioned, exuded a dignity and honesty that were refreshing after Professor Selz's mocking tones." Virtually every reference to Selz put him in a bad light as an inconsistent and, overall, ineffective witness.[63] Ashton and Andersen attribute these "lapses" to a degree of naïveté. But they can also be interpreted as examples of Peter's innate inability to assess a situation realistically in terms of his own participation and the possible consequences. He is, in Wayne Andersen's assessment, unfamiliar with the idea of delayed gratification.

Probably the most enigmatic of Peter's close colleagues, Andersen has had an unconventional, but brilliantly so, academic career, in addition to pursuing a nonconformist series of explorations in several unrelated fields, including maintaining Arabian horses in Arizona. According to Andersen, the two met in 1962 in Paris, where Peter introduced him to Leon Golub. Peter was there on MoMA business in connection with the planned Rodin exhibition, and Wayne was able to play an intermediary role in the difficult negotiations with the Rodin Museum for securing loans and overseeing shipment to New York. This encounter launched a friendship that has lasted to this day.

Two fascinating yet somewhat eccentric studies by Andersen, *Cézanne and the Eternal Feminine* (Cambridge University Press, 2004) and *German Artists and Hitler's Mind: Avant-Garde Art in a Turbulent Era* (Editions Fabriart, 2007), acknowledge Selz specifically and suggest the basis for their close collegial friendship. Enclosed in Peter's copy of the first book was a brief letter that begins, "Dear Peter, I assume by now your book [*Art of Engagement*] is rolling through the press. [As for *Cézanne and the Eternal Feminine*] I think of it as your kind of book. My book on German art is moving right along."[64] The book is inscribed, "For Peter Selz, for forty years of supportive friendship." In the prologue to the 2007 book, Andersen acknowledges his debt to Selz in a way that emphatically declares their close personal relationship: "It pleases me to speak of Peter Selz as a supporting friend over the near whole of my professional life. His path-breaking book, *German Expressionist Painting*, was on my study table when I was an undergraduate at the University of California in Berkeley and has been on my desk and frequently opened throughout the period of writing this book."[65] Although Peter displays a very personal approach to modernism in his writings and exhibitions, he still seeks collegial approval. Andersen, in contrast, seems to disregard potential negative criticism. Still, Wayne admires the risks Peter took with many of his exhibitions, singling out 1959's *New Images of Man:* "He alters, you know, pushes. It isn't so much expanding the envelope as it is ripping it up."[66]

Andersen's personalism, in which the heterosexual male gaze is brought to bear on a variety of subjects that capture his attention, is

echoed in Peter's writing but in a more subdued way. Wayne, differenti-
ating how he and his friend write about artists, points out that Peter "is
interested in artists more than in art."[67] He goes so far as to characterize
Peter's writing as "art appreciation" but, intending it as a compliment,
adds that it is "the best kind of art appreciation." Presumably by that he
means that it is accessible and entertaining in its anecdotal quality; he
appreciates Peter as an effective teacher and storyteller, the kind who
can excite students by his passion for art. Like Selz's friend Gary Carson,
Andersen also sees in him the ability to discern and exploit patterns,
moving in the direction of the startling connections of scholars such as
Robert Rosenblum.

Despite his reservations about Selz as a traditional scholar, Andersen
wrote a long and appreciative review of *Art of Engagement* for the jour-
nal *The European Legacy*. In effect providing a sophisticated indepen-
dent essay on the subject of art and politics, Wayne makes the valid
observation that "Selz's excellent and insightful book [provides] some
background history that comes forward into the California context of
the 1960s. I am referring to the post–World War I span of years during
which Stalin's communism emerged on one side of a common border
and Hitler's fascism on the other and when political dissidence altered
the flow of modern art. . . . The situation for artists in the German and
Russian 1920s helps to clarify the nature of the Californian sociopolitical
art while also positioning Selz as a vital presence and participating force
in the topic of his book."[68]

Wayne's admiration for Selz is based partly on the way Peter sets
himself apart, whether unconsciously or strategically, from most art his-
torians. There is something akin to a sliver of envy when he describes
Selz as a "barbarian" and an authentic outsider: "I mean barbarian in
the ancient Roman sense—an outsider who doesn't speak the same
language, dress the same, share the same values [as his colleagues]. A
kind of savage—he is prone to outbursts and quick to laugh." Andersen
applies an amusing metaphor to Peter's personal level of control: "His
control cutoff point is below that of most others—a thermostat that shuts
off at a lower temperature."[69]

It is almost as if part of Andersen would like to *be* Peter Selz. According

to Andersen, "Peter and I had the potential of bohemianism and a few decades earlier would have been hippies. The strings that eventually joined us were gnarled and knotty, pulled by associations with the same creative people. One of the most important was Leon Golub." In typical fashion, Andersen is ready with a colorful anecdote:

> Leon was featured in critical minds in Selz's *New Images of Man*. His abrasive canvases drew the wrath of the most vocal critic, William Rubin, an ardent supporter of the New York School of Painting. Rubin, whose verbosity matched his pompous outbursts, wrote a scathing review of the entire show that, apart from Golub's canvases, included a selection of sculptures by Cosmo Campoli, also a Chicagoan. Neither was devastated by Rubin's assault. Leon returned the assault as a drawing on plain paper, mailed to Rubin. The drawing depicts Rubin on his knees before a toilet bowl, slurping. Rubin is saying between gulps: "Oh, I love writing art criticism—slurp! Slurp!"[70]

Perhaps one of the greatest attractions of bohemia, for both Wayne and Peter, is the opportunity to conduct one's life largely outside the restrictive domain of conventional rules, the imagination thereby freed to explore and conjure at will, taking in life as one grand fiction. And the idea of writing one's own life story goes quite far in explaining these two close friends and the adhesive that joins them.

Like Peter, Wayne proudly sees himself as operating outside the mainstream. In his latest book, for example, he questions not only the artistic primacy that scholars and critics have accorded Marcel Duchamp, but indeed his claim of being a "genuine" artist at all. The front-jacket-flap text, which introduces *Marcel Duchamp: The Failed Messiah* (2010) with a warning about what the reader should expect, also encapsulates a liberated bohemian-life "ideal" shared by the author and his friend Peter Selz: "Marcel Duchamp's gift to artists was similar to the Marquis de Sade's gift to sadists—relief from moral restraints, accountability, guilt, and shame."[71] The final chapter, "Guilty Passage," is devoted to a comparison of Duchamp's *Étant donnés* and Gustave Courbet's *L'Origine du Monde* (*The Origin of the World*), still generally regarded as the supreme masterpiece of erotic art. Andersen's language is, as required by the subject, frankly and boldly sexual. But there is a kind of detachment from

the graphic and crude sexuality that displays a coolly focused analytical mind at work. One might say that, in the relationship between these mutually admiring friends, Andersen operates more comfortably in the realm of intellectual than emotional response to art. And I think in a way he may envy Peter's fundamentally more direct and unselfconscious joy in looking.

In contrast, there is darkness in Andersen's vision that brings to mind the moral fervor of an Old Testament prophet. A brooding quality—a sense of crisis and impending tragedy—informs his harsh scrutiny of Duchamp and, finally, the art world itself. For all his anti-mainstream views, Selz would never go this far. So, despite their collegial sympathy, this is where the two part company. Andersen may be the deeper thinker, but in the end Selz is the life-affirming optimist.

· · ·

There is an opposing side to what we might call the Selz duality, and it is embodied by his association with an entirely different set of colleagues. Two of them, Jane Daggett Dillenberger and Fr. Terrence Dempsey, who was also a student of Peter's, bring another perspective to Selz the "barbarian" in terms of his collaborative generosity and his loftier interests, redirected from the flesh to the spirit. Jane and Peter traveled paths that could have merged much earlier than actually happened. Jane had switched from studio art to art history at the University of Chicago as an undergraduate shortly before Selz appeared on campus. And, like Peter, she had department chairman Ulrich Middeldorf as her advisor, whose decisive influence she acknowledges: "For both of us [meaning Peter], he was absolutely critical to our careers." She remembers Chicago, along with the Art Institute, as a place that "redirected our lives."[72] But the two never met there. Nor did their paths cross at MoMA in 1959 and the early 1960s, when, as an art history professor (for twelve years) at Drew Theological Seminary in Madison, New Jersey, she had occasion to borrow works from MoMA for various exhibitions.[73]

Jane was a member of the Society for Art, Religion, and Culture (ARC) in New York; Alfred Barr also belonged to ARC and had a lot to do with

arranging loans from MoMA, including the Matisse chasuble, secured by Jane for an exhibition she curated at the Newark Museum. Both Barr and his curator Dorothy Miller were interested in spirituality in art, and this provided a MoMA connection for Jane. Interviewing Barr some years later for ARC, she learned that his father had been a professor at the Presbyterian Seminary in Chicago and that as a young man Alfred had collaborated with his father on a course in church history in which he presented a slide lecture on the history of religious art. But despite this fortuitous access to MoMA, Jane does not remember "being with Peter in the period that I was in New York, though I was in the Museum of Modern Art a lot."[74]

The two had to relocate to California to discover one another and their similar experiences studying art history at the University of Chicago. They establish what turned out to be a lasting friendship in which spirituality had an important, possibly central, role. It was in Berkeley that Jane and her then husband, John Dillenberger, met Peter and found a somewhat strange area of mutual interest, or rather an unexpected basis for it. John and Jane were mainstays of the Graduate Theological Union (GTU), a West Coast counterpart to the New York institution where Paul Tillich, who wrote the prefatory note for Peter's *New Images of Man* catalogue, taught for over twenty years.[75] What is so fascinating about this connection, which illustrates the complex nature of Selz's alliances, is the bond that developed between the self-described atheist and a couple dedicated to their Christian faith and its highest humanitarian and spiritual goals.

It was natural for Jane Dillenberger, given her friendship with Selz, to go to him with her proposal for an exhibition at UAM on American religious art. She had already secured the participation of Joshua Taylor at the Smithsonian's National Collection of Fine Art (now Smithsonian American Art Museum). As Jane recalls, "Peter knew Josh Taylor from Chicago [he had been Peter's dissertation advisor] . . . so he signed on to have the exhibition here [Berkeley], and it was Joshua Taylor who named it *The Hand and the Spirit: Religious Art in America*. . . . I was curator of that show . . . [Taylor] contributed to the catalog and we made the choices together, but I was the person who located everything. And in those

adventures I again had contact with Peter." The exhibition opened in 1972 and "I remember strolling through with Peter . . . I had included a George Inness painting, which was called *September Afternoon.* [All the other artworks had religious imagery or titles.] Peter came to that and he said, 'My God, Jane, can't we at least call it *God's September Afternoon?'* He thought it would be just bewildering . . . why it was in the exhibition. Can't you just hear him saying that?"[76]

Jane now describes Peter as her friend and frequent collaborator (in 2008 they co-taught a course titled "The Spiritual Dimensions in Modern Art and the Collection and Career of Peter Selz" at his home).[77] In regard to his deep interest in Goya, Jane mentions that early interpreters of Goya considered the great artist as an "educator," perhaps thinking that if people looked at the grotesque and cruel things they do, they would be "horrified, and might turn around and . . . reform." Her friend's attraction to the demonic notwithstanding, Dillenberger perceived in this an appreciation of ambiguity and complexity, a feature of the modern world that also interested her.

In a later written communication, Dillenberger offers other thoughts on his interest in the demonic: "Peter's books on the German Expressionist painters are a case in point. The sense of alienation, suffering, and rejection of these artists is expanded and interpreted with sensitivity and his own sense of the demonic. Peter believes that his long interest in Goya deeply influenced his sensibilities. Surely Goya's *Disasters of War* must have resonated with his own existence in war-torn Germany. Peter's interest in German Expressionism must be related also to this."[78]

Jane goes on to define what she sees as Selz's personal strengths: "I know of no one in the art world with a more passionate and persistent love of art. In his nineties he still attends all the gallery and exhibition openings. He knows and is known to artists, art dealers, museums' staffs, and art historians countrywide. For me professionally and personally he has been a precious friend and colleague."[79] And she sees that his broader social conscience parallels liberal religious thought. What she can say about Peter in terms of a relationship to "faith," again in the broader sense, is derived from her observation of his work with GTU graduate students. As to whether Selz's proclaimed atheism affected

their work with their doctoral students, according to Jane, Peter offered advice and direction as if he were "a believer."[80]

To this day Selz has a very close relationship to the GTU, where he has continued to organize exhibitions and teach seminars. His attachment to the institution certainly is a testament to his friendship with the Dillenbergers, but it goes beyond that. Although the faith-based belief system associated even with liberal religion is not Peter's choice, he seems devoted to this ecumenical theological center of learning and inquiry, which is located a few short blocks from the UC campus. When talking with Peter, one gets the impression that the GTU has been a happier association, at least on a personal level, than was the University of California itself.

Jesuit priest Fr. Terrence Dempsey is a close friend of both Jane Dillenberger and Peter Selz. He spent eight years in Berkeley, from 1982 to 1990, working on a Master of Divinity degree and then a Ph.D. at the Graduate Theological Union, and Selz served on his doctoral committee. Prior to his arrival in Berkeley, Dempsey had read several books and essays by Peter revealing his preference for art that dealt with social justice. Dempsey admired Selz's humanistic values and vision, finding in them an avenue for dialogue with people who appreciated the religious and spiritual dimensions of contemporary art. Within three months after he landed in Berkeley, Dempsey introduced himself to Peter and signed up for his course on modern art. It was the beginning of a friendship that has lasted to this day. In 1987 Dempsey was named curator of exhibitions at the Graduate Theological Union, where he worked closely with Jane Dillenberger and Selz in choosing artists to exhibit. As a result of these experiences, he was hired by Saint Louis University, where he established the Museum of Contemporary Religious Art (MOCRA), the first interfaith museum of contemporary art in the world. Among the artists featured in MOCRA's inaugural exhibition in 1992 was Tobi Kahn, a New York painter and sculptor with deep connections to his Jewish heritage. Dempsey saw an interesting and compelling connection between Selz's humanism and Kahn's religious identification and introduced them to each other at the opening conference of the museum. Dempsey was right, and Selz has remained a friend and supporter of Kahn and his work.

The attraction of art history for Terrence Dempsey may have come largely from what Selz presented in his work on German Expressionism, always paying attention to its intuitive and emotional sources. For example, Dempsey now describes the projects of Christo and Jeanne-Claude, for example, as "generalized spirituality." At the time of Peter's retirement in 1988 from the University of California, Dempsey organized a tribute exhibition at the GTU titled *Christo and Peter Selz: The Running Fence Revisited*. Among the things he mentions about his professor is a "strong ethical component beyond just the presence of the human figure." Dempsey was attracted as a theologian to the issues that Selz raised in *New Images of Man*, saying that they made him seem interested in the "rest of the world." According to Dempsey, Selz was passionate about the social identity and power of art, a quality Dempsey felt few other academics seemed to possess. Indeed, this quality may be what made Peter curious about religion, if not susceptible.

Whatever the details of what Dillenberger calls the "appetite for the demonic," Dempsey sees in Selz a "genuine goodness" and a "love of humanity" that he greatly admires.[81] Peter's longtime, dedicated association with the Graduate Theological Union is a tangible expression of how belief and nonbelief are, for him, reconciled. Nonetheless, his attempt to put that reconciliation into words remains slightly ambiguous, as perhaps it must:

> I like the GTU program, combining art with theology. Though I was and am an atheist, I firmly believe in the spiritual quality of good art, as did artists like Kandinsky, Malevich, Mondrian, Rothko. And I do believe that good art is more than its material aspect. That is where I differ with Clement Greenberg, and do not think much of artists like Kenneth Noland. I once described good art as a metaphor for significant human values. This can be thought of as spiritual and would apply to an Impressionist painting as well as to the work of Christo.[82]

Still, with these words the door opens wide enough for a rapprochement between disbelief and a spiritual component that, despite his views on religion, is obviously a powerful ingredient in Selz's core idea of significance in art.

NINE A Career in Retirement

Peter Selz's personal life took a new turn shortly before his retirement when, on 18 December 1983, he married his fifth wife, Carole Schemmerling.[1] Throughout Peter's long journey, women have played a central role. His interest in women is practically legendary, and over the years he has had many relationships—some supportive, others combative; some brief and forgettable, others enduring and profound. What they have in common is not the nature of the connection—whether personal, professional, or familial—but a pattern of dependency that has in part defined Peter's life and career. During the retirement years, Carole, more than any other, has knowingly both challenged and enabled him. His prodigious output would have been impossible without her willingness to support and facilitate these last three decades of his remarkably productive career.

178

With the marriage and the joining of their two families came a new domestic scene for Peter. Carole brought daughters Mia and Kryssa, ages twenty-three and twenty at the time. In addition, there was Kevin Cox, an African American foster son who had been with Carole's family for seven years. His mother had died in a fire in 1975 when Kevin was sixteen, and Mia brought home her classmate, asking if he could come live with them. She announced to Carole and her then husband that "Kevin needs a mother. Doesn't that make your heart cry?"[2] Carole said yes, it did, and agreed to take him in. Peter's daughters, Tanya and Gabrielle, then ages twenty-three and twenty-two, though out of college and living on their own, were still "very dependent upon Peter."[3] Both would continue to spend time in Berkeley with their father and new stepmother. Eventually there were four grandchildren: Mia and Justin Baldwin's daughters, Kyra and Rian; Kryssa Schemmerling and David Rawson's son, Wyatt; and Gaby and ex-husband Bogdon Mync's son, Theo. This is Peter's present family configuration, which allows him the pleasures of being a grandparent.

Fifteen years Peter's junior, Carole is intelligent, politically active, socially committed, and an authentic denizen of the art world, in many respects the ideal marriage partner for Peter (see Figs. 24, 25). With her background in the Los Angeles art world—she was particularly close to several artists of the Ferus Gallery,[4] which Peter had found so interesting when at Pomona—and her contact in San Francisco with the Dilexi Gallery circle, she brought to the relationship sophistication and an independent nature. These qualities have served her well in dealing with her husband's powerful (and controlling) personality. She remains very much her own person.

Peter and Carole met in November 1979 at a restaurant following a movie that she had attended with architectural critic Alan Temko and his wife, Becky. Alan saw Peter and called him over to their table; after coffee Carole gave him a ride home. What followed was a determined courtship by Peter, but, partly due to their age difference, Carole was "not interested."[5] Furthermore, mutual friends, the artist Hassel Smith and his wife, Donna, warned Carole that Peter was "untrustworthy" when it came to women.[6] Peter persisted in his campaign, however (he

commenced by sending her a book on American cartoons—an original offering—which he took back a week later, saying it was his last copy). Three years later she capitulated and moved in. Carole was aware of Peter's reputation regarding women, but something drew her to him. On one level the attraction was what endeared him to many of his students: personal charm, knowledge and love of art, and a fondness for artists, which she shared. And, she confided, she imagined that he was in fact "malleable."[7] She would surely deny that she ever considered him a mentor, but his prominence in the art world promised an interesting life, one that suited her. Furthermore, her children were nervous about her single-woman status.[8]

By the time Peter retired in 1988, he and Carole had been living for six years on Regal Road in the high-modernist house designed by Berkeley architect Donald Olsen (who had been a student of Walter Gropius and had worked with Eero Saarinen). The International Style house was commissioned by Peter as the realization of a youthful dream—born of his first experience of modern architecture in Stuttgart in the 1930s.[9] Carole had become the facilitator of their very active social life, entertaining in this open and art-filled home. She seems to have understood this to be part of her role, one that she graciously performs to this day. In fact, many friends of the couple credit Carole with a noticeable and positive moderating effect on her husband. Her response by way of explanation is that she is Peter's firmest critic, calling him, as she puts it, on relationships with other people and even challenging his judgments on art and artists.[10] Peter had not experienced this kind of scrutiny and direct critical feedback since Thalia, if then.

Despite the demands of her own grassroots environmental work—most notably urban creek restoration[11]—Carole accompanies Peter on their frequent forays into the Berkeley art world and across the Bay Bridge to San Francisco. She also manages his busy travel schedule to Los Angeles, New York, and Europe, a pattern that has not slowed. Carole goes along on the more attractive of these excursions, such as the visits to Paris and Giverny in the summer of 2000. The highlight of that adventure included an expensive cab ride to Milly-la-Forêt in the Forest of Fontainebleau, where they hiked to Tinguely's *Cyclops* installation.

. . .

Peter Selz's departure from academic life, along with Carole's one-person spousal support system, has allowed him to become more involved with art galleries, which pleases him and must raise pleasant memories of his first New York years and the 57th Street galleries, not to mention his early art education in his grandfather's art and antiques emporium. The art journey has thus come full circle. University colleagues may disapprove of this commercial association, but Peter has characteristically found new opportunities to explore and express his fundamental interests. He loves the pursuit, discovery, and introduction of new art and artists, which happens more regularly in galleries than in museums. Selz still thrives on that "rush" of discovery.

Prominent among the gallery directors with whom he has associated over recent years, putting together shows and writing numerous catalogue essays, are Achim Moeller and Michael Rosenfeld (New York); Paula Kirkeby (Palo Alto, California); Jack Rutberg (Los Angeles); Tracy Freedman, George Krevsky, and Martin Muller (San Francisco); Barry Sakata (Sacramento); and the Alphonse Berber Gallery (Berkeley), which mounted in late 2009 a tribute to Peter titled *New Images of Man and Woman*. Other gallery associations include ACA and Gallery St. Etienne (New York) and Tasende Gallery (Los Angeles and La Jolla, California). In 1991 Selz put together an exhibition for Larry Gagosian, perhaps the most visible exemplar of the supreme power of the New York art market that Peter so vocally deplored just before he left MoMA for Berkeley. The draw, however, was the opportunity to present work that he believed in by an artist to whom he is devoted. Gagosian Gallery provided a high-profile venue for *Sam Francis, Blue Balls*. In 2010, Peter accepted an invitation from Jonathan Clark & Co. to write a short essay for the catalogue of an upcoming Eduardo Paolozzi exhibition in London. In addition, the gallery plans to reproduce Peter's introduction to *New Images of Man*, the MoMA exhibition for which he is perhaps best remembered.[12]

Alongside these commercial forays, Selz has devoted much time and energy to galleries that are nonprofit institutions, serving on the boards

of and organizing exhibitions for Meridian Gallery in San Francisco, Kala Institute in Berkeley, Neue Galerie in New York, and, above all, Berkeley's Graduate Theological Union. Many of the shows he has undertaken during retirement are done pro bono. Peter finds it difficult to turn down projects that capture his fancy or provide him an opportunity to revisit old enthusiasms—as in recent exhibitions of Stephen De Staebler (Graduate Theological Union, 2007), Richard Lindner (Krevsky Gallery, 2009), and Robert Colescott (Meridian Gallery, 2009). In 1994, Peter was awarded a residency at the Bellagio Study Center to work on the catalogue for the 1996 Richard Lindner retrospective at the Smithsonian's Hirshhorn Museum and Sculpture Garden. His interest in Lindner goes back well before that exhibition, however. Always adopting a contrary position, Selz rejects the notion of Lindner as a Pop artist, connecting him instead with German Expressionism and *Neue Sachlichkeit* (New Objectivity). Lindner's predecessors, in Peter's view, were Christian Schad and Oskar Schlemmer.[13]

The Colescott show, along with a 2010 Morris Graves retrospective, also at Meridian Gallery, celebrates Peter's unstinting dedication to artists who matter but do not get the attention he feels they deserve. Anne Brodzky, director of Meridian, was determined to present an exhibition of the brilliant African American satirist Robert Colescott. She easily engaged Peter's participation, who then persuaded Daniell Cornell, at that time the Fine Arts Museums of San Francisco's contemporary art specialist, to bring it all together. Peter had wanted for years to do a significant Graves exhibition, and Meridian also provided that opportunity.

Selz was working on the exhibition and catalogue for an Irving Petlin show that was planned for 2009 at the Pennsylvania Academy, but with a change of directorship the project was canceled. Peter was deeply disappointed because, as he said, "I really believe in this work." Petlin's work was, however, shown in three simultaneous gallery exhibitions in New York in 2010, and Peter wrote a feature article about him that appeared in the March 2010 issue of *Art in America*. With his opening lines, Selz encapsulates the main thrust of two careers, the artist's and his own: "For more than fifty years, Irving Petlin has remained a steadfast proponent of art as both a moral and esthetic enterprise. It is his conviction

that the task of the artist is to transmit this sense of commitment to the world."[14]

Perhaps Selz's greatest accomplishment during his retirement years, certainly from a politically engaged perspective, is the role he played in bringing Fernando Botero's controversial *Abu Ghraib* series into the permanent collection of what in 1996 became the Berkeley Art Museum (BAM). According to Peter, he first saw the paintings and drawings in 2006 at Marlborough Gallery in New York: "Like many others, I was impressed by the '*Guernica* of our time.'" When it was initially offered to Berkeley for exhibition the following year, BAM director Kevin Consey declined because the schedule was full. The Center for Latin American Studies converted a former computer room in the university's Doe Library and displayed the works from 29 January to 23 March 2007, attracting a large attendance before the series went on to Europe. Not wanting to profit in any way from American torture, Botero offered to give the entire 105 works to Berkeley.[15] Consey took the position that they did not "come up to the standards of the Berkeley Art Museum." Professor Harley Shaiken, head of the Center for Latin American Studies, contacted Peter, who intervened with the chancellor's office—and the works were accepted. According to Selz, Consey was fired because of his stand on the Botero offer.[16] His successor, Lawrence Rinder, installed a temporary exhibition in 2009–10, and the series now stands as a significant gift to BAM. Selz views the Botero works as a bookend to the famous Hans Hofmann collection, and the two as complementary parts of his legacy to the museum, representing two faces of modernist art.

All these projects have one thing in common: they represent themes, ideas, artists, and directions that have preoccupied Selz from the beginning of his career. For example, in 1989 Peter teamed up with his long-time friend Dore Ashton to co-curate *Twelve Artists from the German Democratic Republic* for Harvard's Busch-Reisinger Museum. The exhibition, introducing work that had been ignored in the West, opened on the very day the Berlin Wall came down.

These postretirement activities all feed into Selz's particular modernist-art worldview and his construction of a critical and historical edifice for the themes that inspire him. The key building blocks all have to do with

the human condition: political engagement, subjectivity and emotion, "peripheral" and unacknowledged artistic vision, and, above all, human presence, whether representational (the human figure) or abstract. These Selz leitmotifs, if we can call them that, are demonstrated in one way or another in the work of all of Peter's favorite artists.

The dedication and loyalty Selz bestows upon these chosen artists could be described more accurately as passion than as simple enthusiasm. Such is the case with the Spaniard Eduardo Chillida, whom he ranks as among the leading sculptors of the twentieth century, "as important as David Smith."[17] Thanks in part to Agnes Denes, who encouraged Peter to explore more thoroughly the conceptual foundations of art, he was able to develop a deep appreciation of Chillida's great public site-specific creations. Selz recalls attending a talk Chillida gave at the California Palace of the Legion of Honor in San Francisco in the late 1990s. The artist was being considered for a major commission, a sculpture to be placed opposite the museum entrance on a site with a sweeping view of the Golden Gate and its vermilion bridge, and beyond to the Marin Headlands. If Chillida had been selected, his piece would no doubt have created a powerful physical and visual connection between people and their environment, built and natural.

In his book *Beyond the Mainstream*—of which, among his many publications, he seems to be especially proud—Selz makes a distinction between modernist sculpture that is self-referential and that which, like Chillida's, performs a meaningful social function, being at once site-specific and universal: "Public sculpture has become an increasingly important aspect of Chillida's *oeuvre*. His public works relate to landscape or city and transform their sites into aesthetically valid environments. Although in the tradition of abstract sculpture, they have become meaningful place markers. The master sculptor assumes a social role, giving aesthetic definition to places of human interaction."[18] This, Peter notes, is Chillida's strength: his work in the public domain "comes to full life only when it enters into a dialogue with the people for whom it was made."[19]

Chillida was in the running for the San Francisco commission after Richard Serra withdrew because the Fine Arts Museums of San Francisco could not accept Serra's condition that the sculpture never be moved (the

Museums do not own the land; it belongs to the city). As things turned out, Chillida did not make a proposal, and a work by Mark di Suvero was installed in the choice location. One cannot help but consider this with regret, given the aggressive quality of what now stands in splendid, almost defiant, isolation, calling attention mainly to itself.[20]

This is a critique of modernist sculpture that Selz has made consistently. His short list of exceptions includes specific works by Brancusi, Giacometti, Miró, Dubuffet, and Noguchi and a few "memorable" temporary installations, such as David Smith's Festival of Two Worlds offering at Spoleto, Italy, in 1962 and Christo's *Running Fence* in Marin and Sonoma counties. But above all, in terms of an ecological awareness as part of humanist concerns, Chillida's *Wind Combs* of 1977 represents for Selz the fully realized ideal of a social, philosophical—and sophisticated—political art. Erected on a formerly inaccessible piece of rocky Basque coast on the western edge of Chillida's native San Sebastián, *Wind Combs* creates in art a perfect union of land, water, and air. A precipitous site overlooking the ocean is transformed into a public plaza where visitors view, experience, and interact with one another and the sculpture. The entire creation speaks eloquently of the profound human relationship to nature and the importance of having places where that relationship is, through art, recognized. Echoing his subject's stated objectives, Selz described three sited sculptures, each thoughtfully placed as representatives of the three elements, standing at the edge of the city where the Pyrenees meet—literally rise from—the Atlantic Ocean. The trio, Selz wrote in 1986, makes for "one of the most magnificent modern sculptures in the public area."[21] Twenty-three years later in an interview, he reiterated that assessment: "*Wind Combs* is one of the greatest works of art done out in nature."[22]

To his credit, Selz knew firsthand of what he wrote. On a 1988 trip to Spain, he and Carole met Herschel Chipp in San Sebastián, purposefully to revisit (the Selzes had been twice before) Chillida's masterpiece. The three Californians and the sculptor were photographed at this great site (see Fig. 21). But there is more to the story. The Selzes and Chipp also convened in Guernica for the dedication of a memorial sculpture by Chillida on 26 April 1988, the fifty-first anniversary of the German Condor Legion's bombing of the town. That bombing, of course, had led

to another masterpiece, Picasso's *Guernica*, a key monument in the history of art. Chipp's exhaustive study of *Guernica*, based on conversations with Picasso and some of the many women in his life, appeared the same year.[23] Professor Chipp, at the invitation of the Basque government (an invitation that Selz says he facilitated), addressed the people of Guernica, saying a few well-chosen and well-received words in Basque to honor the survivors of the bombing and their descendants.[24]

When it comes to art, Peter Selz always makes sure he is present and accounted for, a habit that has impressed many colleagues who lack his energy and that endears him to a younger generation of artists. Peter feels that he is part of modern art history. Of course he would be in Guernica for Chillida—but also to support his Berkeley colleague, whom he had known since the late 1950s (Peter called Herschel and Walter Horn his only true friends on the Berkeley art history faculty). But he was also drawn by the huge artistic and political significance of the day and the place. Two years earlier, he had visited San Sebastián to honor Chillida as well. It is finally a matter of life priorities—how he wants to be, and be perceived, in his world. Selz continues, throughout his retirement, to give priority to the people and events—and the art—of the creative world in which he has formed his own American identity.

Peter Selz, in his writing and curatorial endeavors, expresses strong feelings about the artists he favors. In his retirement years he has been largely free to pick and choose, and in doing so he has formed close personal relationships with his subjects. And these have not been limited to living artists. He considers, for example, Ferdinand Hodler and Lyonel Feininger "close to my heart,"[25] though the greatest attachment of all is Goya, followed by his other all-time favorites, Max Beckmann, Mark Rothko, and Sam Francis. He has been typically most devoted to, and emotionally invested in, artists whose work places them outside the mainstream. His commitment to artists and movements that he feels have been insufficiently recognized is the hallmark of his long career.

San Francisco artist Carlos Villa, a noted activist and champion of multicultural diversity, described as well as anyone Peter's impact on and contribution to the Bay Area art scene and, above all, the artists. He recalls how Peter Selz quickly attached himself to the bohemian artist crowd

that gathered around Pete Voulkos at his studio by the railroad tracks on Gilman Street in west Berkeley. For ten years, everybody knew that there would always be a party there, around the clock. "Pete would be gambling, doing coke," and holding court: "Pete Voulkos was the man." And Carlos considered Pete (along with his other mentor, Harold Paris) one of his best friends. He also came to admire Selz, in no small part because the art historian had chosen *his* world: "Pete [Voulkos] was head of the sculpture department, and he would have his faculty meetings after a poker session. He didn't even have to go to school to get a salary. And Peter Selz had to have gotten swept up with the tide. He could not have been the ruler of the [Bay Area art] world in his new museum without being side by side with Pete Voulkos." He added, "You know, the thing was that Peter Selz was very much part of the art scene. He wanted to be not necessarily the anchor, but he definitely was part of the underpinning."

Carlos went on to express admiration for Selz's insistence on pursuing his own new regional view—notably by creating his personal Funk "kingdom" as a way to identify what is original about the Bay Area: "Peter had his own view. He had his own lens . . . to what everything was. And that's what made the Funk show." Peter wanted to be authentically part of the local art scene. In that, his interests seemed to Villa to go well beyond personal and professional ambition. And his political interests are authentic, providing the willingness to look past his learned Euro-American prejudices about the idea of the "other." Villa credits Selz with being one of the most open of art historians around, one who goes beyond stylistic and formal issues: "It isn't the idea of 'isms' . . . or whether or not figurative art is more eternal or more humanistic—as opposed to de Kooning making marks. It's not about that anymore. It's about the immersion in the human spirit."[26]

Given their deep commitment to group and individual diversity, it carries considerable weight when politically sophisticated artists such as Carlos Villa—joined by Rupert Garcia, Enrique Chagoya, and others— use the words *generous* and *inclusive* to characterize Peter Selz's approach to art and artists.[27] Chagoya sums up the sentiment and expresses gratitude for Peter's contribution: "In the Bay Area I feel a sense of belonging to a community of artists, dealers, writers, and cultural activists unique

in the world. Many come and go, but what really matters is that some of them devote the time and energy to record and analyze artistic events and their connection to the social and political context. Peter, in his research and writing, is the kind of historian who has continued to do just that important task. For his dedication of mind, and especially his appreciation of individual artists, Peter is most special to all of us."[28]

Villa, Chagoya, and Garcia, like Chillida in Spain, attract Peter with their social and political ideals and commitment. As it turns out, Garcia is one of the most enlightening exemplars of the union between Selz's ideas and the artists he writes about. In *Beyond the Mainstream*, Peter begins his discussion of Garcia by quoting and then providing a rejoinder to a Hilton Kramer review in the *New Criterion* in which, in Selz's words, Kramer takes "umbrage with a number of political exhibitions and publications."[29] Although Kramer's hostility toward left-wing political art is not directed at Rupert Garcia per se, it would certainly include the artist's well-known graphic statements such as *Attica Is Fascismo* (1971) and *¡Fuera de Indochina!* (1970). Kramer takes a staunchly negative position on the question of whether moral and political opinions have a place in making art: "We are once again being exhorted to abandon artistic criteria and aesthetic considerations in favor of ideological tests that would . . . reduce the whole notion of art to little more than a facile, pre-programmed exercise in political propaganda."[30] To this Selz responds with his own question: "Does Mr. Kramer, a most political animal himself, actually believe that artists can live and work in total isolation from the political context? What are these 'artistic criteria and aesthetic considerations'? And what was Mr. Kramer's own socio-political milieu in which he acquired his ultra-conservative views?"[31]

This is classic political Selz, an absolute and unbending position, which one sympathetic UC Berkeley colleague, law professor Richard Buxbaum, describes—with more than a bit of liberal admiration—as "his unambiguous approach, that black-and-white bluntness of vision."[32] Garcia himself, however, in talking about his studies and eventual collegial friendship with Selz, downplays, almost ignores, the political component that is the focus of Peter's writing about him. Instead he sees it as a kind of "progressive" intelligence which they naturally share—and if Peter did not care about such things, Rupert declares, "I wouldn't waste

my time."[33] His view of their friendship, why they are important to each other, is actually more nuanced than Peter's emphasis on the political "bond." Garcia's affection for Peter comes from a different place.

Rupert came to Berkeley in 1973 to earn a Ph.D. in art education. When he took a course with Peter Selz, however, he decided to switch to art history. Peter supported his application and he was admitted. He took seminars from Selz and Herschel Chipp, and in the process "got to know them well. The relationship with Herschel was intense, but it was cool. And then with Peter it was intense and warm."[34]

As much as he enjoyed the academic life, Garcia finally had to make a choice between being an artist and writing a thesis.[35] Being an artist won out, a decision that both Selz and Chipp supported—which Rupert interprets as coming from "trust" based on his performance in seminars. Rupert remembers the first time Peter and he interacted outside the classroom, at a symposium at the San Francisco Museum of Modern Art about art and social engagement. Rupert criticized a statement Peter made about artists in general, ignoring the fact that, in Rupert's words, "white artists do something, and it's considered profound. But when artists of color do something, it's considered to be culturally bound. I was thinking, what's with this double standard, man? It was the real world, real life, and Peter never shied away." Rupert looks to that exchange as the beginning of their relationship: "Real friendships are built upon being open to criticism and not taking umbrage against the other person, saying, 'You're out of my life because you don't agree with me.'"[36] At that point, Garcia said, he and Selz were establishing a connection based on intellectual and creative equality. That was important to Rupert, but he is a realist: "I mean, it would be folly to have great expectations of someone like Peter. I have great expectations for myself, but for nobody else."[37]

Rupert came to appreciate Selz's importance beyond the classroom, and specifically to the Bay Area:

> I would say that later in his career when he started to get involved with local artists, I cared [more] about him. Previously I only cared about him because of the book on German Expressionism. That's a fabulous piece of work. I really love that book. So I always knew this guy was very serious. I knew that he was here and that he was at MoMA, and

he did *New Images of Man.* That was a fantastic thing to have done—he brought that with him. So I knew there was this stimulating mind and presence in the Bay Area.[38]

Despite his independence and artistic self-reliance, Garcia is grateful that Peter wrote favorably about his work in several publications, including *Art of Engagement* (2006), one of Selz's two major books of recent years and the culmination of a career-long dedication to political art in the service of humanity. This supportive friendship continues right up to the present. Peter offered to read the manuscript for Garcia's proposed book on Surrealism and Mexican modern painting. Even though sometime earlier he had observed that he was "running out of steam," he read the entire manuscript. "He edited the whole damn thing," said Rupert. "Every page, even the notes."[39] Rupert ended by saying, "Peter is a friend. I consider him my friend. I can talk to him about anything, say anything I want. I feel no need to edit when I talk to him. And I call about anything that I think is important."[40]

Anne Brodzky of Meridian Gallery in San Francisco is another sympathetic colleague, similarly dedicated to progressive goals and humanist values. She and Peter share a deep rapport, one that underlies their collaboration at the nonprofit gallery. In 2005 he joined the board of the Society for Art Publications of the Americas, the nonprofit parent of Meridian Gallery and its innovative program of new music concerts and internships for at-risk, inner-city teens. Located in new quarters in downtown San Francisco, Meridian has an ambitious exhibition program that draws heavily on the knowledge and experience of Peter Selz. Starting in 1995 with a nationwide traveling exhibition, *About Drawing,* Peter has organized shows of the work of Robert Kostka, Robert Colescott, and Kevan Jenson, as well as a Morris Graves exhibition that was on view in the spring of 2010. Brodzky speaks fondly of her association with Selz:

I've worked formally and informally with Peter Selz since our mutual friend Dore Ashton brought us together in the early 1980s. As my mentor, Peter continues to challenge my assumptions about seeing, particularly when it comes to direct work with him on an exhibition. His swift calls are always the adroit, the telling, ones. Peter has continued to

provide guidance to the director and staff, to curate shows and pro-
duce catalogues for each of the exhibitions at Meridian's Powell Street
location. Above all there is a stunning shared congruence between the
gallery's mission and Peter's belief in cultural diversity and the power
of significant art to effect change.[41]

Selz's retirement activities, his writing and exhibitions, and his attrac-
tion to individual artists are in large part determined by political consid-
erations. But this is not to be understood in a narrow polemical or activist
sense. Peter's political view encompasses much more, really constituting
a philosophy of life that he applies to art. For him, art must somehow tap
into the human spirit. Certainly artists like Rupert Garcia and gallery
directors like Anne Brodzky, firmly committed to social change, com-
fortably meet that requirement. But what of other Selz favorites, such as
artists Sam Francis and Nathan Oliveira, Californians whose work is not
overtly political? Francis could easily be described as a formalist, a qual-
ity that Selz holds as suspect. In his view, formalist art typically lacks
human presence. Nonetheless, Sam Francis (see Fig. 20) figured among
Peter's closest friends and is the subject of one of his major monographs.
Dore Ashton describes *Sam Francis* (Abrams, 1975, rev. ed. 1982), along
with his studies on Chillida and Beckmann, as "indispensable to art his-
torians and those who desire to know."[42] Speaking about Peter's writing,
Ashton further clarifies Peter's unique political-*cum*-philosophical posi-
tion, one that encompassed artists representing a broad range of subjects
and styles: "I could never write about Mel Ramos, for instance. To me he's
just a Pop artist—and Pop is not interesting to me. But Peter can, if he's
talking about social, political, and cultural aspects of a subject. And that's
what he did in *Art of Engagement.* . . . But he's done very good work other
than that, like the monograph on Sam Francis. I think it is excellent."[43]

Still, the question remains: just how does Sam Francis fit into the Selz
idea of significant art? Fortunately, Peter himself provides a partially
satisfying answer in his account of his planned retrospective at MoMA.
"Why Sam? Because I thought his work was truly beautiful. The whole
strong feeling for color. They talked about color painting later on. But at
the time it really was this essence of the soul of color, and the color of
soul. I felt his paintings were just a great pleasure to look at—which was

the opposite of what I presented in *New Images of Man*."[44] Yet "beauty" can, in capable hands, skillfully disguise the merely "decorative," something Selz disdains as eliminating the human presence or, put another way, the realm of ideas. But as he goes on, his reasoning becomes clearer: "Abrams [the publisher] wanted to do a book on Sam Francis. I wondered why has Sam, who is acknowledged in Japan as one of the great painters of our time, received little recognition in his own country— even been ignored? Why do his canvases hang more prominently in museums in Tokyo, Paris, Amsterdam, Stockholm, Basel, and Berlin than in American museums?"[45]

In his monograph, Peter saved that question for the final chapter, where he attempted a response beyond the more obvious, and cynical, explanation that Sam Francis had a prosperous Japanese father-in-law and had resided in Japan for a while, and so enjoyed easier access to the Japanese art market. Peter's own answer to his question touches on seemingly unrelated, but very important, issues about American culture that, to a degree, still set us apart—almost schizophrenically—from the rest of the world. Maybe these issues are part of Peter Selz's larger "political" agenda. "What I suggested in the final chapter is that the simple beauty of his [Francis's] work did not appeal so very much to America. We can [appreciate] Dante's *Inferno* much more readily than his *Paradiso*, and Beethoven has always been more popular than Mozart. The sheer idea of beauty and pleasure has been put down to some extent by American Protestant culture." Peter concludes with his overall assessment of the book: "This was a beautiful book, perhaps the most beautiful book I've ever done."[46] From a Selzian political imperative, perhaps it is appropriate to introduce the idea of a "politics of beauty" or "political aesthetics."

Peter relates with fond pleasure his acquisition of the large Sam Francis painting that hangs above his sofa, dominating the north wall and the entire living room with its powerful colors:

> We were doing the book, back and forth. I spent a lot of time working with Sam in Los Angeles and sometimes up here. We became very good friends. I told him about this modern dream house I hoped to build: "Well, the last plan is terrific, but I don't think I can afford it."
> And Sam said, "You really want to do it? Will it have a large wall?"
> I answered "Yes, one is planned."

Sam said, "Well in that case if you build the house you can select a painting of mine to put on that wall."

I selected it and lived with it untitled for a long time. There was a demand for a big exhibition and Sam was sitting on this couch: "I think we should give this picture a title to go with the exhibition."

He thought for a while, looked at it, and said: "Let's call it *Iris*. Not the girl's name but the eye—the open eye."[47]

Although Nathan Oliveira was just as far removed from politics as Sam Francis was,[48] Oliveira's influences and vision lie very close to those of his friend Peter Selz, and with him it is easier to see the connection between artist and writer, which are made even more apparent in Selz's 2002 book *Nathan Oliveira*. In fact, Oliveira and Selz fit together in several ways. Oliveira shared Peter's affinities for Goya and German Expressionism, which were important sources for his art. Max Beckmann, Peter's touchstone, was a major influence on Oliveira, as was Symbolist ambiguity, as in, especially, Odilon Redon. Some of Oliveira's best work, notably his monotypes, derives directly from these sources, which are among Peter's great interests. Understated and mysterious, such images speak to the spiritual qualities that Peter includes within a greater understanding of politics and ideological values. Under this particular construction, the big idea is to use the means available to change perception and the way people engage the world. But is it political? Well, just possibly—at least in Peter Selz's worldview.

Oliveira's interests did indeed parallel Peter's, as both acknowledged. Oliveira saw his project as centered in and around humanist expressionism, with Germany and the painters Selz so admired as a starting point: "Whether it was Beckmann or the German Expressionists, or Giacometti, eventually Peter could attach his views to these people. And certainly I shared that sympathy with him. I wasn't as obvious with the politics as he was, but certainly the 'humanization'—the humanist expression of what I was doing—was enough for him. The fact that the figures in my work were not just painted figures but *about* something. Loneliness— some kind of internal aloneness. Isolation. Yes, the existential condition. I think that appealed to him. And that's the way Peter interprets my work."[49] Writing in *Nathan Oliveira*, Selz echoes his subject's words by placing his work squarely within tradition, with constant reference to

the great expressive achievements of the past. In this Oliveira occupies the creative space that most attracts Selz and informs his view of modernism within a historic framework:

> Nathan Oliveira has not sought dramatic change in his art. Instead, his passion is for continuing an inner-directed artistic tradition attached to the human subject. His art represents a *response* [italics added] to artists, both past and present, an ongoing dialogue with artists from Rembrandt and Goya to Munch, Beckmann, Giacometti, and de Kooning—whom he recognizes for their insights into the human condition using the visual means at the painter's disposal. The evocation of mystery that the viewer experiences . . . derives from a depth of feeling refracted through artistic tradition and transmitted to the spectator by the artist's hand.[50]

This apparent resistance to change (at least for its own sake) and actively looking to the past for inspiration and expressive forms would seem, to some, to run counter to the modernist credo that we must break with the past. However, Oliveira's original interpretation of his influences and sources seems to have freed him to create his own "modernist" figuration, in practice giving form and tangible substance to Selz's ideas. No wonder the two appreciated and admired each other.

Oliveira, in an early interview that Selz quotes in his monograph, acknowledges his artistic debts while endeavoring to explain his objectives. Listing the artists above along with other important influences, Oliveira proceeds to describe his tradition-derived modernist position:

> Goya, Beckmann . . . all these artists, really make up part of me . . . I'm not interested in altering the course of the art world, to be so current, so immediately at the leading edge. . . . I readily admit my influences and those people who are important to me, and in some sense, I'm a composite, as are all artists who are really good. . . . I happen to choose those artists who deal with mystery and if you want to call it that, the supernatural . . . those elements of great mysterious forces—not that I actuate them—but I think of painting as a vehicle. Visual art is a vehicle for creating worlds that are non-existent.[51]

Finally, Oliveira explains the course of Peter's life journey in terms of creative life force. According to Nathan, people—women especially—

provide the energy that fuels this force and the artistic productivity that results, a phenomenon with which he personally identifies.[52] Despite the "handmaiden" connotations, the notion that the woman's role is to enable greatness in men—the idea of the muse—dies hard.

. . .

Peter Selz's unflagging loyalty to the art and artists and the ideas in which he believes remains consistent. Oliveira pinpointed it: "He maintains that loyalty. It's something that is unshakable with him. He's like a bulldog. That's one of the great, endearing qualities with Peter."[53] The same can be said of his loyalty to his earlier writing and exhibition subjects, especially their historical, national, and political components. And as with Sam Francis and Nathan Oliveira, Peter's enthusiasms are often enabled and supported by enlightened art dealers. Among the most important in that respect is Paula Kirkeby, director of Smith-Andersen Gallery with its associated graphics shop. Kirkeby also played a key role in the career of Sam Francis, whom she represented for twenty-five years. Paula thinks of these three closely interconnected friends—Selz, Francis, and Oliveira—in the fondest personal terms. As she recalls in a 2010 e-mail: "In 1969 I opened my first exhibit of Oliveira's monotypes. Peter Selz was right there to see them, as always very enthusiastic. I knew Peter through Adja Yunkers [Dore Ashton's first husband], so there was a small relationship between us prior to the Oliveira show."[54]

She goes on to tell of an early interaction between Peter and Nathan: "I remember a party at our house, lots of Stanford people, Nate included as well as Peter. One of them was wearing a red shirt, I think it was Nate. Peter said he liked the shirt and the next thing I knew they disappeared and returned to the party with Peter wearing the red shirt and Nate Peter's shirt! They were reliably playful guests."

Paula also remembers the more unlikely connection between Sam Francis and Peter: "Sam Francis and Peter were very close. Whenever Sam and family were around, Peter was always there. I always felt it was more about family than anything else."

She concludes by saying: "On different occasions, either here [Bay

Area] or in Los Angeles, when I would go to museums or galleries with Peter, people would recognize him and come and say hello. Some were young unknown artists or students, and Peter was unbelievable with them. . . . He had the time and interest. Wonderful quality in someone who had tremendous power in the art world."

Another important ongoing gallery connection is Jack Rutberg Fine Arts on La Brea Avenue in Los Angeles. Selz and Rutberg have a rapport that embraces not only their interest in individual artists, but also, and perhaps even more so, the political and social passions that these artists manifest. In that respect, there could hardly be a more powerful example than the Swiss American artist Hans Burkhardt (see Fig. 22). When Rutberg first met Peter in the early 1980s, he had already been representing Burkhardt for about a decade, convinced that Hans was "among the most extraordinary painters of our time."[55] Peter had a limited awareness of Burkhardt, but no real exposure to his work. Hans Burkhardt was not *just* a Los Angeles–based artist; he had New York credentials also as a studio mate of Arshile Gorky from 1928 to 1937. Willem de Kooning visited frequently. Burkhardt, however, seems to have been the cannier of the two, being careful as he swept the studio floor at the end of the day to save the rejected drawings that had been tossed aside. Burkhardt arrived in Los Angeles in 1937 with the largest collection of early Gorky works outside the artist's own holdings.

Carole long before had tried to interest Peter in Burkhardt; she had some of his political posters, and her mother was a neighbor of his in the Hollywood Hills. But finally it was Rutberg who brought Peter to Hans's Jewett Drive studio to see the sixty paintings composing the *Desert Storm* series, his response to the Persian Gulf War of 1990–91. Peter was astounded by his first meeting with the artist. It seemed almost unfathomable that Hans, at age eighty-six, could have created the works in the span of a few months. But Peter understood such passion and immediately set about making it known. The first step was to read a paper at the International Congress of Art Critics titled "The Stars and Stripes: Johns to Burkhardt." Anthologized in *Beyond the Mainstream*, the essay served as the text for *Hans Burkhardt: Desert Storms*, the 1991 exhibition at Rutberg's gallery. Peter, with his friend and, in this case, accomplice, Jack

Rutberg, set out to retrieve an accomplished artist and powerful political voice from relative obscurity. Included in that effort was another *Desert Storms* exhibition at the Graduate Theological Union in Berkeley.

Rutberg recalls attending the exhibition of treasures from the Hermitage at the Los Angeles County Museum of Art with Peter: "The excitement of discovery was animated and contagious as we moved through the exhibition discussing and critiquing works. We turned a corner and came upon a small Van Gogh painting of prisoners in a courtyard. It was a magical moment for Peter. This painting . . . was the very image in a postcard that Peter, as a young boy in Munich, so loved and had pinned to his bedroom wall some eight decades earlier." In 2000, Peter and Jack attended the LACMA opening of *Made in California: Art, Image, and Identity, 1900–2000*. According to the official statement of purpose for this ambitious exhibition, it "would not be a traditional art historical survey, nor would it attempt to establish a new canon or identify certain types of artistic production as distinctively 'Californian.' Rather, it would investigate the relationship of art to the image of California and to the region's social and political history."[56] This thematic promise raised high expectations, and the history of the show's reception was largely one of disappointment, despite the enormous staff effort and a degree of democratic process involved in early conceptualization. In a way, the show was bound to come up short. According to Rutberg, Peter Selz judged it harshly: "It's a terrible show." In response to which Jack said, "It's time for you to write your book. After all, you've been writing it all your life."[57] Both Peter and Susan Landauer have different versions of how the book came about, Susan citing an exhibition that they intended to co-curate at the San Jose Museum of Art. When the exhibition was canceled, the museum withdrew as co-publisher. But all three agree that Peter's essay in *Reading California*, a companion to *Made in California*, the catalogue for the LACMA exhibition, did indeed provide the impetus for his award-winning study of political art in California.[58]

Whether or not a museum conversation was the literal beginning of *Art of Engagement: Visual Politics in California and Beyond*, the story underlines the importance to both men of the social and political dimension of art. Another artist they have discussed in these terms is the painter

Jerome Witkin (brother of photographer Joel Peter Witkin). Whereas Hans Burkhardt is the observer of human inhumanity, of holocaust in general, Jerome Witkin focuses on the Nazi Holocaust specifically, in paintings of such brutality that they are almost unbearable to examine. A March 2007 article by Selz in *Art in America* introduces Witkin as one of the greatest examples of figuration in the service of social conscience in recent art. This is exactly the territory where Peter Selz thrives.

Examining the range of Selz's "retirement" projects, we are reminded that his interests and loyalties remain attached to his own roots—in Germany but, more important, with German Expressionism as well as *Neue Sachlichkeit* painting. Over the years, Peter has returned periodically to his old interests, many of them attached to his early work on German art. In 1969 at Berkeley he presented a Richard Lindner retrospective, the first in the United States, which traveled to the Walker Art Center in Minneapolis. Peter's 1973 Ferdinand Hodler exhibition at Berkeley was the first in this country, and it traveled to the Guggenheim Museum in New York and the Busch-Reisinger Museum at Harvard. Peter loves to draw the connections he sees between artists like Hodler and German American Lyonel Feininger. And then in 1978 he presented *German and Austrian Expressionism: Art in a Turbulent Era,* organized by the Museum of Contemporary Art in Chicago and then shown in Minneapolis.

Peter's 2002 appointment to the board of Neue Galerie in New York is one reminder of the pioneering role he has played in connection with German and Austrian art. He is one of the few American scholars whose name almost automatically appears on such a list. Yet the memory of his contributions seems to be dimming as younger curators wrestle to establish primary positions in the highly competitive art history and museum fields. In that competition, the key contributions of their predecessors occasionally—and perhaps inadvertently—go unacknowledged.

Such a problem arose with the catalogue for the Metropolitan Museum of Art's 2006–7 show *Glitter and Doom: German Portraits from the 1920s.*[59] The exhibition was an eye opener and a public success for the museum, the relatively esoteric subject matter notwithstanding. However—and here is the problem—in 1980 a thematically quite similar exhibition, *German Realism of the Twenties: The Artist as Social Critic,* opened at the

Minneapolis Institute of Arts and then traveled to Chicago's Museum of Contemporary Art. Peter was chairman of the exhibition committee of four.[60] For both catalogues, the cover illustration is the same Christian Schad painting, *Count St. Genois d'Anneaucourt* (Musée National d'Art Moderne, Centre Pompidou, Paris), though the Met's catalogue uses a detail of the transvestite standing to the right in the full composition. Nowhere in the grander 2006 publication is mention made of the 1980 show or catalogue, or of its curators. Peter, who in the first publication wrote a chapter titled "Artist as Social Critic," was unhappy that the Metropolitan Museum of Art failed to acknowledge such an important predecessor and encouraged an investigation of the oversight. My polite inquiry initiated a civil, even pleasant, phone and e-mail exchange with the curator and editor of the book, with assurances that in the next printing Selz would be acknowledged.[61] He looks forward to the fourth printing, should it ever occur. For now, it is unfortunate that the art historian who introduced the subject to America—as Selz would like to be seen— has no presence in this recent venture.

Here is how critic Robert Hughes opened his review of the exhibition that Peter and his colleagues put together in 1980: "The show . . . deals with an aspect of modernism that 15 years ago was thought hardly worth discussing. What could be further from the concerns of Matisse and Braque than the images to which German intellectuals gave the name *Neue Sachlichkeit*—'new objectivity'? There, in contrast to the French tradition of measure, delectation and ordered feeling—of art 'above' politics—was a cold, laconic, even squalid-looking art that wanted to contribute its voice to the tormented political theater of the Weimar Republic."[62]

Peter Selz really is returning full circle to his German roots and the art and artists with whom he began his long journey. Scholarship does indeed move forward, providing more information along with new insights and understandings based on serious research. The reward, even the inherent pleasure, in scholarly writing and other means of communicating new ideas turns out to be providing this foundation on which others may incrementally build. Selz is understandably disappointed by the lapse associated with *Glitter and Doom*. But what we really learn

from Peter's momentary annoyance is that for him, his publications and exhibitions are his identity. Like most of us, he wants to be liked, but he also wants to be admired.

So, for Peter, *Glitter and Doom* represents a small rip in the fabric of an unusually independent and largely successful career—the same career that was honored just a few years ago by Selz's College Art Association colleagues on that February day in New York. One would hope that *Art of Engagement* (winner of CAA's award for best art book of 2006)—along with *German Expressionist Painting, New Images of Man, Art in Our Times, Art in a Turbulent Era, The Work of Jean Dubuffet, Alberto Giacometti, Max Beckmann* (also *Beckmann: The Self-Portraits*), *Sam Francis, Chillida, Nathan Oliveira,* and *Theories and Documents of Contemporary Art* (with a major nod to collaborator Kristine Stiles)—would compensate for this single slight. Peter proudly points out that his writing has been translated into fourteen languages, including Basque and, most recently, Finnish.

. . .

This study of a life has relied heavily on the subject's own oral history accounts—his memories—filled in and elaborated, and sometimes contradicted, by the observations of over forty individuals whose lives intersected Peter's in meaningful and revealing ways over nine decades. Although this is a limited sample, most of the important events, accomplishments, and people in Peter's life do appear. It is not the case that in this series of "sketches" no stone was left unturned, but that is probably just as well. We have been guided in this biographical quest by important constants that go back to Munich: Peter's love of art; his problematic relationships, especially with women; and the political life that must grow out of his early involvement in the *Werkleute*. These themes do not entirely explain his life, but they do carry heavy importance and provide useful touchstones.

Peter's reputation lies in the early prominence he achieved as a voice for and about modernist art in Europe and America. In that respect, his assimilation into life in the United States was thorough and complete. His innovative publications and provocative exhibitions have secured

his position as an important presence and voice in his chosen field. This achievement is in part the result, as he is the first to point out, of being in the right place at the right time. In the 1960s, first in New York and then at Berkeley, he became as close to a celebrity as ordinary (which Peter is not) art historians could be. Peter certainly relished the attention and took full advantage of the benefits, social and professional, that that status conferred. In 2008, Peter was honored by a mayoral proclamation from Berkeley's mayor Tom Bates declaring March 25 Peter Selz Day. He was surrounded by his family and friends as he accepted the recognition for his contributions to his adopted city. And it seemed entirely appropriate that, there in city council chamber, he stood facing the 1973 Romare Bearden mural whose commission he had advocated as a civic arts commissioner more than thirty years earlier. Peter cannot complain about being a prophet without honor in his hometown. Nor was this the first such honor he received. Perhaps the most meaningful was the Order of Merit, First Class, awarded by the Federal Republic of Germany on 18 September 1963 for his "interest in twentieth-century German art." The award document was signed in Bonn by Dr. Heinrich Lübke, president of the Federal Republic, and presented at a ceremony in New York.

Ariel Parkinson was among the close friends and family who attended the ceremony at Berkeley's city hall. Ariel lives in the Berkeley hills a few blocks from Peter and Carole.[63] She is almost Peter's age, and the two of them have made a practice of walking through their residential neighborhood several times a week. They are obviously very fond of each other. Ariel is an artist with an interest in scenic design and theater, and as such her art would not seem to appeal to Peter's tastes. Nonetheless, because he likes her, he came to like her art. In 2009–10, in a show he co-curated in a commercial gallery on Bancroft Avenue, directly across from the UC Berkeley campus, he featured, among other works, several of Ariel's life-size stuffed-cloth nude male figures. The exhibition as a whole revisited his 1959 *New Images of Man* show at MoMA. Bearing the same title but with the addition of "and Woman," it aspired to update that controversial and influential exhibition.[64] Among the women included in the exhibition, Ariel stands out for her independent and eccentric vision—definitely producing new images of man—by a woman.

On their walks, Ariel and Peter forged a friendship with, in her words, "a tonic element of disagreement." Ariel, who admires Peter, nonetheless does not allow herself to be submerged by his authority:

> My friendship with Peter had three levels. As an aspiring painter and designer, I was inevitably impressed by his position and power in the art world. I had used, and continue to use, many of his books and articles as source material. I appreciate his scholarship and command of the field, knowing everybody by name, their life histories, what their work looks like and means. But we find grounds for difference on almost everything. I not only differ—I can be to some extent an untutored beast, [challenging him] on such eminences as Carl André and Christo, de Kooning and Guston, David Smith and Serra—along with Flemish portraits, Renaissance drawings, and equestrian bronzes.

Ariel said she thinks Peter tends to "acknowledge, perhaps too generously, the currents of style," but that though they find grounds for difference, they "share certain basic aesthetic tastes." Ariel sticks to her guns, as became evident in our discussion of *New Images of Man*, the exhibition of Selz's that she most respects: "He took two very young—they were in school, mind you—artists from this area, Stephen De Staebler and Nathan Oliveira. These two, then totally unknown, are among the few great artists the United States has produced. I would say Leonard Baskin [another Selz favorite] was one, De Staebler was two, and Oliveira was three." When asked who was number four or five, she paused. I suggested Richard Diebenkorn, whom Selz admires. "No, definitely not Diebenkorn." She explained: "A group of experts programmed a computer for elements of style to see if they could make a painting by so and so. And the only artist they had any success with was Diebenkorn. He had a formula."[65]

But Ariel's affection for Peter trumps her reservations even about his support for artists she found unworthy. Her description of her friend is a tribute, and a somewhat romantic one at that: "Peter has remained a real human being. He loves and appreciates food and drink. He likes dogs and cows. And . . . it's very nice to have Peter as a friend, a real friend that you love. But it's more an affection, for I think of him as a

little boy sometimes. I can see a little boy, with bright eyes, very wide apart under dark eyebrows, loving things himself, responding to the old master paintings in his grandfather's gallery. To the green meadows that they went walking in on Sundays. And girls—endless girls. One girl after another."[66]

Peter thrives on attention. And his persistently youthful enthusiasm is what attracts many people, especially students. For many, too, this patented Selz "passion" excuses perceived shortcomings and character flaws. His daughter Gabrielle is only one of many who point to the "creative life force" that has provided the fuel for him to pursue the art life into his early nineties.[67] He is widely admired as a phenomenon of durability, and this quality is what artists point to as separating Peter from the pack of other art historians.

Painters Kevan Jenson and Ursula O'Farrell are among the up-and-coming artists of whom Peter is so fond. Jenson recently moved from Los Angeles to Berkeley, partly owing to his contact with Peter, who organized and wrote the catalogue essay for his recent one-man show at San Francisco's Meridian Gallery. A close personal connection has developed between the two, very much as between Peter and Tobi Kahn in New York. Jenson is effusive in his appreciation of his friend: "Peter Selz has gone out of his way to help me and others with our careers, but his reminder that you, the artist, are connected to the long tradition of art making provides the deepest inspiration. I once overheard him say that 'painting has been around since Lascaux, and I don't think it's going anywhere.' I knew then I couldn't stop painting."[68]

O'Farrell, whom Peter included in the recent show at the Alphonse Berber Gallery in Berkeley, has this to say: "After graduating from college, I was granted a foreign study scholarship to travel to Germany and Austria to explore my personal fascination with Expressionism. . . . I was quite fortunate to run across several paperback books [in English] in a few German stores—all written by Dr. Peter Selz. His writings guided me and helped me to better appreciate the art I was enthralled with . . . to understand the nature and context of these forceful paintings."[69]

Book editor Lorna Price (now Dittmer) came into Peter's life and career during his time at Pomona College, where as an undergradu-

ate she showed his lecture slides. Then—remarkably, in her view—he hired her to do the preliminary editing of *German Expressionist Painting*, which was being prepared for the University of California Press. Lorna followed Peter as one of his main editors for years, including several based at UC Press. Along with Kristine Stiles, Lorna may be the most intimately involved with Peter's publications.

> Peter has always been able to invest confidence in the people he's worked with, whether aspiring young art historians ready to embark on their own careers, or whether someone like me, not an art historian or even an art history major. I'm forever grateful that he placed confidence in the (then rather lightly tried) skills that I could deploy as reader/editor—skills that could serve us both over the years. That confidence did serve to show me the way to a new career track—one which has brought me enormous satisfaction over the course of five decades.[70]

Late in life, Peter Selz remains surrounded by a veritable congregation of friends, family members, and colorful admirers. There may be fewer such folk among his colleagues, but those who do maintain contact with him tend to be generally indulgent and affectionate. They appreciate his best qualities and are amused—perhaps even charmed—by his foibles. The following words, written by his step-granddaughter, Kyra Baldwin, seventeen years old and preparing to enter university, put it all into satisfactory perspective:

> So anyway, I had a great talk with Peter! He asked me why I wanted to go to each school and what I do with my time, and then he just asked me to keep talking. I told him what I had done that day—cut up a Northeastern University sticker and put it back together to spell "another tiny universe" on a windowpane. His eyes lit up. . . . Peter is a supportive, lively grandparent. When we walk into the Berkeley Art Museum or SFMOMA, he knows the people working at the desk. Other museum visitors come up to him and chat. It's a fun experience, spending time with such a well-known man in his element. Peter insists on taking me to see the SFMOMA permanent collection every couple of years; at this point, it is familiar enough to work as a context for other art I see.[71]

It turns out that there is a certain sustained—and sustaining—pattern to Peter's life in art. Despite personal and professional difficulties

along the way, he remains committed to an aesthetic and intellectual ideal that has guided him throughout his life. The passion and enthusiasm—it would not be overstating the case to call it wonder—implanted by his grandfather Drey's expert introduction to the world of great art have only grown over the years. And Kyra's visits to SFMOMA, like Gabrielle's regular trips with her father to the Met, bring the art experience full circle. For Peter Selz, those Sunday afternoon visits to Munich's Alte Pinakothek to study the old masters amounted to a life-defining legacy, the pleasure and inspiration of which he has passed on to subsequent generations.

A Conclusion

LOOKING AT KENTRIDGE AND WARHOL

Throughout his long journey in the subjective, unpredictable, and contradictory world of contemporary art, Peter Selz has steered a focused, if not always steady, course. The study and interpretation of art is almost the opposite of science. Reputations wax and wane—as do the conceptual frameworks employed to identify and measure relative importance. Art is much closer to fashion, especially in a market-driven environment, than most historians or even critics find desirable. Understanding of it is neither absolute nor immutable, and therein may lie part of its attraction. Mystery and enigma are at the heart of the aesthetic experience.

In this fluctuating world, Peter has not feared to adjust his opinions and views when it seemed prudent, most notably with regard to Pop Art. In response to its eventual critical and art-historical acceptance, he revised his initial dismissal. But that partial acknowledgment of a criti-

cal "miscall" does not prevent him from maintaining an unassailable humanist position in his appraisal of two highly significant figures, one the star of the second half of the twentieth century and the other perhaps the most important, in Selz's view, in recent and current art.

In 2009 Selz had the opportunity to visit two concurrent major retrospectives in San Francisco: *Warhol Live,* at the M.H. de Young Memorial Museum; and *William Kentridge: Five Themes,* at the San Francisco Museum of Modern Art.[1] The pairing was fortuitous and instructive. There could hardly be a better way than through a comparison of these two artists to illustrate the enduring aesthetic beliefs and personal values that Peter Selz brings to art.

Critic Leah Ollman characterizes Kentridge's art in terms that would resonate with Peter's thinking:

> References to particular social and political circumstances abound in Kentridge's films, as well as in his prints, drawings and theater productions. His art is permeated with the texture of resistance yet it remains open-ended and thus is antithetical to propaganda. While it does share with agitprop art an immediacy, emotional urgency, and accessibility, it targets no particular person, class or regime as much as the broader, erosive power of forgetting, the phenomenon of "disremembering." The moral dimensions of memory, the discontinuities it provokes, the burden of its light (or shadow) are all present in Kentridge's deeply affecting films.[2]

Her words neatly pinpoint the elements of Kentridge's art that Peter Selz finds most compelling and expressive of his own values. Seated among the roof garden sculptures at SFMOMA, following the last of five visits to view *Kentridge,* Peter spoke for the record on what he learned there:

> *Kentridge* is one of the most exciting shows of contemporary art I have seen, certainly since I saw the [Anselm] Kiefer show at MoMA some years ago. [In terms of modernism,] Kentridge has put it all together. . . . His method is located in early filmmaking. He makes films, engravings, drawings, photographs. He comes originally from the theater . . . at the same time he has all these important references to history, to politics, to art, to narration. He brings it together like nobody has done before. This man is one of the few contemporary artists who I think is a genius.

Peter went on to describe his visits to the show almost in terms of a pilgrimage, one that represents his deepest feelings about what art can and should be in the modern world:

> I've seen this show many times, and I heard him lecture at Berkeley. In the *Magic Flute* he records all this light music of Papageno and shows Sarastro as the wise man of the Enlightenment. At the same time, he shows people chopping off heads as the colonialists were bringing the Enlightenment to the Dark Continent, specifically the German genocide of the natives of German Southwest Africa. . . . I think of him quite a lot, and what I see is a continuation of existentialism because, especially in *The Nose*—but also in other works—he's interested in the absurd. And that's what you see— the existential talking about action in face of the absurdity of life.[3]

When asked what connections he would draw between Kentridge and earlier modern art, Selz was at no loss for words on the subject. He framed his response as a challenge to Pop Art and color-field painting, two phenomena he resisted in the early 1960s:

> I would say [Kentridge] is the opposite of Pop Art. And in a way, Warhol and the other Pop artists are very much like the color-field painters of the same time. . . . Marshall McLuhan called that "cool" art. "Hot" art came before, drawing from Abstract Expressionism. And Kentridge is . . . entirely on the side of "hot" art, with all kinds of energy. There is no energy that I get from a Warhol painting. Or, well . . . a painting by Frank Stella. . . . Leo Steinberg wrote an important essay in which he said the mind is part of the eye—[and I see the mind] lacking in the "cool" art.
>
> As for the connection to earlier modernism, I was happy to read and, when [Kentridge] came to Berkeley, to hear directly of his great admiration for Beckmann. . . . I see the same deep connection to the human being and to history, the continuity of history, in Kentridge as I see in Beckmann. . . . And certainly Picasso comes to mind [and the other] great figurative artists of the twentieth century—and expressionism. But Kentridge goes back further, to Goya. And it's that tradition which I think is most important.[4]

Selz wrapped up that idea with a reference to a recent conversation he'd had with his neighbor and friend Ariel. In one of their many discussions of what makes good art, how one may define it, he told her that "good art is a visual metaphor for significant human experience."[5] That,

he said, was precisely the quality that was missing in the Warhol retro-spective at the de Young Museum. For Peter, Kentridge has it; Warhol does not. Selz cites Kentridge as the only living artist who comes close to Kiefer in metaphorically depicting significant human experience.

Selz's 1963 rebuke of Pop Art has clung to him throughout his career. At the time, Peter and most of his colleagues at MoMA were becoming somewhat marginalized by their resistance to new art in general.[6] From a strategic career perspective, Peter now looks back at his position as unfortunate. Yet he has not entirely recanted his opposition. In fairness, MoMA was somewhat more open-minded regarding Pop than Selz's vocal antagonism would suggest. Bill Seitz, representing the museum, acquired a Marilyn painting for $250 from Warhol's 1964 show at the Stable Gallery. When Selz called his associate to disparage the show, asking, "Isn't that the most ghastly thing you've ever seen?" Seitz pur-portedly responded, "Yes, isn't it? I bought one."[7]

In an ironic turn of events, Selz may prove to have been at least partly justified. Warhol, as the emperor of Pop, is undergoing rather strenuous reevaluation. His anointment as the leading heir to Marcel Duchamp is increasingly questioned.[8] It is not exactly that the emperor has no clothes, but perhaps his suit is off the rack. And if the suit is the sum and substance of the art, then it may be time to question the entire enterprise. If that in fact proves to be the art-historical eventuality, the Peter Selz position, at the time unpopular, may assume the authority of prescience. However the dust on that particular issue settles, the theme in connec-tion with Peter's career remains valid: that is to say, Selz very often swam against the prevailing current of popular interest, critical endorsement, and even scholarly validation.

What is remarkable, and defines Selz's position, is an unfaltering con-viction about the way—his way—to approach and understand art and artists. His fundamental and frequently contrary vision of how art best functions as a worthy metaphor for "significant human experience" is unwavering. In the end, it remains the hallmark of Peter Selz's distinc-tively unconventional life. Seduced by a vision of art, the Munich teen-ager carried it with him to his new world and found a way to apply it to his life, thereby creating a career, an identity, and a way to be in the world.

Notes

ABBREVIATIONS

AAA 1982 Author interview with Peter Selz, July, August,
 and September 1982 (housed in the Archives
 of American Art, Smithsonian Institution)

Andersen interview Author interview with Wayne Andersen,
 17 January 2008

Ashton interview Author interview with Dore Ashton,
 16 February 2007

Bachert interview Author interview with Hildegard Bachert,
 15 January 2008

Carole Selz interview Author interview with Carole Selz, 20 April
 2007

Christo and Jeanne-Claude Telephone interview with Christo and
interview Jeanne-Claude, 27 June 2007

Denes interview	Author interview with Agnes Denes, 15 January 2008
Dickinson interview	Author interview with Eleanor Dickinson, 3 January 2008
Dillenberger interview	Author interview with Jane Dillenberger, 12 June 2008
Edgar Selz interview	Author interview with Edgar Selz, 19 November 2007
Forbes interview	Author interview with Hannah Forbes and Peter Selz, 9 February 2008
Garcia interview	Author interview with Rupert Garcia, 3 June 2009
Hedrick interview	Author interview with Wally Hedrick, 10 and 24 June 1974
Hinckle interview	Author interview with Marianne Hinckle, 1 August 2008
McCray interview, AAA	Porter McCray in an oral history interview with Paul Cummings, 17 September– 4 October 1977, Archives of American Art, Smithsonian Institution
Memoir 1	Author interview with Selz, 1 September 2005
Memoir 2	Author interview with Selz, 25 August 2007
Memoir 3	Author interview with Selz, 8 November 2007
Memoir 4	Author interview with Selz, 5 December 2007
Memoir 5	Author interview with Selz, 10 March 2008
Memoir 7	Author interview with Selz, 23 June 2008
Memoir 8	Author interview with Selz, 4 August 2008
Memoir 9	Author interview with Selz, 7 January 2009
Memoir 10A	Author interview with Selz, 8 April 2009
Memoir 10B	Author interview with Selz, 22 April 2009
MoMA (Zane)	Sharon Zane interview with Selz, February 1994, for the Museum of Modern Art Oral History Project
Oliveira interview	Author interview with Nathan Oliveira, 7 September 1980

Spafford/Sandvig interview	Author interview with Michael Spafford and Elizabeth Sandvig, 25 July 2008
Stiles interview	Author telephone interview with Kristine Stiles, 25 June 2008
Thalia Tapes	Taped conversations between Peter and Thalia Selz, November 1993 and July 1994

PREFACE

1. The improvisational nature of Banyan's music matches Norton Wisdom's free-form painting, recalling the collaborative performances of the 1950s involving jazz and Abstract Expressionist gestural painting.

2. Author phone interview with Norton Wisdom, 25 November 2009. Selz's receptivity to new and shifting cultural phenomena is evident in the "Countercultural Trends" chapter of his book *Art of Engagement: Visual Politics in California and Beyond* (Berkeley: University of California Press, 2006). The section on the punk movement, which Selz was not overly familiar with, benefited from his conversations with people, no doubt including Bruce Conner, who were enthusiasts themselves. That included the author of this book, who introduced Selz to the garage band X, which, coincidentally, established its national reputation at the Whisky a Go Go. As it happened, according to Wisdom (phone conversation, 10 June 2010), X's singer Exene Cervenka was among the artists in attendance at the same Banyan concert.

3. Author phone conversation with Charles and Zelda Leslie, Bloomington, Indiana, 6 May 2008. Charles Leslie was a fellow student at the University of Chicago and a professor of anthropology at Pomona College when Selz was on the faculty. The couples were very close, and Peter has kept in touch. Charles died in 2009.

4. Author interview with Gabrielle Selz, Berkeley, 16 April 2007.

5. Roberta Smith, "Martín Ramírez: Outside In," *New York Times*, 26 January 2007.

6. From the citation for the Charles Rufus Morey Book Award presented to Peter Selz for *Art of Engagement: Visual Politics in California and Beyond*. Selz has had a close relationship with the University of California Press over the years as the author of several books and collaborator on others. The award jury was chaired by William Wallace, Washington University (St. Louis). The quotation here is slightly edited and abridged.

7. The entire Selz Biography Oral History Project, both digital recordings and transcripts, have been accepted into the collection of the Regional Oral History Office at the Bancroft Library, University of California, Berkeley.

1. CHILDHOOD

1. Peter explains that the American immigration people required a second name. A friend had told him he looked like the actor Leslie Howard. Not wanting to use the German-sounding Hanns, and with Howard also starting with an H, the young arrival chose Howard. Professionally for years he used Peter H. Selz.

2. Author interview with Selz, Berkeley, 8 November 2007; hereafter referred to as Memoir 3. Other memoirs are indicated by their numbers, with dates indicated at first entry. Most of the quotations in this book come from a series of interviews conducted by the author with Selz and many individuals important to his life and career.

3. Memoir 3, 49.

4. Ibid., 28–29.

5. Ibid., 45.

6. Ibid., 30.

7. Memoir 4 (5 December 2007), 16.

8. Ibid., 16–17.

9. As recounted by Peter's friend Marianne Hinckle, phone conversation, 21 February 2008. Selz was pleased to have this detail added; he had evidently forgotten telling Hinckle the story years earlier.

10. Edgar Selz interview, Laguna Woods, Calif., 19 November 2007, 21; hereafter Edgar Selz interview. Memoir 3, 29; Memoir 4, 2–3. According to Peter, his grandfather was admired by the great Rembrandt scholar Jakob Rosenberg, who purportedly told Peter, "The most I ever learned about art was not at the university but from your grandfather" (Memoir 3, 32).

11. Memoir 2 (25 August 2007), 4–5.

12. Memoir 3, 30–31.

13. Edgar Selz interview, 35–36.

14. Memoir 3, 41.

15. Several books include mention of these groups, German and Jewish, but few seem to consider fully the way in which they were used to manipulate young minds in the service of national goals. Among the notable exceptions is Peter Gay's memoir, *My German Question: Growing Up in Nazi Berlin* (New Haven: Yale University Press, 1998). In a sense, Peter's innocent Munich youth and the intimations of the horrors on the way seem to come together in the *Werkleute* and the urgent, soon desperate, circumstances that determined its purpose and agenda within the Jewish community.

16. Memoir 4, 4–5.

17. Edgar Selz interview, 35.

18. Memoir 3, 34.

19. Selz, *Art of Engagement*, 25.

20. Memoir 3, 56.

21. Memoir 4, 5–6.

22. Memoir 3, 15–16.

23. Two excellent books on this subject, both of which locate the rise of Hitler, right-wing radicalism, and anti-Semitism within the Weimar Republic, are Peter Gay's *Weimar Culture: The Outsider and Insider* (1968; New York: Norton, 2001) and Eric D. Weitz's *Weimar Germany: Promise and Tragedy* (Princeton: Princeton University Press, 2007).

24. Memoir 3, 16.

25. Memoir 4, 7.

26. Ibid., 8.

27. Memoir 3, 12. Weimar politician Walter Rathenau (Jewish foreign minister of the Weimar Republic, assassinated in 1922) famously observed that sometime in his or her youth, each and every German Jew realizes "he is a second-class citizen" (quoted in Anthony Heilbut, *Exiled in Paradise: German Refugee Artists and Intellectuals in America from the 1930s to the Present* [Boston: Beacon Press, 1984], 10). Heilbut provides a useful summary guide to Peter Selz's immigration story, including his enthusiastic embrace of America and his summary dropping of the German language. The importance of language as a way to maintain German identity is discussed by Heilbut (89). The other side of the language coin, the hostility that met the German language, especially after the United States entered the war, is mentioned by Jarrell C. Jackman in the introduction to *The Muses Flee Hitler: Cultural Transfer and Adaptation, 1930–1945*, ed. Jarrell C. Jackman and Carla M. Borden (Washington, D.C.: Smithsonian Institution Press, 1983), 19.

28. Memoir 3, 13.

29. Memoir 3, 2.

30. Edgar Selz interview, 21.

2. NEW YORK

1. Memoir 3, 13–14.

2. Sharon Zane interview with Selz, February 1994, for the Museum of Modern Art Oral History Project, 5; hereafter MoMA (Zane).

3. Peter Gay, *My German Question: Growing Up in Nazi Berlin* (New Haven: Yale University Press, 1998). The experience of getting out of Germany for the Fröhlich family (surname changed to Gay—one meaning of *fröhlich*—upon entering the United States) was harrowing. Peter Gay credits his father for his tenacity and creative responses to essential harassment that finally delivered

him and his family to the less than welcoming United States (this was 1939, when the quotas had been tightened). ·

4. Memoir 3, 20, 21–22.

5. Edgar Selz interview, 34.

6. Ibid., 26.

7. Author interview with Hildegard Bachert, New York, 15 January 2008, 4, 5; hereafter Bachert interview.

8. Author interview with Hannah Forbes and Peter Selz, Marina del Rey, Calif., 9 February 2008; hereafter Forbes interview. (Some of the interview is condensed in the following quotes.)

9. Forbes interview, 27.

10. Ibid., 30.

11. Ibid., 31

12. Ibid., 33. Hildegard says she came to the United States with the name, made up by her group in Germany because they disliked the Germanic "Hildegard" (letter, 1 October 2010).

13. Memoir 3, 4.

14. Ibid. Some online genealogies list Drey's death in 1930.

15. Bachert interview, 3, 6, 8.

16. Ibid., 20–21, 23, 24. Hildegard describes a social life that increasingly included "superficial parties, drinking, and small talk that put me off." Selz (e-mail to author, 9 August 2009) strenuously objects to this characterization, pointing out that at the time he was often working the night shift at his sponsors' brewery in Bushwick. Instead, he attributes her breaking off the engagement to a romantic attachment she had with an art dealer.

17. Bachert interview, 34.

18. Ibid., 29.

19. Author interview with Peter Selz, Berkeley, Calif., July, August, and September 1982 (housed in the Archives of American Art, Smithsonian Institution), 5; hereafter AAA 1982.

20. MoMA (Zane), 4. An almost identical account appears in the 1982 interview for the Archives of American Art. It is evident that in Selz's mind his long professional career began with these early experiences.

21. AAA 1982, 5.

22. Ibid., 5–6.

23. MoMA (Zane), 5.

24. Memoir 3, 3–4.

25. Ibid., 4.

26. AAA 1982, 7.

27. MoMA (Zane), 7–8.

28. Memoir 3, 24. Parades and Nazi regalia were not forbidden in New York

City until after March 1938, when the Nazi government declared that no *Reichs-deutsche* (Germans living abroad) could be members of the German-American Bund, and no Nazi emblems were to be used by the organization. Nonetheless, on 20 February 1939, a Bund rally at Madison Square Garden had an attendance of 20,000. See Sander A. Diamond, *The Nazi Movement in the United States, 1924– 1941* (Ithaca and London: Cornell University Press, 1974).

29. Ibid.

30. Ibid., 28.

31. AAA 1982, 6–7.

32. Ibid., 7–8. The Donahues were among Selz's first close non-Jewish American-born friends, and presumably represent a widening of his social milieu. Selz credits Donahue's first teaching position as contributing to his awareness that one could make a living from the study of art and art history.

33. Memoir 4, 17.

34. Memoir 4, 17.

35. E-mail from Peter Selz to the author, 8 August 2009.

36. Selz has remained consistent in his antiwar position.

37. Peter Selz phone conversation with the author, 2 October 2008. For the story of OSS involvement (after having achieved grudging British approval to take part in their operations), see Colin Beavan's *Operation Jedburgh: D-Day and America's First Shadow War* (New York: Viking Penguin, 2006). I am also indebted to Meredith Wheeler for sharing information from her own study of Operation Jedburgh and other OSS covert operations in France (e-mail, 29 November 2010).

38. Selz phone conversation, 2 October 2008.

3. CHICAGO TO POMONA

1. MoMA (Zane), 10.

2. AAA 1982, 10.

3. Ibid., 14. Selz also acknowledges Ernest Scheier at Wayne State University, Detroit, as an early authority who knew a lot and "was helpful" (ibid., 15).

4. Ibid., 15.

5. Memoir 2, 4–5.

6. Ibid.

7. Ibid., 6.

8. The other modern art dissertation, on Cubism, was written by Herschel B. Chipp at Columbia, who also ended up at the University of California, Berkeley. Peter remembers meeting Herschel at one of the College Art Association meetings while he was at Pomona, and Herschel later wrote a long, generally positive review of *German Expressionist Painting* in *Art Bulletin* 41, no. 1 (March

1959): 123–24. After Selz's arrival at Berkeley in 1965, and especially through the 1970s, he and Chipp were the art history department modernists. Peter says he and Herschel eventually split the teaching of the history of twentieth-century modernism: "[We] shared the students doing their graduate work in modern art. And it was an extremely interesting combination. . . . Herschel was the more methodical. I was more explorative and paid more attention to new ideas, which then had to be rectified and put in context" (Memoir 10A [8 April 2009], 1).

9. Memoir 2, 6.

10. AAA 1982, 11.

11. Ibid.

12. MoMA (Zane), 11–12.

13. AAA 1982, 13, 17; additional details provided in e-mail communication, 9 January 2010.

14. Ibid. Selz's attraction to the work of Beckmann was immediate and introduced a fifteen-year study of the artist, culminating in a 1964 Museum of Modern Art book and exhibition (in collaboration with the Museum of Fine Arts, Boston, and the Art Institute of Chicago). His long essay in *Max Beckmann* is among Selz's most compelling artist treatments. A sense of immediacy and interaction (as in conversation) seems to be typical when he had direct personal access to his subject. This quality informs and enlivens some of Selz's best writing, growing as it does from his keen interest in people as individuals.

15. Selz in "Modernism Comes to Chicago," originally published in *Art in Chicago, 1945–1995* (Chicago: Museum of Contemporary Art, 1996), reprinted in Selz, *Beyond the Mainstream* (Cambridge: Cambridge University Press, 1997), 196.

16. AAA 1982, 16.

17. Ibid., 16. The Selz scrapbook for the 1940s and 1950s (Peter Selz Papers, Archives of American Art, Smithsonian Institution) contains a few reviews, an announcement, and the catalogue for the summer 1947 exhibition. In the 1982 interview, Selz said: "I did a show of Chicago art. . . . I saw all of the Chicago artists and selected a show of forty pictures." In fact, as Selz acknowledges in the small catalogue for the show, this was a collaborative effort by the Student Committee (of which he was chair) of the Renaissance Society, in which students selected the artists who then submitted works. Selz wrote in the foreword that "the exhibition though small in number is large in scope, illustrating many trends in contemporary art." These ran from "traditional" realism through "Midwest style" and Expressionism to Surrealism and abstract art, including a nonobjective example from "the late Laszlo Moholy-Nagy." It is likely that Selz provided the informed art-historical framework for the show. Among the few familiar names, in addition to Moholy-Nagy, were Aaron Bohrod and Felix Ruvolo, as well as African American artists Archibald Motley Jr. and Eldzier Cortor.

18. Frank Holland, "World of Art: Society Opens Exhibition of Chicago Art," undated and unidentified clipping, Selz scrapbook, 1940s–1950s.

19. AAA 1982, 16–17.

20. Ibid., 18.

21. MoMA (Zane), 13–14.

22. AAA 1982, 17. This revised notion of a heretofore homogeneous Bauhaus style and program was the subject of a recent exhibition, *Bauhaus 1919–1933: Workshops for Modernity,* at the Museum of Modern Art in New York (8 November 2009–25 January 2010).

23. AAA 1982, 18.

24. Ibid., 19.

25. Ibid.

26. Author interview with Michael Spafford and Elizabeth Sandvig, Seattle, 25 July 2008, 9, 13; hereafter Spafford/Sandvig interview.

27. Ibid., 26.

28. Ibid., 51.

29. Ibid., 23.

30. Ibid.

31. Phone conversation with Charles and Zelda Leslie, 5 May 2008.

32. Spafford/Sandvig interview, 23.

33. Phone conversation with Charles and Zelda Leslie, 5 May 2008.

34. AAA 1982, 19–20.

35. Ibid., 21.

36. Panel discussion, Laguna Art Museum, 15 March 2009: "Alternate Universe: 1950s and 1960s—Los Angeles and the Claremont Group." Panelists: Paul Karlstrom, moderator; Jack Zajac, Doug McClellan, Paul Darrow, and Tony DeLap.

37. AAA 1982, 21.

38. Ibid., 22.

39. Spafford/Sandvig interview, 25.

40. MoMA (Zane), 2–21.

41. Leonard Pitt and Dale Pitt, "Freeways," in *Los Angeles A to Z* (Berkeley: University of California Press, 1997), 157–61.

42. For the authoritative source on this cultural phenomenon in Southern California, see Dorothy Lamb Crawford, *Evenings On and Off the Roof: Pioneering Concerts in Los Angeles, 1939–1971* (Berkeley: University of California Press, 1995). See also her more recent contribution on the subject, *A Windfall of Musicians: Hitler's Émigrés and Exiles in Southern California* (New Haven: Yale University Press, 2009).

43. AAA 1982, 26–27.

44. Ibid., 22–23.
45. Ibid., 30.
46. Ibid., 31.
47. Ibid.

4. BACK IN NEW YORK

1. AAA 1982, 31.
2. Ibid.
3. MoMA (Zane), 26.
4. Ibid., 27–28.
5. New York MoMA certainly deserves the title of "greatest." As for first, Katherine Dreier's Société Anonyme (1920) precedes MoMA by almost a decade, with the Phillips Collection in Washington, D.C. (1921), just behind. Established by Dreier, Marcel Duchamp, and Man Ray as the "first experimental museum for contemporary art," the Société in conceptual vision trumped MoMA as a bastion of the avant-garde. For an informative treatment of the history and superb collection of the first truly great modern art endeavor, see *The Société Anonyme: Modernism for America* (New Haven: Yale University Art Gallery and Press, 2006).

6. Alice Goldfarb Marquis, *Alfred H. Barr Jr.: Missionary for the Modern* (Chicago and New York: Contemporary Books, 1989). The fascinating story of the "founding mothers," starting with several pages devoted to Abby Aldrich, appears on pages 59–65. The key role of women at MoMA emerges, but it is not an explicit focus. The history of misogyny, anti-Semitism, and racism at this all-white male Christian institutional enclave appears only in fragmentary fashion elsewhere. Given the importance of Selz's position at MoMA and his sometimes controversial exhibitions, as well as the fact that he was discovered by Barr, it is surprising that Selz is not mentioned in Marquis's biography. In effect, hers is an abbreviated, somewhat superficial history of MoMA. For a more thoughtful (if less lively and anecdotal), art-historically informed account, see Sybil Gordon Kantor, *Alfred H. Barr Jr. and the Intellectual Origins of the Museum of Modern Art* (Cambridge, Mass.: MIT Press, 2001).

7. Marquis, *Alfred H. Barr Jr.*, 63–64. Paul Sachs was secure in his choice, and he had the respect of the committee planning the new museum.

8. Kantor, *Alfred H. Barr Jr.*, 364. Barr's problems with the board and the circumstance of his firing are presented with insight and nuance by Kantor (see epilogue, 354–77). With her exclusive emphasis on Barr, as in Marquis's biography, Kantor gives curators short shrift, further enhancing the Barr legend. Neither Selz nor associate curator William Seitz appears in the index. Doro-

thy Miller appears seven times, including a section pretty much her own titled "American Artists Find Their Champion" (234–39). Although she played an early role in recognizing trends in American art, in the 1960s Selz and Seitz, among a few others, were the curators who mounted the significant exhibitions.

9. Philip Johnson, *Memorial Service for Alfred Barr* (New York: Museum of Modern Art, 1981), unpaginated; quoted in Kantor, *Alfred H. Barr Jr.*, 365.

10. MoMA (Zane), 31.

11. Ibid., 32–33. Peter's account of bringing William Seitz from Princeton to MoMA for the Monet exhibition conflicts with that of Barr's biographer Marquis, who states that "in 1960, Barr brought Seitz as a curator to MoMA" (*Alfred Barr Jr.*, 262). Selz confirmed his version in a phone conversation (2 April 2010), however, reiterating that the selection of Seitz as his associate was his, seconded by Barr, and then effected, despite the director's reservations, by René d'Harnoncourt. It was, after all, Peter's department and presumably his decision.

12. MoMA (Zane), 36. Having interviewed many former staff members, interviewer Sharon Zane was well versed in the inside stories as well as the public programs and exhibitions of MoMA. She did a good job in teasing out of Selz and her other in-house subjects details and anecdotes about the eccentric (some have suggested dysfunctional) aspects of the museum's operation.

13. Author phone conversation with Selz, 2 April 2010. That view of Malraux's motives is supported by Porter McCray in an oral history interview with Paul Cummings, Archives of American Art, Smithsonian Institution, 17 September–4 October 1977 (www.aaa.si.edu/collections/interviews/oral-history-interview-porter-mccray-12974); hereafter McCray interview, AAA. This account was considered important enough to be mentioned in John Russell's obituary for McCray in the *New York Times*, 10 December 2000.

14. McCray interview, AAA.

15. Author phone conversation with Selz, 2 April 2010.

16. MoMA (Zane), 34.

17. Ibid., 36–37.

18. Ibid., 37–38.

19. AAA 1982, 31.

20. Ibid., 38.

21. Ibid., 39–40.

22. Ibid., 40–41.

23. ibid., 41.

24. Ibid., 41–42.

25. McCray interview, AAA.

26. AAA 1982, 42. Selz's use of the word *triumph* in connection with the New York School of painting is a slightly ironic nod to the popular idea of Abstract Expressionist supremacy, as expressed in Irving Sandler's influential study *The*

Triumph of American Painting (New York: Praeger Publishers, 1970). This markedly chauvinistic assumption was challenged by Serge Guilbaut in *How New York Stole the Idea of Modern Art*, trans. Arthur Goldhammer (Chicago: University of Chicago Press, 1983).

27. Selz in phone conversation with author, 3 March 2009.

28. Selz was then, as he is now, sensitive to the resistance shown by the still insular New York art establishment to major talents such as Mark Tobey and Morris Graves, both largely ignored, if not dismissed out of hand, because they were working outside New York City (though they did exhibit there). It amounted almost to professional suicide to insist on plying the artist's trade in regional backwaters such as the Pacific Northwest. The major critics, among them Clement Greenberg and Irving Sandler, sustained that prejudicial view of Tobey's work, despite his being mentioned as a source for Jackson Pollock's "all over" imagery and "drip" technique. Pollock in fact admired Tobey, with whom he exhibited in two 1944 group shows. In a letter (undated, postmark 5 January 1946) to Portland artist Louis Bunce (the two met at the Art Students League in the 1930s when Bunce and Willem de Kooning were studio assistants of Arshile Gorky), Pollock wrote: "New York seems to be the only place in America where painting (in the real sense) can come thru. Tobey and Graves seem to be an exception." And in a different letter: "Do you ever see Tobey or Graves? I still like their work a lot." Quoted in Paul J. Karlstrom, "Jackson Pollock and Louis Bunce," *Archives of American Art Journal* 24, no. 2 (1984): 26.

29. AAA 1982, 43.

30. Ibid., 43–44.

31. Ibid., 44.

32. The "pan" review to which Selz refers is no doubt the unsigned "New Images of (Ugh) Man" that appeared in *Art News* 58, no. 6 (October 1959): 38–39, 58. While crediting Selz and the museum for being involved in "something more important than a genial contemporaneity" by mounting "a protest against the Abstract Expressionists," the writer (Manny Farber)—apparently no longer a fan of Abstract Expressionism—takes Selz to task for including Pollock and de Kooning, thereby rendering the whole intent of the show "ridiculous."

33. AAA 1982, 32–33.

34. Memoir 9 (7 January 2009), 30.

35. Memoir 8 (4 August 2008), 1–5.

36. Ibid., 6.

37. Thomas B. Hess, "Editorial: Notes on American Museums," *Art News* 65, no. 7 (November 1966): 27.

38. Memoir 3, 42–43.

39. Author interview with Dore Ashton, New York, 16 February 2007, 10–11; hereafter Ashton interview.

40. Author interview with Marianne Hinckle, San Francisco, 1 August 2008, 8–9; hereafter Hinckle interview. Hinckle was close to the famous *Ramparts* journalist Hunter E. Thompson and interviewed Eldridge Cleaver, among other Bay Area "radicals," when she was in her twenties. Historian Kevin Starr told her she was "more political" than her brother, Warren (Hinckle interview, 15). From the beginning, politics—"civil rights and the antiwar thing"—were an important connection with Peter.

41. Hinckle interview, 7. Art historian Hans Maria Wingler was author of a book on Oskar Kokoschka as well as several books on the Bauhaus, among them *Bauhaus: Weimar, Dessau, Berlin, Chicago* (Cambridge, Mass.: The MIT Press, 1969).

42. Hinckle interview, 20.

43. Ibid.

44. Memoir 9, 37–38.

45. Ibid., 39.

46. Ibid.

5. MoMA EXHIBITIONS

1. Telephone conversation and typed note from Selz, 27 January 2009.

2. AAA 1982, 32–34.

3. Paul Tillich (1886–1965) was a leading Protestant theologian best known for his "methodology of correlation," a synthesis of Christian revelation with existential philosophy. Born in Brandenburg Province, Germany, he emigrated with his family—and with the encouragement of Reinhold Niebuhr—to the United States to accept a professorship (1933–55) at New York's Union Theological Seminary. In 1955 he went to Harvard Divinity School and in 1962 to the University of Chicago, Peter Selz's alma mater.

4. Paul Tillich, "A Prefatory Note by Paul Tillich," in Selz, *New Images of Man* (New York: Museum of Modern Art, 1959), 9.

5. According to Jed Perl, many artists objected to *New Images of Man* because the artists included "failed to dot their *i*'s and cross their *t*'s." Giacometti was the exception. See Perl, *New Art City: Manhattan at Mid-Century* (New York: Alfred A. Knopf, 2005), 503. Realist Fairfield Porter wrote a scathing review in *The Nation:* "The common superficial look of the exhibition is that it collects monsters of mutilation, death, and decay" (reprinted in Porter, *Art in Its Own Terms*, ed. Rackstraw Downes [New York: Taplinger, 1979], 59). Many reviews echoed this charge.

6. [Manny Farber,] *Art News* 58, no. 6 (October 1959): 39. In fairness to the New York critics, there were more positive reviews of *New Images of Man* than

Selz remembers. Although it is true that much of the imagery was generally described as grotesque and horrific, and that the show could be seen as a challenge to Abstract Expressionism, some critics were willing to consider the stated objectives of the exhibition as articulated by Selz. Among the more sympathetic critics were Emily Genauer (of whom Selz was not a fan), Dore Ashton, Katherine Kuh, and even John Canaday in the *New York Times*. Certainly not all critics, as Selz has it, were upset by or hostile to *New Images of Man*.

7. For Farber, see also chap. 4, n. 32.

8. John Canaday, "New Images of Man: Important Show Opens at Modern Museum," *New York Times*, 30 September 1959.

9. Aline B. Saarinen, "'New Images of Man'—Are They?" *New York Times Magazine*, 27 September 1959, 18–19.

10. Selz, *New Images of Man*, 12.

11. Saarinen, "'New Images of Man,'" 18.

12. Katherine Kuh, "Disturbing Are These 'New Images of Man,'" *Saturday Review*, 24 October 1954, 48–49. Coincidentally, Kuh succeeded James Thrall Soby, a trustee who performed as acting director prior to René d'Harnoncourt.

13. Peter Schjeldahl, "Beasts: Leon Golub's Stubborn Humanism," *New Yorker*, 17 May 2010, 116–17. The sentences that set Selz off actually recall the terms of the realist/abstraction divide and the outside–New York "loyalty to humanist strains in modern art . . . against the grain of American high art after Abstract Expressionism. A postwar fashion for humanist styles expired in a famous flop of an exhibition . . . which perhaps only Golub, of the younger artists included, survived without despair" (ibid., 117).

14. Letter from Peter Selz to Peter Schjeldahl, 18 May 2010 (copied to editor David Remnick), Peter Selz Papers, Archives of American Art, Smithsonian Institution.

15. Jean Tinguely, quoted in D. Hall and P. Wykes, *Anecdotes of Modern Art* (Oxford: Oxford University Press, 1990), 350.

16. Selz video interview conducted by the author for the British artist Michael Landy's *H2NY*, a documentary on Jean Tinguely's *Homage to New York* (1960). The interview was recorded by videographer/documentarian Douglas Weihnacht at Selz's Berkeley home on 12 December 2007.

17. Richard Cándida Smith, *The Modern Moves West: California Artists and Democratic Culture in the Twentieth Century* (Philadelphia: University of Pennsylvania Press, 2009), 110. Cándida Smith acknowledges, however, that "given the artists invited to appear [including Jasper Johns, Robert Rauschenberg, and Frank Stella] . . . *Sixteen Americans* seems to have predicted with remarkable accuracy the ruptures about to tear apart modern art in the United States" (ibid.).

18. See Marquis, *Alfred H. Barr Jr.*, 139–49. Miller was married to Holger

Cahill, head of the WPA art programs. There were rumors of an intimate relationship with Barr, which in a 1986 interview she dismissed, saying: "It's not anybody's business. Lots of women were in love with Alfred" (quoted ibid., 141).

19. Video interview of Peter Selz about Jean Tinguely's *Homage to New York,* conducted by the author, 14 December 2007.

20. AAA 1982, 34–36.

21. Memoir 8, 8.

22. John Canaday, "Machine Tries to Die for Its Art," *New York Times,* 18 March 1960.

23. AAA 1982, 36.

24. K. G. Hultén in handout for Tinguely, *Homage to New York: A self-constructing and self-destroying work of art conceived and built by Jean Tinguely,* Museum of Modern Art Sculpture Garden, 17 March 1960, 6:30–7:00 P.M. Hultén, later known professionally as Pontus Hultén, was a Swedish collector and respected international museum director. At the time of the Tinguely event at MoMA he was the newly appointed director of the Moderna Museet (Stockholm); he was also founding director (1973–80) of the Centre Georges Pompidou in Paris, and from 1980 to 1984 he was in Los Angeles as founding director of the Museum of Contemporary Art (MOCA). The California connection reinforced his friendship with Sam Francis and added, among younger L.A. artists, conceptualist Greg Colson. Hultén is author of *Tinguely: "Méta"* (London: Thames and Hudson, 1975) and *Jean Tinguely: A Magic Stronger than Death* (New York: Abbeville Press, 1987).

25. Peter Selz, "Acknowledgments," in *Art Nouveau: Art and Design at the Turn of the Century,* ed. Peter Selz and Mildred Constantine (New York: Museum of Modern Art, 1960, © 1959), 6.

26. AAA 1982, 36.

27. Ibid.

28. Ibid., 37.

29. Selz, "Painting and Sculpture, Prints and Drawings," in *Art Nouveau,* 55. The Gauguin painting on wood was alternately attributed to the School of Pont-Aven. Selz's essay illustrates Bonnard's *Le Peignoir* (ca. 1892) and the color lithograph *Screen* (published in 1899).

30. Selz, introduction to *Art Nouveau,* 12.

31. Ibid., 17.

32. Meyer Schapiro, "The Armory Show" (1950), in *Modernist Art: Nineteenth and Twentieth Centuries* (New York: George Braziller, 1978), 152.

33. Memoir 5 (10 March 2008), 22–23.

34. Emily Genauer, "Art: They're All Busy Drawing Blanks," *New York Herald Tribune,* 22 January 1961.

35. Peter Selz in *Rothko* (New York: Museum of Modern Art, 1961), 12–

14. This paragraph, an attempt to suggest depth of feeling in universal terms, stands out in, and somehow apart from, the rest of the essay. Perhaps more than any other art phenomenon, certainly more than the color-field painting with which Rothko is identified, Symbolism provides a more enlightening context for his work. The rest of the essay is written in Selz's straightforward descriptive style, one that he graciously acknowledges benefits from his editors.

36. John Canaday, "Is Less More, and When for Whom? Rothko Show Raises Questions About Painters, Critics and Audience," *New York Times*, 22 January 1961.

37. For a recent look at how the unregulated commercial (fine) art market impacts artists and their interdependent relationship with critics and curators, see Holland Cotter, "The Boom Is Over. Long Live the Art!" *New York Times*, 12 February 2009.

38. MoMA (Zane), 44–45.

39. Peter Selz, introduction to *Directions in Kinetic Sculpture* (Berkeley: University Art Museum, 1966), 6.

40. Ibid., 5.

41. Memoir 8, 7.

42. Conversation with Peter Selz, San Francisco, 24 May 2010. Selz was adamant on this distinction between the two terms (French and English).

43. Canaday quoting Jean Dubuffet in "Is Less More?"

44. Wylie Sypher in *Loss of the Self* (1962), quoted by Harold Rosenberg, "The Art World: Primitive à la Mode," *New Yorker*, 26 October 1968, 145.

45. Rosenberg, ibid., quoting Selz in *The Work of Jean Dubuffet* (Museum of Modern Art, 1962), 43.

46. MoMA (Zane), 78–79.

47. This feud and the dinner exchange that brought it out into the open are documented in increasingly hostile letters between the two men written between 6 September and 29 October 1980 (located in the 2010 installment of the Peter Selz Papers at the Archives of American Art, Smithsonian Institution). "I was surprised to say the least," wrote Elsen on 5 October, "when the other night at a dinner table in front of strangers you complained that you had been hearing that the 1963 MoMA Rodin exhibition was my show. . . . When I pointed out that I had picked the show, you looked as if you wished to challenge that fact. So challenge it now, in writing." Selz responded on 29 October in a conciliatory but unyielding manner: "I am sorry if I embarrassed you by discussing this matter at our dinner at the Swigs, but I don't think that anyone actually overheard our rather private discussion." In fact, the discussion was not in front of strangers, as I was there along with prominent collector and art dealer Rena Bransten and, as I recall, Helen Lundeberg, the guest of honor. And, whatever the merits on either side of the argument, it was indeed overheard by the entire table. Peter rests his

case on the acknowledgment of Elsen's role in the exhibition brochure: "I want to express my special thanks to Professor Albert E. Elsen of Indiana University not only for his authorship of the book on Rodin which the Museum is publishing in connection with this exhibition, but also for his essential advice and assistance through the preparation of the exhibition." The acknowledgments were signed: "Peter Selz, Director of the Exhibition."

48. *Max Beckmann* opened at the Museum of Fine Arts, Boston, 1 October 1964, before moving to MoMA for a December 14 opening and then on to Chicago, Hamburg, Frankfurt, and London.

49. Quoted in Selz, *Max Beckmann* (New York: Museum of Modern Art, 1964), 55. Alfred Barr's tribute to Beckmann appeared on the label for the triptych during its special memorial exhibition at MoMA.

50. Selz, *Beckmann*, 61.

51. Quoted in Selz, *Beckmann*, 58.

52. Ibid.

53. Libby Tannenbaum, "Beckmann: St. Louis Adopts the International Expressionist," *Art News* 47, no. 3 (May 1948): 21.

54. Selz, *Beckmann*, 91–92.

55. Max Beckmann, "Letters to a Woman Painter," ibid., appendix, 132–34. Translated by Mathilde Q. Beckmann and Perry T. Rathbone, the letters were read aloud by Mrs. Beckmann at Stephens College on 3 February 1948. Subsequently they were read at the School of the Museum of Fine Arts, Boston; over the radio in St. Louis during the 1948 Beckmann retrospective; at the Art School of the University of Colorado, Boulder; and at Mills College, Oakland, California. They were published in the *College Art Journal* 9, no. 1 (Autumn 1949): 39–43.

56. Perry Rathbone, "Max Beckmann in America: A Personal Reminiscence," in Selz, *Beckmann*, 125.

57. Ibid., 127.

58. MoMA (Zane), 80–81.

59. Selz, in *Alberto Giacometti* (New York: Museum of Modern Art, 1965), 7.

60. Ibid., 11.

6. POP GOES THE ART WORLD

1. Louise Bruner, "High Priest of Modern Art Speaks Nonobjectively," *The Blade* [Detroit], 11 December 1960. According to the article, two hundred people attended at a ticket price of $15 per person and $20 per couple, a fairly stiff admission fee for the time. Peter Selz was an art world celebrity. The sampling of thoughtful questions that were featured in the article indicate that at least some among the audience were informed about art and museum issues. One person

asked, "Since critics and museums in the past have been mistaken about the art of their times, why do you feel your taste in today's art is valid?" Selz's response was to the point: "We aren't secure; we only try to avoid pre-established theories of what art should be."

2. The changing role of MoMA as the exclusive arbiter of taste in terms of modern and contemporary art was much discussed by critics at the time. This issue seems to have come to a head first in the museum's delayed response to Abstract Expressionism and then a decade later in its lukewarm reception of Pop when it exploded on the scene. See the proceedings of MoMA's *A Symposium on Pop Art* (13 December 1963), organized and moderated by Peter Selz, in Steven Henry Madoff, ed., *Pop Art: A Critical History* (Berkeley: University of California Press, 1997), 65–81. Especially relevant to MoMA's responsibility to introduce new art is the symposium exchange between Hilton Kramer and Leo Steinberg. Kramer introduced the subject with a comment directed to Steinberg: "I think, Leo, that you are completely ignoring the role that the Museum plays in *creating* history as well as *reflecting* it. It is its responsibility as a factor in determining the course of what art is created that people are objecting to." Steinberg responded: "Of course the Museum has a role to play in making history . . . but there is a balance of power. The Museum is not alone" (ibid., 77).

3. Peter Selz was but one of the players in the kaleidoscopic picture of 1960s Manhattan painted by Perl. The role of the Museum of Modern Art is prominently discussed, including the influence of the *Art Nouveau* exhibition ("landmark in the history of taste," p. 383) that Peter conceived and initiated with a team of specialist curators. Selz's *New Images of Man* exhibition (1959) is mentioned twice (pp. 412 and 503), in each instance as if it represented Alfred Barr's interests and ideas about the role of MoMA in relation to contemporary art. These exhibitions are discussed almost as if they were formed by committee—as if the institution made the decisions and selections, rather than the curators. Selz's recollections differ on that important point. Many living artists remember *New Images* as a major statement against the Abstract Expressionist status quo as finally embraced by MoMA. The idea of who is in the leadership position—artists or institutions—is a major theme in Perl's book.

4. Fred Kaplan reviewing the Acquavella Galleries' exhibition of forty-four works from the former Scull collection in the *New York Times*, 10 April 2010, C1. In his introduction to *Pop Art: A Critical History* (Berkeley: University of California Press, 1997), Steven Henry Madoff further describes the changed and changing situation: "What was publicized and debated was driven by a rising power nexus in the art world of new collectors (most notably the Sculls) and dealers such as Leo Castelli, Virginia Dwan, and Sidney Janis" (xv).

5. By 1962 various critics were writing about the New Realism, also identified as Neo-Dada, under the name Pop Art. In addition to Sidney Tillim in *Arts Magazine*, February 1962, 34–37, most of the other leading critics weighed in.

John Canaday, two years later, as usual carved out the most conservative posi-
tion: "But whatever Pop is—its patrons and practitioners are still haggling over
definitions—it has arrived and gives every sign of staying around at least for a
little while. Whether or not Pop is a new art, and whether or not it can last, it
has supplied a new bandwagon. And in the art circus as it operates today, that
is the final accolade of success" ("Pop Art Sells On and On—Why?" *New York
Times Magazine*, 31 May 1964, 7ff.). Ironically, this may well have matched pretty
closely the view of Peter Selz, who was definitely no fan of Canaday. Among the
other writers paying attention in 1962 were Max Kozloff ("Pop Culture, Meta-
physical Disgust, and the New Vulgarians," *Art International*, March 1962, 35–
36); Brian O'Doherty ("Art: Avant-Garde Revolt," *New York Times*, 31 October
1962, 41); and, from the West Coast, Jules Langsner ("Los Angeles Letter," *Art
International*, September 1962, 49). Langsner was reviewing the historic exhibi-
tion *New Paintings of Common Objects* at the Pasadena Art Museum. This show
was distinguished by the inclusion of artists from California, notably Wayne
Thiebaud and Ed Ruscha, whose work Peter Selz had become acquainted with
during his few years at Pomona.

6. John Canaday, "Art That Pulses, Quivers, and Fascinates," *New York
Times*, 21 February 1965, Sunday magazine, 12.

7. Sidney Tillim, "Further Observations on the Pop Phenomenon," *Artfo-
rum*, November 1965, 17–19; reprinted in Madoff, *Pop Art: A Critical History*, 137.

8. Ibid., 139n2.

9. Henry Geldzahler, quoted in "A Symposium on Pop Art," *Arts*, April
1963, 37.

10. Hilton Kramer, quoted ibid., 38.

11. Perl, *New Art City*, 454, 454n37.

12. Thomas B. Hess, *Art News*, December 1962, 12; quoted ibid., 453). The
"old fogies" apparently included many of the Abstract Expressionists, but there
was also room for museum curators—including a few at MoMA—and others
associated with the established order. Peter Selz may well have been among
them. Certainly his romantic humanism and sense of social engagement ran
counter to the material-focused and antiphilosophical empiricism that was tak-
ing over the New York art world (see Perl's chapter titled "The Empirical Imagi-
nation: Beginning Again," 493–528). The emotionalism of Abstract Expression-
ism, together with the personal expression, an allusive quality Selz looked for
in both abstract and figurative art, became increasingly suspect in the early
1960s.

13. Peter Selz, "The Flaccid Art" (mistitled "Pop Goes the Artist"), *Partisan
Review* 30, no. 3 (Summer 1963): 316.

14. Richard Dorment, "What Is an Andy Warhol?" *New York Review of Books*
56, no. 16 (22 October 2009): 14–18. Dorment discusses Arthur Danto's *Andy War-
hol* (New Haven: Yale University Press, 2009), Tony Sherman and David Dalton's

Pop: The Genius of Andy Warhol (New York: Harper, 2009), and Richard Polsky's *I Sold Andy Warhol (Too Soon)* (New York: Other Press, 2009).

15. Arthur C. Danto, quoted in Dorment, "What Is an Andy Warhol?" 14.

16. Horst Weber von Beeren, cited ibid., 16. In this disregard for the authorial control of art production, Warhol was anticipated slightly by Salvador Dalí, whom he acknowledged as an influence.

17. Andy Warhol, quoted ibid.

18. AAA 1982, 46.

19. Ibid., 47.

20. Ibid.

21. Ibid., 48. The distance between what was meant by the New Realism and Selz's *New Images of Man* is evident in critic Sidney Tillim's definition of the New Realism as "anti-expressionist and anti-rhetorical" (*Arts,* March 1963; quoted in Perl, *New Art City,* 505). The "anti-expressionist" part alone would have been sufficient to turn Peter off.

22. AAA 1982, 50.

23. Ibid.

24. Perl, *New Art City,* 391–432 (a chapter titled "Going to the Modern").

25. The 1960s, as the time of abandoning the ideals of high art and seeing the world through low-art goggles, are central to a number of careers that sought to reconcile high and low at MoMA and elsewhere. Many years after the appearance of Pop, the new chief curator of painting and sculpture at MoMA, Kirk Varnedoe, attempted to do just that with his controversial exhibition *High and Low: Modern Art and Popular Culture* (1990). This ambitious blockbuster, co-directed by writer Adam Gopnik, opened to a critical "thrashing" (Grace Glueck, *New York Times,* 3 December 1990). Among the criticisms was that it imposed too strict an order on a sprawling topic and that the "low art" actually became partially domesticated within the institutional setting. In some respects, the initial hostile critical reception recalled the response to Peter's *New Images of Man.* Both exhibitions fared better with the public.

Peter was among those caught between potent and competing 1960s cultural forces, which inevitably had an effect on his career. Open though he was to new forms of authentic expression, he required that art encompass not just serious ideas but also knowledge of the history that made that art possible. The visual arts, whether in the hands of Donald Judd, Fairfield Porter, or Frank Stella, remained attached to an elitist vision of high art and culture that kept it separate from authentic popular manifestations. A still younger generation of artists simply wanted their own pool to swim in. But despite the fact that many of them adopted rock and roll as their soundtrack, pop songs did not immediately supplant jazz, considered the appropriate accompaniment to Abstract Expressionist painting in the 1950s, as advanced art's musical equivalent. In this distinction

between contemporary fine art and popular (mass entertainment) forms, a degree of elitism lingered.

26. Hess, "Editorial: Notes on American Museums," 27.

27. Russell Lynes, *Good Old Modern: An Intimate Portrait of the Museum of Modern Art* (New York: Atheneum, 1973), 418. Further light on the circumstances of Peter's departure is provided by Director of Public Information Elizabeth Shaw: "I do remember that, with René's assent, he stayed on four or five months ... in order to qualify for some kind of pension rights. René said it would be silly for him to leave in January, if by staying until May he would be entitled to something" (interview with Sharon Zane, MoMA Oral History Project, October/November 1991, 101).

28. Selz has commented several times during our conversations on the lack of friendliness among the staff at MoMA, returning to a wistful complaint that appeared in his 1994 interview with Sharon Zane (83): "I remember [thinking]— shortly before I left—Do any of these people spend their evenings together? . . . Do any of them ever invite each other to dinner? No." After reviewing the first draft of this book, Selz cautioned me: "Tone down my great optimism about MoMA. Yes I was able to do good things, but it wasn't all that rosy. There was respect among the curators, but not much friendship" (undated note to author).

29. Walter Bareiss interviewed by Sharon Zane, MoMA Oral History Project, September/October 1991, 87. Bareiss moved into the Modern Painting and Sculpture Exhibitions Department after Selz and Seitz departed.

30. Helen M. Franc interviewed by Sharon Zane, MoMA Oral History Project, April/May/June 1991, 168.

31. Ibid., 199.

32. Alicia Legg interviewed by Sharon Zane, MoMA Oral History Project, June/October 1991, 45.

33. Frances Pernas interviewed by Sharon Zane, MoMA Oral History Project, July 1994, 53. Pernas was publications manager from 1940 to 1962. She worked closely with curatorial staff, including Selz and Seitz, on catalogues. She remarked that Seitz was the better writer, but Selz was better organized.

34. Memorandum to Peter Selz from Richard H. Koch (Deputy Director and General Counsel), 20 January 1961; MoMA Archives (RdH, iv.2i78).

35. Conversation with Peter Selz, San Francisco, 30 April 2009.

36. The Seitz-Selz working relationship at MoMA appears to have been complicated, as René d'Harnoncourt cautioned Peter it might be before Seitz was hired. However, there is ample evidence that they enjoyed a warm personal friendship in the beginning. In a letter to Peter and Thalia dated 27 July 1960, Seitz exults about his upcoming job at MoMA: "It is not simply the Museum, or New York, but the unique possibilities I feel we have, for reasons I can't quite explain, working together." The letter is signed "Love (and that includes Irma)." William Seitz Papers, Smithsonian Archives of American Art.

37. Taped conversations between Peter and Thalia Selz, November 1993 and July 1994. According to daughter Gabrielle (e-mail to author, 11 May 2009), the first three sessions were recorded at her old apartment on 12th Street in New York City; the others were taped at the Selz residence in Berkeley. Quotations in the text that are not cited are from these recorded conversations, hereafter referred to as Thalia Tapes. Throughout the tapes, Thalia assumed the role of interviewer and narrator.

38. Telephone conversation with Selz, 15 May 2009.

39. E-mail from Dion Cheronis, 17 December 2009.

40. Memoir 9, 13.

41. Ibid., 14.

42. Norma Schlesinger's account has her, with her two boys in tow, departing without prior notice, her reason being the steady string of women who paraded through their marriage. She reiterated in her interview what Selz's other wives and lovers have stated was the main obstacle to a continuing relationship with him: Peter's refusal to understand that "extracurricular" connections, whether or not he considered them "serious," undermine essential trust in the primary relationship. Author interview with Norma Schlesinger, San Francisco, 7 March 2008, 18.

43. Memoir 9, 15.

44. Ibid., 19–20.

45. In the tapes, Thalia freely acknowledges that she had lovers.

46. Memoir 9, 28–29.

47. The manuscript that Gabrielle Selz allowed me to read was a draft, which she has classified as a work of autobiographical fiction.

48. Author interview with Tanya Selz, 26 February 2008.

49. Author interview with Peter and Gabrielle Selz, 15 February 2007, 6. She has often said that this father-daughter tradition, visiting museums and talking about art—i.e., being admitted to the world that matters to him the most—is what she especially values in their often troubled relationship.

50. E-mail from Gabrielle Selz, 11 May 2009. Perhaps more interesting in connection with parental love is her comment "We were just like houseplants. Water them every other day, and then leave them alone" (telephone conversation, 10 May 2009).

51. Letter from Thalia Selz to Peter Selz in Europe, 13 July 1964, New York. Communication #13, Thalia Selz papers, housed with Gabrielle Selz (estate of Thalia Cheronis Selz).

52. Thalia Selz journal entry for 12 January 1965; Thalia Selz papers.

53. Thalia Tapes.

54. Letter from Thalia to Peter in Europe, 2 July 1964; Thalia Selz papers.

55. Letter from Thalia to Peter, 13 July 1964; Thalia Selz papers.

56. Memoir 9, 13.

57. Peter's attempts at reconciliation with Thalia in Berkeley failed. But to this day he wishes they could have found a solution to their troubled marriage. He saw Thalia in many ways as his "soul mate." According to daughter Gabrielle, Thalia and Peter tried over the years to reconcile: "They stayed really connected. They worked on projects together . . . like a Greek-American art show at the Queens Museum about eight years ago [ca. 2000]" (Author interview with Gabrielle Selz, New York, 15 February 2007, 22–23).

7. BERKELEY

1. AAA 1982, 67. In the interviews conducted for the Archives of American Art during the summer and fall of 1982, almost ten years after he retired as museum director, Peter provided an informative account of his adventures in pursuit of those goals at the museum during his directorship, 1965–72 (pp. 54–72).

2. Ibid., 55.

3. For a thorough and up-to-date account of the Berkeley protest movement of the 1960s, see Robert Cohen, *Freedom's Orator: Mario Savio and the Radical Legacy of the 1960s* (Oxford: Oxford University Press, 2009). The author of this first biography of Savio is also co-editor, with Reginald E. Zelnik, of *The Free Speech Movement: Reflections on Berkeley in the 1960s* (Berkeley: University of California Press, 2002). A personal account of encountering the Free Speech Movement memorial, discreetly set in the pavement of Sproul Plaza, the placement and design reflecting Selz's participation and advice, is offered by artist Hassel Smith's stepson, painter Mark Harrington: "Peter told me this was a memorial to Mario Savio. . . . He described his own commitment at the time, newly arrived from NYC and committed to the student initiatives and their meaning. I found this moving in many ways, given Peter's own experience of repression as a youth in Nazi Germany . . . and the engagement of my stepfather, then teaching as a guest artist at UCB. He actively supported the students—as did Peter" (e-mail to author, 26 April 2010).

4. AAA 1982, 55.

5. Ciampi's "radical" brutalist concrete building shared familial traits with several other 1960s and 1970s museum designs, chief among them Marcel Breuer's Whitney Museum (1966) in New York and Gordon Bunshaft's (Skidmore, Owings & Merrill) doughnut-shaped Hirshhorn Museum (1974) on the Mall in Washington, D.C., none of which has stood the test of time. In "Artful Way to Expand a Museum," *New York Times*, Arts sec., 12, Roberta Smith describes the now evident shortcomings of the Whitney Museum of American Art's Madison Avenue building—many of which apply as well to the University Art Museum.

6. Peter Selz, 2006 notes toward an essay solicited for a book titled *Living with Artists* that was never published.

7. Author interview with Norma Schlesinger, San Francisco, 7 March 2008. Schlesinger wrote an account of her relationship with Mark Rothko, which she offered to share. However, she was in the final stages of terminal cancer when we conducted the interview, and died less than a month after; the written account was never sent. Although much of her interview was marked by bitterness toward her former husband, by the end of it she softened somewhat and acknowledged that, despite the marital difficulties, she retained some warm memories of and feelings for Peter (transcript pp. 22–23, as well as post-recording conversation).

8. Ibid., 22–23. Peter says Rothko gave *him* the red painting in recognition of his curating the Rothko retrospective.

9. Peter Selz, *Living with Artists* notes.

10. AAA 1982, 61.

11. For a colorful account of the truly inspired creation of the MoMA film library, the "event that had the greatest impact upon the Museum and its future," see Russell Lynes, *Good Old Modern: An Intimate Portrait of the Museum of Modern Art* (New York: Atheneum, 1973), 108–14. For example: Iris Barry—"an extremely handsome Englishwoman in her late thirties with navy blue eyes, fine features in a long oval face, and shining black hair"—impressed architect and MoMA board member Phillip Johnson so much that he not only offered to pay her salary as MoMA's first librarian but also gave her money to buy a dress at Saks Fifth Avenue (ibid., 110).

It was convenient that a film library was in the original prospectus for the new museum. Iris Barry's new husband, John E. Abbott, was appointed director of the Film Library, although Iris, as curator, actually ran the film program. Sexism has certainly played a role in MoMA's history. Some have made similar charges about the early years at Berkeley's UAM, among them former director Jacquelynn Baas (e-mail, 2 May 2010).

12. Renan and Langlois met in 1968; in 1969 Selz and Langlois signed an agreement setting out their shared goals. Lee Amazonas, "Guerrilla Cinematheque Comes of Age: The Pacific Film Archive," *Chronicle of the University of California*, no. 6 (Spring 2004), 147–49. Sheldon Renan, quoted in a February 1971 interview that introduces Amazonas's essay.

13. Sheldon Renan, e-mail to the author, 11 July 2010.

14. Phone interview with Tom Luddy, 9 July 2010. Still angry about the university's treatment of him, Peter, and PFA, Luddy seems to particularly resent dean Roderic Park and Edward Feder, both of whom "hated Peter." According to Luddy, the administration considered PFA "illegal." Furthermore, again according to Luddy, film was supposed to have been based at the Los Angeles campus.

In 1980, frustrated and humiliated by the administration's treatment of him, Luddy quit and accepted a job offer from Francis Ford Coppola. As director of PFA, he was "going broke," paid less than the union wages of janitors and slide projectionists.

15. Many recent books accept this idea of California cultural exceptionalism as a given, taking their lead from Carey McWilliams's classic *Southern California: An Island on the Land* (Salt Lake City: Peregrine Smith, 1973). In his introduction, McWilliams asserts that Los Angeles was different from the rest of the country, reflecting on his personal experiences from 1922 to 1951, when the region began to "make a real impact on national and world opinion" (xxi). See also Kevin Starr's *America and the California Dream* series, especially *Inventing the Dream: California through the Progressive Era* (New York: Oxford University Press, 1985) and *Coast of Dreams: A History of Contemporary California* (New York: Knopf, 2004). This sense of "difference" runs throughout the series, part one of which deals directly with art and culture, high and low. For a broader perspective, see Michael Kammen, *Mystic Chords of Memory: The Transformation of Tradition in American Culture* (New York: Knopf, 1991). Kammen's most relevant observation in connection with California may be that the concept of invention applies more productively to "developing nations" than to "established ones" (693).

16. AAA 1982, 57.

17. Ibid.

18. Ibid., 59.

19. Ibid., 62.

20. Phone conversation with Peter Selz, September 2007. Anecdote published in the author's introduction to the limited-edition exhibition catalogue, *Tribute to Peter Selz* (Sacramento: b. sakata garo, 2007), 21.

21. William T. Wiley's account "Remembering Peter Selz . . while he is here . . " appears in *Peter Selz: Limited Edition* (Sacramento: b. sakata garo, 2007), 61. It was published in conjunction with the exhibition *Tribute to Peter Selz* held in the b. sakata garo (gallery), Sacramento, 6 November–1 December 2007.

22. Lucinda Barnes, "Collecting the Moment—The Berkeley Art Museum," *Chronicle of the University of California: A Journal of University History* 6 (Spring 2004): 129–42. Barnes is now chief curator and director of programs and collections at the museum.

23. Phone conversation with Norton Wisdom, 25 November 2009.

24. Peter Selz, *Directions in Kinetic Sculpture* (Berkeley: University Art Museum, 1966), 6–7. Shortly before he joined the Bauhaus faculty (1922), László Moholy-Nagy with A. Kémeny published what amounted to a kinetic art manifesto (*Dynamisch-konstruktives Kraftsystem*) in the influential German Expressionist publication *Der Sturm*. An English translation appeared as *Vision in Motion* (Chicago: Paul Theobald, 1947).

25. Richard Buckminster Fuller, quoted by Calvin Tomkins in "In the Outlaw Area" [Profile], *New Yorker*, 8 January 1966, 36; quoted by Selz in *Directions in Kinetic Sculpture*, 5.

26. Author interview with Fletcher Benton, San Francisco, 7 January 2008.

27. AAA 1982, 58.

28. Ibid., 59.

29. Ibid., 60.

30. Harold Paris, "Sweet Land of Funk," *Art in America* 55 (March 1967): 94–98.

31. Author interview with Selz for the Archives of American Art, Smithsonian Institution, 1999, 14. Published in Paul J. Karlstrom and Dore Ashton, *Crosscurrents in Modern Art: A Tribute to Peter Selz* (New York: Achim Moeller Fine Art, 2000), 20 and 27. What united Rothko and Conner with Nathan Oliveira was emotional content ("soul").

32. Selz often featured Conner in exhibitions and articles and regularly describes Conner as one of California's great artists, a figure of national and international significance. In his survey on modern art, *Art in Our Times: A Pictorial History, 1890–1980* (New York: Harcourt Brace Jovanovich and Harry N. Abrams, 1981), Selz reproduces *Child* (1959–60) with the following text: "Bruce Conner's disquieting necrophilic *Child* was created to express his outrage against the brutality of the death penalty. . . . The anguished, distorted, and desecrated head screams in torture. This is a work of unrelieved pain—meant perhaps as a talisman or votive object against unmitigated horror" (396). (Echoes from *New Images of Man* reverberate here.) When asked about the specific ways in which he promoted Conner, Selz starts with his including the artist in William Seitz's *Art of Assemblage* (MoMA, 1961) with two works, *Deadly Nightshade* (1959) and *Last Supper* (1961). "This pretty well established him in NY, but he was never appreciated as much as he deserves" (e-mail to author, 16 April 2010). Peter also brought *The Box* (1960) to the attention of Alfred Barr, who bought it for MoMA despite the fact that it was a "gruesome assemblage . . . which was rarely shown" (ibid.).

33. Phone conversation with Bruce Conner, 20 June 2007. Famously elusive, Conner initially declined a request to be interviewed for this book. But despite his initial refusal to talk about Peter, he proceeded for almost half an hour to air his general grievances and express indignation about art institutions, most curators and writers, and above all art dealers.

34. Peter Boswell, quoted by Ken Johnson in "Bruce Conner, Beat Artist and Filmmaker, Dies at 74," *New York Times*, 10 July 2008, C-13.

35. Phone conversation with Conner, 20 June 2007.

36. Interview with Paula Kirkeby for the Bruce Conner Oral History Project, conducted by the author, 26 April 2011, Palo Alto, Calif.

37. Notes from phone interview with Peter Selz, 2 August 2010.

38. Deborah Paris Hertz, e-mail to the author, 14 August 2010.

39. Author interview with Wally Hedrick, San Geronimo, Calif., 10 and 24 June 1974; Archives of American Art, Smithsonian Institution, transcript available at www.aaa.si.edu/collections/interviews/oral-history-interview-wally-hedrick-12869. Hereafter Hedrick interview.

40. William T. Wiley in dinner conversation, Selz residence, Berkeley, 13 February 2009.

41. Hedrick interview.

42. Paris, "Sweet Land of Funk," 57.

43. See Constance Lewallen, "Commitment," *Chronicle of the University of California,* no. 6 (Spring 2004): 169–72. From 1979 to 1987, Lewallen was curator of the museum's MATRIX series, established by director James Elliott in 1978. The program featured international and local Conceptual artists of the first and succeeding generations. Current BAM/PFA director Lawrence Rinder served as curator from 1987 to 1997.

44. Ibid., 169.

45. Ibid.

46. Conversation with Peter Selz at poetry reading (Michael McClure and David Meltzer) at Oakland hills home of Carl and Susan Landauer, 14 April 2010. This conversation was followed by an e-mail from Selz more fully describing the origins of the *Funk* exhibition at the Berkeley Art Gallery.

47. Phone conversation with Peter Selz, 15 April 2010.

48. Richard Cándida Smith, *The Modern Moves West* (Philadelphia: University of Pennsylvania Press, 2009), 105.

49. E-mail to author from Sophie Dannenmüller, 16 April 2010. Dannenmüller is a Sorbonne art history doctoral candidate widely acknowledged as an expert on California assemblage art.

50. Deborah Paris Hertz, e-mails to author, 9 and 10 August 2010. Unless otherwise specified, these are the sources for all the information and quotes on the extracurricular recreational activities of Selz and Paris.

51. Deborah Paris Hertz, e-mail to author, 15 August 2010.

52. Terri Cohn, e-mail to author, 11 February 2010. Cohn, a respected and prolific oral historian, curator, and art writer, is a faculty member and graduate faculty advisor at the San Francisco Art Institute. She describes her training at Berkeley as "incredibly formalist"—valuable, but ultimately having little to do with the direction her artist-focused career eventually followed (e-mail, 15 August 2010).

53. Terri Cohn in conversation, 8 July 2010.

54. AAA 1982, 56.

55. Peter Selz, *Selection 1966: The University Art Collections* (Berkeley: University of California, 1966), 1.

56. AAA 1982, 63.

57. Ibid., 64–65.

58. Svetlana Alpers in *Selection 1968* (Berkeley: University Art Museum, 1968), 77–78.

59. Typed anecdotal notes sent to author by Peter Selz, 12 December 2008.

60. E-mail from Rinder to the author, April 30, 2010. Larry Rinder earlier spoke to this part of the museum's history in a conversation with Peter Selz, moderated by the author, Meridian Gallery, San Francisco, 10 July 2008.

Rinder is a true Selz heir in that he was hired to be the first director of a new university museum building—this one at a different campus location, on Oxford and Center Streets. Among other benefits beyond up-to-date earthquake construction, this building would have been more accessible to the Berkeley community. Unfortunately, the initial plan, featuring an exciting architectural design by Toyo Ito, fell victim to the economic collapse of 2009. New plans are afoot, but the financial trials remain an obstacle.

61. Memoir 1 (1 September 2005), 30.

62. Ibid., 31–32 and 66.

63. This account of the efforts to secure the Peggy Guggenheim collection appears in two interviews: AAA 1982, 65–66; and Memoir 1, 30–33. It is remarkable how closely the two accounts—separated by almost thirty years—duplicate each other.

64. Typed anecdotal notes sent to author by Peter Selz, 12 December 2008.

65. AAA 1982, 66.

66. Ibid., 67–68.

67. Barnes, "Collecting the Moment," 34–35.

68. James Cahill, e-mail to the author, 2 May 2010. Cahill had no personal ax to grind regarding Selz; in fact, he enjoyed his frequent visits to Peter's "spectacularly modern house. Those were good parties." In the same e-mail Cahill described the early exhibitions at the Powerhouse: "Later it was discovered that the floor was too weak to hold a lot of people, and we had to stop using it—few faculty members turned up for exhibition openings."

69. As listed in the *Funk* catalogue (Berkeley: University Art Museum, 1967), unpaginated. As early as 1967, the list of faculty curators read as follows: Svetlana Alpers, Baroque Art; Darrell A. Amyx, Classical Art; William R. Bascom, Primitive Art; James Cahill, Oriental Art (Cahill succeeded Selz as director for one year); Herschel B. Chipp, Modern Art; Alfred Frankenstein, American Art; Spiro Kostof, Architecture; Juergen Schulz, Renaissance Art; David H. Wright, Medieval Art.

70. AAA 1982, 68.

71. Ibid., 68–69.

72. For an insightful account of Norton Simon's art and political involve-

ment in California, see Suzanne Muchnic's *Odd Man: Norton Simon and the Pursuit of Culture* (Berkeley: University of California Press, 1998).

73. Memoir 1, 23–25.

74. Selz, e-mail to the author, 12 May 2010. Peter's account is contradicted by curator Brenda Richardson, who independently cites Walter Horn as supportive of her professional "dilemma" within UAM. She also denies that she expected to become director or even sought that role and goes on to say that leaving Berkeley was personally difficult, but "the right move professionally at the time" (e-mail, 29 April 2010).

75. Brenda Richardson, phone conversation with author, 28 April 2010.

76. Ibid.; AAA 1982, 69.

77. Richardson, e-mail to the author, 29 April 2010. Perhaps the most revealing observation Richardson makes is that the entire process was "a travesty carried out by an academic administration eager to take Peter down. Little did he know that when he submitted a complaint about me to the Dean, it would end so badly for him."

78. James Cahill, e-mail to the author, 24 September 2010. Other faculty members shared the view that Peter's departure from the museum was involuntary, among them Loren Partridge, art history chair at the time, as well as artist and friend Karl Kasten (now deceased) and medievalist David Wright. Even fierce supporters such as Sheldon Renan of PFA acknowledge that Peter spent money whether or not it was there and/or authorized for projects he believed in. Others viewed the Selz style more positively: classicist Andrew Stewart— who arrived in Berkeley somewhat later—appreciated his enthusiastic embrace of contemporary art and artists as well as his willful independence. Cahill adds that he did "excite students, and draw lots of them." Cahill also remembers that at his own hiring there were administrative instructions to move away from contemporary art toward "exhibitions and programs tied in with campus departments and organizations" (a strategic effort to secure university education funding for the museum); these were greeted with alarm by UAM staff members who found the direction overly academic. He recalls that Richardson alerted the San Francisco art critics, "who saw this, as did she, as a threat" (e-mail, 5 October 2010).

79. Jacquelynn Baas, e-mail to author, 29 April 2010. Jackie reports that in the middle of a budget crisis she talked with Clark Kerr and Roger Heyns about the museum's financial situation, which provided insight into the earlier problems.

80. Tom Freudenheim, e-mail to author, 2 May 2010.

81. Baas e-mail, 29 April 2010. Jim Elliott was director from 1976 to 1987. Baas became director in 1988.

82. Richard Buxbaum, phone interview and e-mail to author, 7 January

2010. UC law professor Buxbaum met Selz shortly after the latter's arrival in 1965. Buxbaum also followed Selz's exhibitions, remembering especially the *Funk* show and their shared interest in art.

8. STUDENTS, COLLEAGUES, AND CONTROVERSY

1. Author interview with Norton Wisdom, San Francisco, 8 April 2009, 2.

2. Sidra Stich studied with Herschel B. Chipp and Svetlana Alpers; Selz was on her doctoral committee. Although she came to Berkeley because of the museum training program, when she discovered that the art history department was not interested in museum work as a professional career she concentrated on the more intellectual and academic strengths of the University of California. Her contributions to the museum included the highly regarded exhibitions and catalogues *Made in USA: An Americanization in Modern Art, the '50s and '60s* (Berkeley: University Art Museum and University of California Press, 1987) and *Anxious Visions: Surrealist Art* (Berkeley: University Art Museum; New York: Abbeville Press, 1990). Peter Selz considers the latter particularly significant.

3. Sidra Stich interview, San Francisco, 27 July 2009, 2.

4. E-mail conversation with intellectual historian and Berkeley professor Richard Cándida Smith, 16 June 2010. As with other writing projects, I am grateful to this friend for suggestions and information generously given.

5. Telephone interview with Christo and Jeanne-Claude, 27 June 2007, 3–4; hereafter Christo and Jeanne-Claude interview.

6. Peter Selz, *Art of Engagement: Visual Politics in California and Beyond* (Berkeley: University of California Press, 2006), 230. The same story was recounted to the author in conversation.

7. Christo and Jeanne-Claude interview, 11.

8. Ibid., 17.

9. Author interview with Gary Carson, Berkeley, 2 May 2007, 18.

10. Ibid., 17.

11. Ibid., 12. The late Robert Rosenblum made connections in thinking about art that were unprecedented. Peter Selz brings this same curiosity to his way of looking at art and is at least as willing to graze over the entire creative landscape.

12. Susan Landauer, telephone interview, 17 October 2009.

13. Susan Landauer, telephone conversation, 15 April 2010. Landauer, with her deep respect and affection for Selz, has been able to reconcile these "two sides."

14. Susan Landauer was among the first to bring attention to Bay Area gestural painting as an independent analogue to New York Abstract Expressionism. Her book, *The San Francisco School of Abstract Expressionism* (Berkeley: Uni-

versity of California Press; Laguna Beach, Calif.: Laguna Art Museum, 1996), helped to change the way California was perceived by the East Coast critical establishment. Peter's friend Dore Ashton wrote the introduction. The book accompanied an exhibition at the Laguna Art Museum (27 January–21 April 1996) and the San Francisco Museum of Modern Art (18 July–8 September 1996).

15. Susan Landauer was chief curator at San Jose Museum of Art for a decade, until 2009. Among the books and exhibitions that grew out of the Landauer-Selz museum collaboration were *Nathan Oliveira* (Berkeley: University of California Press, 2002) and *Art of Engagement*.

16. Susan Landauer, telephone conversation, 16 October 2007. Taken out of context, this response seems unlikely, even if one is little concerned with the judgment of others. However, it disturbed Landauer enough for her to relate it as an indication of Selz's deficit in empathy for others, especially (as with Duchamp) women.

17. Author telephone interview with Kristine Stiles, 25 June 2008, 3; hereafter Stiles interview. Also "Notes for Conversation Regarding Peter Selz," 25 June 2008, 1.

18. Stiles interview, 5, 6; "Notes," 1.

19. Stiles interview, 15; "Notes," 2.

20. In the preface and acknowledgments to *Art in Our Times*, Selz wrote, "I want to express my thanks to the friends, colleagues, and students who have helped significantly in completing this book. Above all I wish to acknowledge Kristine Stiles, whose suggestions were particularly helpful in the final chapters" (n. 7). The index does not recognize feminism as an art term, but many activist women artists make their way into the book, particularly in the chapters where Stiles was most "helpful."

21. Selz typically tries to attach himself, often retroactively, to movements that gained favor later. His own complicated relationship to women, and his treatment of them, would speak against his being an early feminist. It is one thing to "like" women, but quite another to fully empathize and understand the professional and social obstacles they are struggling to remove.

22. Kristine Stiles, e-mail, 10 November 2009.

23. Ibid.

24. Moira Roth, telephone conversation, 15 October 2009.

25. Memoir 10B (22 April 2009), 24. Chase-Riboud monograph: Peter Selz and Anthony F. Janson, *Barbara Chase-Riboud: Sculptor* (New York: Harry N. Abrams, 1999).

26. Performance art, found to be a particularly effective means of conveying feminist concerns, was the subject of an anthology edited by Selz's student Moira Roth, *The Amazing Decade: Women and Performance Art in America, 1970–1980* (Los Angeles: Astro ARTZ, 1983). For the feminist art movement gener-

ally, see Norma Broude and Mary D. Garrard, eds., *The Power of Feminist Art: The American Movement of the 1970s—History and Impact* (New York: Harry N. Abrams, 1994).

27. Author interview with Eleanor Dickinson, San Francisco, 3 January 2008, 19–20; hereafter Dickinson interview. Selz does not acknowledge sexism as a problem at UAM, insisting that he gave full support to women in the museum's programming. Nonetheless, in *Art of Engagement* he describes gender discrimination elsewhere: "Artists began to look for women's art in museums and commercial galleries, finding enormous discrepancies between male and female representation; the ratio of artists being reviewed in *Art in America* in 1970–71 was twelve males to one female" (190–91).

28. Phone conversation with Peter Selz, 4 August 2010.

29. Conversation during manuscript review meeting with Selz, 6 July 2010. The report on O'Hagan's refusal to sign the oath appears in the Online Archive of California, http://www.oac.cdlib.org/view?docId=hb738nb7fq;NAAN=13030& doc.view=frames&chunk.id=div00002&toc.depth=1&toc.id=&brand=calisphere.

30. H. W. Janson interviewed by Eleanor Dickinson at the College Art Association annual convention, Washington, D.C., 1 February 1979.

31. Dickinson interview, 17–18.

32. Peter Selz, "San Francisco: Eleanor Dickinson at Hatley Martin," *Art in America,* September 1989, 219.

33. Telephone interview with Carole Selz, 31 October 2009.

34. Author interview with Agnes Denes, 15 January 2008, 2; hereafter Denes interview.

35. Peter Selz, "Agnes Denes: The Artist as Universalist," in *Agnes Denes,* ed. Jill Hartz (Ithaca, N.Y.: Herbert F. Johnson Museum of Art, Cornell University, 1992); reprinted in Selz, *Beyond the Mainstream: Essays on Modern and Contemporary Art* (Cambridge: Cambridge University Press, 1997), 240.

36. Ibid., 236.

37. Denes interview, 6 and 7.

38. Ibid., 5 and 6.

39. "Anonymous Was a Woman" is taken from Virginia Woolf's *A Room of One's Own.* Denes said, "You look it up on the Web—Anonymous Was a Woman. It's totally anonymous. But it comes with $25,000, so . . . that's all you need to know" (Denes interview, 10).

40. Denes interview, 12.

41. Selz, "Agnes Denes," in *Beyond the Mainstream,* 240.

42. Paul Tillich, *The Religious Situation,* trans. Richard Niebuhr (New York: Meridian Books), 85.

43. Selz, "Agnes Denes," in *Beyond the Mainstream,* 249.

44. Ashton interview, 2–3, 4.

45. Ibid., 12–14.

46. Ibid., 15.

47. Ibid., 28–29.

48. Ibid., 15.

49. According to Selz's account, Rothko's intention regarding distribution of his estate was that the children be provided for but not be made "wealthy." The Mark Rothko Foundation was established to support older artists, but it was "being pushed aside . . . by the children." AAA 1982, 73.

50. See Lee Seldes, *The Legacy of Mark Rothko* (New York: Holt, Rinehart and Winston, 1974).

51. Henry Lydiate, "Art After Death," www.artquest.org.uk/artlaw/art -after-death/artists-estates/the-rothko-wrangle.htm.

52. Quoted ibid.

53. Ibid.

54. AAA 1982, 73–76.

55. Ashton interview, 18.

56. Ibid., 17–20.

57. Peter Selz, e-mail to the author, 12 May 2010. The longer account in the AAA 1982 interview is consistent in most details with this recent one. But a key element, the stated purpose of the Rothko Foundation, is surprisingly missing in the latter (see note 49 above).

58. Manuscript review meeting with Selz, 7 July 2010.

59. Author interview with Wayne Andersen, Boston, 17 January 2008, 45; hereafter Andersen interview. Wayne and Dore agree that Peter made a mistake, but they come at agreement from opposite directions. Both know Peter well enough to allow that the fee played a role, but Wayne downplays that: "He got paid $25,000 [actually $20,000]—the word was it built his house in Berkeley." However, with a somewhat strange ethical logic, Wayne compares that relatively modest amount to the "millions" that Bill Rubin made "off of artists' gifts" (ibid.).

60. AAA 1982, 75. In the interview, Peter did not limit the "crook" characterization to Frank Lloyd, adding: "But I think that can be said about any dealer, as far as I've observed." In truth, Peter has had cordial and long-standing professional and personal relationships with a number of dealers.

61. Andersen interview, 42–43. This fascinating character study amounts to an indictment of Frank Lloyd that validates Peter's use of the word *crook*. David McKee says he did not leave Marlborough because of the Rothko trial (telephone interview, 13 February 2008).

62. Andersen e-mail, "Selz," 7 December 2009. In our 13 February 2008 telephone interview, David McKee used pretty much the same words in describing Peter's role.

63. Seldes, *Legacy of Mark Rothko*, 255.

64. Wayne Andersen, letter to Peter Selz, 11 May 2005. *Cézanne and the Eternal Feminine* (London: Cambridge University Press, 2004) is a brilliant analysis of a painting at the J. Paul Getty Museum in Los Angeles. It is also exaggeratedly unconventional, a combination of thoughtful research and extremely personal interpretation.

65. Wayne Andersen, *German Artists and Hitler's Mind: Avant-Garde Art in a Turbulent Era* (Boston and Geneva: Editions Fabriart, 2007), v.

66. Andersen interview, 3. Andersen's fundamental irreverence for the field, along with a spectacular ability to conjure up original, almost heretical, art-historical insights, allows him to appreciate the best qualities that Selz brings to his work.

67. Ibid., 25. A few pages later (29), *people* is substituted for *artists,* making the important point that Selz is fundamentally a social creature. Art is the point of entry.

68. Wayne Andersen, review of Selz, *Art of Engagement, European Legacy* 11, no. 3 (2006): 312. In typical manner, Andersen goes beyond the apparent to raise philosophical questions of his own: "Rather than say that sociopolitical art [estranged from art history] cannot be located in the stream of art history, let us question whether there is a thing such as 'the history of art' in which at each stage of a moving narrative the immediate past generates the present" (ibid., 321).

69. Andersen interview, 40. Also "Selz" e-mail.

70. Andersen e-mail, "Selz Addenda," 7 December 2009.

71. Wayne Andersen, *Marcel Duchamp: The Failed Messiah* (Geneva: Editions Fabriart, 2010). This thoroughly irreverent study must be among the most unorthodox "debunkings" in the critical literature of modern art. It is truly outside the academic mainstream, occupying a singular territory of its own. The angry and very long review by Francis Naumann at Toutfait.com (The Marcel Duchamp Studies Online Journal), updated 7 December 2010, was answered by Andersen in an even longer counterpunch. Andersen clearly goes where others, including Peter Selz, fear to tread. Peter feels that Wayne goes "overboard in his condemnation of Duchamp," but he thinks the book is important and agrees that the influence of Duchamp, over time, has been "largely negative" (e-mail from Selz to author, 19 May 2011).

72. Author interview with Jane Dillenberger, Berkeley, 12 June 2008, 2; hereafter Dillenberger interview.

73. Ibid., 4.

74. Ibid.

75. Telephone conversation with Peter Selz, 26 February 2009, about Selz's association with Paul Tillich in connection with *New Images of Man* and his interest in collaborating with Christian existentialists.

76. Dillenberger interview, 7.

77. Ibid., 2.

78. Dillenberger's handwritten note, returned with her review of her quotes, 4 October 2010.

79. Ibid.

80. Telephone conversation with Jane Dillenberger, 23 November 2009.

81. Author interview with Terrence Dempsey, 27 June 2007, 29–30.

82. Peter Selz, e-mail to author, 23 November 2009.

9. A CAREER IN RETIREMENT

1. His third and fourth marriages, to art historian Dolores Yonker in 1972, and then to Deirdre Lemert in 1978, were both short-lived, and he categorizes them as "big errors." The late Dolores Yonker was a specialist in the art and culture of Haiti, focusing on Vodun (Voodoo) as both artistic expression and religious practice. The level of her commitment and emotional engagement with her work should have appealed to Selz, but their marriage lasted only a few months. Deirdre Lemert was one of the Berkeley students who assisted Peter Selz with the research for *Art in Our Times*.

2. Carole Selz phone conversation with author, 13 April 2010.

3. Ibid.

4. Author interview with Carole Selz, San Francisco, 20 April 2007; hereafter Carole Selz interview. Also telephone interview with Carole Selz, 31 October 2009. Among Carole's circle of Los Angeles art friends were Ed Kienholz, Wallace Berman, Walter Hopps, Robert Alexander, and Craig Kauffman. She was also a member of Ferus artist Bob Alexander's Temple of Man in his home in Venice, California, a gathering place for artists and poets.

5. Carole Selz interview, 23.

6. Ibid., 47–48. Carole gives several examples of Donna Smith's efforts to "warn her off" Peter. She and her expatriate husband, Hassel Smith, spent years in Bristol (where he taught art) and Bath, England, but he retained close ties to the Bay Area, where he had been on the UC Berkeley art faculty as visiting professor on several occasions. Despite their initial disapproval of Peter as a life partner for Carole, the Smiths maintained a friendly relationship with the Selzes over the years, visiting back and forth on various occasions, though it appears they were more Carole's enthusiasm than her husband's.

7. Ibid., 53.

8. Telephone interview with Carole Selz, 31 October 2009.

9. "I went to visit a cousin in Stuttgart. I'll tell you why this is important— because it is. There was no twentieth-century modern architecture to be seen in Munich. They just didn't have any. In Stuttgart I saw a beautiful building,

a modern-designed department store by Erich Mendelsohn . . . the Schocken Department Store, part of the Schocken chain. And I liked it very much" (Memoir 4, 9). Mendelsohn, who moved to San Francisco in 1945, taught at Berkeley until his death in 1953.

10. For example, Peter initially had little interest in Hassel Smith's work. But he took her on a visit to England as part of the courtship, and they visited the Smiths in Bristol. Before long he came around to join Carole in her appreciation of Smith's earlier Abstract Expressionist painting. The two also disagreed about Sam Francis and others to whom Peter became devoted, including a number of younger artists of dubious talent (Carole Selz interview, 49).

11. In 1982 Carole Selz, while serving as chair of the Berkeley Parks Commission, independently (working with state government) established the first organizations in the country devoted to opening up urban creeks: Urban Creeks Council and Strawberry Creek Watershed Council. During her time on the board four creeks were opened and another restored. Telephone conversation with Carole Selz, 14 December 2009.

12. Letter to Selz from Simon Hucker, Jonathan Clark & Co. Fine Art, London, 6 May 2010.

13. Evidently, Selz to some degree identifies personally with Lindner: he notes in the Krevsky Gallery catalogue that Lindner fled Munich in 1933, three years before he himself did. The show traveled from Washington, D.C., to the Haus der Kunst in Munich. Peter's essay, despite the rejection of the Pop label, nonetheless introduces Lindner as the only visual artist to appear on the Peter Blake–designed cover of the Beatles' *Sgt. Pepper's Lonely Hearts Club Band*.

14. Peter Selz, "Irving Petlin: The Committed Brushstroke," *Art in America*, March 2010, 107. The concurrent Petlin exhibitions were at Kent Gallery, Jan Krugier Gallery, and Richard L. Feigen & Co.

15. According to Selz (e-mail to author, 4 August 2010), Botero selected Berkeley because of its reputation for political activism and free speech.

16. Peter Selz, e-mail to the author, 4 August 2010. His account of the acquisition of the Botero *Abu Ghraib*, a major political statement despite what detractors say about its artistic quality, also reflects Berkeley internal politics involving the administration and BAM, something with which the founding director is all too familiar.

17. Memoir 10B, 10–11.

18. Peter Selz, "Eduardo Chillida: Sculpture in the Public Domain," in *Beyond the Mainstream: Essays on Modern and Contemporary Art* (Cambridge: Cambridge University Press, 1997), 137. This essay draws from Selz's book *Chillida* (New York: Harry N. Abrams, 1986) as well as from an article in *Arts Magazine* 63, no. 1 (September 1988): 84–87.

19. Selz, "Eduardo Chillida," in *Beyond the Mainstream*, 141.

20. Notes from phone conversation with Peter Selz, 3 May 2010.

21. Selz, "Eduardo Chillida," in *Beyond the Mainstream*, 132.

22. Memoir 10B, 11.

23. Herschel B. Chipp, *Picasso's "Guernica": History, Transformations, Meanings* (Berkeley: University of California Press, 1988).

24. Memoir 6, 6.

25. Memoir 7 (23 June 2008), 4.

26. Author interview with Carlos Villa and Mary Valledor, San Francisco, 12 January 2008, 15–17, 21, 24.

27. Rupert Garcia and Enrique Chagoya helped establish a visible Mexican American presence in Bay Area art. Both were involved in the founding and the early years of San Francisco's Galería de la Raza, the politico-cultural center for Chicano art in the region (though the Mexican-born Chagoya does not describe himself as Chicano). Chagoya remembers meeting Selz in 1984 at "Artists' Call Against Intervention in Central America," a protest organized by Lucy Lippard and Salvadorean poets and held at the San Francisco Art Institute, where he was a student at the time. Selz wrote a brief catalogue essay, which Chagoya says introduced him to Selz's political position and "role as an art historian that goes beyond art for art's sake." Enrique Chagoya, "About Peter Selz," in *Selz* (Sacramento: b. sakata garo, 2007), 29 (catalogue for exhibition *Tribute to Peter Selz*, November 2007).

28. What appears here is a statement by Chagoya derived from a phone conversation (27 December 2009) and e-mail (4 January 2010).

29. Selz, "Rupert Garcia: The Artist as Advocate," in *Beyond the Mainstream*, 279.

30. Hilton Kramer, "Turning Back the Clock: Art and Politics in 1984," *New Criterion*, April 1984, 68; quoted ibid., 279.

31. Selz, "Rupert Garcia," ibid., 279–80.

32. Telephone interview (4 January 2010) with and e-mail (7 January 2010) from Richard Buxbaum. A longtime faculty friend of Selz's, Buxbaum admired Peter's "passion and style." He also was drawn to Peter's exhibitions at the university museum; he himself collected modernist and contemporary art, and his own politics and suspicion of the administrative "mind" placed him somewhat in the Selz camp within the university. Buxbaum served on the defense team of certain important civil rights trials related to the Free Speech Movement and various Berkeley student protest actions.

33. Author interview with Rupert Garcia, Oakland, 3 June 2009, 19; hereafter Garcia interview.

34. Ibid., 3.

35. At the time Garcia, while working on his thesis, was also teaching at Berkeley in Chicano studies and popular culture.

36. Garcia interview, 15.

37. Ibid., 20.

38. Ibid., 21.

39. Ibid., 22.

40. Ibid., 25.

41. Anne Brodzky, e-mail to author, 6 January 2010.

42. Dore Ashton, "Homage to Peter Selz," in *Crosscurrents in Modern Art: A Tribute to Peter Selz* (New York: Achim Moeller Fine Art, 2000), 14.

43. Ashton interview, 34–35.

44. Memoir 10A, 4.

45. Ibid., 5.

46. Ibid., 5, 6.

47. Memoir 10B, 1.

48. Sam Francis's paintings may have no obvious political content, but his non-art "real world" activism indicates that his thinking was far left. Representing the Smithsonian Institution (a trust instrument of Congress), I had the personal experience of meeting with Sam Francis and confronting his political absolutism. My job was to invite him to leave his papers to the Archives of American Art. His response was polite enough, but essentially he let me know that he viewed me as a possible CIA operative. The Smithsonian, despite repeated efforts, never was designated his chosen repository.

49. Author interview with Nathan Oliveira, Archives of American Art, Smithsonian Institution, Washington, D.C., 7 September 1980, 13; hereafter Oliveira interview. Donald Judd, reviewing Oliveira's second show at the Alan Gallery, commented favorably on Oliveira's use of "an advanced abstract technique" and his sharing the "malaise of the French Existentialists" ("In the Galleries," *Arts*, November 1960, 54; quoted in Selz, *Nathan Oliveira* [Berkeley: University of California Press, 2002], 64). This was in accord with a major theme in Selz's *New Images of Man*, which had included the young Californian, at MoMA the preceding year.

50. Selz, *Oliveira*, 9.

51. Oliveira interview, 46–47; quoted ibid., 67.

52. Author interview with Nathan Oliveira, Stanford, 21 December 2007, 25–26.

53. Oliveira interview, 9.

54. Paula Kirkeby, e-mail to author, 11 January 2010. The following quotations are from this message.

55. Jack Rutberg, e-mail to author, 9 January 2010, recapitulating an interview conducted with author, Los Angeles, 4 April 2007. The following account and quotations are from this message.

56. Stephanie Barron, "Introduction: The Making of *Made in California*," in

Made in California: Art, Image, and Identity, 1900–2000, ed. Stephanie Barron, Sheri Bernstein, and Ilene Susan Fort (Los Angeles: LACMA; Berkeley: University of California Press, 2000), 27.

57. Rutberg e-mail, 9 January 2010.

58. Peter Selz, "The Art of Political Engagement," in *Made in California,* 339–51.

59. Sabine Rewald et al., *Glitter and Doom: German Portraits from the 1920s* (New York: Metropolitan Museum of Art; New Haven: Yale University Press, 2006).

60. *German Realism of the Twenties: The Artist as Social Critic* (Minneapolis: Minneapolis Institute of Arts, 1980). The Exhibition Committee: Peter Selz, Chairman, Professor, History of Art, University of California, Berkeley; Emilio Bertonati, Director, Galleria del Levante, Munich and Milan; Gregory Hedberg, Curator of Paintings, Minneapolis Institute of Arts; Wieland Schmied, Director, Deutscher Akademischer Austauschdienst, Berlin.

61. Author's e-mail exchanges and phone conversation in April 2008 with Sabine Rewald at the Metropolitan Museum of Art. The impression she gave was that the Minneapolis show and catalogue, and Peter Selz, simply fell between the cracks.

62. Robert Hughes, "The Twenties' Bleak New World," *Time,* 10 November 1980, 90–92.

63. Ariel is the widow of Tom Parkinson, University of California "beat" poetry scholar and author of the first book on the beats.

64. Alphonse Berber Gallery, Berkeley, 4 December 2009–30 January 2010. Exhibition catalogue essays by Peter Selz and Cameron Jackson.

65. Interview with Ariel Parkinson, Berkeley, 22 August 2007, 3, 17. Ariel's quotes reflect amendments and additions returned 9 October 2010 with her review of quotes.

66. Ibid., 22.

67. Telephone conversation with Gabrielle Selz, 4 December 2009.

68. Kevan Jenson, e-mail to author, 4 January 2010.

69. Ursula O'Farrell, e-mail to author, 12 January 2010. O'Farrell is currently represented by Toomy Tourell Fine Art in San Francisco.

70. Lorna Price Dittmer, e-mail to author, 6 January 2010.

71. Kyra Baldwin, e-mail to author, 4 January 2010.

10. A CONCLUSION

1. *Warhol Live* was on view 14 February–17 May 2009, and *William Kentridge: Five Themes,* 14 March–31 May 2009. Selz viewed the Warhol retrospective

in a single visit; he returned to the Kentridge four times. The fifth visit was the occasion for an interview.

2. Leah Ollman, "William Kentridge: Ghosts and Erasures," *Art in America,* January 1999, 71.

3. Author interview with Peter Selz, San Francisco Museum of Modern Art, 25 May 2009, 1–2.

4. Ibid., 3–4.

5. Ibid., 4.

6. For instance, MoMA had recently lost its role in selecting American representation at the Venice Biennale; in 1964, Alan Solomon had been installed as the official. Some critics charged that art dealer Leo Castelli engineered the appointment of Solomon, thus ensuring that Robert Rauschenberg won the Grand Prize. The point is that Castelli cut MoMA out of the action. There were hard feelings, as conveyed by Solomon in a letter to Castelli: "Peter Selz . . . was full of sour grapes and nasty as usual. . . . He told me that the gossip in New York was that Seitz did not accept [the invitation to the jury] because the telegram of invitation was signed by you. . . . Barr told me the same thing. . . . I suppose a lot of this is attributable to the frustration and annoyance of the MoMA people" (Alan Solomon to Leo Castelli, 3 August 1964, Alan Solomon Papers, Jewish Museum Archives; quoted in Annie Cohen-Solal, *Leo and His Circle* [New York: Alfred A. Knopf, 2010], 301–2). In contrast, Peter in his interviews gives himself some credit for Rauschenberg's controversial achievement on behalf of the new American art.

7. Victor Bockris, *The Life and Death of Andy Warhol* (New York: Bantam Books, 1989), 117. This account could well be apocryphal, but it suggests the changes under way in the early 1960s that were already undercutting MoMA's previously unchallenged authority.

8. Among the recent revisionist articles is David Wallace-Wells, "Andy Warhol: Factory Man," *Newsweek,* 14 December 2009, 66–68. A more thoughtful and nuanced examination of Warhol's position appears in Louis Menand's "Top of the Pops: Did Andy Warhol Change Everything?" *New Yorker,* 11 January 2010, 56–65. Richard Dorment, in "What Is an Andy Warhol?" *New York Review of Books,* 22 October 2009, 14, 16–17, addresses the issue of originality. The most recent reappraisal appears in "The Warhol of Our Minds" by Eleanor Heartney, a perceptive review of three new Warhol books by Arthur Danto, Gary Indiana, and Tony Scherman and David Dalton, in *Art in America* (available online at www.artinamericamagazine.com/books/the-warhol-of-our-minds).

Selected Bibliography and Exhibition History

The following selected bibliography and exhibition history have been compiled by Jeff Gunderson, longtime librarian at the San Francisco Art Institute, the intended repository for the Peter Selz library. Gunderson worked closely with the author of this book, along with Selz himself, in setting up the guidelines for inclusion. For a full bibliography of articles, essays, books, and catalogues by Peter Selz, as well as a complete list of exhibitions for which he was curator, see www.ucpress.edu/go/peterselz.

The lists presented here demonstrate Selz's wide range of interests and expertise, as well as his advocacy for fine artists and his belief that art can be a fitting vehicle for social and political commentary. For the two bibliographic sections, "Books and Catalogues" and "Journal Articles and Essays," the selection of titles was made on the basis of their significance and the contribution that they represent. Although Selz has been involved in and responsible for numerous exhibition-related publications, the extent of his involvement in these catalogues has varied widely. Those listed here (and indicated

by an asterisk) are for the projects in which he took the lead authorial role, whatever his position in conceiving or producing the accompanying exhibition. Selz wrote a great number of magazine articles and reviews as well, many of them as West Coast correspondent for *Art in America*. With few exceptions, the regional exhibition reviews are not included. On the other hand, independent articles that represent the development and application of his thinking about modernist art are cited. In this section, too, exhibition catalogues are indicated by an asterisk.

Over an extensive career, Peter Selz has been responsible for a long list of innovative and challenging exhibitions, many outside the "mainstream" of modern and contemporary focus. Again, the selection listed here is based on the importance of the exhibitions and the role Selz played in conceiving and realizing them.

BOOKS AND CATALOGUES

Elsen, Albert Edward, Peter Selz, Joseph Masheck, and Debra Bricker Balken. 1996. *Dimitri Hadzi*. New York: Hudson Hills Press.

Selz, Peter. 1957. *German Expressionist Painting*. Berkeley: University of California Press.

*———. 1958. *Stieglitz Circle: Demuth, Dove, Hartley, Marin, O'Keeffe, Weber*. Claremont, Calif.: Pomona College Galleries.

*———. 1959. *New Images of Man*. New York: Museum of Modern Art.

*———. 1960. *Sculpture and Painting by Peter Voulkos: New Talent in the Penthouse*. New York: Museum of Modern Art.

*Selz, Peter, and Mildred Constantine. 1960. *Art Nouveau: Art and Design at the Turn of the Century*. New York: Museum of Modern Art.

*Selz, Peter. 1961a. *15 Polish Painters*. New York: Museum of Modern Art.

*———. 1961b. *Mark Rothko*. New York: Museum of Modern Art.

*———. 1962. *The Work of Jean Dubuffet*. New York: Museum of Modern Art.

*———. 1963. *Emil Nolde*. New York: Museum of Modern Art.

*———. 1964. *Max Beckmann*. New York: Museum of Modern Art.

*———. 1965. *Reva Urban*. New York: Grippi & Waddell-Gallery.

*———. 1966a. *Directions in Kinetic Sculpture*. Berkeley: University Art Museum.

*———. 1966b. *Seven Decades, 1895–1965: Crosscurrents in Modern Art*. New York: New York Graphic Society and New York Public Education Association.

*———. 1967. *Funk*. Berkeley: University Art Museum.

*———. 1968. *Eduardo Paolozzi: Print Retrospective*. Berkeley: Worth Ryder Art Gallery.

*————. 1970. *Pol Bury*. Berkeley: University Art Museum.

*————. 1972a. *Ferdinand Hodler*. Berkeley: University Art Museum.

*————. 1972b. *Harold Paris: The California Years*. Berkeley: University Art Museum.

————. 1975. *Sam Francis*. New York: Harry N. Abrams.

*Selz, Peter, and Thomas Blaisdell. 1976. *The American Presidency in Political Cartoons, 1776–1976*. Berkeley: University Art Museum.

*Selz, Peter. 1979. *2 Jahre amerikanische Malerei*. Zurich: Städtische Kunsthalle.

*Selz, Peter, and Dore Ashton. 1979. *Peinture américaine, 1920–1940*. Brussels: Palais des Beaux-Arts.

Selz, Peter. 1981. *Art in Our Times: A Pictorial History, 1890–1980*. New York: Harcourt Brace Jovanovich and Harry N. Abrams.

————. 1985a. *Art in a Turbulent Era*. Ann Arbor: UMI Research Press.

*————. 1985b. *Rupert Garcia*. San Francisco: Harcourts Gallery.

————. 1986. *Chillida*. New York: Harry N. Abrams.

*————. 1991a. *Hans Burkhardt: Desert Storms*. Los Angeles: Jack Rutberg Fine Arts.

*————. 1991b. *Sam Francis: Blue Balls*. New York: Gagosian Gallery.

*————. 1992. *Max Beckmann: The Self-Portraits*. New York: Gagosian Gallery.

————. 1996. *Max Beckmann*. New York: Abbeville Press.

————. 1997a. *Beyond the Mainstream: Essays on Modern and Contemporary Art*. Cambridge: Cambridge University Press.

Selz, Peter, Dore Ashton, and Michael Brenson. 1997. *Tobi Kahn: Metamorphoses*. Lee, Mass.: Council for Creative Projects.

*Selz, Peter. 1998. *John Grillo: The San Francisco Years*. Mill Valley, Calif.: Robert Green Fine Arts.

*Selz, Peter, and Annette Vogel. 1998. *Max Beckmann: Das Graphische Werk*. New York: Serge Sabarsky, Inc.

*Selz, Peter. 1999. *Spaces of Nature*. Richmond, Calif.: Richmond Art Center.

Selz, Peter, and Anthony Janson. 1999. *Barbara Chase-Riboud: Sculptor*. New York: Harry N. Abrams.

*Selz, Peter. 2001. *Marsden Hartley: Observation and Intuition*. San Francisco: Hackett-Freedman Gallery.

*————. 2002a. *Hassel Smith: 55 Years of Painting*. Santa Rosa, Calif.: Sonoma County Museum.

*————. 2002b. *Nathan Oliveira*. Berkeley: University of California Press.

————. 2003. *Lyonel Feininger: 20 Watercolors*. Lancaster, Pa.: Demuth Foundation.

*————. 2005. *George Grosz: His Visual and Theatrical Politics*. New York: Moeller Fine Art.

*———. 2006. *Art of Engagement: Visual Politics in California and Beyond*. Berkeley: University of California Press.

*———. 2007. *Robert Colescott: Troubled Goods, a Ten Year Survey (1997–2007)*. San Francisco: Meridian Gallery.

*———. 2008a. *Jess: Paintings and Paste-Ups*. New York: Tibor de Nagy Gallery.

*———. 2008b. *Kevan Jenson: Paintings, Drawings, and Photograms*. San Francisco: Meridian Gallery.

*Selz, Peter, Alicia Haber, and Tonino Sicoli. 2008. *Bruce Hasson*. San Francisco: Meridian Gallery.

*Selz, Peter. 2010a. *Botero in L.A.: Drawings, Paintings, Sculpture*. Los Angeles: Tasende Gallery.

*———. 2010b. *Rudolf Bauer: Works on Paper*. San Francisco: Weinstein Gallery.

*———. 2010c. *The Visionary Art of Morris Graves*. San Francisco: Meridian Gallery.

Stiles, Kristine, and Peter Selz, eds. 1996. *Theories and Documents of Contemporary Art: A Sourcebook of Artists' Writings*. Berkeley: University of California Press.

JOURNAL ARTICLES AND ESSAYS

Bear, Donald, and Peter Selz. 1956. "Painting." In *Encyclopaedia Britannica*, 14th ed., vol. 17, 37–66.

Malone, Patrick T., and Peter Selz. 1955. "Is There a New Chicago School?" *Art News* 54 (October): 36–39, 58–59.

Selz, Peter. 1951. "Younger French Painters of Today." *College Art Journal* 11: 10–17.

———. 1956. "A New Imagery in American Painting." *College Art Journal* 15: 290–301.

———. 1957. "The Aesthetic Theories of Wassily Kandinsky and Their Relationship to the Origin of Non-Objective Painting." *Art Bulletin* 39 (June): 127–36.

———. 1963a. "The Flaccid Art." *Partisan Review* 30 (Summer): 313–16.

———. 1963b. "John Heartfield's Photomontages." *Massachusetts Review* (Winter): 309–36.

Selz, Peter, Henry Geldzahler, Hilton Kramer, Dore Ashton, Leo Steinberg, and Stanley Kunitz. 1963. "A Symposium on Pop Art." *Arts* 37 (April): 36–45.

Selz, Peter. 1967a. "The Berkeley Symposium of Kinetic Sculpture." *Art and Artists* [London] 1 (February): 26–37.

*———. 1967b. "Notes on *Genesis*." In *Rico Lebrun*, 55–61. Los Angeles: Los Angeles County Museum of Art.

———, intro. 1968a. "Fauvism and Expressionism: The Creative Intuition" and

"Art and Politics: The Art of Social Order." In Herschel Chipp, *Theories of Modern Art: A Source Book by Artists and Critics*, 124–92, 456–500. Berkeley: University of California Press.

———. 1968b. "The Hippie Poster." *Graphis* 24, no. 135: 70–77, 91–92.

———. 1968c. "The Influence of Cubism and Orphism on the Blue Rider." In *Festschrift Ulrich Middeldorf*, 582–90. Berlin: Walter de Gruyter.

*———. 1969. "The Precision of Fantasy." In *Lyonel Feininger*. New York: Marlborough-Gerson Gallery.

———. 1974. "The Artist as Dactylographer." *Art in America* 62 (July/August): 98–99.

———. 1975. "Agnes Denes: The Visual Presentation of Meaning." *Art in America* 63 (March/April): 72–74.

———. 1976a. "Foreword." In Paul Von Blum, *The Art of Social Conscience*, ix–x. New York: Universe Books.

———. 1976b. "The Genesis of *Genesis*." *Archives of American Art Journal* 16, no. 3: 2–7.

———. 1978. "Helen and Newton Harrison: Art as Survival Instruction." *Arts* 52 (February): 130–31.

*———. 1980. "The Artist as Social Critic." In *German Realism of the Twenties: The Artist as Social Critic*, 29–40. Minneapolis: Institute of Arts.

*———. 1981. "Max Beckmann, 1933–1950: Zur Deutung der Triptychen." In *Max Beckmann: Die Triptychen im Städel*, 14–33. Frankfurt: Städelsches Kunstinstitut.

*———. 1984. "Max Beckmann: Die Jahre in Amerika." In *Max Beckmann: Retrospective*, 159–72. St. Louis: The [St. Louis Art] Museum, in association with Prestel-Verlag, Munich.

———. 1985. "Surrealism and the Chicago Imagists of the 1950s: A Comparison and Contrast." *Art Journal* 45 (Winter): 303–6.

———. 1986. "Bedri Baykam: American Xenophobia and Expressionist Drama." *Arts* 61 (November): 19–21.

———. 1987a. "The Eduardo Chillida Symposium." *Arts* 61 (January): 18–21.

———. 1987b. "Rupert Garcia: The Moral Fervor of Painting and Its Subjects." *Arts* 61 (April): 50–53.

———. 1988. "The Rosenbergs and Postwar Social Protest Art." In *The Rosenbergs: Collected Visions of Artists and Writers*, ed. Rob A. Okun, 82–84. New York: Universe Books.

———. 1989a. "Mice, Temples, Audience: An Interview with Gu Wenda." *Arts* 64 (September): 36–40.

*———. 1989b. "Revival and Survival of Expressionist Trends in the Art of the GDR." In *Twelve Artists from the German Democratic Republic*, 24–40. Cambridge, Mass.: Busch-Reisinger Museum, Harvard University.

————. 1990. "Experienza del Transcendente in Barnett Newman e Mark Rothko." In *Quaderni di The Foundation for Improving the Understanding of the Arts*, 13–19. Milan: Jaca Book.

————. 1991. "Rupert Garcia: The Artist as Advocate." *Artspace* 15 (March/ April): 60–62.

*————. 1992a. "The Artist as Universalist." In *Agnes Denes*, 147–54. Ithaca, N.Y.: Cornell University Press.

————. 1992b. "Grisha Bruskin: L'oeuvre unique." *Cimaise* 39 (September/ October): 33–48.

————. 1992c. "William Congdon: Cinque decenni di pittura." In Peter Selz, Fred Licht, and Rodolfo Balzarotti, *Congdon: una Vita*, 61–106. Milan: Jaca Book.

————. 1993. "Americans Abroad." In *American Art in the 20th Century: Painting and Sculpture, 1913–1993*, ed. Christos M. Joachimides, Norman Rosenthal, and David Anfam, 177–85. Munich: Prestel.

————. 1996a. "The Impact from Abroad: Foreign Guests and Visitors." In *On the Edge of America: California Modernist Art, 1900–1950*, ed. Paul Karlstrom, 96–119. Berkeley: University of California Press.

*————. 1996b. "Richard Lindner's Armored Women." In *Richard Lindner*, 5–8. Washington, D.C.: Hirshhorn Museum and Sculpture Garden.

*————. 1997a. "Helnwein: The Artist as Provocateur." In *Gottfried Helnwein*, 11–98. St. Petersburg, Russia: State Russian Museum; Ludwig Museum, Palace edition.

*————. 1997b. "John Altoon Reconsidered." In *John Altoon*, 12–13. San Diego: Museum of Contemporary Art.

*————. 1998. "Lyonel Feiningers Rückkehr nach Amerika." In *Lyonel Feininger: Von Gelmeroda nach Manhattan, Retrospektive der Gemälde*. ed. Roland März, 347–54. Berlin: Neue Nationalgalerie.

*————. 1999. "Modern Odysseys: A First Generation of Greek American Artists." In Katerina Koskina, Peter Pappas, Peter Selz, Thalia Cheronis Selz, and William Valerio, *Modern Odysseys: Greek American Artists of the 20th Century*. New York: Queens Museum of Art.

————. 2001a. "Giacomo Manzu and His Portals of St. Peter's." *Sculpture* 20 (December): 32–37.

————. 2001b. "Morris Graves." *Sculpture* 20 (June): 63–65.

————. 2002. "Stephen de Staebler." *Sculpture* 21 (May): 24–27.

————. 2004. "David Ireland: The Alchemist." *Art in America* 92 (December): 124–27.

*————. 2006. "Aquarelle aus Feiningers amerikanischer Zeit." In Ingrid Mossinger and Harald Loebermann, *Lyonel Feininger: Zeichnung, Aquarell, Druckgrafik*, 219–34. Munich: Prestel.

————. 2007a. "Alexander Calder." *Sculpture* 26 (March): 71–72.

————. 2007b. "The Persistence of Suffering [Jerome Witkin]." *Art in America* 95 (March): 160–64, 189.

*————. 2009. "Gustav Klimt: A Vanished Golden Age." In Jane Kallir and Alfred Weidinger, *Gustav Klimt: In Search of the "Total Artwork,"* 15–19. Munich: Prestel.

————. 2010a. "Foreword." In *Word on the Street: Photographs by Richard Nagler,* 1–7. Berkeley: Heyday Books.

————. 2010b. "Irving Petlin: The Committed Brushstroke." *Art in America* 98 (March): 106–15.

*————. 2010c. "Jordi Alcaraz: Expanding the Legacy." In *Jordi Alcaraz,* 101–27. Barcelona: Galeria Nievez Fernandez.

*————. 2010d. "Remembering Serge." In Renee Price, *From Klimt to Klee,* 18–20. New York: Neue Galerie.

————. 2011. "A Brief History of Abstract Painting." In *Framing Abstraction: Mark, Symbol, Signifier.* Los Angeles: Los Angeles Municipal Gallery.

EXHIBITIONS

Pomona College

1955	*The Architecture of Greene and Greene.*
1956	*Rico Lebrun.*
1957	*German Expressionist Painting, 1900–1950.* Also University of California, Berkeley, and Santa Barbara Museum of Art.
1957	*The Work of Buckminster Fuller.*
1958	*Stieglitz Circle.*

Museum of Modern Art, New York

1959	*New Images of Man.* Also Baltimore Museum of Art.
1960	*Jean Tinguely: Homage to New York.*
1960	*Art Nouveau.* Also Carnegie Institute, Pittsburgh; Los Angeles County Museum of Art; Baltimore Museum of Art.
1961	*Mark Rothko.* Also London, Amsterdam, Brussels, Basel, Rome, Paris.
1961	*Futurism.* Also Detroit Institute of Arts and Los Angeles County Museum of Art.
1961	*Fifteen Polish Painters.* Circulated courtesy the CBS Foundation, Inc.
1961	*Chagall: The Jerusalem Windows.* Also Paris.
1962	*The Work of Jean Dubuffet.* Art Institute of Chicago and Los Angeles County Museum of Art.

1963 *Emil Nolde.* Also San Francisco Museum of Art and Pasadena Art
 Museum.
1963 *Auguste Rodin.* In collaboration with the California Palace of the
 Legion of Honor, San Francisco.
1964 *Max Beckmann.* Also Museum of Fine Arts, Boston, and Art Institute
 of Chicago.
1965 *Alberto Giacometti.* Also Art Institute of Chicago; Los Angeles
 County Museum of Art; San Francisco Museum of Art.

University Art Museum, Berkeley

1966 *Directions in Kinetic Sculpture.* [First international show of kinetic art
 in U.S.] Also Santa Barbara Museum of Art.
1967 *Funk.* Also Institute of Contemporary Art, Boston.
1968 *Hundertwasser.* [First Hundertwasser exhibition in U.S.] Also Santa
 Barbara, Houston, Chicago, New York, Washington.
1969 *The Drawings of Eric Mendelsohn.* Also Museum of Modern Art, New
 York.
1969 *Richard Lindner.* [First Lindner retrospective exhibition in U.S.] Also
 Walker Art Center, Minneapolis.
1969 *De Kooning: Recent Paintings.* Also Art Institute of Chicago and Los
 Angeles County Museum of Art.
1972 *Harold Paris: The California Years.*
1973 *Ferdinand Hodler.* [First major museum show of Hodler in U.S.] Also
 Guggenheim Museum, New York, and Busch-Reisinger Museum,
 Harvard University.
1976 *The American Presidency in Political Cartoons, 1776–1976.* Sent on
 national tour, concluding at National Portrait Gallery, Washington,
 D.C.

National and International Exhibitions and Activities

1959 Selection of American Painting and Sculpture for *I. Paris Biennale
 des Jeunes.*
1961 Leonard Baskin exhibition for Museum Boymans Van Beuningen,
 Rotterdam.
1962 Commissioner, Committee of Selection of American Art, *31st
 Biennale, Venice.*
1963 Selection of American Sculpture for *Battersea Park Exhibition,*
 London.
1966 *Seven Decades, 1895–1965: Crosscurrents of Modern Art.* Sponsored by
 the Public Education Association, New York; held in ten New York
 galleries.

1978 *German and Austrian Expressionism: Art in a Turbulent Era*. Museum of Contemporary Art, Chicago. Also Minneapolis Institute of Arts.

1979–80 *Amerika: 2 Jahrzehnte Malerei, 1920–1940*. Städtische Kunsthalle, Düsseldorf.

1979–80 *2 Jahrzehnte amerikanische Malerei, 1920–1940*. Kunsthaus, Zurich.

1979–80 *Peinture américaine, 1920–1940*. Palais des Beaux-Arts, Brussels.

1980 *German Realism of the Twenties: The Artist as Social Critic*. Minneapolis Institute of Arts. Also Museum of Contemporary Art, Chicago.

1989 *Twelve Artists from the German Democratic Republic*. Busch-Reisinger Museum, Harvard University. Also Frederick S. Wight Gallery, UCLA; University of Michigan Museum of Art, Ann Arbor; Albuquerque Museum of Art.

1991 *Sam Francis: Blue Balls*. Gagosian Gallery, New York.

1992 *Max Beckmann: The Self-Portraits*. Gagosian Gallery, New York.

1997 *Diversity*. Hugo de Pagano Gallery, New York; Bomani Gallery, San Francisco.

1997–99 *Tobi Kahn: Metamorphoses*. Museum of Fine Arts, Houston, and seven additional venues.

2001–2 *Nathan Oliveira*. San Jose Museum of Fine Arts and four additional venues.

2005 *Atheism and Faith: The Art of Leonard Baskin*. Graduate Theological Library, Berkeley, California.

2007 *Robert Colescott*. Meridian Gallery, San Francisco, followed by national tour.

2010 *Centenary Exhibition of Morris Graves*. Michael Rosenfeld Gallery, New York.

2010 *The Visionary Art of Morris Graves*. Meridian Gallery, San Francisco.

2011 *Heads*. Dolby Chadwick Gallery, San Francisco.

Acknowledgments

The debts incurred by the author of a book such as this are legion. This biography relies heavily upon oral history interviews to construct a nuanced picture of its subject. The complexity of any life may not be discerned from a single source, including and perhaps especially the subject himself, and so the interview subjects are deserving of the author's deepest gratitude. My own experience throughout this process of asking, listening, and recording has been one of grateful discovery. The net result is the illusion that I have come to know my subject intimately. That, of course, is not the case, but without the interviewees and others who have shared their own firsthand experiences and observations of Peter Selz, I would not have had the confidence to begin writing and certainly not to continue as the story became increasingly complicated and elusive.

For this gift of personal insight and knowledge I wish to introduce and applaud my main sources who were interviewed between 2007 and 2010: Wayne Andersen, Dore Ashton, Hildegard Bachert, Fletcher Benton, Gary

Carson, Christo and Jeanne-Claude, Fr. Terrence Dempsey, Agnes Denes, Eleanor Dickinson, Jane Daggett Dillenberger, Hannah Forbes, Rupert Garcia, Marianne Hinckle, Tobi Kahn, Karl Kasten, Jerelle Kraus, Susan Landauer, Charles and Zelda Leslie, Ronald Mallory, David McKee, Karen Moss, Nathan Oliveira, Ariel Parkinson, Jack Rutberg, Elizabeth Sandvig, Carole Selz, Edgar Selz, Gabrielle Selz, Peter Selz, Tanya Selz, Norma Schlesinger, Michael Spafford, Sidra Stich, Kristine Stiles, Mary Valledor, Carlos Villa, and Norton Wisdom.

Another category of informants falls somewhere between a proper recorded interview and a phone conversation with notes taken. Often the voice contact was followed by e-mailed accounts and further phone clarification of important details. Among this important group of individual sources to be thanked are Svetlana Alpers, Jacquelynn Baas, Birgitta Wohl Baer, Kyra Baldwin, Anne Brodzky, Richard Buxbaum, James Cahill, Richard Cándida Smith, Derrick Cartwright, Enrique Chagoya, Dion Cheronis, Terri Cohn, Bruce Conner, Sophie Dannenmüller, Lorna Price Dittmer, Tom Freudenheim, Peter Gay, Nancy Genn, Mark Harrington, John Held Jr., Deborah Paris Hertz, Kevan Jenson, Mark Dean Johnson, David Jones, Paula Kirkeby, Tom Luddy, Susan Matthews, Michael Meyer, Achim Moeller, Ursula O'Farrell, Loren Partridge, Sheldon Renan, Brenda Richardson, Lawrence Rinder, Andy Stewart, William T. Wiley, and David Wright. I also thank the many others with whom I have spoken, even casually, about the project and who have made comments that, though not recorded, have shaped some part of my thinking on the subject and the time period. In fact, I owe special gratitude to those many friends and other generous souls who indulged me over the past several years as I took advantage of their good nature to give regular updates on my Selz progress. Several individuals read early versions of chapters and made useful, frequently significant, suggestions. Chief among these were Peter Gay, Ellen Heath, Leo Holub, Carl Landauer, Susan Landauer, Peter Mendenhall, Barry Menikoff, Michael S. Moore, Ilona Staprans, Raimonds Staprans, and David Vershure.

There were also several generously supportive funders for this project, specifically for the research and writing. For this I am particularly grateful because the book could not have been realized otherwise. Among the project funders, all friends and admirers of Peter Selz, in addition to one anonymous donor, were Douglas Adams (Graduate Theological Union), Fletcher and Bobbie Benton, Charles and Glenna Campbell, Tracey Freedman and Michael Hackett (Hackett-Freedman Gallery), Paula Kirkeby, Russ McClure, Harry Y. Oda, Harold and Gertrud Parker, Jack Stuppin, and the Hans G. and Thordis W. Burkhardt Foundation.

The transcriber for the entire Selz Oral History Project, Debi Devitt of

Pioneer Transcription Services, Penn Valley, California, took on a prodigious assignment consisting of fifty-five sessions. Included in that figure are eleven generally shorter sessions with Peter Selz conducted over the duration of the research phase. These were undertaken to augment the major oral history I conducted in 1982 for the Smithsonian Archives of American Art's renowned oral history program. That key transcript, along with those for my subsequent Selz interview of 1999 and the official interviews conducted by Sharon Zane in 1994 for the official Museum of Modern Art Oral History Program, constitutes the primary source material for the biography. Ms. Zane's excellent and informative interviews with several other MoMA staff were most valuable in augmenting my own interviews. My treatment at the Museum Archives of the Museum of Modern Art, New York, was most hospitable. For that I have to thank associate archivist Michelle Harvey, who graciously and efficiently assembled the relevant archival materials I requested, including papers of individuals as well as the Zane transcripts. Ms. Harvey was coincidentally preparing a thesis on Selz's main associate at MoMA, William Seitz. Her subsequent and thorough handling of a key photograph inquiry seemed to me to go beyond what might ordinarily be expected. Others who were helpful with photography requests were Stephanie Cannizzo (Berkeley Art Museum), Eleanor Dickinson, Robert Emory Johnson (Chester Kessler Estate), Sue Kubly, Dennis Letbetter, Peter Mendenhall, Achim Moeller, Richard Nagler, and Jack Rutberg. Final choices for inclusion in the book came from their offerings and from Peter Selz's own albums and scrapbooks.

Throughout this long process Peter and Carole Selz were encouraging and patient, guiding me back to the main biographical highway when I found myself tempted by picturesque side roads. Peter's daughter Gabrielle from the outset was taken with the project, which she helped to launch as subject of the first interview in the Selz series other than her father's. Throughout the research and writing she was available for consultation and confirmation of a wide range of family lore and facts. She also made available the tapes her mother, Thalia, and Peter recorded in 1993 and 1994 in New York and Berkeley. Their reminiscences about their life together and the failure of their marriage in New York constitute the most emotionally stirring and character-revealing documents of the entire project. Gabrielle herself was the subject of two separate interviews, one conducted in New York and the other in Berkeley. Thomas B. Selz was helpful in arranging an interview with his father, Peter's older brother, Edgar, who died some months following at age ninety-three. Edgar was the last remaining direct link to the Selz brothers' shared Munich past.

This brings me to the critical editorial phase of the writing and my greatest debt of all. As I was struggling to bring together the complicated compo-

nents of a hybrid biography—seeking a way to effectively join multiple interview quotes with the many people, events, times, and themes that provide the context for Selz's life—my wife, Ann Heath Karlstrom, took notice and, with spousal compassion along with an understandable measure of trepidation, stepped in. As editorial consultant and book development editor, she brought to the project the considerable experience of her years as director of publications at the Fine Arts Museums of San Francisco as well as having patiently listened to me as I narrated the progress of the research. As her colleague at the University of California Press, Deborah Kirshman, the guiding light of this endeavor from the beginning, told me, "She is exactly what you and this book need." Deborah was, as is usually the case, right on the mark. I am grateful to Deborah and to her colleagues at the press: Kari Dahlgren, Sue Heinemann, Eric Schmidt, Claudia Smelser, Heather Vaughan, and Jacqueline Volin. Also, Anne Canright provided a welcome and thorough final edit of the manuscript. The book owes a great deal to the professionalism of these individuals. Finally, Jeff Gunderson, librarian at the San Francisco Art Institute, deserves special appreciation for agreeing late in the process to prepare the selected Selz bibliography and exhibition history.

Index

Fig. and *Figs.* refer to the gathered illustration section.

di Suvero, Mark, 185
Dittmer, Lorna Price, 203–4
Donahue, Daisy, 23, 217n32
Donahue, Kenneth (Kenny), 22–23, 27–28, 217n32
Dorment, Richard, 101, 229–30n14
Dove, Arthur, 19, 46, 47
Downtown Gallery (N.Y.C.), 46
Dreier, Katherine, 220n5
Drew Theological Seminary, 173
Drexler, Arthur: *Art Nouveau* exhibition and, 83; at MoMA planning retreat, 65, 66; MoMA role of, 52–53, 54, 57
Drey, Edith. *See* Selz, Edith (Drey) (mother)
Drey, Julius (maternal grandfather): death of, 6, 216n14; illustration of, *Fig. 3;* knowledge of art, 1, 4–5, 214n10; living situation of, 2, 3; mansion and gallery of, *Fig. 2, 1;* Peter influenced by, 1, 4–6, 14, 139, 205
Drey, Marie (maternal grandmother, Frau Julius Drey), 17
Dubuffet, Jean: "assemblage" coined by, 88–89; MoMA exhibitions of, 55, 72, 89–91; Ossorio influenced by, 74; Selz influenced by, 32; Selz's view of, 185; work in *New Images of Man* exhibition, 64, 70
Duchamp, Marcel: on art as idea, 101; opening at Cordier Ekstrom, 116; poem by, on handout for *Jean Tinguely*, 81; at Pop Art symposium, 101; reconsideration of work, 172–73, 209, 244n71; scholarship on, 158; Seitz and Selz on, 70–71; Selz's view of, 244n71; sexual behavior of, 156; Société Anonyme and, 220n5; works: *Étant donnés,* 172–73
Duncan, Robert, 125
Dürer, Albrecht, 4

Eakins, Thomas, 103
Einstein, Albert, 127
El Greco, 5
Elliott, James, 146, 148, 237n43
Elsen, Albert, 92, 226–27n47
Emil Nolde (exhibition), *Fig. 14,* 66–67, 91
Ettlinger, L. D., 151
Europa (steamship), *Fig. 8,* 11, 12
European Legacy, The (journal), 171
"Evenings on the Roof" music series, 43
Excellence (exhibition), 124

Exhibition Momentum (group), 33–34
exhibitions: curatorial freedom in, 55–57, 58; idea vs. execution of, 58; listed, 257–59; political and market-driven influences on, 59–60; Selz's voice in, 200–205; as tributes to Selz, 177, 181, 235n21, 247n28; trustees' influence on, 58–59
—by Selz at BAM: Barbara Chase-Riboud, 158, 159; criticism of, 158–59; *Directions in Kinetic Sculpture,* 123, 126–28; *Excellence,* 124; René Magritte, 123; Jules Pascin, 123. See also *Funk* (exhibition)
—by Selz at LACMA: *Four Abstract Classicists,* 43–44
—by Selz at MoMA: *Alberto Giacometti,* 72, 92, 95–96; *Art Nouveau,* 73, 82–85, 228n3; *The Art of Assemblage* (with Seitz), 73, 88–89, 236n32; *Auguste Rodin,* 91–92, 170, 226–27n47; *Emil Nolde, Fig. 14,* 66–67, 91; *Fifteen Polish Painters,* 61; *Futurism,* 87–88; *Max Beckmann,* 72, 92–95, 218n14; *U.S. Representation,* 53–54; Venice Biennales, 56, 60–61; Peter Voulkos, 62; *The Work of Jean Dubuffet,* 55, 72, 89–91. See also *Jean Tinguely* (exhibition); *Mark Rothko* (exhibition); *New Images of Man* (exhibition)
—by Selz at Pomona College: contemporary artists, 34, 218n17; Leon Golub, 41; Greene and Greene (architects, exhibition), 41; *Stieglitz Circle,* 45–47
—by Selz in later years: venues and overview of, 181–82; *About Drawing,* 190; *Centenary Exhibition of Morris Graves,* 190; Ferdinand Hodler, 186, 198; *German and Austrian Expressionism: Art in a Turbulent Era,* 198; *Hans Burkhardt* (with Rutberg), 196–97; Richard Lindner, 182, 198; *Robert Colescott,* 182; *Sam Francis,* 181; *Twelve Artists from the German Democratic Republic* (with Ashton), 183; *The Visionary Art of Morris Graves,* 182
existentialism, 74–75, 157
Expressionism (arts festival), *Fig. 12*

False Image, The, 33
Family of Man, The (exhibition), 59
Farber, Manny, 75, 222n32, 223n6
Farm Security Administration, photographs by, 59

121; Selz's relationship with administrators at, 138–39, 141–48. *See also* Berkeley Art Museum (BAM, formerly University Art Museum [UAM]); UC-Berkeley art history department

UC-Berkeley art history department: BAM and faculty of, *Fig. 18*, 41, 138, 143–44; conservatism of, 151–52; Selz and Chipp as modernists in, 152, 217–18n8; Selz's friends in, 186; Selz's tenured position in, 119, 148, 149; sexism of, 159. *See also* art history; students; teaching

University of California Press, 152, 204, 213n6

University of California Regents: administrative and budget changes, 141, 143, 145; Guggenheim proposal accepted by, 141; responses to student activism, 140, 145–46

University of Chicago: contemporary art exhibition of, 34, 218n17; political participation at, 38; students at, 27–29, 173, 174

University of Illinois at Chicago (UIC), 30

U.S. Representation (exhibition), 53–54

Valentin, Curt, 20, 28
Valentiner, William, 28
Valley Curtain project (Christo and Jeanne-Claude), 153
Van Gogh, Vincent, 197
Varnedoe, Kirk, 230–31n25
Vedova, Emilio, *Fig. 18*
Venice (Italy): proposed study center at, 140–42; Selz's visit to, 67
Venice Biennales, 56, 60, 250n6
Vietnam War, 24, 133
Villa, Carlos, 186–87, 188
Visionary Art of Morris Graves, The (exhibition), 182
Voulkos, Peter: at BAM opening, 125; circle of, 135–36, 187; foundry assistant of, 150; illustration of, *Fig. 18*; Selz's support for, 62, 156; work in *Funk* exhibition, 123, 128, 130

Wagner, Ronald, 119
Walden, Herwarth, 35–36
Walker Art Center (Minneapolis), 198
Wallace, William, 213n6

Warhol, Andy: collectors of, 98; Conner compared with, 130; instant art history of, 100; Pop Art of, 101–2, 104; reconsideration of work, 209, 250n8; retrospective on, 207, 209; scholarship on, 101, 229–30n14
Warhol Live (exhibition), 207, 209
Watts Towers (Rodia), 155
WCA (Women's Caucus for Art), 158, 159–60
Weber, Max, 34, 46
Weihnacht, Douglas, 224n16
Weil, Paul (half-brother), 1–2, 10
Weitz, Eric D., 215n23
Werkleute (Working People): activities of, 6, 7; centrality for Selz, 113; reading and discussions in, 7–8; role in adapting to New York City, 14–15, 17; sexuality and, 16
Wertheimer, Trudy (later, Selz, sister-in-law), 13, 30
Wesselmann, Tom, 100
Wessels, Glenn, 138
West East Bag (WEB), 158–60
Westermann, H.C., 33, 78
Whisky a Go Go (club), vii–viii, 150, 213n2
Whitney Museum, 46, 233n5
Wight, Frederick, 41
Wiley, William T.: in BAM collection, 142; at BAM opening, 125; circle of, viii; on Funk, 131, 132; Slant Step show and, 128; work in *Funk* exhibition, 128
William Kentridge (exhibition), 207–8, 209
Williams, Joanna, 144
Wind Combs (Chillida), 185
Wingler, Hans Maria, 67, 223n41
Winston, Donald, 44–45
Winston, Elizabeth, 45
Wisdom, Ireland, viii
Wisdom, Norton ("The Artist"): on BAM, 126, 150; performance work of, vii; on Selz, viii, x, 150; on X (band), 213n2
Wisdom, Robin, viii
With, Karl, 41
Witkin, Jerome, 198
Wittkower, Rudolf, 168
women: discrimination against, 158–60, 234n11, 242n27; key role in creating MoMA, 49–51, 220n6; as muse, 194–95; Selz's reputation around, 155–56, 157, 164. *See also* feminism

Text: 10/14 Palatino
Display: Bauer Bodoni, Univers Condensed Light 47
Compositor: BookMatters, Berkeley
Indexer: Margie Towery
Printer and binder: Sheridan Books, Inc.